FALLING ROCKET

JAMES WHISTLER, JOHN RUSKIN, AND THE BATTLE FOR MODERN ART

PAUL THOMAS MURPHY

PEGASUS BOOKS

NEW YORK LONDON

FALLING ROCKET

Pegasus Books, Ltd.
148 West 37th Street, 13th Floor
New York, NY 10018

First Pegasus Books cloth edition December 2023

Interior design by Maria Fernandez

Library of Congress Cataloging-in-Publication Data is available.

ISBN: 978-1-63936-491-6

10 9 8 7 6 5 4 3 2 1

Printed in the United States of America
Distributed by Simon & Schuster
www.pegasusbooks.com

To Mike Guilfoyle

CONTENTS

CHAPTER 1

WHISTLER'S MOTHER

In the summer of 1871 James Abbott McNeill Whistler achieved his immortality: he regained the confidence he had lacked for years, perfected his distinct style, and suddenly—miraculously—began producing his greatest masterpieces. And when this happened, his mother was with him.

More than simply with him: Anna McNeill Whistler was instrumental in bringing about her Jemie's transfiguration.

Whistler's mother had come to London from the Confederate States of America seven years before. She was born a southerner in Wilmington, North Carolina, but for most of her adult life she had lived in the north—in Massachusetts, Connecticut, and New York. It was her second son, William, or Willie, who brought her south again. In 1860 Willie married a southerner, Ida Bayard King, and settled in Richmond, Virginia. In 1862 he joined the Confederate Army as an assistant surgeon. A year after that Ida fell fatally ill and Anna crossed enemy lines to tend to her until her death. After that, in the face of the appalling carnage of the Battle of Gettysburg, with Willie away at the front and conditions in Richmond deteriorating, Anna fled for England. She boarded a steamship in the city

of her birth, successfully ran the Union blockade, and in January 1864 landed in Portsmouth, England.

"General upheaval!!" James Whistler wrote of her arrival to his friend, Parisian artist Henri Fantin-Latour; "goings-on up to my neck!" For the past few months Whistler had lived at 7 Lindsey Row, on the Chelsea side of the Thames, sharing his home with French artist Alphonse Legros and Joanna "Jo" Hiffernan, his copper-haired Irish Catholic model, house-keeper, hostess, occasional agent, muse, and lover. He scrambled to resettle Legros, find Jo a "buen ritiro" a mile away, and "to empty my house and purify it from cellar to attic!"

Contributing to the upheaval, Whistler was at that moment engaged in battle with his London relations. Since his teens Whistler had found a refuge at the affluent Sloane Street home of his half-sister (and his mother's stepdaughter) Deborah, or Debo, and her husband, Francis Seymour Haden, a successful surgeon and, like Whistler, an extremely talented etcher. But over the years Haden's insultingly patronizing attitude toward his much younger brother-in-law had corroded their relationship. Now, Haden's overdelicate social sensibilities virtually destroyed it when he suddenly refused to have dinner at Whistler's home if Jo were also there. Maddened by this insult, Whistler rushed to Sloane Street and confronted Haden in "a great skirmish!" Haden threw Whistler out of his home and forbade his wife from seeing her brother at Lindsey Row.

Upon arriving, Anna complicated matters even further by immediately reintroducing her fervent Episcopal faith to her son's morally relaxed world. "God answered my prayers for his welfare, by leading me here," Anna wrote to an American friend a month after arriving. "I . . . do all I can to render his home as his father's was." That meant, more than anything else, restoring to her son the belief in an all-knowing and ever-immanent God. From her Jemie's earliest childhood, Anna Whistler had struggled to inculcate that belief into him, instituting a strict daily routine of prayer and memorizing scripture, and instituting an even stricter observation of the Sabbath, which began on Saturday when Anna would empty her children's pockets of any worldly distractions, hide their toys, and scrub them clean for

Sunday—a day of up to three sittings at church, shut off from visitors, any entertainment, and any reading beside the Bible. The routine continued when Jemie moved with his family from Massachusetts to St. Petersburg, Russia, where Whistler's father, George Washington Whistler, had taken on the daunting task of building the St. Petersburg–Moscow Railway (and where he died of cholera in 1849); there, Anna managed to press her son into evangelical advocacy, setting him to distribute religious tracts to passing Russian troops. Whenever young Jemie was away from his family, Anna barraged him with letters exhorting him to keep to the path of righteousness. When he was fourteen and a pupil at an English boarding school, she wrote beseeching him to "Love him & honor his day & study His word & pray to him & dread to offend Him!" Three years later when Jemie, following in his father's footsteps, became a cadet at West Point, Anna clearly began to fear that he had strayed from the path. "Shew you have moral courage, by resisting idle examples," she urged; "none can work out your sanctification but yourself!" And when in 1855, twenty-one-year-old Whistler fled America for the bohemian stir of Left Bank Paris, determined to become an artist, Anna's hopes and fears for him were summed up, letter after letter, in one relentless refrain: "Oh Jemie keep innocency!"

But by then Jemie had long lost his innocency. During his schoolboy year in England he took to drink—or at least his parents feared he had. At West Point, he struggled academically but excelled at piling up demerits for idleness and for insubordination. At eighteen, Whistler was treated at the Academy's infirmary for gonorrhea—a fact of which his mother remained blissfully ignorant. After he was expelled from West Point, Whistler took a government job mapping for the US Coast Survey and quickly lost it, largely because of his complete refusal to abide by working hours. In Paris he devoted himself body and soul to the bohemian life; he took as mistresses first the spitfire Fumette and then the cancan dancer Finette and was much more interested in carousing with English and "no shirt" French artist friends than in pursuing his lessons at the atelier of the painter Charles Gleyre.

But while Whistler had strayed from his mother's path he found his own, abandoning her God for what he would later call his "whimsical goddess": art. At ten, Whistler studied drawing at St. Petersburg's Imperial Academy of Fine Arts, having already studied under a personal tutor from the Academy. At fourteen, he declared to his father his resolve to become a painter: "I wish to be one so *very* much and I don't see why I should not, many others have done so before." While he floundered in most of his other classes at West Point, he excelled at drawing. During his short time at the US Coast Survey he mastered the skill of etching, an art form he had almost certainly dabbled in years before while living with his brother-in-law Seymour Haden. Though he might have learned little in Paris from Charles Gleyre, the two lessons he *did* learn from him proved invaluable. First, he learned the practice of carefully choosing and arranging the limited colors of his palette before beginning: in effect, forcing himself to create a work fully in his mind before translating it to canvas. Second, he adopted as gospel the conviction that the color black was a "universal harmoniser," a part of and a basis for every other tone. His days and nights carousing with his young fellow artists were hardly time wasted, for they provided him with an intense schooling in art history and art theory, with constant debates about the opposed schools of Neoclassicism and Romanticism—the powerful lines of Ingres set against the glorious colors of Delacroix—and with discussions of the emerging school of Realism and its emphasis upon the accurate depiction of life. Realism's best-known exponent, Gustave Courbet, Whistler had already met; later, the two would work together, and Whistler would even consider himself Courbet's disciple—for a time.

During his final days as a student in Paris in 1859, Whistler proved his irrevocable commitment to his whimsical goddess by creating the masterwork of his apprenticeship. *At the Piano*, Whistler's portrait of his half-sister Debo playing while her daughter Annie watches, anticipates in many ways the great Whistler portraits that would follow over the next five decades, with its simple, careful arrangement and its limited and yet glorious sense of color: balanced black and white figures of mother and daughter backed by golds, browns, and greens "reappearing continually here and there like

the same thread in an embroidery," as Whistler later described this central effect of his style. Whistler would not use the term "harmony" to title any of his paintings for years to come, but in *At the Piano* Whistler had created his first true harmony. Whistler submitted *At the Piano* to the prestigious Paris Salon of 1859. It was rejected. He then submitted it to the 1860 exhibition at London's Royal Academy. 1860. It was accepted, and was a great success. It was "the most vigorous piece of colouring in this year's exhibition," lauded Tom Taylor, art critic for the *Times*. The esteemed artist John Everett Millais concurred, telling Whistler that "I never flatter . . . but I will say that your picture is the finest piece of colour that has been on the walls of the Royal Academy for years."

The English success of *At the Piano*, its sale to a member of the Royal Academy, and the prospect of further commissions all motivated Whistler by 1860 to leave Paris and relocate to London. Before long he had discovered and taken up with seventeen-year-old Jo Hiffernan, and together they pursued his whimsical goddess to a place few had pursued her before: the seedy bankside of the industrial Thames. They moved into rough quarters in Rotherhithe, where they lived, according to fellow artist George du Maurier, "among a beastly set of cads and every possible annoyance and misery, doing one of the greatest chefs d'oeuvres—no difficulty discourages him." This *chef d'oeuvre* Whistler called *Wapping*, a vignette of a prostitute (modelled by Jo) peddled by her pimp, the chaotic Thames shipping minutely detailed behind them. *Wapping* gave Whistler immense difficulty and discouraged him: he abandoned it for two and a half years, not finishing it until his mother was there to see him do it.

By mid-1862 Whistler moved upriver to Chelsea, lured both by the Thames and by its growing community of artists. He and Jo took lodgings at 7a Queen's Road, and in March 1863 they moved to 7 Lindsey Row, directly abutting the river and offering a view Whistler loved: a jumble of rowboats resting on the near bank, the dirty river beyond, bustling with ferries, pleasure boats, and lighters, and beyond that, across the wooden-piered Old Battersea Bridge, the gritty industry of Battersea itself—flour and sawmills, turpentine and chemical works: raw industry softened for

the Chelsea viewer both by distance and by London's usual smoky fogs. The rowboats belonged to his neighbor Charles Greaves, who lived two doors down with his salt-of-the-earth wife and children: "a sort of Peggotty family," Whistler said of them. As boatbuilder, oarsman, and ferryman, Charles Greaves had a generation before performed his own great service to high art: back when the great Joseph Mallord William Turner was his neighbor, Greaves had guided the aging artist, sometimes in the company of his aging mistress, on inspirational excursions about the Thames. Soon after moving in, Whistler found his own guides to the river in Greaves's sons.

He came upon seventeen-year-old Henry and nineteen-year-old Walter Greaves by the riverbank, painting the scene while he watched. "Come over to my place," he suddenly said. They did—and instantly became acolytes. "I lost my head over Whistler when I first met him and saw his painting," Walter remembered. He never quite got it back again. For the rest of his long life—long after Whistler eventually abandoned him—Walter adored Whistler: dressing like him, adopting his mannerisms, imitating his painting style, and always looking back upon their years together as a golden age. For the next dozen years and more, Walter and Henry served Whistler with a slavish devotion; they were his unpaid assistants—but also his nonpaying pupils. They prepared his canvases, his paints, his frames; they witnessed his often turbulent sessions with models; and they shared his techniques as they painted beside him—Whistler painting from nature or his models; the Greaves brothers painting from his paintings.

"He taught us to paint," Walter remembered, and "we taught him the waterman's jerk"—taught him, in other words, to row the Thames. Within the next few years they would spend countless nights and early mornings on the river with Whistler, always the dandy, ostentatiously nautical in white trousers, blue coat, and a sailor's hat. While they rowed, he sketched with black and white chalk on brown paper: upriver to Putney, downriver to Wapping—or simply rambling about the Chelsea and Battersea shores, where he could see the fireworks of nearby Cremorne Gardens rise up over the arch of Old Battersea Bridge. The Greaves boys introduced him to the demimonde pleasures of Cremorne as well: its sideshows and pyrotechnics,

its dancing by gaslight and shady bowers. He would sometimes go there with one of the Greaves' sisters, sometimes with Jo, but always flanked by the brothers. There, too, he would sketch. The Greaves home itself Whistler adopted as his haven, spending many evenings in the little parlor chatting, flirting with the girls, joking, dancing, and singing comic songs—and sketching, always sketching. When his mother arrived in Chelsea in early 1864, she quite happily joined him there.

———

From the moment she came to the newly purified 7 Lindsey Row, Anna Whistler did her best to restore God to her Jemie's life. She instituted nightly prayers and Bible reading for family and servants. She faithfully attended nearby Chelsea Old Church, which she chose for its "Evangelic spirit." She insisted that her Jemie scrupulously honor the Sabbath by forgoing any socializing and refraining from all work—particularly from painting. Whistler benignly accepted her pervasive piety. But none of it had any effect upon his soul. Evening prayers hardly kept him from enjoying late nights with his artist friends or from prowling Cremorne's profane paths. On Sundays he would dutifully accompany his mother to church and dutifully accompany her back home. While first, simply to please her, he would stay for the service, in time he did this less and less. And his relentless desire to create often overwhelmed her Sabbatarianism; one time Anna, returning from church, was indignant to find that he had with the help of the Greaves brothers painted two great ships onto the hallway walls.

If Whistler's respect for his mother's God was slight, Anna's respect for his goddess was heartfelt and strong. Although ever-mindful of the world to come, Whistler's mother was neither blind nor hostile to the beauty of this world, nor to her son's extraordinarily sensitive appreciation of that beauty. Seeing her Jemie sketch not long after he began to walk and talk, she had done her best to cultivate his talent, visiting galleries, academies, and palaces on their travels to England and Russia, and introducing Jemie to artists such as Sir William Allen, who discerned in nine-year-old

Jemie "uncommon genius," or the Academician William Boxall, who was commissioned in 1849 to paint fourteen-year-old Whistler—allowing the boy to see himself hanging at the Royal Academy's exhibition later that year. While Anna responded cautiously when that same year Jemie vowed to be an artist, she supported his decision at twenty-one to study art in Paris—perhaps because she knew very well that she couldn't stop him. When Jemie created his first saleable art—twelve etchings that became known as the *French Set*—Anna became her son's most enthusiastic promoter, hawking sets to American friends and relatives. Now in Chelsea, immersed in her son's artistic world, she convinced herself that in his worship of beauty Whistler actually served *her* God: "His is natural religion," she wrote in 1872. "He thinks of God as the diffusive source of all he enjoys, in the glories of the firmament, in the loveliness of flowers, in the noble studies of the human form. The Creator of all!"

She clearly enjoyed being a part of her son's world, even if she found it a bit dizzying at first. "The Artistic circle in which he is only too popular, is visionary & unreal tho so fascinating," she wrote a month after she arrived. It must have seemed to her as if all of London's art world were making their way to Lindsey Row. Among visitors were those of the "Paris Gang," with whom Whistler had played and worked in France—Edward Poynter, Thomas Lamont, Tom Armstrong, and George du Maurier. Alphonse Legros, the French artist whom Whistler had to relocate to make room for his mother, now visited regularly—for a time. There was the circle of artists who lived and worked near Holland Park, including Frederick Leighton, George Watts, and Val Prinsep. One of Whistler's earliest patrons, the Greek consul Alexander Ionides, came often, and so did his family, whom Anna particularly liked. But the group that dwelt at the heart of Jemie's artistic universe and would dwell there throughout the 1860s and into the 1870s was the "Rossetti lot," as George du Maurier called them, enviously aware that they and Whistler were "as thick as thieves." In October 1862 Dante Gabriel Rossetti, haunted by the disturbing memories of his wife Elizabeth Siddal's suicide, had fled Blackfriars for Chelsea and the palatial Tudor House, a short walk downriver from the Whistlers. Rossetti

brought with him roommates: his brother William Michael Rossetti, the writer George Meredith, and the wildly free-spirited poet Algernon Charles Swinburne. Although that arrangement did not last, his brother William and Swinburne remained constant visitors. To ward off recurrent melancholy, Rossetti surrounded himself with an overabundance of exotic furnishings and an ill-managed menagerie that included wombats, kangaroos, and peacocks; installed his mistress Fanny Cornforth as fallen angel of the house; and opened Tudor House to a host of companions: first- and second-generation Pre-Raphaelites, budding Aesthetes, collectors, enthusiasts, and hangers-on. Frequent visitors included the artists Ford Madox Brown, William Morris, Edward Burne-Jones, William Bell Scott, and Frederick Sandys. The dealer Murray Marks did his best to keep Tudor House overfurnished. James Anderson Rose came as a friend and a collector, but also as Rossetti's solicitor: he soon became Whistler's—and Whistler's mother's. A continual presence, as well, was the inimitable Charles Augustus Howell, the fabulously inventive storyteller and liar, the schemer with a hand in everyone's business, and, at times, the masterful agent to Rossetti—and later to Whistler. "It was easier to get involved with Howell than to get rid of him," Whistler claimed. Finally, there was the one frequent guest to Tudor House that Whistler somehow managed *not* to meet: John Ruskin, once Rossetti's and the Pre-Raphaelites' staunchest supporter, unquestionably England's top art critic, and, more recently, irrepressible, thundering social critic and modern prophet.

At Tudor House Whistler could rendezvous with Jo and indulge until the early hours in conversation lubricated by drink. Anna, given Tudor House's bachelor atmosphere and her own perpetual and respectable widowhood, never visited. Instead, Tudor House came to her. Of the entire Rossetti lot, the one to whom she most warmed and who warmed most to her was Swinburne. It seemed on its face an odd affinity—the stolid, abstemious, devout widow and the wildly exuberant young man, the unabashed pagan, the alcoholic, the ardent flagellant. But Swinburne saved his excesses for elsewhere: his naked horseplay for Tudor House, his alcoholic scenes for the street or his clubs, his profounder blasphemies for his poetry, and his

sessions under the lash for two understanding prostitutes in St. John's Wood. At Lindsey Row and in Anna's sobering presence, Swinburne was partly a gentleman and partly a boy in need of mothering—mothering that Anna willingly gave him. He was for a time her "Algernon." She was known to lecture him parentally on the evils of alcohol. When he suffered a convulsive fit in her home, it was Anna who nursed him.

When Anna arrived in Chelsea, the Rossetti lot were in the clutches of a mania—one Whistler himself had provoked. "This Artistic abode of my son, is ornamented by a very rare collection of Japanese & Chinese," she wrote of his porcelain; "his companions (Artists) who resort here for an evening relaxation occasionally, get enthusiastic as they handle & examine the curious subjects portrayed, some of the pieces more than two centuries old; he has also a Japanese book of painting, unique in their estimation." Whistler was in Paris in the years after Japan's forced opening to western trade, when a growing stream of oriental art and artifacts attracted the attention of French artists. His acquaintances there—the etcher Félix Bracquemond and his printer Auguste Delâtre—began collecting woodcuts by the great Ukiyo-e artists Hokusai and Hiroshige. By the time Whistler moved to Chelsea, he was an avid collector of these, and more. The fever spread; Dante Gabriel Rossetti in particular competed with Whistler to procure the best blue and white china available.

Whistler's study of Japanese art had long influenced his style; *At the Piano*, in particular, demonstrates a debt to the Japanese print, with its deliberate flatness, its emphatic verticals and horizontals, its limited palette, and its harmonious repetition of color. But by the end of 1863 Whistler's passion with *Japonisme* took on a new form as he began to produce paintings that did not simply reflect oriental technique, but burst with Asian ornament: fans, kimonos, blue and white china, carpets, prints, and screens. He was working on three of these paintings when his mother arrived. Anna described the first: "A girl seated as if intent upon painting a beautiful jar which she rests on her lap, a quiet & easy attitude, she sits beside a shelf which is covered with Chinese Matting a buff color, upon which several pieces of China & a pretty fan are arranged as if for purchasers. . . ." The girl was Jo, though as

far as Anna was concerned she was simply one of Whistler's several models. The painting is *The Lange Leizen of the Six Marks*, the marks referring to the Chinese characters painted on the bottom of Chinese vases. For his painting *La Princesse du Pays de la Porcelaine* (*The Princess of the Country of Porcelain*), Whistler employed a colorful, kaleidoscopic collection of Asian artifacts—salmon robe, silver kimono, blue carpet, mottled screen, and fan—to set off the stunning model Christine Spartali, a Greek beauty Whistler had met through the Ionides family. Twice a week in early 1864 Spartali, always accompanied by her sister Maria, would come to pose for Whistler. Anna assisted, providing an "American" lunch at 2:00: champagne, roast pheasant, tomato salad, and apricots and cream, according to one menu. Maria Spartali was struck by Whistler's sincere devotion to his mother, as well as by Anna's calm dignity.

The third painting Anna describes as well: "a group in Oriental costume on a balcony, a tea equipage of the old China, the[y] look out upon a river, with a town in the distance. . . ." This was *The Balcony*—actually painted upon the Whistlers' upstairs balcony. Again, Whistler broadened his palette, this time with four distinctly western models in varicolored Japanese clothing, weighed down with Japanese props. What differed in this painting was its distinctive background: nothing Japanese, but rather industrial London: a monochromatic rendition of the factories and smokestacks of Battersea, transformed by haze into something more exotic, more mysterious, more magical than the foreground with which it competes. The Japonaiserie of *The Balcony* reflects the phase that Whistler was going through. The view beyond, however, offers a hint to Whistler's artistic future.

Whistler's embarking simultaneously upon three paintings of such color and variety suggests that his mother came at an inspired and productive point in his career. Actually, his career was entering a prolonged period of doubt and frustration. He confessed as much to Henri Fantin-Latour: "I should like to talk to you about myself and my own painting—But at this moment I am so discouraged—always the same thing—always such painful and uncertain work! I am *so slow!*" Slowness, however, was never

really Whistler's problem. Throughout his career, Whistler demonstrated again and again that, once he carefully chose and laid out his paints on his table-sized palette, he could compose and fill out, with remarkable finish, an entire canvas in one sitting. His problem now was a crippling lack of confidence. Whistler was an obsessive perfectionist, and if a painting fell short of his expectations in any way, he would rub it down and begin again—and again, and again. "I wipe off so much!" he complained to Fantin-Latour about *Lange Leizen*. And although he was adept at hiding from his Chelsea companions his lack of confidence with his relentless swagger, his vivacity, his brilliant and dominating presence in any room, his mother could see it: "no wonder Jemie is not a rapid painter," she wrote to a friend, "for his conceptions are so nice, he takes out & puts in over & oft until his genius is satisfied." He had genius, certainly—but a fragile one hampered by insecurity. Of all his paintings at this time, *The Balcony* proved the most frustrating of all: reworked, abandoned, and altered, Whistler would not complete it for another six years.

For Whistler's models and sitters, then and in the decades to come, posing was often an ordeal involving dozens of sessions aggravated by Whistler's barking insistence that they be still for hours as he painted, scraped, and repainted. That was certainly the case for Christine Spartali, sitting (or rather standing) for *La Princesse du Pays de la Porcelaine*. The work went quickly at first, her sister Maria remembered, but soon began to drag; just when they thought Whistler nearly finished, they would return to the studio to find that everything had to be done over. Whistler had a particular problem capturing Christine's head, and insisted she stand without rest as he worked and reworked. Christine silently endured the fatigue as long as she could; in the end, she became ill, or pleaded illness, and stopped coming, forcing Whistler to have a model stand in for her in order to finish the work.

In spite of the constant difficulties, Whistler persisted. He usually worked in his small studio upstairs in the back of the house, a *sanctum sanctorum* generally closed to his mother. "I am never admitted there, nor any one else but his models," Anna wrote—a prohibition she appreciated

when, years later in their next home, she slipped and walked into Jemie's studio unannounced to find a parlormaid "posing for 'the all-over!'" Of all Whistler's models, Jo Hiffernan was still his favourite. Though an exile from Whistler's home and his bed since Anna's arrival, she remained a continual presence in his studio and remained ubiquitous in his art, posing for *Lange Leizen* and almost certainly for *The Balcony*. Before that, in the winter of 1862, Jo had posed for the painting Whistler later titled *Symphony in White, No. 1: The White Girl*. Expressionless but wide-eyed, holding a drooping lily, Jo stands on a bearskin rug, her red hair blazing against her white dress and the white background. Whistler had great hopes for this painting and submitted it for the 1862 Royal Academy. It was rejected. He then submitted it for the 1863 Paris Salon. It was again rejected—as were three-fifths of all the paintings submitted. As a result of the vociferous protest that ensued, French emperor Napoleon III decreed an alternative exhibition, the *Salon des Refusés*. There, *The White Girl* gained more attention than any other painting with the possible exception of *Le Déjeuner sur l'herbe*, Édouard Manet's scandalous depiction of two women, nude and seminude, picnicking with two fully clothed men. *The White Girl* was a painting whose apparently symbolic elements—the lily, the white dress, the grinning bear at Jo's feet—begged for interpretation, for reduction to a narrative. But Whistler detested storytelling art, detested the sentimental narratives that informed and inspired most of the paintings of his day—including most Royal Academy paintings. A painting, he believed then and throughout his career, should be self-sufficient: beautiful within itself, not as the vehicle for a story or a moral. When, however, in the wake of the Royal Academy Exhibition, Whistler exhibited this painting in a small London gallery, critics and the public could not help but see it as an illustration from fiction because the gallery's owner mistakenly titled it *The Woman in White*—the title of Wilkie Collins's novel, hugely popular at the time. A reviewer in *The Athenæum* was scathing: the painting was "bizarre" and "one of the most incomplete paintings we have ever met with." Worst of all, "the face is well done, but it is not that of Mr. Wilkie Collins's 'Woman in White.'" Whistler quickly shot off a letter to the editor in response,

repudiating any narrative intent: "I had no intention whatsoever of illustrating Mr. Wilkie Collins's novel; it so happens, indeed, that I have never read it. My painting simply represents a girl dressed in white standing in front of a white curtain." That was the first—and perhaps the politest—of Whistler's many attempts to shape his image through his letters to the press.

When in late 1864 his mother, in poor health, left Lindsey Row for a stay in Torquay, Whistler brought Jo back to live with him and to pose for two more paintings. The first, *The Golden Screen*, is yet another fully loaded Asian fantasy: a kimonoed Jo sits on an oriental rug before a Japanese painted screen, next to a blue and white pot, contemplating a Hiroshige print. For the second, later titled *Symphony in White, No. 2: The Little White Girl*, Whistler brought Jo out of the studio and down to the drawing room, where she posed before the fireplace. In contrast to the Japonaiserie excess of his recent paintings, in this one Whistler showed remarkable restraint. The Asian elements are there, but are peripheral: two vases on the mantel, a Hiroshige fan in Jo's hand, a spray of azaleas in the foreground. As in *The White Girl*, simple whiteness predominates: in the dress, the mantelpiece. Jo stands in repose, her head, turned toward the mirror, conveying a distinct sense of melancholy—a melancholy even more pronounced in her reflected image. Strikingly, she wears a wedding ring, something that Whistler in reality never gave her.

The Little White Girl clearly aims for a self-contained depiction of pensive beauty and could not be mistaken as an illustration or depiction of any story, as *The White Girl* had been mistaken. Algernon Swinburne, however, was so deeply impressed by the painting that it became the basis for his poem "Before the Mirror," two verses of which Whistler appended to its frame. Swinburne sent a copy of this poem to John Ruskin, his friend through Dante Gabriel Rossetti, and in an accompanying letter Swinburne praised Whistler's painting to the skies: "whatever merit my song may have, it is not so complete in beauty, in tenderness and significance, in exquisite execution and delicate strength as Whistler's picture." He exhorted Ruskin to come with him, Edward Burne-Jones, and Charles Howell to Whistler's studio to view his paintings. "Whistler (as any artist worthy of his rank must be)

is of course desirous to meet you, and to let you see his immediate work . . . If I could get Whistler, Jones and Howell to meet you, I think we might so far cozen the Supreme Powers as for once to realise a few not unpleasant hours." Some kind of gathering might or might not have ensued, but John Ruskin took no part in it. Whistler exhibited *Symphony in White, No. 2: The Little White Girl* at the 1865 Royal Academy exhibition, where reviews were at best lukewarm, and after that at the Paris salon, where they were decidedly negative.

Also on display at the Royal Academy that year was a painting that mesmerized Whistler: *The Marble Seat*, a depiction of three women in classical dress reposing on a bench, languidly eyeing a naked youth pouring wine from a pitcher into a kylix. It was painted by twenty-four-year-old artist Albert Moore, whom Whistler may already have met; certainly he was familiar with Moore's work. But this work was different than anything by Moore he had yet seen. With its studied interplay of color, its linear rhythms, its refusal to fit any narrative, *The Marble Seat* demonstrated significant shared concerns with Whistler's work. But Whistler also could see a technical virtuosity in Moore's painting exceeding anything he himself had achieved. Viewers today might be hard-pressed to understand the novelty and the significance that Whistler and others saw in this work. But in 1865, *The Marble Seat* was a revolution and a revelation: as an uncompromising declaration of the power of art for art's sake, it was a foundational work of the Aesthetic movement. Algernon Swinburne, writing three years later of another of Moore's paintings, *Azaleas*, captured what Whistler saw in *The Marble Seat*:

> . . . of all the few great or the many good painters now at work among us, no one has so keen and clear a sense of this absolute beauty as Mr. Albert Moore. His painting is to artists what the verse of Theophile Gautier is to poets; the faultless and secure expression of an exclusive worship of things formally beautiful. That contents them; they leave to others the labours and the joys of thought or passion. The outlines of their work are pure,

decisive, distinct; its colour is of the full sunlight. This picture of
"Azaleas" is as good a type as need be of their manner of work. . . .
The melody of colour, the symphony of form is complete: one
more beautiful thing is achieved, one more delight is born into the
world; and its meaning is beauty; and its reason for being is to be.

During his Paris days, Whistler had formed with French artists Henri
Fantin-Latour and Alphonse Legros the Société des Trois, more a mutual
admiration society than an artistic movement. After seeing *The Marble Seat*,
he proposed to Fantin-Latour a reformulation of that society: throwing out
Legros—"a bit of a mongrel!" Whistler now called him—and bringing in
the "one other worthy of us": Albert Moore. "Oh Fantin I know so little!"
he had declared in despair a year before; now he began to think that this
young artist—seven years his junior—offered a solution to his problems. He
sought out Moore in his Fitzroy Street studio and began to spend a great
deal of time there, studying Moore's methods and finding inspiration for
his own work. Moore's influence can clearly be seen in Whistler's *Symphony
in White, No. 3*, which he began later that year. In it, Whistler retained the
white on white palette of the two earlier symphonies—*The White Girl* and
The Little White Girl—but radically reconsidered his composition to reflect
Moore's, draping his two models (one of them Jo) with determined, even
contorted languor about a sheet-shrouded sofa (rather than a marble bench).
For Whistler, this was a breakthrough: "I feel I am reaching the goal that I
set myself," he wrote to Fantin. "I am now fully conscious of everything
I am doing! So from day to day everything is getting simple—and now,
I'm particularly occupied with composition." Significantly, this was the
first painting to which Whistler actually gave a musical title; the other two
Symphonies in white and other earlier works he then retroactively renamed
similarly to emphasize his commitment to pure aestheticism, to evocative
arrangement rather than narrative depiction. Titling his works *Harmonies*,
Symphonies, *Notes*, *Arrangements*, and *Caprices* quickly became Whistler's
convention: an affront and a source of amusement to public and critics, and
fodder for *Punch* magazine.

In 1865, the Whistler family was reunited; Willie joined his mother and brother in London after a journey more harrowing than his mother's. Deciding to spend a four-month furlough from the Confederate army in London, carrying dispatches for Confederate agents in England and failing to run the Union naval blockade, Willie risked execution as a spy by crossing enemy lines. He made his way to New York and took ship for Liverpool. Just a week after he arrived in London, Lee surrendered at Appomattox and the Confederacy fell. With no reason to return, Willie settled in London to pursue his surgical career. Like his brother, Willie never returned to the United States. From the moment Willie arrived, the two brothers were "almost inseparable," according to Anna, as Whistler integrated Willie into London's art world, with frequent visits in particular to Tudor House, where the Whistler and Rossetti brothers formed similarly odd pairs: Jemie and Dante Gabriel ebullient, expressive, impulsive; Willie and William Michael sober, reserved, deliberate.

With sound medical training and as yet no license to practice in England, Willie had the ability and time to attend to his mother's worsening health, particularly to her deteriorating eyesight. In September, he brought her for treatment to a spa at Malvern, and after that to Koblenz to visit a celebrated oculist. Whistler accompanied them to Germany, but he quickly slipped away to join Jo in Trouville on the coast of Normandy, where, needing the money, he hoped to produce some saleable seascapes. There, apparently unexpectedly, he and Jo met Gustave Courbet. That autumn the two artists painted the sea together. In the evenings, Jo "played the clown to amuse us," sang Irish songs, and managed to work her way into Courbet's heart. Courbet now referred to Whistler as "my pupil." Once, Whistler too had seen himself that way, but his work of that summer indicates his profound departure from Courbet's realism. While Courbet in his own seascapes recreated what he saw with meticulous, textured detail, Whistler aimed not to recreate but to evoke: thinning his oils to watercolor consistency, he washed in with broad, visible brushstrokes horizontal bands of color suggesting

beach, sea, and sky, but also veering toward abstract arrangements of forms. He was experimenting with a style that was neither Courbet's nor Moore's but entirely his own.

Whistler returned to London in mid-November, and soon afterward Willie embroiled him in the most bizarre episode of his life. Willie was one of many rootless Confederate expatriates in London. Another was Henry Doty, an acquaintance of Willie's who had designed torpedoes for the Confederate navy. Doty, eager to put his exclusive skills to mercenary use, found his opportunity when in September 1865 Chile, bullied by the Spanish navy, declared war upon Spain. In January 1866 Chile contracted Doty to build torpedoes and torpedo boats for the Chilean navy, assemble a crew to ship them, and destroy the Spanish naval force then blockading the city of Valparaiso. Doty recruited Willie; Willie brought his brother in. Whistler could hardly have had any political motive for joining the expedition. But his years at West Point had given him an unrealistic and lifelong belief in his own military ability, and he almost certainly reveled in the notion of playing the soldier, especially after having sat out the American Civil War. More importantly, he needed the money. At a time when he found it difficult both to produce and to sell his art, the expedition offered the enticing prospect of a steady wage, travel and living expenses, and a hefty commission—if they succeeded. Whistler agreed to be Doty's secretary. While Doty and crew made their way west around Cape Horn, Whistler would travel more directly to Chile across Panama, escorting Doty's wife to Valparaiso, where he would then take note of naval and diplomatic movements in advance of Doty's arrival. Willie Whistler, on the other hand, fell away from the mission, most likely because as an unrepentant Confederate he could not obtain the US passport he needed to travel to South America. After making a will leaving everything to Jo and after farming out his mother to the Hadens, Whistler set out for Valparaiso in January 1866.

He and Mrs. Doty slipped into the city in early March to find its harbor blockaded by an eight-ship Spanish squadron. Ships from the US, Britain, France, Russia, and Sweden were also anchored there in the hope of negotiating a truce and reopening the trade route. Whistler—with his good

French and his passable Spanish and Russian—set about spying, filling out a notebook with gleanings from officials and officers, and traveling by rail and horseback about Chile and Chile's ally Peru: he got at least as far as Lima. On the last morning of March Whistler, back in Valparaiso, saw his first and only military action when for three hours Spanish ships bombarded the city. Whistler had taken refuge in the hills with city officials, and when a Spanish ship fired a single shell in their direction, they panicked: "I and the officials turned and rode as hard as we could, anyhow, anywhere." Later in the day they returned to Valparaiso to find that "all the little girls of the town had turned out, waiting for us, and, as we rode in, called us Cowards!" When soon afterward the Spanish squadron sailed north to Peru, that was in effect the end of his mission—and the end of any hopes for a hefty commission. Doty and the torpedoes, however, were still four months away, and Whistler had little to do except wait, drink, smoke a mountain of cigars, and socialize with, borrow from, and apparently sleep with Mrs. Doty.

And to paint.

Five, perhaps six paintings survive from Whistler's journey to Valparaiso. All are seascapes. And all, to a greater or lesser extent, show him experimenting as he had at Trouville, thinning his paints, working with long, fluid, horizontal strokes, aiming to capture a mood rather than recreate reality. The six form a series of sorts: studies of the ocean at different times of the day and night. Three of them are tentative, conservative, tending toward the representational. But two are revolutionary. *Crepuscule in Flesh Colour and Green: Valparaiso* depicts war but evokes peace, with warships of several nations suspended in a delicate balance between gentle grey-green sea and blue-violet twilight sky. And *Nocturne in Blue and Gold: Valparaiso Bay* relies on a palette limited almost entirely to a single, indeterminate blue-grey-green, a color mixed with greater or lesser amounts of black to allow for limited definition—a dock with the merest suggestion of a crowd of human beings, an indeterminate number of ships, muted hills on the horizon. Visible sources of light in the painting are minimal—yellow pinpricks on the ships and across the bay, a shower of sparks in the upper left

corner—and illuminate nothing. It was his very first nocturne, darkness forcing him toward abstraction.

In late July 1866 Doty finally arrived in Valparaiso and precipitated the final, farcical collapse of the mission. He publicly accused Whistler of seducing Mrs. Doty, but when Whistler challenged him to a duel, he withdrew the accusation. The Dotys soon left for England and Whistler followed a month later, animated by an angry, pugnacious spirit: an obsession with the not-so-gentle art of making enemies that would haunt him for months, that indeed would never quite leave him. On the voyage home he found a target in a luckless traveler from Haiti whom he derisively christened the "Marquis of Marmalade," who "made himself . . . obnoxious to me, by nothing in particular except his swagger and his colour." When this man dared share his meal with the other passengers, Whistler kicked him across the deck and down the companionway stairs. When Whistler later regaled his Tudor House friends with his account of this assault, William Rossetti, appalled by Whistler's blatant racism, expressed his disgust. Edward Burne-Jones, also there, "did not give vent to words of indignation," William Rossetti remembered. "But the look of his countenance spoke volumes on the subject." Confined to his cabin after the attack, Whistler the next day found his second victim: the ship's mail agent, "a strong abolitionist" according to Whistler, who gave him "a long and impertinent sermon" on his behavior. Whistler slapped him—and got his eye blackened in return. A final skirmish occurred when Whistler exited his train at Waterloo Station. Henry Doty, somehow catching wind of Whistler's arrival, confronted him there. For this "astounding impudence" Whistler punched Doty—and, according to Doty, he paid the price: Doty struck him back and shouted "this is Whistler the artist, a scoundrel, a seducer, a betrayer of his trust; mark him!" upon which Whistler abandoned his baggage and took cover in the station's cloakroom.

Whistler's emotional turmoil did not end there. Back in London Whistler went to live with Jo in her *buen ritiro*, but that arrangement did not last long. While he had been away, Jo had apparently slipped over to Paris to serve as model and possibly lover to Gustave Courbet. While there she

quite likely posed for Courbet's *Le Sommeil*, a brazenly erotic depiction of two nude women sleeping locked in an embrace. Jo's excursion could not have remained a secret for long, and Whistler could not have seen it as anything but a betrayal. In any case, around this time Jo abruptly ceased to be Whistler's muse and model and their relationship cooled—although it didn't quite end. By Christmas Whistler had returned to Chelsea and the Thames, and to his mother.

They moved to a larger house on Lindsey Row, number 2, which Whistler quickly set to decorating with the same minimalist sensibility he was now bringing to his paintings, rejecting Victorian surfeit for sparsely furnished rooms and harmonious arrangements of color on the walls. The dining room he painted blue, with darker blue dado and doors and with an accent of Japanese: "a fluttering of purple fans." The parlor he painted dark red with black woodwork. His studio he painted grey with black doors and dado. The drawing room he scrambled to finish in early February 1867 before his first dinner party, calling upon the Greaves brothers to help him paint the walls, doors, and woodwork in a harmony of beige, pale yellow, and white. "We three worked like mad," Walter Greaves said; he told Whistler the paint would never be dry in time. "What matter?" said Whistler, "it will be beautiful." Later Walter Greaves heard that dinner-guests—he was of course not one of them—left the house mottled with beige and yellow paint.

1867 was a rootless and anxious year for Whistler, a "whirl of excitement of ambition and hopes and disappointments and bitterness," he wrote to his mother from Paris that spring, as he shuttled back and forth between there and London, promoting himself in exhibitions in both capitals. Most of the paintings he managed to show were older ones. He did exhibit one of his Valparaiso paintings, *Crepuscule in Flesh-Colour and Green*, with several others at the Paris Exposition Universelle, but there all his paintings were hung so badly that "they have been more or less damned by *every* body." Although he did have a "complete success" at the Salon, the two paintings he showed there—*At the Piano* and *The Thames in Ice*—dated from the beginning of his career. At the Royal Academy he showed three

paintings, including *Symphony in White, No. 3*. That marked the public debut of his first musically titled work—and therefore offered the critics their first opportunity to attack his titles as evasive, pretentious, and altogether silly. Or inaccurate: Philip Hamerton of *The Saturday Review* noted that *Symphony in White, No. 3* "is not precisely a symphony in white" since it contained a yellowish dress, brown hair, a blue ribbon, and so on. Whistler lashed back, shooting off a letter to the editor that *The Saturday Review* chose not to publish: "*Bon Dieu!* did this wise person expect white hair and chalked faces? And does he then, in his astounding consequence, believe that a symphony in F contains no other note, but shall be a continued repetition of F F F? . . . Fool!"

He lashed out physically as well. That April, while visiting his friend Luke Ionides at his office, Whistler came upon his ex-friend Alphonse Legros. The two had apparently quarreled about money before Whistler left for Valparaiso, and now they quarreled again; when Legros suggested that Whistler was a liar, Whistler thrashed him—"covered me in wounds," Legros claimed. News of the assault split London's art world; Whistler's relationship with Rossetti cooled and Burne-Jones was particularly enraged, wanting to "call in the police." Just days after this, in Paris with his brother Willie, Whistler turned on his brother-in-law Seymour Haden. Though he hardly needed any new reasons to despise Haden, he found some anyway: Haden had, in Whistler's opinion, been slandering his recently dead partner, a man named James Traer, whom Whistler now claimed as his own very good friend. More than this, Haden, in Paris to organize Traer's funeral, had as far as the Whistlers were concerned made miserly and disrespectful arrangements; Traer's was the funeral "of a dog got rid of," according to Willie. Coming upon Haden in a Paris café, Whistler shoved him through a plate-glass window. Haden returned to London seething, determined to have his brother-in-law expelled from the Burlington Fine Arts Club, of which they were both members. Several months later, having carefully documented Whistler's string of assaults from Valparaiso to Paris, he succeeded. Again the art world took sides, William and Dante Gabriel Rossetti immediately resigning from the Burlington in sympathy with

Whistler. Whistler's family, too, was split: Anna informed Debo "I can never again enter the door of 62 Sloane St." Whistler and Haden never spoke again.

Whistler's outwardly directed rage at this time was more than matched by rage directed inward, as overwhelming self-doubt threw him into the deepest crisis of his artistic career. He poured out his frustration that autumn in a self-lacerating confession to Henri Fantin-Latour, castigating himself as a failure, as nothing more than a "degenerate student," and realizing that he could have been so much more if he had had the proper training. "Ah my dear Fantin," he lamented, "what a frightful education I gave myself—or rather what a terrible lack of education I feel I have had!" He had fallen under the spell of the wrong master. "Courbet! and his influence was odious!" Courbet's brand of Realism, dictating depiction over evocation, had ruined him: "Where could you have found an apostle more ready to accept this theory, so appealing to him! this remedy for all disquiet—What? All he had to do was to open his eyes and paint what was there in front of him! beautiful nature and the whole caboodle! that was all there was to it! and then people went to see it! And they saw—the piano, the White Girl, the Thames pictures—the seascapes . . . canvases produced by a nobody puffed up with pride at showing off his splendid gifts to other painters. . . ." Though Whistler never doubted his incredible skill with color, he now perceived his art nevertheless to be a failure. Without a sure sense of line, without discipline in draftsmanship, color sense was worse than nothing. Color guided by line, he claimed, is "a splendid bride with a spouse worthy of her," and beauty came from the union. But without that, color was "a swanky tart," resulting in nothing but "chaos, or intoxication, of trickery, of regrets—of unfinished things!"

"Oh, how I wish I had been a pupil of Ingres!" Whistler complained. Ingres, the great Classicist, the master of line and drawing: "how *soundly* he would have guided us!" It was too late for that, of course. But it was not too late for Whistler to commit himself to a reeducation under Britain's modern master of line and form: more determinedly and energetically, more obsessively than before, Whistler bound himself to the "exacting and

demanding" style and method of Albert Moore. This meant forgoing his usual spontaneity for endless preparation for every work: a multitude of sketches of live models, both nude and clothed, as well as sketches of Greek sculpture he made in an attempt to realize ideal rather than idiosyncratic beauty. Willie Whistler witnessed the ludicrous lengths his brother went to in forcing the classical upon his art. "It was his habit," he remembered, "to pose his model beside a skeleton, with a bust of Venus de Milo at hand." Now, like Moore, rather than paint as before upon a blank canvas, Whistler drew cartoons, full outlines on paper, and transferred these to his canvas by means of pinpricks and charcoal dust.

For two years Whistler worked in Moore's thrall toward a specific goal—a commission for a new patron, Frederick Leyland. Leyland, a shipping magnate and a "modern-day Medici" whom Whistler almost certainly met through Dante Gabriel Rossetti, who owned mansions both in London and outside of Liverpool, and who had both the wealth and the burning desire to saturate them with beauty, artworks both classical—Botticelli in particular—and modern: Rossetti, Burne-Jones, and now Whistler. By August 1867 Leyland had commissioned Whistler to paint two works for 300 guineas each.* Whistler proposed as subject a fourth *Symphony in White*: three young women loosely draped in gowns neither Japanese nor classical but a hybrid of both, posing gracefully about a hothouse plant. *Three Girls*, he called it.

Surviving studies for the *Three Girls* reveal that Whistler's genius for color had never been stronger, with blues, violets, and oranges woven into the prevailing whites. But the arrangement of the picture—and the arrangements of the several variations on this theme that Whistler sketched out at this time—were not Whistler's at all, instead borrowing heavily from Albert Moore. Leyland likely never realized, and Whistler likely never admitted to himself, the suspicious resemblance between the arrangement

* A guinea, which had the value of one pound plus one shilling (which was then worth one-twentieth of a pound), was in the nineteenth century largely considered the appropriate payment for a professional—and for this reason Whistler generally demanded payment in guineas rather than pounds.

of the *Three Girls* and that of Moore's *Pomegranates*, which Moore had painted just a year before.

Whistler intended to exhibit the *Three Girls* at the 1868 Royal Academy exhibition, but that deadline came and went with nothing to show; he worked more obsessively than ever, but just as fruitlessly. "I am up to my neck in work!" he wrote Fantin-Latour that September. Anna felt abandoned by her son as he shut himself up in his studio all day while she turned away visitors. He never worked harder. But for all of his work over those two years, he completed nothing, exhibited nothing—sold nothing. Frederick Leyland was an amazingly trusting and generous patron, paying whatever advances Whistler asked for the *Three Girls*, eventually paying more than Whistler had asked for. But it was not enough; with costs for supplies and models "who *must* be paid," it was a "continued outgoing and nothing coming in." "We all & each have to be very prudent in our expenses," Anna wrote in December. But by then, Whistler had incurred a new one: frantic to complete the *Three Girls* for the 1869 Royal Academy exhibition, he left his mother and moved to a room and a studio he rented from his friend, architect Frederick Jameson, at 62 Great Russell Street. The house looked out on the British Museum with its inspirational Greek sculptures. More importantly, it was close to the studio of his master Albert Moore. There, from September until March 1869 Whistler strained to complete the *Three Girls*, but Jameson dismally reported these months "unproductive and uneventful." Whistler lived a Sisyphean nightmare, always nearing completion only to rub his canvas "down to the bed-rock" and start again. "I had a large picture of three figures nearly life size fully underway," Whistler wrote an American friend, "indeed far advanced towards completion—the owner delighted—and everyone highly pleased with it—except myself. Instead of going on with it as it was, I wiped it clean out! Scraped it off the canvas and put it aside that I might perfect myself in certain knowledge that I should overcome imperfections I found in my work. . . ."

A month before the 1869 Royal Academy exhibition, he broke down. Realizing he would not finish the *Three Girls* or any of its variations in time to exhibit, he stopped working, instead wandering in despair with Jameson

through London's galleries and museums. On March 10 he surprised his mother at Lindsey Row and confessed his failure. "Leyland must be written to! but I cannot do it!" he told her. And so Anna wrote him. "It has become more & more impossible to satisfy himself," she explained. She begged Leyland to allow her son to set aside the work altogether "til he should be in better tone," and relayed her son's offer to repay Leyland's advance of £400. She offered her own analysis of his failure; God, she thought, was rebuking her Jemie. "I could not but fear this check upon Jemie's temerity in setting aside the divine wisdom of resting from labour on the Lord's day. I failed in my argument to convince him that he should profit by the day of rest, not only to recover tone, but to seek the blessing promised to *obedience*." Whistler set aside the *Three Girls* and all its variations. That work would haunt him, and he would return to it. But he would never finish it.

Whistler did try to make good on his debt to Leyland, begging for a loan first from his elder half-brother George, and then from Thomas Winans, an American friend and one of his first patrons. But there is no evidence that he got money from either. Instead, Whistler and Leyland renegotiated: the *Three Girls* was set aside and Whistler instead agreed to paint portraits of the Leylands, both parents and children. They likely brokered that deal that September when Whistler visited Speke Hall, Leyland's new country estate, for the first time. He stayed a month and began work on Leyland's portrait. And he brought his mother, who endeared herself to the Leylands by nursing several of their children back from bouts of scarlet fever. After this, the Whistlers became frequent and welcome visitors to the Leylands, both at Speke Hall and at their London mansion. The failure of the *Three Girls* did nothing to hamper their growing friendship.

When a year later in the autumn of 1870 Whistler returned to Speke Hall to work on Leyland's portrait and to sketch the family, he found a way to break free from Albert Moore's paralyzing technique. While he had for years shamelessly stolen ideas and subjects from Moore, his enormous yet fragile ego would never allow him to admit it. Instead, he accused Moore of stealing from *him*. Whistler had introduced Moore to Leyland, and Leyland had commissioned from Moore *Shells*, a study of a statuesque young woman

on a windswept seashore. As it happened, Whistler had earlier set one of his *Three Girls* variations on a windswept seashore. And when Leyland showed him Moore's preliminary sketches for *Shells*, Whistler detected a resemblance between Moore's subject and one of his own. Although even Whistler realized that the resemblance was slight, he wrote Moore a tentative yet clearly accusatory letter. He proposed that they have mutual friend William Nesfield mediate by viewing the two works and deciding whether "we may each paint our picture without harming each other in the opinion of those who do not understand us and might be our natural enemies." Moore, though surely bemused, agreed. Nesfield examined both paintings and diplomatically stated the obvious: the "effect & treatment" of the paintings were so different that Whistler and Moore could safely finish their works. (Moore did; Whistler did not.) With that Whistler was, symbolically, free.

But he was not in the clear. He still struggled to complete a painting. The portrait of Leyland drove him to distraction. Consumed with the difficulty of painting an atmospheric pitch-black background for Leyland's pitch-black suit, he found himself in the same excruciating cycle of building up and rubbing down, while Leyland found posing for Whistler "my own martyrdom." Whistler nearly cried, Leyland remembered, over getting his legs right; in his frustration he regressed to Moore's technique, hiring a nude model to remind him of the musculature beneath the trousers. Leyland's martyrdom would continue, on and off, for another three years.

Whistler was by the end of the 1860s fading from the view of the public. In 1868 and 1869, he exhibited nothing. For the 1870 Royal Academy exhibition all he could muster was his seven-year-old *The Balcony*, now reworked, renamed *Variations in Flesh Colour and Green*, and given one significant innovation: signed not with a name but with an emblem of a butterfly, suggesting his free-spirited aestheticism, providing him with a new public identity. (Ironically, the idea may have come from Anna, decades before, as she begged her son to keep innocency: "I only warn you not to be a butterfly sporting about from one temptation to illness to another . . .") And then, in 1871, the work that gained him attention was not paintings,

but etchings: sixteen etchings newly published as the *Thames Set*, though nearly all of them were at least a decade old.

Whistler's chief *new* creation at this time was not painting or etching, but a child. Charles James Whistler Hanson was born on June 10, 1870, to Louisa Fanny Hanson, a twenty-one-year-old parlormaid from Clapham. How Whistler met her, exactly, is not known—but he was captivated enough, apparently, to coax her to his studio to model. Whistler described his son as his "infidelity to Jo," suggesting that while his relationship with Jo Hiffernan had cooled three years before, she still meant something to him. In the years to come, Jo was to mean a great deal more to Whistler's son. For the first two years of his life, Charles Hanson was farmed out to a nurse, but after that Whistler entrusted his upbringing to Jo; Jo therefore became the closest thing to a mother that Hanson had. (Louisa Fanny Hanson married and had a new family after her son's birth, and seems largely to have faded from his life.) Anna Whistler apparently never learned about the existence of her grandson.

In summer 1871 Whistler suffered yet another artistic failure, another "hope deferred which maketh the heart sick," as Anna scripturally put it. Two years before, in the midst of his enthrallment to Albert Moore, Whistler had undertaken a commission for William Graham, a serious connoisseur and a member of Parliament. The subject was a surprising one for Whistler, who generally shunned as contagion literary subjects: a portrait of the title character of Edgar Allen Poe's poem "Annabel Lee." (The idea must have been Graham's, and Whistler was in no position to refuse him.) Whistler envisioned the painting as a fantasy in the style of the *Three Girls*: a lithe young girl on the shore of her kingdom by the sea, virtually nude under transparent gauze. For his model Whistler found a beautiful fifteen-year-old girl named Maggie—her last name unrecorded—and he promised Graham a finished painting by August 1871. As that deadline approached, Whistler found himself in the familiar and painful position of building up

and rubbing down with no end in sight. Maggie was a "novice" of a model, according to Anna, and suffered from Whistler's demands to remain still for hours, day after day. One day she stopped coming altogether, sending the excuse that she had suffered convulsions at home. Whistler had another painting that he would never finish.

"I saw his misery," Anna wrote of her son. "But," she added, "he is never ill, his talent is too eager, if he fails in an attempt he tries another." That evening, Whistler prepared a large canvas by reversing one of his failures—possibly a study for the *Three Girls*. The next morning, he appealed to Anna: "Mother I want you to stand for me! it is what I have long intended and desired to do, to take your portrait." With some reluctance—"I was not as well then as I am now," she later remembered—she agreed, and the two ascended to the studio. There Anna, wearing her usual black widow's dress and her white cap, collar, and cuffs, presented her son with an instant harmony of color with the studio itself, with its black dado and curtain, its grey wall, its black and white prints (Whistler's own, of course): she offered him the exciting prospect of painting with a palette so severely restrained as to be nearly monochromatic. He at first posed her standing: turned slightly to the left and gazing directly toward him, if an etching he likely completed around this time is any indication. For two sessions, perhaps three, she stood for him, "bravely" and frail, suffering but still, until Whistler, generally oblivious to his sitters' distress, could not ignore hers, and relented. He decided to reimagine his arrangement completely: he would paint his mother sitting.

He brought her a simple, straight-backed wooden chair, one that emphasized her constant uprightness. He turned her to the right, parallel to the wall; that position, aided by the diffused, shadow-free light of the studio, created an absence of depth that echoed the subject of a Japanese print. Her face, in perfect profile, lost all of its usual flabbiness and became hard and angular. He had her gaze forward, placidly yet steadily, oblivious to the viewer and seemingly in silent, exclusive, and customary communication with her God. And with that, he had it: a perfect harmony of forms and colors, the strict horizontals and verticals of the room balanced, softened, by the diagonals of the human body: an image of subtle but unmistakable

beauty. "Art," Whistler later wrote, "should be independent of all clap-trap—should stand alone, and appeal to the artistic sense of eye or ear, without confounding this with emotions entirely foreign to it, as devotion, pity, love, patriotism, and the like." He was depicting his mother and he loved her, but he had no interest whatsoever in conveying her life story or in communicating any sense of what bound her to him. He was not painting *Whistler's Mother*. He was painting *Arrangement in Grey and Black*. "To me," he wrote, "it is interesting as a picture of my mother; but what can or ought the public to care about the identity of the portrait?"

Having settled upon his arrangement, he executed it with an ease that had for so long eluded him. "Jemie had no nervous fears in painting his Mother's portrait," Anna wrote, "for it was to please himself & not to be paid for in other coin." Shunning Moore's technique of preparatory studies and strict outlining, Whistler instead painted directly onto the rough canvas, washing in broad masses of color with paint so diluted with turpentine that it bled completely through. Texture—the wall, or the warp and weft of the handkerchief his mother clutched—he suggested not by visible brushstroke but by the rough weave of the canvas itself. He did at times revise, experimenting for example with the positioning of his mother's limbs, and at one point lowering footstool, chair, and his mother's body on the canvas to allow her dress to break free from rigid confinement within the frame. He did have moments of doubt, although this time they were blessedly few. "Only at one or two points," his mother remembered, "I heard him ejaculate 'no! I can't get it right! It is impossible to do it as it ought to be done perfectly,'" and then, of course, she prayed for him, "silently lifted my heart, that it might be as the net cast down in the Lake at the Lord's will!" Within weeks—less than three months—it was done. "Oh mother it is mastered, it is beautiful!" he exalted. And then, he kissed her.

In the midst of that miraculous creation came two more paintings. One hot, brilliantly clear day at the end of August, when Anna told her son

that she was simply too feeble to sit, Whistler proposed instead they get out and visit a friend of hers in Westminster. Together they strolled to nearby Battersea pier and boarded a steamship. The Thames revived the mother and inspired the son: "Jemie so seldom goes out in the day, he was charmed with life on the Thames. He took out his pencil & tablets as we side by side on the little Steamer were a half hour or more benefitting by the sunshine and breezes." Anna's Westminster friend was not at home, so instead the two ambled through St. James's Park before hailing an open hansom cab and returning to Chelsea. They got home an hour before sunset, Anna noting at their gate "the river in a glow of rare transparency." Her son saw it too; it inspired him to hurry to his studio and create. He rushed upstairs, grabbing easel and brushes on the way, directing his mother to follow him carrying tubes of paint. In the studio he set easel, canvas, and his large, distinctive palette table by the window so that he could paint by the fading sunlight, and then by the light of the rising moon. He set out in pots his carefully chosen colors, so thinned with turpentine that he called them his "sauce." Then he began, washing color onto canvas with rapid but careful strokes while his mother stood beside him, captivated by his "magic touches."

Within an hour or two he had something he had struggled in vain for years to achieve: a finished painting—finished to his satisfaction. He called it *Variations in Violet and Green*. It marked a genuine turning point in Whistler's career. Its foreground harkened back to his *Three Girls* obsession: framed by blossoming sprigs, three women—one with the obligatory parasol—repose gracefully on the green sward of a riverbank. So much for Whistler's past inspiration. The rest of the painting looked, literally and figuratively, beyond all that, and anticipated the great work soon to come. In subdued browns, blues, and violets he captured the Thames, serene in the twilight, deserted save for a solitary sailboat that Whistler placed carefully to counterbalance the forms of the women below. Beyond that—distant, obscure, monochromatic—lay the Battersea shore. It was a vision Whistler had hinted at with *The Balcony*, one that he had experimented with in his Valparaiso series. It was a vision he was at the point of realizing fully with

his very next work. And it was Whistler's mother—according to Whistler's mother—who pushed him on to that creation.

She watched until the full moon rose and "faced us from the window." Under that same moon, Anna knew, her son had, in the days before, gone out upon the Thames with the Greaves brothers. And now it was time to act upon that inspiration. "Oh Jemie dear," she now exclaimed, "it is yet light enough for you to see to make this a moonlight picture of the Thames." He needed no more encouragement than that. He reset his table with a much more severe palette than before, setting out black and white for tone, the slightest touch of yellow for highlight, and an abundance of blue-green sauce: this painting he envisioned as virtually monochromatic, its definition created not by shifts of color, but by shifts of tone within the same color. Although he painted from the window, his studio was at the back of the house and looked away from the river. So he worked from his memory of the Thames, or perhaps from one of his black and white sketches drawn on the river itself. His viewpoint was not to be from Chelsea at all, but *of* Chelsea, from the Battersea side of the river: with Chelsea Old Church—Anna's church—a distinctive feature on the horizon.

After washing a dark undercoat onto the canvas, he again worked quickly but carefully, washing his sauce on in long, wide horizontal strokes. The paint this time was thick enough to leave streaks that suggested slow-flowing, lapping water, suggested somber, heavy skies. Darkening his paint, Whistler then washed in the near shore and the horizon—distant, quiet Chelsea and its elongated reflection. To balance that sweeping horizontal mass in the upper third of the painting, in the lower third he sketched out with a few swift touches a ghostly fisherman, and next to him an unmanned, perfectly horizontal barge. ("To Mr. Whistler," Walter Greaves later explained, "a boat was always a tone, to us it was always a boat.") Finally, with a fine brush and his bit of yellow, Whistler gave Chelsea muted life: tiny spots of light on the houses, trembling thin streaks in the water below. Again, he was finished to his satisfaction in an hour or two. He called it *Harmony in Blue-Green—Moonlight*. Later, when the unstable blue-green color had faded into a moody blue, he called it *Nocturne: Blue*

and Silver—Chelsea. It was the first of his London nocturnes—the first of his many revelations of the haunting beauty and pure tranquility of the night, discovered in the midst of the world's busiest seaport.

Whistler later claimed that he had invented moonlights. He had not, of course: night paintings had been around at least since Giotto and the fourteenth century; it would perhaps be more difficult to find a great landscape painter since then who had *not* attempted to depict the night. Uccello, El Greco, Goya, de La Tour, and Turner were famous for them. But there is a crucial difference between Whistler's moonlights and all others. They had focused on light in the darkness—on the way the moon, firelight, and lamplight combatted the dark to create definition, to fill out a subject, to depict a scene. Turner, known as the painter of light, did not make an exception to this in his moonlights. Whistler, on the other hand, surrendered to the darkness, captivated by its power to reducing nature and humanity to shadowy forms—beyond definition, beyond narrative. He later spoke of painting portraits in the darkness: "as the light fades and the shadows deepen, all petty and exacting details vanish, everything trivial disappears, and I see things as they are in great strong masses: the buttons are lost, but the garment remains; the garment is lost, but the sitter remains; the sitter is lost, but the shadow remains; the shadow is lost, but the picture remains. And *that* night cannot efface from the painter's imagination." Darkness, he discovered, forced abstraction. And approaching abstraction, Whistler found beauty. Other painters of the night clung to the light; Whistler let go.

CHAPTER 2

NO WEALTH BUT LIFE

As James Whistler immortalized his mother on canvas, John Ruskin—England's, if not the world's, foremost critic of art—coped with his own mother's all-too-apparent mortality. Through all of 1871 Margaret Ruskin, ninety years old, bedridden, flickering in and out of consciousness, her son often by her side, drifted slowly and inexorably toward death. She had been declining at least since the day over a decade before that she had fallen and broken her leg—or her "limb," as she delicately put it. The break had been badly set and left her painfully lame. With characteristic stubbornness, however, she shunned the sinful comfort of being pushed about by her husband or son in a wheeled chair, instead shuffling through the house clutching to the back of one. Her mobility since then had only declined, as had her hearing and her sight. By 1864, the year her husband died, Margaret Ruskin was almost entirely confined to the family's home and garden at Denmark Hill, Camberwell, on the southern verge of London. Her mind remained sharp, however, and until the last year of her life she tenaciously held on to her authority as mistress of her home, despotically ruling the servants, commanding and routinely correcting her middle-aged son, freely and indiscriminately imposing her fierce evangelicalism upon all

within earshot. She did her best to dominate the dinners John gave for his literary and artistic friends and never hesitated to challenge them for their follies and their flaws. She interrupted the self-aggrandizing Charles Augustus Howell, for example—at that time Ruskin's secretary—in the midst of one of his cock-and-bull stories, crying out to the gathering, "How *can* you . . . sit there and listen to such a pack of lies?" She startled Georgiana Burne-Jones, wife of the artist, by asking her soon after they met, "Do you love God?" When Georgiana timidly said she did, Margaret exclaimed "I don't," and proceeded to lecture her on her arrogance for daring to love the Creator. Georgiana realized that it was not dogma but rather "sheer love of contradiction" that motivated her. Georgiana's husband Edward Burne-Jones found Margaret's "sharp, decisive manner" repulsive. Ruskin, however, as Georgiana observed, accepted his mother's cantankerous condescension with "indescribable gentleness."

At the beginning of 1871, then, Margaret was bedridden, and because Ruskin was busy with his duties as the first Slade Professor of Art at Oxford University, he largely left her in the care of two women. The first was their seventy-two-year-old Annie Strachan, servant to the Ruskins since she was fifteen. Ruskin loved his Annie; so had his father. But there existed a lifetime's worth of acrimony between Margaret and Anne, Margaret always treating Anne as a child, Anne always stubbornly resisting Margaret's authority. Their long war ended abruptly that March, however, when Anne died. Margaret commemorated her passing with typical sanctimony: "She always persecuted *me*. But one must hope there are intermediate kinds of places where people get better." With Anne's death, Margaret's care passed into the hands of Joan Agnew, a young distant cousin who had come to tend Margaret when Ruskin's father died, and never left. Joan proved adept at handling Margaret, and Margaret quickly grew fond of her. Less than a month after Anne died, Joan married Arthur Severn—himself an artist, and an acquaintance of Whistler and Swinburne. Ruskin returned from Oxford for the ceremony, held in the parlor at Denmark Hill. His mother, too ill to make her way downstairs, could only bless the couple while they stood at her bedside. The Severns then left on an extended honeymoon

and Ruskin returned to Oxford, leaving Margaret for a time in a "patient solitude," assisted only by the remaining servants.

When Oxford's long vacation came that June Ruskin could have joined his mother. Instead he joined Joan and Arthur, still honeymooning, at Matlock Spa in Derbyshire, a place he remembered fondly from childhood. He hoped to rest there after a very stressful few months. His duties at Oxford had been "worrying." There had been the self-imposed pressure of a monthly deadline of the lengthy letters he published for the workmen of England—*Fors Clavigera*, a project he had begun that January which he would adhere to faithfully for the next seven years. There was the recent fracture in his very close friendship with Edward Burne-Jones, Ruskin finding fault with Burne-Jones's painting, and Burne-Jones deeply disturbed by Ruskin's recent dismissive public remarks about Michelangelo. There had been horrible, daily reports from France of the appalling carnage that followed the collapse of the Paris Commune. Worst of all, the unceasingly torturous course of his relationship with the love of his life, young Rose La Touche, had become more torturous than ever as Ruskin, in a bid to prove his legal right to marry her, had recently been forced to share with his lawyers painful personal and sexual details of his previous, annulled marriage to Effie Gray—now Effie Millais, wife of the artist John Everett Millais.

At Matlock at the beginning of July, then, Ruskin in his dark mood had a dark vision, a vision that with his characteristic impulse to share *everything* with his readers, he described in *Fors Clavigera*:

> the sky is covered with grey cloud;—not rain-cloud, but a dry black veil which no ray of sunshine can pierce; partly diffused in must, feeble mist, enough to make distant objects unintelligible, yet without any substance, or wreathing, or colour of its own. And everywhere the leaves of the trees are shaking fitfully, as they do before a thunderstorm; only not violently, but enough to show the passing to and fro of a strange, bitter, blighting wind. Dismal enough, had it been the first morning of its kind that summer had sent. But during all this spring, in London, and at

Oxford, through meagre March, through changelessly sullen April, through despondent May, and darkened June, morning after morning has come grey-shrouded thus.

He knew that the "poisonous smoke" of industry contributed to this cloud, noting that "there are at least two hundred furnace chimneys in a square of two miles on every side of me." But it was more than that: "it looks more to me as if it were made of dead men's souls." The world, he realized, was growing darker—but there was a moral component of that physical darkness, as there was, for Ruskin, in all physical things. He was looking upon what he called "plague-cloud." He had caught glimpses of this earthly darkness before, felt the depression, sensed in it the fall of humanity. But from this moment on, that darkness would remain with him, and he would monitor it obsessively. It would haunt him until the end of his life.

The next day Ruskin collapsed with a serious inflammation of the bowels. He fell into a delirium; he raved at his doctors and at the friends who rushed to be with him; he came, he declared, "within an ace of the grave." Back at Denmark Hill his mother grew fearful when his usual daily letters to her stopped; she was sure he had died. The shock could only have accelerated her own decline. When later that month Ruskin recovered and returned home with Joan, he found his mother's condition so alarming that he canceled his Michaelmas lectures at Oxford to return to Denmark Hill and take his place in the armchair beside her bed, watching over her, sleeping beside her, holding her hand, reading to her the evangelical tracts that she loved—and that he had grown to hate. And, one imagines, he reflected upon their past life together, upon what she and his father had meant to him—and what he had meant to them.

Margaret Ruskin was thirty-seven years old when her John, her only child, was born on February 8, 1819. From the instant of his birth John Ruskin became everything to his parents. When he was just six weeks old

Margaret wrote proudly yet humbly to her husband, John James Ruskin, that "your infant is a most promising one and he will I trust make up in some degree for his mother's deficiencies." Young John was not, however, without his flaws, the most serious of which Margaret detected by the time he was four months old: "he is . . . beginning to give more decided proof that [he] knows what he wants and will have it if crying and passion will get it." Two days after his first birthday, she proposed her remedy to this dangerous self-will and independence: "this I trust will be cured by a good whipping when he can understand what it is for properly at present I am compelled to give way more than I like for fear of baiting it." She soon overcame her reticence, whipping John soundly and often. Ruskin was deeply grateful for her attention. "Being always summarily whipped if I cried, did not do as I was bid, or tumbled on the stairs," he wrote in *Praeterita*, his autobiography, "I soon attained serene and secure methods of life and motion." In one memorable instance, his mother employed the opposite strategy to check his will: "One evening,—my mother being rather proud of this told me the story often,—when I was yet in my nurse's arms, I wanted to touch the tea-urn, which was boiling merrily . . . My mother bid me keep my fingers back: I insisted on putting them forward. My nurse would have taken me away from the urn, but my mother said—'Let him touch it, Nurse.' So I touched it,—and that was my first lesson in the meaning of the word Liberty." It was a lesson he apparently never forgot: the dangers of freedom became central to his social and political thinking.

Ruskin remembered his childhood as one of evangelical austerity, his mother shielding him from every luxury, any temptation. At their Camberwell home he played in their beautiful garden, replete with fruit trees, but the difference "between the nature of this garden, and that of Eden," he observed, was that "in this one, *all* the fruit was forbidden." He claimed that he had no pets, no companions, and few toys, remembering the heartbreaking day his aunt brought him "the most radiant Punch and Judy she could find in all the Soho bazaar." His mother was obliged to accept it, "but afterwards quietly told me it was not right that I should have them;

and I never saw them again." Ruskin, however, exaggerated. He did have toys and pets. He did have at least one neighborhood companion and the company of several cousins in nearby Croydon. But his life was indeed one of material restriction if not utter deprivation, a "monastic poverty." Ruskin was later grateful for this as well, claiming that it taught him *see*: to find pleasure and purpose in patient, detailed observation of the world around him, "contentedly in tracing the squares and comparing the colours of my carpet;—examining the knots in the wood of the floor, or counting the bricks in the opposite houses; with rapturous intervals of excitement during the filling of the water-cart, through its leathern pipe, from the dripping iron post at the pavement edge; or the still more admirable proceedings of the turncock, when he turned and turned till a fountain sprang up in the middle of the street."

While his father, John James Ruskin, a wine merchant, spent his days either in the City or traveling and selling in the country, Margaret took complete charge of her son's education—an education, at first, entirely religious. Margaret Ruskin's ardent evangelicalism matched Anna Whistler's, but her spiritual ambitions for her son were far greater: Margaret Ruskin had from the moment of his birth committed her son to the service of God. She trained him with that goal in mind. Once John could read with any fluency, he and his mother studied the King James Bible, reading and memorizing three verses a day, day after day, from Genesis to Revelation. They read at this rate the entire Bible in about a year. And then they read it again, and again, not stopping until Ruskin became a student at Oxford. "She read alternate verses with me, watching, at first, every intonation of my voice, and correcting the false ones, till she made me understand the verse, if within my reach, rightly, and energetically." She compelled him, in other words, not simply to read the Bible, but to *hear* it, with its majestic constructions and cadences, until they became second nature to him, became to him the epitome of fine writing—became the basis of his own prose. "Though I have picked up the elements of a little further knowledge—in mathematics, meteorology, and the like, in after life,—and owe not a little to the teaching of many people, this maternal installation of my mind in

that property of chapters I count very confidently the most precious, and, on the whole, the one *essential* part of all my education."

As his son grew older, John James Ruskin provided his son with a rich secular education to complement his wife's religious one. He shared his wife's evangelicalism and would have been delighted to see his son a bishop, but early on he realized that his son's great gifts might take him elsewhere. "Any children I see appear half idiots compared to him," he wrote when John was eight; "he is surely the most intellectual creature of his age that ever appeared in any age." John James as a young man had his own dreams of a literary career, hoping to study law as a means of achieving it, but his father destroyed those dreams, forcing him at the age of sixteen to take a clerkship in the wine trade, a clerkship that led, after years of hard work, to the chief partnership in the highly prosperous wine firm of Ruskin, Telford and Domecq. Never forgetting his own crushing disappointment, John James vowed that his son would never follow him into the trade, but would rather be a scholar, or even a poet: certainly, a gentleman. John James did everything he could to foster all of his son's many talents. He supplied John with geological specimens. He filled the family library with literature that both he and his son would read and discuss. He taught John the finer points of Latin once Margaret—well-educated despite her humble origins as the daughter of a Croydon publican—had taught John the rudiments. When John was ten, John James engaged the first of several private tutors to prepare his son for what he saw as the finest college at the finest university: Christ Church, Oxford. When John began to write, John James became his son's first and his most enthusiastic reader, his sounding board, his promoter.

Ruskin's writing began early; from age four he wrote letters to his traveling father, letters that demonstrated precocious erudition, wit, and style. He soon began to write poetry, again usually for his father, who became convinced that he had generated a second, better, more virtuous Lord Byron. His pride for his son's work was boundless; he carried John's poems with him, shared them with his literary friends, promoted their publication. The first poem published, "On Skiddaw and Derwent Water," Ruskin

wrote when he was eight, and it was published in the evangelical *Spiritual Times* when he was ten.

That poem was inspired by a trip that the family took to the Lake District. John James regularly brought his family with him upon annual summer excursions selling sherry at the great country houses across England, Scotland, and Wales, the family seeking out on the way the literary, the historical, the picturesque. These were magical, inspirational experiences for John, broadening his education and instilling within him the creative process he would follow throughout his career: weeks and months of close observation, note-taking and sketching, and then, after a period of reflection, a flood of composition.

In 1833 the family—Margaret, John James, fourteen-year-old John, and now John's cousin Mary Richardson, whom his parents had adopted—traveled much further afield. Leaving the business in the hands of his generally sleeping partner, John James led his family on a three-month tour of Europe, establishing a model for travel abroad that his son would follow for the next fifty years. Margaret, surprisingly, had proposed the trip, when she noticed her husband's and her son's enthusiasm for a collection of the artist Samuel Prout's lithographs of Flanders and Germany—and suggested that the family see for themselves every view. Three weeks later they were off. "I had certainly more passionate happiness, of a quality utterly indescribable to people who never felt the like, and more, in solid quantity, in those three months, than most people have in all their lives," Ruskin remembered. The trip brought together the three greatest influences upon him: the Alps, Italy, and the art of J. M. W. Turner.

Tracking Prout brought the family through Belgium to Germany and up the Rhine, where they entered Switzerland at Schaffhausen. There Ruskin experienced one of the most profound moments of his life, thunderstruck with his first glimpse of the Alps. "They were as clear as crystal," he later wrote, "sharp on the pure horizon sky, and already tinged with rose by the sinking sun. Infinitely beyond all that we had ever thought or dreamed,—the seen walls of lost Eden could not have been more beautiful to us; not more awful, round heaven, the walls of sacred Death." He was

gazing at nature at its purest and its most beautiful, but he was at the same time gazing at more: nature suffused with, burning with spiritual energy and spiritual motion. He was, he understood, looking upon the face of God. In that instant he comprehended the simple notion that would underlie every thought in every work he later wrote: all truth, all beauty, emanated from God and was revealed in nature. *Seeing* God in nature, comprehending this truth and conveying that truth to others—this was, Ruskin realized, his calling. "I went down that evening from the garden-terrace of Schaffhausen," he wrote, "with my destiny fixed in all of it that was to be sacred and useful." He was not simply an artist or a critic: he was a *seer*.

As the family passed over the Alps and into Italy, a corollary revelation followed: that the artist J. M. W. Turner more clearly than any other mortal both perceived God's energy in nature and recreated that energy in his own work. The year before John had received from his father's business partner the magnificent gift of *Italy*, a volume of poetry by Samuel Rogers, lavishly filled with fifty illustrations, half of them—and by far the finest of them—engraved after works by Turner. It was the first time Ruskin had actually seen anything by the great artist, and he was dazzled: "I took them for my only masters, and set myself to imitate them as far as I possibly could by fine pen shading." And now at Lake Como, Turner, Alps, and Italy came together when for the first time in person he witnessed the sublime scene that, thanks to Turner, was to him "familiar at once, and revered." After this, tracking Turner's views to their natural sources would become an obsession for Ruskin.

Returning to London, Ruskin, hungry for more Turner, sought out that artist's contributions to that year's Royal Academy exhibition. Turner had six paintings on display—and Ruskin was baffled by them. The finest of them, for example, *Mouth of the Seine, Quille-Boeuf*—a magnificent stormy seascape, every square inch of which crackles with celestial and terrestrial energy—Ruskin dismissed as having "little charm in colour." Turner's offerings the next year, at the 1834 Exhibition, Ruskin considered equally disappointing. His mythical paintings *The Fountain of*

Indolence and *The Golden Bough*, to Ruskin, were unpleasantly fantastic when compared to Edwin Landseer's naturalism or to the Scottish painter David Wilkie's "intelligible finish." And Ruskin was utterly confused by Turner's 1835 submissions—particularly by his two scenes set at night. The first of these, *Keelmen Heaving in Coals by Moonlight*, he considered void of color—an amazing conclusion, for though technically a moonlight painting, it has none of the tonal restraint Whistler would later exercise in his nocturnes, but rather *bursts* with color—the moon shining with the intensity of the sun, the blue sky, the sea-green river, the brilliant fire ringing the ships to the side. The second, *The Burning of the Houses of Lords and Commons*—a painting that anticipates Whistler's Thames nocturnes in the way that darkness obscures otherwise familiar features on both banks of the river—Ruskin, in his account of this visit, simply fails to mention. Shrouding night, it seems, puzzled and disturbed him—even in the work of his favorite artist.

At the next year's exhibition, however, seventeen-year-old Ruskin gazed upon Turner's three offerings—*Juliet and Her Nurse*, *Rome from Mount Aventine*, and *Mercury and Argus*—was astonished at their "skill and enthusiasm," and was reconvinced of Turner's genius. The critics, on the other hand, were generally far less impressed. One in particular—John Eagles, writing in *Blackwood's Magazine*—was disgusted by them, and savaged all three as incomprehensible messes created by a dotard. *Juliet and Her Nurse* showed Venice "thrown higgledly-piggledly together, streaked blue and pink, and thrown into a flour tub," *Rome from Mount Aventine* was "a most unpleasant mixture, wherein white gambouge and raw sienna are, with childish execution, daubed together," and *Mercury and Argus* was "perfectly childish," "all blood and chalk." "Turner has been great," Eagles concluded, "and now when in his vagaries he chooses to be great no longer, he is like the cunning creature, that having lost his tail, persuaded every animal that has one, that it was a useless appendage."

Enraged, Ruskin drafted a passionate reply, one that in style and content anticipated his many later writings in Turner's defense. In it, Ruskin deemed Turner a god among men: he was the greatest artist alive, with an

imagination "Shakespearean in its mightiness," who captured in his works "the soul and essence of beauty." "He is a meteor, dashing on in a path of glory which all may admire, but in which none can follow." Ruskin had every intention of sending this letter to *Blackwood's*, but his father dissuaded him, counseling him instead to send it first to Turner, whom the Ruskins had not yet met. Ruskin dutifully complied. Turner was delighted; nonetheless he advised Ruskin not to send it on: "I never move in these matters, they are of no import save mischief." Instead, Turner forwarded the letter to the patron who had bought *Juliet and Her Nurse*, who set it aside; in this way, Ruskin's first true salvo as an art critic escaped public notice for sixty years.

Two weeks after Ruskin sent this defense to Turner, he fulfilled his father's dream for him by matriculating as a gentleman-commoner at Christ Church, Oxford. His entire family followed him there: his mother and cousin Mary taking rooms in nearby High Street and his father coming up on the weekends. They would remain with him there for the next three years. Margaret cited John's fragile health as her reason for refusing to leave him, but her admission to her husband at around this time that "all our earthly happiness depends on him" suggests the real reason. Ruskin was expected to come to his mother's room for tea every evening and to stay until curfew. Occasionally, and entirely for his parents' benefit, he brought along one or more of his fellow gentleman-commoners. Ruskin despised nearly all of these as aristocratic louts uninterested in education, while to them "Ruskin was only famous as a sort of *butt*, and not a genius." (One day a fellow gentleman-commoner, by one account, rode Ruskin as one might ride an ass around Tom Quad to the cheers of other fellow gentlemen-commoners, until an older and more studious undergraduate intervened. That undergraduate was Henry Acland, who would become Ruskin's close and lifelong friend.) John's hobnobbing with the lords and gentlemen satisfied his father's deep-rooted snobbery and boded well for Margaret's dream of her son's future career in the church: good lords, after all, meant good livings. Twenty-five years later, when John James Ruskin declared his antipathy to relatively low-born Edward Burne-Jones, Ruskin's

pent-up resentment against his parents' snobbish preference for these high-born cads finally erupted:

> You and my mother used to be delighted when I associated with men like Lords March & Ward—men who had their drawers filled with pictures of naked bawds—who walked openly with their harlots in the sweet country lanes—men who swore, who diced, who drank, who knew *nothing* except the names of racehorses—who had no feelings but those of brutes—whose conversation at the very hall dinner table would have made prostitutes blush for them—and villains rebuke them—men who if they could, would have robbed me of my money at the gambling table—and laughed at me if I had fallen into their vices—& died of them.

Ruskin's fiercest ambition at Oxford was to take the Newdigate Prize, awarded annually to the university's best undergraduate poem. In 1837, 1838, and 1839 Ruskin researched extensively and then hammered out over-erudite poems according to the assigned esoteric subjects. His first two attempts failed, but his third—a poem on a particularly obscure Indian subject *Salsette and Elephanta*—succeeded, incidentally beating out the submission by the greater poet Arthur Hugh Clough. To his own "entirely ridiculous and ineffable conceit and puffing up" Ruskin recited his poem before a crowd of two thousand at the Sheldonian Theatre, with William Wordsworth handing him the prize. His father cried with joy. It was Ruskin's first great poetic triumph. It was also his last. Ruskin *père* might have been certain that he had sired the world's next Byron. Ruskin *fils* knew better.

Much more in line with his future career was Ruskin's other literary work done at Oxford, a book that had little to do with his studies and everything to do with his extensive traveling. Inspired by a family trip to the Lake District in 1837 and by a thorough pondering of the cottages both of Westmoreland and Italy, Ruskin composed a treatise that linked

architecture with national character. *The Poetry of Architecture*, published in monthly installments in the *Architectural Magazine* during Ruskin's first two undergraduate years, ceased abruptly only because the magazine folded. Ruskin scorned English architecture as "at a miserably low ebb" and berated English architects for their "lamentable deficiency of taste and talent." Any hope for restoring that taste and talent would never come from them; rather, it seemed, it could only come from him, as his peremptory judgments on the good and the bad in European cottages and villas made clear. He made clear as well that this, his first work of architectural criticism, was also his first work of *art* criticism. For to him, architecture *was* art, having everything to do with the ornament of a building—the forms and colors that ennobled the space and delighted the mind—and nothing to do with its structure, which he considered the province of the builder rather than the architect. *The Poetry of Architecture* earned Ruskin little notice, though what there was of it was generally positive.

In April 1840, the moment that Margaret had long anticipated finally arrived when her son began coughing up blood. She immediately removed him from Oxford to Herne Hill, where she and her husband tended to him as an invalid. He would not return to Oxford to complete his degree for another two years. 1840 was the year when Ruskin came of age; his father recognized this by settling a small independent income upon him. Independence itself, however, continued to elude as it had eluded him throughout his childhood, when he could find it during the fleeting moments apart from his parents: during precious minutes of introversion in the garden at Herne Hill, for example, when "my entire delight was in observing without being noticed," temporarily free of "the interference of the public—represented by my mother and the gardener." It was not until a year after leaving Oxford, at the age of twenty-two, that he attempted to escape the family cocoon, defying the advice of a council of doctors his parents had convened, and setting out on his first journey without them—a ramble through Wales with one of his few childhood friends. But his father quickly scuttled his plans, ordering him with a letter to report to a spa in Leamington for a six-week regimen. Ruskin immediately abandoned his

friend and complied. While taking the waters there, he managed to knock off in a couple sittings *The King of the Golden River*, a fairy tale to "amuse a little girl." The girl was Euphemia Gray—Effie—the eleven-year-old daughter of family friends. *The King of the Golden River* would in time become Ruskin's bestselling work.

The work that made him famous, however, came a year later, and had its genesis in yet another examination of the Turners at a Royal Academy exhibition. Turner exhibited five paintings in 1842: two views of Venice, a portrait of Napoleon on St. Helena entitled *The Exile and the Rock Limpet*, and two seascapes, *Peace—Burial at Sea* and the magnificent *Snow Storm—Steam-Boat off a Harbour's Mouth*, a view that Turner claimed he had lashed himself to a ship's mast for hours to capture. Again, Ruskin marveled. And again, the critics responded with bafflement and ridicule. The critic from the *Literary Gazette* scoffed that the two views of Venice "are produced as if by throwing handfuls of white, and blue, and red, at the canvas, letting what chanced to stick, stick." The critic from *The Athenæum* similarly disparaged *Snow Storm*: "This gentleman has on former occasions chosen to paint with cream, or chocolate, yolk of egg, or currant jelly,—here he uses his whole array of kitchen stuff. . . ." Ruskin, reading at least one of these reviews, again fell into a rage and determined this time publicly to defend his master, "to write a pamphlet and blow the critics out of the water." The project grew—from a pamphlet to a volume, and then to a series of volumes. In his study at the family's new home at Denmark Hill—hard by their old home, but far grander—Ruskin began to write his magnum opus.

Ruskin's own title for the work—*Turner and the Ancients*—promised far less than Ruskin eventually delivered. His publisher, George Elder, instead titled the work *Modern Painters* in order to attract a wider audience. But that, too, understates the scope of the completed work. The five volumes and three thousand pages of *Modern Painters* offer not simply a broad critical appreciation of European painters, both modern and classical, but offer as well an intricate and comprehensive theory of art. His first volume, to be sure, published in 1843, anonymously by "A Graduate of Oxford," hews closely to the limits set by the original title, focusing upon Turner

as the paragon of landscape artists, with an unmatched skill at capturing and recreating the truth (to Ruskin, the "Truth") of nature in his works, in tone, in color, in chiaroscuro, in space. The "ancients," on the other hand—and in this volume, Ruskin meant by that the landscape painters of the past, and particularly Dutch and French landscape painters of the seventeenth century—Ruskin castigated as blinded by convention and by formula to nature's Truth, so that in their work "that which ought to have been a witness to the omnipotence of God, has become an exhibition of the dexterity of man."

Volume 2 appeared in 1846, volumes 3 and 4 in 1856, and the final volume appeared in 1860, a full seventeen years after the first. Naturally, the work evolved as Ruskin did, with "oscillations of temper, and progressions of discovery." After 1845, for example—after Ruskin finally managed his first independent journey to Italy and for the first time appreciated the glories of Tintoretto and the Venetian school of painters—he was compelled to give them and not Turner center stage in his second volume. And as he gradually sloughed off the evangelical sensibilities his mother had so enthusiastically impressed upon him, the narrow but fervent evangelicalism prominent in that second volume diminishes in later ones and disappears in the fifth and final volume, replaced by the pronounced humanism that characterizes his later work. But for all its oscillations and its progressions, even its contradictions, the spiritual and intellectual basis of *Modern Painters* remained constant throughout. "In the main aim and principle of the book," Ruskin assures his readers in the last volume, "there is no variation, from its first syllable to its last. It declares the perfectness and eternal beauty of the work of God; and tests all work of man by concurrence with, or subjection to that." In other words, *Modern Painters* and all Ruskin's thinking about art is nothing more than, and nothing less than, his revelation as a fourteen-year-old at Schaffhausen of God's suffusion in nature: contemplated, enlarged, transformed into theory. Art revealed God by reflecting nature. The greatest artists—the Turners, the Tintorettos—were supremely gifted with the power to see God's truth, and with the imagination that allowed them to recreate that truth in their art. Communicating

that truth through art entailed far more than simply imitating nature. Imitation Ruskin loathed as the most degraded form of art—the "colourful daguerrotypism," for example, of Canaletto, one Italian artist that Ruskin despised. Imitative artists, in painting a tree, simply painted wood. Great artists, on the other hand, in painting a tree captured its spirit, "the exquisite designs of intersecting undulations in its boughs, the grace of its leafage, the intricacy of its organization, and all those qualities which make it lovely or affecting of its kind." The great artists mirrored God; their works bore the stamp of the divine. Of Tintoretto, for example, Ruskin wrote "there is not the commonest subject to which he will not attach a range of suggestiveness almost limitless; nor a stone, leaf, or shadow, nor anything so small, but he will give it meaning and oracular voice."

Truth—God's truth—imaginatively expressed in painting: this was art, to Ruskin. This was beauty. The beautiful, in other words, was *moral*, always involving something higher, something greater than itself. For that reason, the very notion of "l'art pour l'art"—then current in France, and soon, as the mantra "art for art's sake," to sweep across Britain with the Aesthetic movement, with James Whistler at its center—made absolutely no sense to Ruskin. Art was much more important than that. Rather, art for *God's* sake, or for the soul's. He did allow that it was possible for one to simply to *feel* beauty, to take sensual pleasure in a work's form or color. He even gave a name in his theory to that ability: *Aesthesis*. But he thought *Aesthesis* a lesser faculty, belittling it as mere "animal consciousness." True appreciation of beauty involved the intellect and not simply the senses: involved understanding the moral truth of a work. To that higher ability Ruskin gave the name *Theoria*: "the full comprehension and contemplation of the Beautiful as a gift of God; a gift not necessary to our being, but added to, and elevating it." That ability was not instinctive but learned. And in every volume of *Modern Painters*, with brilliant insight and seraphic prose, Ruskin made the case that his own *Theoria* was second to none—and that no one was more qualified to teach the world about art than he was. *Modern Painters* made him a Victorian sage.

Sales of *Modern Painters'* first volume, slow at first, grew. Ruskin was first noticed by England's cultural elite—Turner himself, Samuel Rogers,

Tennyson, Wordsworth—and then, positively, by reviewers. Within months, the identity of "A Graduate of Oxford" became an open secret, and invitations to breakfasts, dinners, and soirées poured in. Ruskin accepted them—for a time, and reluctantly, for anonymous crowds and unfamiliar places tended to bewilder and dismay him. "Nasty crowded party at Inglis's," he wrote of one gathering in 1844; "nothing but elbows and legs—couldn't talk to anyone." He much preferred his evenings at home with his parents, and the few reliably safe dinner companions his father would invite—J. W. M. Turner often among them. His relationship with his public, both in print and in person, would remain forever conflicted.

In the midst of writing *Modern Painters*, during the ten-year stretch between second and third volumes—1846 to 1856—Ruskin, to his father's dismay, suspended his work on art to return to architecture. It was a detour he felt compelled to make after a momentous trip to Italy in 1845—significantly, his first trip to Europe without his parents. Everywhere he went—Lucca, Pisa, Florence, Verona, Venice—he realized with horror that the great architecture of Italy was disappearing, was *dying*: from neglect, from demolition, from ignorant "restoration." "One sees nothing but subjects for lamentation," he wrote to his father from Lucca, "wrecks of lovely things destroyed, remains of them unrespected, *all* going to decay, nothing rising but ugliness and meanness." In response, frantically taking copious notes and making detailed but fragmentary drawings ("a mass of Hieroglyphics . . . truth in Mosaic," as his father described them), Ruskin took upon himself the task of preserving the memory of a vanishing culture. From this came, in 1849, his *The Seven Lamps of Architecture*, an extended meditation upon the spiritual qualities of fine architecture, all built upon the premise that great buildings, like great paintings, communicated great thoughts. Later—after fifteen months in Venice, ceaselessly scrambling upon scaffolding, measuring, again note-taking, drawing and daguerreotyping—came in 1851 and 1853 the three-volume *Stones of Venice*.

It was during these years that he had made his most determined effort to emancipate himself from his parents—in taking for his wife the girl for whom he had written his fairy tale. He married Effie Gray—whom his

parents thought "lowly born and lowly bred"—on April 10, 1848, a day famous for two fiascos. The first of these—in London—was the dismal collapse of the Chartist march upon Parliament, reduced by rain and an overwhelming police presence to a handful of men in a cab presenting to Parliament a "monster" petition that Parliament quickly and scornfully dismissed. The second—in Scotland—was John and Effie's wedding night. What happened then—or rather what *didn't* happen then—has become fodder for endless speculation. John Ruskin refused to consummate the marriage that night—or ever. He offered a host of reasons for rejecting Effie: hatred of infants, religious motives, a wish to travel without hinderance, the desire to preserve Effie's beauty, and finally, cryptically, something about Effie herself: "though her face was beautiful, her person was not formed to excite passion. On the contrary, there were certain circumstances in her person which completely checked it." That statement has led to a great deal of unpleasant conjecture about Effie's defects. But the true reason that Ruskin never had sex with Effie—or, almost certainly, with any other human being—lay not with Effie but entirely with Ruskin: sexuality, his wife's and his own, terrified him. "My own passion," he conceded about his wedding night, "was much subdued by anxiety." Ruskin's sexual anxiety was primal and lifelong.

Effie and John lived at first with his parents for as long as Effie could stand their overbearing condescension, after which, in the autumn of 1849, they moved to Mayfair and to the heart of society—which Effie enjoyed and Ruskin endured. But at the end of that year, after another stay with her in-laws, Effie fled to Scotland and her own home, leaving Ruskin free to make a five-month trip to Europe with his parents. When he finally returned to his wife, she pleaded with him to take her—immediately—to Venice. They were there from November 1849 until March 1850, and there again from September 1851 until June 1852. While Ruskin clambered about his beloved but deteriorating stones Effie ascended the ladder of Venetian society, generally escorted by Austrian officers then occupying the city. When Ruskin finished his research the two, to Effie's dismay, returned not to Mayfair but to a house that John James had procured for them at Herne

Hill, next door to Ruskin's childhood home. There Effie took some solace in callers willing to make their way to Camberwell, while Ruskin traveled daily to the study in his parents' house Denmark Hill, where he wrote the final volumes of *The Stones of Venice*.

The Stones of Venice transfers the theory Ruskin espoused in *Modern Painters* from canvas to stone: architecture, like all art, Ruskin writes in *The Stones of Venice*, "is valuable or otherwise, only as it expresses the personality, activity, and living perception of a good and great human soul." But *The Stones of Venice* expands that theory considerably, with the addition of historical and social dimensions. The creative soul, he argues in his study of Venice, cannot exist within a vacuum but can only thrive in good and great cultures, cultures rich in social, political, and spiritual awareness. Venice was one of the world's great cultures, and therefore, Venetians produced magnificent art. And then it wasn't, and they didn't. Ruskin dated the fall of Venetian art from 1418 with the death of the great Doge Carlo Zeno, followed by a precipitous decline in both political stability and spiritual sensibility. Not coincidentally, that date marks the significant architectural shift from what Ruskin considered the vital, truthful, spiritually suffused Medieval Gothic to the enfeebled, soulless, excessive travesties of the prideful, pleasure-seeking, profane Renaissance.

Corrupt, fallen cultures produce bad art, or no art at all. What was true of Venice was true everywhere. But in the first paragraph of the first chapter of *The Stones of Venice*, Ruskin targets one particular culture on the brink of a similar collapse: "Since the first dominion of men was asserted over the ocean, three thrones, of mark beyond all others, have been set upon its sands: the thrones of Tyre, Venice, and England. Of the First of these great powers only the memory remains; of the Second, the ruin; the Third, which inherits their greatness, if it forget their example, may be led through prouder eminence to less pitied destruction." From the start, then, Ruskin conceived *The Stones of Venice* with a dual purpose: not simply to record the rise and fall of Venetian culture, but to warn of England's cultural and spiritual decline—to employ his voice to prevent its fall. He became a social critic.

And he did so brilliantly with "The Nature of Gothic," a chapter in the second volume. There Ruskin proclaimed the most noble, and only essential quality of Gothic architecture to be savageness, or rudeness: Gothic finds its greatness in its very imperfection, for in that imperfect work one can see the thought, the humanity, the soul of the artisan—himself imperfect—shining through. Any demand for perfection from the artisan would be nothing less than a demand for slavery, for it forces the artisan to defer entirely to an architect's commands, resulting in rote, thoughtless, soulless production. With that idea in mind, Ruskin turned to his own society—and turned against his own readers. The English, he argued, demand absolute perfection in all things: the straight lines and precise measurements born of the factory, and of the factory's division of labor and mass production. It was a demand, imposed by one social class upon another, with a spirit-destroying cost:

> And now, reader, look round this English room of yours, about which you have been proud so often, because the work of it was so good and strong, and the ornaments of it so finished. Examine again all those accurate mouldings, and perfect polishings, and unerring adjustments of the seasoned wood and tempered steel. Many a time you have exulted over them, and thought how great England was, because her slightest work was done so thoroughly. Alas! if read rightly, these perfectnesses are signs of a slavery in our England a thousand times more bitter and more degrading than that of the scourged African, or helot Greek.

In that terrible social injustice lay the promise of social collapse: "Let me not be thought to speak wildly or extravagantly. It is verily this degradation of the operative into a machine, which, much more than any other evil of the times, is leading the mass of the nations everywhere into vain, incoherent, destructive struggling for a freedom of which they cannot explain the nature to themselves." Ruskin sounded this warning in 1853. Seven

years later, he would again take up social prophecy; it would then become a ruling passion until the end of his career.

Meanwhile, his marriage was collapsing. Among Effie's callers at Herne Hill that year was a fateful one: "These last days I have been sitting to Millais from immediately after breakfast to dinner thru all the afternoon to dark," she wrote her mother that June. The Ruskins had met John Everett Millais two years before, soon after Ruskin had taken up the defense of the Pre-Raphaelite Brotherhood with two letters to the *Times*. By 1853, Ruskin saw himself as a close friend of and mentor to Millais; he invited Millais and his brother to travel with him and Effie to the Scottish Highlands, where Millais would paint Ruskin's portrait. There, Effie and Millais fell in love while Ruskin remained oblivious. His marriage with Effie was doomed; it struggled on for six months more in an increasingly noxious atmosphere of mutual acrimony, careless insinuation, parental intrusion, and unbearable tension; Ruskin and his parents were now convinced that Effie was insane. Finally in April 1854 Effie fled for good, leaving behind her wedding ring, house keys, account book, and a bitter letter to Margaret Ruskin laying bare the conjugal failings of her son. The marriage was annulled that July on the grounds of Ruskin's incurable impotency. And Ruskin was free.

Free, that is, to return to his parents. "They have got him now," wrote John Millais of the elder Ruskins, "and will keep on either side of him like two policemen, or the two outside horses in the Edinburgh omnibuses." (Millais himself would marry Effie within a year.) Ruskin moved back to Denmark Hill and soon afterward traveled again with his parents to Switzerland. He would be with them for the rest of their lives, his freedom from them, as before, only temporary, found in the friendships he kept largely apart from them, and in his frequent travels, by himself, to the countryside and to the continent.

His closest friendships for the rest of the 1850s were with Pre-Raphaelites. Millais was his first Pre-Raphaelite friend, and Ruskin with incredible naivete thought their friendship would survive the collapse of his marriage. When in December 1854, however, Ruskin wrote Millais a cordial letter

inviting him to join him in his new project, teaching drawing at the newly-opened Working Men's College in Holborn, Millais set him straight and cut him dead: "I can scarcely see how you can conceive it possible that I can desire to continue on terms of intimacy with you."

By then, Ruskin had largely shifted his attention to Millais's fellow Pre-Raphaelite, Dante Gabriel Rossetti. The two remained close for over a decade, their friendship enduring for as long as the two were able to satisfy one another's needs. Rossetti when he met Ruskin was living impecuniously with his model and mistress Elizabeth Siddal, struggling to sell his art. He desperately needed a patron and found a generous one in Ruskin; Ruskin just as desperately needed to be needed, to have a protégé he could nurture and transform into the great artist he was sure Rossetti could be. That May, he sent Rossetti all his written works; Rossetti reciprocated with a watercolor drawing. They agreed that Ruskin would pay Rossetti a fixed amount every year, in return for the pick of his artwork. Within a year Ruskin developed wildly inflated notions about Rossetti's lover Lizzie Siddal's promise as an artist. He had known five geniuses, he wrote in 1855: "Turner, Watts, Millais, Rossetti, and this girl." And so Ruskin worked out an arrangement with Siddal as well, paying £150 a year for anything she could produce.

Rossetti thrived as much upon Ruskin's praise as his money: "He is the best friend I ever had *out of my own family*," Rossetti wrote at the time; and at the time Ruskin would have concurred. The turbulence in the friendship, when it came, came with Ruskin's need to shape Rossetti; free-spirited, Bohemian, and adverse to any restraint, Rossetti, like Whistler, had an enormous ego and abundant faith in his own artistic instincts. He hardly needed or appreciated Ruskin telling him how to paint. Ruskin, on the other hand, with his equally enormous ego and abundant faith in his own critical instincts, could never understand that his advice could be anything but valuable. While dependent upon Ruskin's patronage, Rossetti tolerated Ruskin's advice. But as his success and his patronage grew, he began to despise it. For the ten years or so until the two reached the tipping-point, however, Ruskin found a place at within the Rossetti circle, and

made Rossetti's companions his own: Rossetti's brother, William Michael; Rossetti's own protégés William Morris and Edward Burne-Jones; Pre-Raphaelite hanger-on and factotum Charles Howell, who quickly became Ruskin's personal hanger-on and factotum; briefly but intensely, Algernon Charles Swinburne. But never—never—despite Swinburne's best attempts to bring them together, with James Whistler.

The 1850s were, in Ruskin's own words, "my days of serious critical influence," both *Modern Painters* and *The Stones of Venice* having established him without question as England's preeminent art critic. In 1855 he released the first of his *Academy Notes*, annual assessments of the Royal Academy exhibitions. All of them he wrote with a tone of haughty certainty that he considered he had earned: "twenty years of severe labour, devoted exclusively to the study of the principles of Art, have given me the right to speak on the subject with a measure of confidence." While he did not hesitate to praise works where he thought praise was due, his forte was in censuring blunders and berating falsity. The reputation of an artist offered no protection from his censure. In his first *Academy Notes*, for example, he savaged *Beatrice*, a painting by President of the Royal Academy Charles Eastlake, and he pilloried both the wildly popular artist Daniel Maclise and his painting *The Wrestling Scene in "As You Like It"*: "very bad pictures may be divided into two principal classes—those which are weakly or passively bad, and which are to be pitied and passed by; and those which are energetically and or actively bad, and which demand severe reprobation, as wilful transgressions of the laws of all good art. The picture before us is of the last class." Ruskin became the scourge of modern painters, not so much because of the acerbity of his attacks—other reviewers were quite capable of that—but because of the weight of his influence: he could make or break and artist's reputation, could hasten or hinder a sale. In 1856 *Punch* magazine recognized that power with its "Poem by a Perfectly Furious Academician":

> I takes and paints,
> Hears no complaints,
> And sells before I'm dry:

Till savage RUSKIN
He sticks his tusk in,
Then nobody will buy.

And just as his earlier denunciations of the state of British architecture
had made him enemies among architects, *Academy Notes* made him enemies
among painters. Eastlake, certainly, was one: his wife, Lady Eastlake, was
to become Ruskin's most vituperative critic. Ford Madox Brown, friend
and mentor to the Pre-Raphaelites, was another. So was William Powell
Frith, the most popular artist of the day. Ruskin could not care less about
their enmity. To him, the Truth was worth any number of ruffled feathers.

Ruskin issued the last of his *Academy Notes* in 1859.* In 1860, he issued
the fifth and final volume of *Modern Painters*. And then "I gave up my art-
work and wrote this little book—the beginning of the days of reprobation."
The "little book," in the form of four essays in *Cornhill Magazine*, was *Unto
This Last*: the first of his many salvos against John Stuart Mill and his fellow
political economists, who with their "science of darkness" had encouraged
and enabled the unchecked rise of foul and dehumanizing industry with
its attendant evils—class conflict and civil disorder, environmental degra-
dation, appalling poverty amid plenty, disease and misery, the collapse of
culture—and therefore the disappearance of true art. Ruskin had by 1860
moved far past his mother's evangelicalism, and had even begun to doubt
in an afterlife, but he had no doubt whatsoever that hell existed, all about
him: "the folly and horror of humanity enlarge to my eyes daily." Madden-
ingly, Mill and his fellow dismal scientists had convinced the public that
this disintegration was *progress*! Ruskin resolved to unconvince them. His
writing thus took on the polemic tone of an outcast prophet addressing a
stubborn and fallen people. He courted opprobrium. He got it.

His attempt to demolish the political economists with *Unto This Last* was
quickly met with a virulent critical reaction. *The Saturday Review* in par-
ticular was relentless upon "the utter imbecility of Mr. Ruskin's reasoning

* He did resurrect *Academy Notes* sixteen years later, issuing one number in 1875.

powers," and his "absolute nonsense": "intolerable twaddle" written by a "mad governess" who "whines and snivels" and "can only write in a scream." Another critic declared the essays "one of the most melancholy spectacles, intellectually speaking, that we have ever witnessed," while another lamented "It is no pleasure to see genius mistaking its power, and rendering itself ridiculous." The onslaught proved too much for *Cornhill's* publisher, George Smith, and he cut Ruskin off after four issues. (William Makepeace Thackeray, *Cornhill's* editor, gave Ruskin the bad news.) Two years later, Ruskin returned to the battle with a second set of essays, this time in *Fraser's Magazine.* These essays, later published as *Munera Pulveris,** provoked vitriol stronger, if anything, than before; after six essays this time Fraser's editor, James Anthony Froude, suspended them. After that Ruskin mounted his attack by fits and starts. There were his lectures, several of which he published in *Sesame and Lilies* (1865) and *The Crown of Wild Olive* (1866). There were his steady stream of letters to the editors of various newspapers. There was his *Time and Tide* (1867), letters ostensibly addressed to a single workman. And then, beginning in 1871, there was *Fors Clavigera*, his monthly letters addressed to *all* the workmen of England. Together, they constitute Ruskin's attempt to demolish orthodox political economy and set in its place his own unorthodox and humanistic one.

Ruskin's social criticism, as his art criticism, sprang from the truth of his indelible fourteen-year-old Schaffhausen moment, the truth that matter and spirit were inextricably bound. With age, however, and with his ever-growing awareness of the ever-widening physical and spiritual darkness of the modern world, that truth had become more complicated. Every single thing in Ruskin's universe had its moral component: something might tend to good or to evil, but it could not be morally neutral. The fatal flaw of the orthodox political economists lay in their spinning out systems in which the spiritual was entirely stripped away from the material, discarded, and

* The title translates as *Gifts of the Dust*, an ironic reference to the empty materialism Ruskin was attacking.

forgotten. For them, men lacked souls; they were simply interchangeable units of physical force. And to them, society lacked spirit; its highest end lay in producing and consuming the greatest possible amount of material goods. In removing spirit from matter, the political economists described a world that never was and never could be.

True wealth, to Ruskin, did not lie simply in the abundant production of things. The moral *quality* of the things produced, and not simply the quantity, made all the difference. Not all material "goods" were actually good. True wealth stemmed from the production of those things that restored and elevated humanity, that nurtured body and soul. Ruskin shouted that truth, textually, at the beginning of *Unto This Last*: "THERE IS NO WEALTH BUT LIFE." All things that degraded body and soul—things adulterated, polluting, contentious, vicious—were not goods at all, but *bads* as Ruskin put it, and their production created not wealth, but its opposite: *illth*. The darkening of England, the increase of social misery, the death of the beautiful—all demonstrated the absurdity of allowing enlightened self-interest and the invisible hand of the laissez-faire marketplace to operate unchecked: competition allowed the profit of the few at the debilitating, dehumanizing cost to the many. Instead of competition, Ruskin proposed cooperation, a marketplace ruled by love: the interaction of honest and moral individuals, set upon collective growth and mutual prosperity. And to rule them, Ruskin proposed replacing the invisible hand of the free market with the authoritative hand of a paternal government, one that promoted true wealth and discouraged *illth* by authorizing production of goods and prohibiting that of *bads*, by setting and enforcing fair wages, by protecting the weak and the elderly, and by creating an enlightened, honest, cooperative citizenry through universal and—above all—*moral* education. It was all a form of socialism, but not the progressive socialism of an uncertain future. Rather, it was socialism rooted securely in an idealized, distant past, in Ruskin's beloved Middle Ages: hardly communism but rather communalism, a resurrection of the social structure of the village and the economic organization of the guild, all guided by a true, authoritarian monarch, and all infused with the spirit of the New Testament. It was radical change born

of the deepest conservatism. When Ruskin declared in his autobiography that "I am . . . a violent Tory of the old school," he meant it.

———

Ruskin's turn from art criticism to social prophecy in the 1860s cast him into an intellectual wilderness, where he was unceasingly perplexed at the stubborn ignorance of opponents and public alike in the face of what he took to be obvious truths. Those who didn't vilify his social writings, it seemed, simply tolerated them as eccentric diversion from his true talent: writing beautifully about beauty. Ruskin did remain in great demand throughout the 1860s as a public speaker; his well-established reputation as arbiter of art and master of oratory guaranteed that. But he was haunted now by the conviction that while many continued to hear him, few actually *understood* him. That conviction was surely driven home to him in April 1864, when he traveled to Bradford to speak on the occasion of the opening of its new corn exchange, which had been constructed in imitation of the Venetian Gothic that Ruskin so loved. The citizens of Bradford expected him to praise them for their choice. But Ruskin came to excoriate. He denounced the exchange as a bauble of tasteless fashion and as a profane temple to the "Goddess of Getting-on." He blasted the burghers of Bradford for their greedy and materialistic worship of her, seeing in it the destruction of their souls and the collapse of their culture. "Continue to make that forbidden deity your principal one," he warned, "and soon no more art, no more science, no more pleasure will be possible. Catastrophe will come; or, worse than catastrophe, slow mouldering and withering into Hades." In this way assailed and denounced, Ruskin's audience felt no shame and recognized no error; rather, they listened politely, enjoyed the easy erudition and elevated rhetoric, applauded at the all the right places, and in the end voted Ruskin their hearty thanks.

Ruskin's friends were alarmed and dismayed by his turn from art to political economy. One, John Brown of Edinburgh, greeted the first release of the first part of *Unto This Last* with a letter bemoaning "this *unlucky*

paper." Dante Gabriel Rossetti thought that entire work "bosh." One man, however, was delighted by Ruskin's turn to political economy, and the two became far closer because of it. Thomas Carlyle, who had pioneered Ruskin's way as Victorian social prophet with his own *Past and Present* and *Latter-Day Pamphlets*, had had little interest in Ruskin's art criticism, but saw a kindred spirit and a protégé in Ruskin's bitter attack on Mill and his fellows. He greeted *Unto This Last* with jubilation: "You go down through those unfortunate dismal-science people like a treble-X of Senna, Glauber, and Aloes; like a fit of British cholera, threatening to be fatal! I have read your paper with exhilaration, exultation, often with laughter, with bravissimo! Such a thing flung suddenly into half a million dull British heads on the same day, will do a great deal of good." He was equally delighted with *Munera Pulveris*: "there is a felicity of utterance in it such as I remember in no other writer, living or dead, and it's all as true as gospel." Ruskin, who would in later years address Carlyle as "my dearest Papa," found in Carlyle a new father figure.

In his own father Ruskin suddenly found far less of one, for in attacking orthodox political economy Ruskin attacked the principles that John James Ruskin had lived by and thrived upon. Having failed to convince his son to "spare his brain" and abandon *Unto This Last*, John James at first weathered the ensuing opprobrium bravely, writing of his son's critics "it is rather amusing to see the commotion they make" while admitting "perhaps I should have preferred his not meddling with Political Economy for a while!" But when *Munera Pulveris* renewed the critical onslaught, the elder Ruskin lost his courage. His son attempted to restore it. "Mind critiques as little as possible," Ruskin wrote to his father; "read, of me what you can enjoy, put by the rest, and leave my 'reputation' in my own hands, and in God's." It was no good. They had reached an intellectual impasse. "We disagree about all the Universe," Ruskin wrote of their relationship in 1862. With his mother, too, there were divisions—not because of his social thinking, which meant little to her, but with their religious differences, which had become profound and irreconcilable. For some time Ruskin had strayed from his mother's adamantine evangelicalism—a movement capped by

the striking revelation Ruskin had in Turin in 1858 when after being overwhelmed by the "God-given power" of a painting by Veronese, he attended an evangelistic chapel and was horrified by the "little squeaking idiot" preaching there. "I came out of the chapel, in sum of twenty years of thought, a conclusively *un*-converted man." Gone then was any vestige of his mother's narrow, joyless, anti-Catholic Protestantism, and gone were the comforting religious certainties of his youth. Although he never relinquished his belief in God, his doubts grew as he aged: doubts in the literal truth of the Bible, the personal intervention of God into human lives, the immortality of the soul. With his mother, then, he also disagreed about all the universe.

By the early 1860s, as Ruskin's friendship with Rossetti had cooled, a new one kindled—and would burn for the rest of his life. Rossetti's protégé Edward Burne-Jones, still in his twenties when they first met in 1857, was far more temperamentally suited to be a true friend to Ruskin than Rossetti had been: quiet and unassuming, and with an ego far more restrained than Rossetti's, he was more than willing to give Ruskin the worship he craved. Indeed, that worship had begun years before, when Burne-Jones as an Oxford undergraduate had read and fallen in love with Ruskin's writing: "There never was such mind and soul so fused through language yet. It has the brilliancy of Jeffrey, the elegance of Macaulay, the diction of Shakespeare had he written in prose, and the fire of—Ruskin—we can find no other." When in 1860 Burne-Jones married, his wife Georgiana happily fell in with her husband's hero-worship. In his letters to them, Ruskin addressed them as "My Dearest Children" and posited himself as their "Papa."

As he grew closer with this pretend family, he grew more distant from his actual one. "I am in a state of subdued fury whenever I am at home, which dries all the marrow out of every bone in me" Ruskin wrote his friend Lady Trevelyan in 1862. He took to escaping from his parents with extended visits to the country houses of friends: Northumberland and the Trevelyans, Hampshire and the Cowpers—and Kildare, Ireland and the La Touches, whom Ruskin first met in London at the beginning of

1858, immediately developing a profound affection for their nine-year-old daughter Rose. Ruskin sought refuge, as well, at Winnington Hall, a girl's school in Cheshire that he had adopted and that had adopted him. There he happily wiled away the hours with the girls, teaching, dancing, playing. And he repeatedly returned to Europe—without his parents. But if he could run from his family troubles in this way, he could not escape the often-profound depression that followed him—followed him, for example, in May 1862, when he set out with Edward and Georgiana Burne-Jones for Italy. "At Boulogne we stayed the night, at the Hôtel des Bains," remembered Georgiana, "and in the afternoon he took us a walk down the shore, where the tide was far out and only a great stretch of wet sand lay before us. Here a mood of melancholy came over him and he left us, striding away by himself towards the sea; his solitary figure looked the very emblem of loneliness as he went, and we never forgot it." Georgiana had no doubt about the origin of his depression: *Unto This Last* was about to appear as a book, and she knew that "the thoughts expressed in these prophetic pages had not found acceptance even in the heart of his own father—no wonder that to us he was silent." She did not realize, however, that he had a further cause for his misery: the departure the month before of the La Touches and Rose—now fourteen and with whom Ruskin was now passionately, hopelessly in love—from London to Ireland, for what would be a three-year separation. "Since that day of April, 1862," Ruskin wrote, "I have never had one happy hour—all my work has been wrecked—all my usefulness taken from me."

After ten weeks in Italy Edward and Georgiana Burne-Jones returned to England but Ruskin settled in Switzerland where, except for short trips to England, he lived for the better part of a year and a half in lonely misery, suffering something close to literary paralysis—though he did manage to produce his *Munera Pulveris* essays. He was determined to make his separation from his parents permanent. While his earlier plan to move into Tudor House with Meredith, Swinburne, and the Rossetti brothers had come to nothing, he now planned a greater escape: he would buy a chalet in the mountains near Geneva and remain there. "I know my resolution to

stay here must give you must pain," he wrote his father; "I am sorry, but it is unavoidable." He clung to that resolution for well over a year, alarming his friends as well as his parents. In November 1863 John James Ruskin dashed his son's escape plans altogether, sending Ruskin's Christ Church tutor, Osborne Gordon, to Switzerland to convince Ruskin of the practical absurdity of Alpine isolation. "I *have* quite given up all thoughts of that house in Switzerland now," Ruskin wrote his father that December. On Christmas Eve, he returned to Denmark Hill.

Ruskin was there three months later when his father, who had been suffering deeply from kidney stones, abruptly stood up, made his way to his bedroom, locked the door behind him, and collapsed. Ruskin followed, knocked, and, when there was no response, raised the alarm. It was the family's aged servant Annie Strachan who rushed outside, climbed a ladder, crawled through a window, and opened the door. They put the old man to bed; Ruskin lay beside him and held him through the night until he died at 11:30 the next morning.

Ruskin's grief at the loss of his father was augmented by his bitter regret at the division that had grown between them over the past few years. He refrained from expressing that grief, however, with the elaborate trappings of Victorian mourning, which he despised and shunned. He had his father buried quietly, and he convinced his mother to forgo the usual widow's weeds, convincing her in particular not to wear the traditional widow's cap—the cap that Anna Whistler had adopted for life after her own husband's death. But while Ruskin's grief was genuine, it was accompanied by an unshakeable sense of anger against John James for the way he had destroyed his son's life, stunting and distorting it in order to suit his own ambitions. "You have never had," Ruskin wrote to Henry Acland, "nor, with all your medical experience have you ever, probably, seen—the loss of a father who would have sacrificed his life for his son, and yet forced his son to sacrifice his life to him, and sacrifice it in vain."

With his father's death Ruskin inherited a substantial fortune—a fortune that, driven both by guilt and social principle, he quickly set about

reducing so effectively that within a decade most of it was gone. First there were the relatives that he thought his father had overlooked: he promptly distributed £17,000 to them. Then there were educational and social projects to fund. He donated heavily to the Winnington School, and after he took up his duties at Oxford he donated thousands to create a new school of drawing there: the Ruskin School. Among his many social causes, he subsidized in 1866 Octavia Hill's earliest experiments in improved working-class housing, and in the 1870s he sunk much of his fortune into the Guild of St. George, the utopian agrarian society he envisioned as an alternative to soulless industrialism. As Ruskin's generosity became dangerously widely known, there was as well the inevitable deluge of petitions and begging-letters to attend to. For these he was forced to employ a personal almoner—employ, of all people, the remarkably efficient but also opportunistic Pre-Raphaelite parasite Charles Howell. Over the next couple years Ruskin sent Howell on a hodgepodge of errands: to relieve the penury of the once-great and now aged and ailing illustrator Charles Cruikshank; to assess whether to aid a "rather nice, half crazy old French lady"; for some reason to buy a lizard canary at nearby Crystal Palace and then to give it away. In 1868 Ruskin abruptly and without surviving explanation dispensed with Howell's services—a break that quite possibly had something to do with Howell's habit of blabbing all of Ruskin's secrets among his Pre-Raphaelite friends, but also, surely, had to do with Ruskin's discovery of Howell's essential dishonesty—something Ruskin's mother had been aware of all along.

A month after his father's death, Ruskin's seventeen-year old second cousin Joan came to the Ruskins for a week, and remained for a lifetime. Margaret Ruskin failed to intimidate Joan as she intimidated everyone else, and Joan quickly became her companion. Within a year, Ruskin made her his ward. He could now leave his mother safely in her hands, but for the next two years, whether motivated by remorse for his father, duty to his mother, or simply by inertia, he rarely did. After that, however, Ruskin resumed his pattern of flight and return, staying with friends, touring the lakes, and roaming across the continent.

His diaries at this time show his battle with darkness, physical and emotional, which would culminate in 1871 with the Matlock vision of the plague cloud, was well underway. In his obsessive observations of the weather, rare bright days are overwhelmed by dull, dreary, miserable ones. The "black blight," he already knew, was growing: "Nature herself not right" he wrote while in Switzerland in June 1866, and, in one memorable succession of entries a year later, the same refrain appears, day after day: "Black Fog." For Ruskin, meteorological and psychological gloom, subject to the same spiritual forces, invariably reflected one another: his entry for June 16, 1867, for example, reads "Black fog and storm all day . . . One of the most wretched days I ever spent." "Wretched," "despondent," "dismal," "sorrowful," and "sad" are terms he repeatedly used to describe himself. Though his natural disposition toward depression largely explains his misery, his depression now had a specific cause: his ongoing, long-distance, and endlessly torturous relationship with Rose La Touche.

By then, his passion for Rose had grown to control him and distract him at times to the brink of madness. Early in 1866, soon after Rose's eighteenth birthday, Ruskin had impulsively proposed to her, setting off an explosion that would devastate them both. Rose, happy enough to have her "St. Crumpet" as playful friend and informal tutor, could not fathom the thought of becoming his wife, and fended him off by deferring her answer for three years. Rose's parents were shocked as well by his proposal: the sudden mutation of this middle-aged man with a notorious marital past from Rose's tutor to her suitor was disturbing enough, but worse to them was his religious skepticism. Rose's mother, Maria, was so troubled by Ruskin's falling away from evangelicalism and his religious doubts that in 1862 she made him promise not to publish them for a decade. Rose's father, John, a fervid and freshly converted evangelical with an uncompromising Calvinistic belief in the absolute divide between elect and damned, was even more horrified. They quickly forbade contact between Ruskin and Rose. Since then, Ruskin had only seen Rose once, by chance and disastrously in 1870 at the Royal Academy's inaugural winter exhibition: when he tried to speak to her she cut him dead. He remembered the

day as one of the worst in his life. Two years before this, clearly hoping to put an end to the very possibility of Ruskin becoming her son-in-law, Maria La Touche had contacted both her solicitors and Effie Millais about the legal possibility of Ruskin's marrying for a second time. The lawyers informed her—incorrectly—that Ruskin could not remarry because if he was impotent the marriage would not be valid, and if he wasn't, then his first marriage stood and a second one would be bigamous. Effie in her response bitterly denounced Ruskin as "quite unnatural" and constitutionally incapable of sex with women. Sexually naïve Rose, learning of Effie's letter, could only have been both deeply confused and deeply repelled by its intimations of monstrosity.

In 1871, after Rose turned twenty-one, Ruskin consulted with his own lawyers, who concluded that he was perfectly free to marry again. That July at Matlock, while recovering from his serious illness, Ruskin, armed with this conclusion, wrote to Rose renewing his proposal, telling her "all is ascertained & safe." If he thought that, with the legal hurdle cleared, Rose would fall into his arms, he misjudged her entirely. By then Rose had surpassed her parents in resisting any idea of marrying him. She had grown to espouse an evangelicalism stronger than her father's; she embraced the spiritual and rejected the material with a self-destructive intensity, resulting in self-starvation and stunted growth, and in bouts of mental and physical illnesses from which she would never fully recover. In her mind, a genuine affection for Ruskin battled continually against her fears and doubts about his dark and unforgiveable sins; upon reading Ruskin's letter from Matlock, the fears and doubts won out. Her letter flatly rejecting his proposal does not survive, but Ruskin's stunned reaction does: "she sent an answer which for folly, insolence, and selfishness beat everything I yet have known produced by the accursed sect of religion she has been brought up in." He resolved to end the relationship, proclaiming himself "entirely satisfied in being quit of her." By the end of that year, as he watched over his dying mother, Ruskin had convinced himself that his love for Rose was dead.

Despite his emotional turmoil, Ruskin continued to study and to write across a wide range of disciplines. His drive to reform society competed with his drive to teach art. "There is so much misery and error in the world which I see I could have immense power to set various human influences against, by giving up my science and art, and wholly trying to teach peace and justice," he wrote his mother in 1868; "and yet my own gifts seem so specially directed towards quiet investigation of beautiful things that I cannot make up my mind, and my writing is as vacillating as my temper." He dabbled as well in botany and geology, focused upon mythology with *The Queen of the Air* (1869), and in 1866 had produced what was surely his oddest work in *The Ethics of the Dust*, a tribute to his many sojourns at Winnington: set in the form of rather excruciating dialogues with the schoolgirls, the work peculiarly blends geology, philosophy, theology, and very dubious pedagogy.

Then, in August 1869, circumstances pushed him again toward the investigation of beautiful things, when he was elected Slade Professor at Oxford. His appointment was largely due to the efforts of two friends from his undergraduate days: Henry Acland, who supported him whole-heartedly, and Henry Liddell, dean of Christ Church and vice-chancellor of the university, whose support was far more reserved, for he feared Ruskin's politics. In the end Liddell chose him largely because of the deficiencies he perceived in Ruskin's two rivals for the position: the art critic for *The Saturday Review* Francis Turner Palgrave, and the critic for the *Times*, Tom Taylor.

Ruskin began his Oxford lectures in February 1870, again employing the deeply moral aesthetic theory that had, in *Modern Painters*, made him famous. Fineness in art, he instructed his undergraduates in his third lecture, "is an index of the moral purity and majesty of the emotion it expresses"; "you cannot paint or sing yourselves into being good men; you must be good men before you can either paint or sing, and then the colour and sound will complete in you all that is best." But for all his revision to past theory, Ruskin was now far less comfortable than he had been in his belief in the power of the aesthetic in the modern world; now, there

were always doubts, always the fear that society had deteriorated into a place where both the production and the comprehension of true art was no longer possible. In *Fors Clavigera*, in 1874, he articulated the fear that social decline had rendered art—and his position of Slade Professor of Art—absurdities:

> One day last November, at Oxford, as I was going in at the private door of the University galleries, to give a lecture on the Fine Arts in Florence, I was hindered for a moment by a nice little girl, whipping a top on the pavement. She was a *very* nice little girl; and rejoiced wholly in her whip, and top; but could not inflict the reviving chastisement with all the activity that was in her, because she had on a large and dilapidated pair of women's shoes, which projected the full length of her own little foot behind it and before; and being securely fastened to her ankles in the manner of mocassins, admitted, indeed, of dexterous glissades, and other modes of progress, quite sufficient for ordinary purposes; but not conveniently of all the evolutions to the pursuit of a whipping-top.
>
> There were some worthy people at my lecture, and I think the lecture was one of my best. It gave some really trustworthy information about art in Florence six hundred years ago. But all the time I was speaking, I knew that nothing spoken about art, either by myself or other people, could be of the least use to anybody there. For their primary business, and mine, was with art in Oxford now; not with art in Florence, then; and art in Oxford now was absolutely dependent on our power of solving the question—which I knew that my audience would not even allow to be proposed for solution—"Why have our little girls large shoes?"

Ruskin had promised Dean Liddell, in accepting the professorship, that he would keep his politics, his "own peculiar opinions," out of the

lecture-hall. But that was a promise he could not keep; from the start, the social critic struggled against the professor of aesthetics. "I could easily teach you," he told his students in his fourth lecture, "as any other moderately good draughtsman could, how to hold your pencils, and how to lay your colours; but it is little use my doing that, while the nation is spending millions of money in the destruction of all that pencil or colour has to represent. . . ." For a short time after becoming Slade Professor, his politics were generally confined to dark asides such as these to the undergraduates. It was not enough, however, and from the beginning of 1871 he found a new forum and a new audience for his social prophecy with what would become his most personal and most extensive literary project: *Fors Clavigera*, the monthly exposure of mind, heart, and soul to the workmen of Great Britain.

Fors translates from Latin as force, fortitude, or fortune; *Clavigera* as club-bearer, key-bearer, or nail-bearer. To Ruskin, there were three *fors*: the force of the club-bearer, the fortitude of the key-bearer, the fortune of the nail-bearer—courage, patience, and, above all, fortune, his three prescriptions for the uncertain future he and his readers faced. For the next thirteen years—the first seven with monthly regularity, the following six intermittently—Ruskin spoke with stream-of-consciousness intimacy about "the thousand things flitting in my mind, like sea-birds for which there are no sands to settle upon": about Giotto and Carpaccio, about Shakespeare, Chaucer, Sir Walter Scott; about the Battle of Crécy and the Paris Commune; about his childhood; about the ever-encroaching plague cloud; about Theseus's vegetable soup, crocodiles, and Yorkshire goose pie; literally about cabbages and kings. He returned again and again to his alternate political economy, his attempt to turn the tide and save the world, to overcome the dark satanic Mills, both of the manufactory and the dismal-scientist variety. To that end, *Fors Clavigera* quickly became the official journal for the Guild of St. George, Ruskin's utopian project to buy up land—with, at first his own money, and then with the support of others he was sure would follow—to form agrarian communities comprised of true believers, with himself as undisputed master: communities that valued work by hand and eschewed machinery. He dreamed that the Guild might, slowly but surely,

replace the body- and soul-destroying illth of industrialism with life-giving material and spiritual wealth: pure air, water, and earth; admiration, hope, and love. Of all Ruskin's many projects, this was by far the most ambitious. Seeded by the £7,000 that Ruskin literally tithed to the Guild in its first year, the project began grandly, but over the years petered out, until little more than a little museum in Sheffield survived.* That was later. In 1871, *Fors Clavigera's* first year, Ruskin devoted himself to the periodical and to its mission with the energy and enthusiasm of one who was sure he could alter the universe.

From January to November 1871, Ruskin kept strictly to his *Fors* deadline: neither his duties at Oxford, nor his journey to Matlock and his serious illness, nor his ongoing vigil over his dying mother prevented him from issuing a *Fors* letter on the first working day of each month. Nor did one other trip that he made that autumn during his mother's final decline. He had fully intended that summer, when he canceled his lectures for the rest of the year, to remain with his mother until her inevitable end. "My mother is so very feeble," he wrote that August to a friend, "that I cannot in the least say whether there is any chance of my getting away from home." Within a month, however, an overpowering temptation did pull him away: the opportunity to begin a new life after his mother's impending death. That opportunity had come from out of the blue that summer, when William James Linton, a radical engraver and printer then in self-imposed exile in the United States, hardly a good friend of Ruskin's but somehow aware of his love of the Lake District, contacted him offering to sell him Brantwood, his dilapidated estate off Coniston Water, for £1,500. Ruskin jumped at the offer and bought the house sight unseen. He would, after his mother died, sell Denmark Hill and relocate to the Lakes. In the future, when he visited London he would stay in the house at Herne Hill, which he had given to Joan and Arthur Severn when they married.

Having bought Brantwood, he could not resist the urge to see it. In September he made his way there by train, and for the next three weeks inspected the house and arranged for its renovation; he rowed the lake,

* And *continues* to survive.

rambled about the estate, and fell in love with the views. This, he knew, was where he belonged: "Here I have rocks, streams, fresh air, and for the first time in my life, the rest of the proposed *home*. I may by some new course of things be induced to leave it, but have no intention of seeking ever again for a home, if I do." After that, and after, for good measure, a week touring Scotland, Ruskin returned to his mother and, save for a lightning trip to Oxford, stayed with her until the end.

Margaret Ruskin was by then beyond the point of communicating. "My mother has been merely asleep—speaking sometimes in the sleep—these last three weeks," Ruskin wrote to a friend at the end of November. "It is not to be called paralysis, nor apoplexy—it is numbness and weakness of all faculty—declining to the grave. Very woeful: and the worst possible sort of death for *me* to see." On December 5, 1871, after gradually sinking into total unconsciousness while her son endured "one ghastly monotony of indescribable shadows," she died.

Deeply unsettled by his mother's last days, Ruskin for the first time missed his monthly deadline for *Fors*. It came out two days before Christmas. In it, Ruskin confided to his readers that he wrote it while sitting beside her corpse. He buried his mother beside his father, again reputedly flaunting Victorian convention by burying her in a sky-blue coffin. To commemorate her, he set to reclaiming and purifying a spring near Croydon and placing a plaque devoted to her there. This project failed: the spring soon lost its purity and the plaque was taken down. He was surprised to find that he missed his mother deeply; he was plagued by a sense of regret "for the contrary of love and kindness" he considered he had shown her while she lived. But he also realized that he did not love her. "I never loved my mother," he wrote to his friend George MacDonald. "I was deeply grateful to her—imperfectly dutiful to her—but there was no real intercourse possible between us, for many and many a day—far gone." All love, he thought in his grief, he had exhausted upon his Rose: "All that I had of love was given to one person—and thrown to the kites and crows." But he was far from done with love, or with Rose La Touche.

CHAPTER 3

NOCTURNES

Having created his miraculous twilight and moonlight on that miraculous evening in August 1871, Whistler lost no time in putting them before the public and the critics. That October he sent them to the Dudley Gallery in Piccadilly to be shown at its *Winter Exhibition of Cabinet Pictures in Oil*. Then he left for Liverpool, the *Mother* in tow, for an extended stay with the Leylands at Speke Hall, trusting to Walter Greaves to report to him the critics' response to his work. Not surprisingly, several were baffled. The critic for the *Examiner* allowed that the two paintings were "unique and striking," but concluded that "they are not pictures, whatever else they may be." The *Daily News* thought Whistler's "vagaries in colour" were "rather amusing than unpleasant." They were "peculiar smudges" to the *Morning Advertiser*, "two of the most eccentric productions that even Mr. Whistler has ever exhibited." "To . . . willfully reduce art to this, its very simplest infantine expression," scoffed the critic from the *Illustrated London News*, "approaches the extreme limit of absurdity." Other critics, on the other hand, could see the beauty behind the novelty. The critic for the *Pall Mall Gazette* noted the "concentration in them of the most delicate and evanescent kind of truth"; the one for *The Athenæum* their "exquisite harmony in

chromatics." Anna Whistler was so delighted by this last review that she clipped it out and sent it to her sister in New York.

By far the most perceptive and glowing assessment came from the critic of the *Times*, Tom Taylor. Taylor, a true renaissance man among the Victorians, had been trained as a barrister and long served as secretary to the Board of Health. But he was best known as an astoundingly prolific writer. He was a journalist for a host of newspapers for the past three decades, writer for and later as editor of *Punch* magazine, and Victorian England's most copious playwright: he wrote more than a hundred plays, only one of which is now widely remembered—not for its merit but as an historical footnote: *Our American Cousin* was the play Abraham Lincoln was watching when he was shot. Finally, Tom Taylor served as art critic for both the *Graphic* and the *Times*. Despite his titanic stature as a Victorian man of letters, Taylor was not considered England's most renowned art critic; John Ruskin had taken that honor years before and seemed destined to hold it for life. But Tom Taylor was certainly first among equals when it came to the rest. And after a careful examination that November of Whistler's two paintings in the Dudley, England's second-most renowned critic gave them unqualified approval. The two paintings "are illustrations of the theory," Taylor declared, "not confined to this painter, but most conspicuously and ably worked out by him, that painting is so closely akin to music that the colours of the one may and should be used, like the ordered sounds of the other, as means and influences of vague emotion; that painting should not aim at expressing dramatic emotions, depicting incidents of history, or recording facts of nature, but should be content with moulding our moods and stirring our imaginations, by subtle combinations of colour, through which all that painting has to say to us can be said, and beyond which painting has no valuable or true speech whatsoever." Both *Variations in Violet and Green* and *Harmony in Blue-Green, Moonlight*, Taylor concluded, triumphantly vindicated Whistler's theory: anyone seeing them "will feel the beauty and charm *sui generis* of these pictures. They are, at least, the result of a very peculiar faculty, and are marked with an individual stamp, and this is the rarest thing in pictures at present."

Walter Greaves sent a copy of this review to Whistler at Speke Hall; Whistler therefore experienced the great pleasure of knowing that an important critic not only liked but *understood* his work. On top of that, he experienced the pleasure of a quick sale: *Harmony in Blue-Green, Moonlight* was sold from the exhibition, and sold for Whistler's asking price of 200 guineas. Its buyer was wealthy banker and collector William Cleverly Alexander, who quickly became for Whistler a patron to rival Leyland, commissioning from him several portraits, as well as the redecoration of his London home. If Whistler needed encouragement to produce more nocturnes, he had it. But by that point, he needed little outside encouragement: he was already committed. He had already produced at least a dozen nocturnes by then, and over the next few years he would produce dozens more.

And over the next few years, while Whistler worked the Greaves brothers worked with him. At night—sometimes *all* night—they explored the river, Whistler sketching, or more and more simply gazing, memorizing. And during the days the brothers shared his studio, fetching and preparing his supplies, supplies that included dark red mahogany panels from their boatyard, that color good, according to Walter Greaves, for "forcing up the blues." More often, though, Whistler painted on canvases that the Greaves boys prepared for him with an undercoat of black paint, or grey: "The day is grey, the sky is grey and the water is grey, therefore the canvas should be grey," he told them. And once everything was ready, Whistler allowed the two to paint beside him, sharing his sauce and his ideas.

Every one of Whistler's nocturnes was an experiment both in effect and in technique. He experimented with the thinness of his sauce; at times he was forced to lay his canvas flat on the floor to avoid dripping. (At other times he simply allowed his paint to drip.) He experimented with drying times, setting canvases to dry slowly inside the studio or to dry more quickly outside in the garden or on the roof: a neighbor remembers "seeing the Nocturnes set out along the garden wall to bake in the sun." And he experimented with the view, moving from the river to Cremorne Gardens, to the streets of Chelsea and central London, as well as to the seashore and, in time, to

Venice and Amsterdam. For a year he called his creations "moonlights," but in late 1872, when Frederick Leyland suggested a more fittingly musical title, Whistler adopted it immediately and gratefully. "I say I can't thank you too much for the name 'Nocturne' as a title for my moonlights," he wrote Leyland. "You have no idea what an irritation it proves to the critics and consequent pleasure to me—besides it is really so charming and does so poetically say all I want to say and *no more* than I wish!"

Exactly when Whistler painted some of his nocturnes is impossible to say, since many of them remained in his studio for years before going on display. One of his greatest, for example—*Nocturne in Blue and Silver: Old Battersea Bridge**—quite possibly dates from as early as 1872, when Whistler painted a very similar scene upon a folding screen at Lindsey Row. But its existence can only be proven from 1875, when it was first exhibited at the Brighton Pavilion. Of all the nocturnes, *Nocturne in Blue and Silver* best demonstrates Whistler's refusal to allow adherence to nature to get in the way of the beautiful effects he sought. Ostensibly, the nocturne depicts Old Battersea Bridge from below, as Whistler would have seen it while the Greaves brothers did their waterman's jerk, while fireworks from Battersea Park explode in the distance. But the actual Battersea Bridge never looked like this. Its piers are actually squat and thick; Whistler narrowed and stretched them. Its central arch is in reality nearly horizontal; Whistler transformed it with a graceful curve, reimagining it as a footbridge traversed by restless, ghostly figures that balance the solitary and quiescent bargeman below. Whistler's memory was not failing him here; rather, he was synthesizing his mental image of the Thames at night with his knowledge of some of the more sublime effects of Japanese Ukiyo-e—prints such as Hiroshige's *Bamboo Yards, Kyōbashi Bridge*, also depicting a gracefully arched wooden bridge at night, with pedestrians above and bargeman below. Considered as a realistic attempt to capture the Thames at night, *Nocturne in Blue and Silver: Old Battersea Bridge* was certainly a failure. Considered as an attempt

* After 1886, titled *Nocturne in Blue and Gold: Old Battersea Bridge*.

to evoke the beauty of night, it was one of his greatest successes—though it got almost no notice when exhibited at Brighton.

The second of Whistler's great nocturnes can be dated with more certainty. In September 1875 Whistler's mother—by then retired for her health to Hastings—wrote to America of her son's most recent nocturne, "lately finished of Cremorne Gardens at Chelsea." Whistler painted several nocturnes at Cermorne, but his *Nocturne in Black and Gold: The Falling Rocket* was the one he exhibited soon afterward. For that painting, Walter Greaves remembered, Whistler called for a leaden undercoat, appropriate for one of the darkest nocturnes of all. This work was *not* a moonlight at all; there was nothing in it of the soothing dark blue-green tone of his earlier nocturnes. Here, he sought to capture pitch-black darkness illuminated only by fireworks: the climactic—apocalyptic—moment during the nightly fireworks display at Cremorne when ground, gallery and sky burst with flares, illuminations, and rockets. It is, certainly, a view of Cremorne. But Whistler later freely admitted that anyone hoping to *see* that view in his painting would be seriously disappointed. Despite the incendiary brilliance, sheer darkness overwhelms and reduces both nature and humanity to near nothingness. Three forms in the foreground are brushed on with the merest touches of thin and opaque paint so that they melt into their surroundings. It is impossible to tell if the space in front of them is a pool or a sward: a pool, reflections suggest, but a sward according to Victorian maps of Cremorne. The fireworks gallery at the center would disappear entirely into the night save for the tiny spots of illumination on its platforms and minarets. A tree to the left is only visible by its utter blackness, given definition by a greyer smoke behind it. Only the fireworks themselves provide strong evidence of life, and Whistler painted these with exquisite skill: choosing his brushes and colors carefully and arranging each tiny spot on the canvas to arrest and represent accurately the distance between rockets, their falling motion, their kaleidoscopic brilliance. His arrangement here is as carefully thought-out and executed as his arrangement of his mother's portrait. But in *Nocturne in Black and Gold: The Falling Rocket*, Whistler pursued darkness to a revolutionary point he had not reached before and

would never as successfully reach again. With this painting, he declared war upon realism, upon the Royal Academy, upon Victorian convention. He had reached his subversive limit. When, years later, Whistler's friend Théodore Duret wrote of the nocturnes, he seemed to have this one in mind: "He attained to that extreme region, where painting, having become vague, in taking one more step would fall into absolute indefiniteness and could no longer say anything to the eyes."

In exhibiting, therefore, his *Falling Rocket* at the Dudley Gallery that autumn, paired with *Nocturne in Blue and Gold, No. 3,** a moonlight view of the Thames, Whistler certainly realized he was provoking his critics and the public.

"Mr. Whistler sends two pictures which almost drive us to ask him whether he is poking fun at us" wrote one critic; the painting "shows such willful and headlong perversity that one is almost disposed to despair of an artist who, in a sane moment, could send such a daub to any exhibition." Another felt regret "that an artist who might have done so much for art has wasted his time and talent upon a mere whimsical theory, for to suppose that Mr. Whistler's system of art could ever be universally accepted would be to suppose all the best qualities in art thrown back upon their primitive elements. Colour, composition, drawing, &c., go for nothing in such fanciful representations of landscape as Mr. Whistler has latterly exhibited." A few critics did see value in the painting: one thought the view "felt and realised with great truth," and another thought it "a marvellous study of pictorial harmonies."

And then there was Tom Taylor, who offered his judgment in the December 2 issue of the *Times*. It had been four years since he saw Whistler's first London nocturne. In that time his enthusiasm for Whistler and his work had fallen—sharply. He had gotten tired of the "pretension" of Whistler's titles, and tired as well as the novelty of his custom-made frames. But, most importantly, he had lost his love for the art itself and the theory that inspired it. He conceded that Whistler's nocturnes deserved

* Later mellowed and retitled *Nocturne: Grey and Gold—Westminster Bridge.*

admiration—but not as art. "The painter," he wrote, "appraises them beyond their value, as pictures instead of mere tone studies" that "only come one step nearer pictures than delicately graduated tints on a wall paper would do." Whistler, he concluded, "must not attempt, with that happy half-humorous audacity which all his dealing with his own works suggests, to palm off his deficiencies upon us as manifestations of power, and try to make us believe that this sort of thing is the one best worth doing, because it is the only thing he can do, or all events, cares for doing."

Whistler read this review, just as he had read Taylor's earlier one. But his confidence in his own powers could not be shaken, for mid-exhibition he had triumphed with the sale of the *Falling Rocket*'s companion piece. "You will be pleased to hear," he reported to a friend, "that one of my much blackguarded 'masterpieces' *Nocturne in Blue & Gold* has just sold itself to a total stranger 'for the price named in the catalogue' as the official note from the Dudley informs me"—that is, for 200 guineas. "So you see," he crowed with ironic hyperbole, "this vicious art of butterfly flippancy is, in spite of the honest efforts of Tom Taylor, doing its poisonous work and even attacking the heart of the aristocracy as well as undermining the Working Classes!"

So much for England's second-most renowned art critic.

England's *foremost* critic would not have his say for another two years.

—⁓—

Four months after the death of his mother, John Ruskin, having left Denmark Hill forever and having given at Oxford a single course of lectures on the relation of natural science to art, set out for Italy with the remnant of his family: the now-indispensable Joan Severn and her far more dispensable husband Arthur. By the end of June 1872 the group had reached Venice, where Ruskin planned an extended stay in order to study thoroughly the paintings of his new favorite among the Venetian masters, Vittore Carpaccio. But by then Rose, back in Ireland, seeking but not finding happiness in God's service, had turned to George MacDonald, a

friend she and Ruskin shared, with a desperate plea for help. In a series of overwrought letters that betrayed her acute mental fragility, Rose begged MacDonald to show her the path to contentment. She hardly mentioned Ruskin, and when she did it was with regret for what he had become: "If it could have been so that I could have kept the *friend* who has brought such pain and suffering and torture and division among so many hearts—if there had never been anything but friendship between us—how much might have been spared." In one of these letters to MacDonald Rose enclosed a separate letter to Ruskin, brutally denouncing him and his "shipwrecked" faith: "when I think what you *might* have been, to Christ, to other human souls, to me! How the angels must have sorrowed over you! How some hearts are sorrowing still!" MacDonald never sent that letter on to Ruskin. Nor did he fully understand what Rose was telling him, for while she described an impasse, he saw in her plea the opportunity for a breakthrough: if Ruskin could return to London to explain and defend his love for Rose, MacDonald thought, the two might find happiness. MacDonald enlisted another mutual friend, Georgiana Cowper-Temple, into this cause, and the two repeatedly wrote to Ruskin in Venice exhorting him to return. Ruskin, rightly suspicious about Rose's feelings for him and unsure about his own for her, hesitated. "I will not move unless in certainty of seeing her," he wired, and then wrote "if nothing can be done—I will have not talking. I have thrice all but lost my life for this, and my life is now not mine. The little of it she has left me must be tormented with anger no more—with hope it cannot now be disturbed—the time for that is past. I trusted her with my whole heart: she threw it to the dogs to eat—and must be satisfied: but we might at least contrive that we could each think of the other without horror." He held to his resolve for two weeks, then succumbed and with wild and dangerous hope rushed across Europe back to London, arriving at the end of July. He found Rose to be a ghost of the child he knew—an anorexic skeleton too frail to sit at the table to eat dinner, which consisted on one day of "three green peas" and on the next of "one strawberry and half an Osborne biscuit." During the next three weeks, and for the first time in over six years, he and Rose sat together, conversed, rediscovered one

another—and loved. They were "days of heaven" to Ruskin: "She brought me back into life, and put the past away as if it had not been—with the first full look of her eyes."

Then she took it all away. That August, when Rose set out to return to Ireland and her parents, Ruskin set out with her, intending to accompany her to the ferry at Holyhead. On the way, they stayed with friends in Toft, Cheshire, where Ruskin gave Rose a letter declaring his love for her, and he had his final moments of joy—standing beside her in church and holding her prayer book. His letter, with its suggestions of their future life together, burst her bubble of contentment: all her fears and aversions flooded back. On the train that day to Crewe Junction, Rose broke down and publicly, furiously, loudly, relentlessly lacerated him with foul declarations of pure hatred. At Crewe the two separated—Rose to Holyhead and home, and Ruskin, deeply shaken, to London, where, rather than return to Joan at Herne Hill, he took a room at the Euston Square Hotel (a place he hated) and collapsed, cowering in a corner.

The rest of Rose's short life was one of inexorable mental and physical decline. By 1874 she was back in England with a nurse as her constant companion, shuttling between nursing homes, the homes of friends, and rooms in fine hotels. Ruskin followed her descent, but only at a distance: Rose refused his letters and would not write him. She did, however, happily welcome Joan Severn's visits, and Ruskin learned of Rose through her. It was through a letter Rose sent to Joan in the autumn of 1874 that Ruskin learned of another seismic shift of Rose's emotions: she—what was left of her—was now willing to marry him. Again, Ruskin hurried back from Europe—from Mont Blanc and Chamonix this time. From October until December he visited with her: at her fine London hotels, as her escort to church, and once at Herne Hill. Then Rose returned to Ireland, but managed—mind and body ravaged—to return to London the next February, where Ruskin saw her again: "*Of course* she was out of her mind in the end; one evening in London, she was raving violently till far into the night; they could not quiet her. At last they let me into her room. She was sitting up in bed; I got her to lie back on her pillow, and lay her

head in my arms, as I knelt beside it. They left us, and she asked me if she should say a hymn. And I said yes, and she said, 'Jesus, lover of my soul,' to the end, and then fell back tired and went to sleep. And I left her." He left her for good: she was removed to her parents' home and died there on May 25, 1875.

Writing to the workmen-readers of *Fors Clavigera* in June 1887, Ruskin neatly, if oversimplistically, divided up the work of his biblically allotted threescore and ten years into separate decades. "At twenty, I wrote *Modern Painters*; at thirty, the *Stones of Venice*; at forty, *Unto This Last*; at fifty, the Inaugural Oxford lectures; and—if *Fors Clavigera* is ever finished as I mean—it will mark the mind I had at sixty; and leave me in my seventh day of life, perhaps—to rest. For the code of all I had to teach will then be, in form, as it is at this hour, in substance, completed." Art, therefore, in the 1840s; the detour to architecture in the 1850s; social criticism and activism in the 1860s—and then, before transforming society with *Fors* and the Guild of St. George in the 1880s, a consolidation in the 1870s of his standing as England's arbiter of art through his Slade professorship. To strengthen his position as aesthetic sage, Ruskin struggled on two fronts: with his students at Oxford, and with the wider public. With both his lectures and through his founding, at substantial cost, of a new school of art at Oxford, he aimed to elevate his undergraduates into true gentlemen, with higher aesthetic ability and awareness: so that through enlightened patronage and as the future social elite they might bring about a renewal of truly great art. At the same time, everything he taught them he was careful to broadcast widely, both by opening his lectures to the public (and generally by giving two of each one of them), and by publishing virtually all of them. As for the content of his lectures, he remained consistent as to the essential theory he had set out in *Modern Painters*, but his subjects varied to embrace his continually shifting enthusiasms. He now focused upon the great Italian artists of the past, products, of course, of a greater

society than his own, and focused particularly the deeply spiritual Italian masters—Cimabue, Giotto, Fra Angelico—that he had grown to adore.

About modern artists, the lesser talents of his lesser society, he now had little to say beyond disdainful asides. In 1873, for example, he announced his plans to republish the second volume of *Modern Painters* and reintroduce his theory upon art to the world, compelled to do so because modern artists—particularly those in the emerging schools of British aestheticism and French impressionism—had lost any true conception of beauty: they, like the contemporary student of art, had "plunged . . . into such abysses, not of analytic, but of dissolytic,—dialytic—or even diarrhœtic—lies, belonging to the sooty and sensual elements of his London and Paris life. . . ." Later that same year, he took aim at one egregious offender among artists: the worst of the bad. While praising the artists of medieval Florence, who gave their best possible work for a just wage, he noted in contrast this modern transgressor: "I never saw anything so impudent on the walls of any exhibition, in any country, as last year in London. It was a daub professing to be a 'harmony in pink and white' (or some such nonsense); absolute rubbish, and which had taken about a quarter of an hour to scrawl or daub—it had no pretence to be called painting. The price asked for it was two hundred and fifty guineas."* Ruskin didn't actually name this artist, but the painting's distinctively musical title made that name obvious to all. James Whistler likely never saw this attack, buried as it was in an Oxford lecture and then, a year later, in Ruskin's book *Val d'Arno*. He would not, however, miss the next one.

In his lectures as Slade Professor, Ruskin now strayed far beyond the boundaries of aesthetics, presenting entire courses of lectures upon birds, upon flowers, upon the geology of the Alps. Outside of his lectures, he strayed as well, persisting with his crusade to transform society with his monthly *Fors Clavigera* letters, his many duties as master of the Guild of

* If Ruskin, as he claimed, actually saw this painting in 1872, he was almost certainly looking at Whistler's *Nocturne: Blue and Gold—Southampton Water*, probably the painting exhibited that year at the Dudley Gallery as *Nocturne in Grey and Gold*, listed for sale not for the 250 guineas that Ruskin remembered—but for an even more shocking 300. (YMSM 117)

St. George, and with his quixotic projects. In 1872, he set his gardener and a crew to sweep the streets about the British Museum—a project he had hatched while watching over his dying mother. In 1874, he established in Paddington a shop for the poor, selling unadulterated tea in small portions and at fair prices: an experiment in cooperative, nonprofit marketing that failed because, Ruskin realized, the poor preferred show over substance: they "only like to buy their tea where it is brilliantly lighted and eloquently ticketed." The same year, he attempted to entice his undergraduates into public service and healthy labor by building a road and improving drainage in the nearby village of Ferry Hinksey. That project netted Ruskin both notoriety and disciples, among them the then twenty-year-old undergraduate from Magdalen, Oscar Wilde. Wilde, during his time at Oxford, would become a disciple of *both* titans of nineteenth-century British aesthetics: first Ruskin, and then the classical fellow at Brasenose, Walter Pater, whose just-published *Studies in the History of the Renaissance*, with its exhortation to burn with "gem-like flame" in the ecstasy of higher perception, had made him a founding father of the Aesthetic movement. Ruskin himself never met Pater, although the two must surely have passed one another often on the streets of Oxford. As with Whistler, Ruskin was adept at avoiding people he had no desire to see.

Ruskin's duties as a professor at Oxford did little to prevent him from indulging in the compulsion to wander as he had all his life. He kept during this time rooms at Corpus Christi College, where he was an honorary fellow. But he often escaped to the studies in his two other residences, at Brantwood and at his former nursery at Herne Hill. Even while his responsibilities kept him in Oxford he often secluded himself away from the city's academic heart by staying at an inn, the Crown and Thistle, seven miles away in Abington. When he *wasn't* bound by his duties—and when he curtailed those duties, which he did more and more as the decade progressed, by abbreviating and abandoning lectures or by requesting leaves of absence—he fled Oxford for Brantwood, for London, or further afield. Brantwood he much preferred over London, for there he could renew himself in nature. After spending his early mornings wrestling with his

latest lecture or book, he generally exercised outdoors: walking the roads and fells, ascending the Old Man of Coniston, rowing Coniston water, or reclaiming and improving his estate, by gardening—digging holes, he claimed, was a favorite activity—by diverting streams, or by rebuilding his little harbor. London was now his lesser refuge, and he needed a good reason to go there: to see Rose when he could, to Christmas with Joan, to visit Burne-Jones or Carlyle or other carefully chosen friends, to take in a farce or a pantomime at the theatre, or to view the latest exhibition.

In October 1875, four months after Rose La Touche's death, Ruskin sought out a third refuge, with Georgiana and William Cowper-Temple at their country estate in Hampshire, Broadlands. The Cowper-Temples urged Ruskin to treat their home as his own, and he did: keeping his own hours, secluding himself to write his *Fors* letters and chapters of his book on flowers, *Proserpina*, sending for his Brantwood gardener to fix up a clogged fountain, and setting himself as well as the children of and visitors to the estate to work gathering firewood for the poor. He was comfortable enough there to consider—briefly—making it his primary residence.

And at Broadlands that December Rose, he thought, returned to him.

Both Cowper-Temples had long been enthusiastic spiritualists, adherents to the flourishing movement that had swept over from the United States thirty years before, based upon the belief that the dead could, and for some reason did, interact with the living. For over a dozen years the Cowper-Temples had attended dozens of séances conducted by the choicest of mediums. In 1864 they had tried their best to win Ruskin over to their belief, and convinced him to attend a few séances He was curious but skeptical: "I was always ready to accept miracles—if only I could get clear and straightforward human evidence of it," he wrote. But the paltry evidence he saw there for communication beyond the grave—whistles, rappings, wobbly and bouncing tables, bursts of air across the fingers—left him thoroughly unconvinced. In 1868 he rejected spiritualism completely as "doubtful and painful enquiry," and worse, as "an awful sign of the now active presence of the Fiend among us."

With Rose's death, however, everything changed. In 1875 he had, in his aching desire to see Rose again, a need to believe that spirits walked. And

in this the Cowper-Temples were happy to oblige. That December, when Ruskin returned to Broadlands from lecturing at Oxford, he was introduced to two houseguests, two women considered to be powerful clairvoyants. One of them, Mrs. Annie Acworth, soon captivated Ruskin with reports of the ghost of a girl she saw wandering around the house, searching for something—and then, with Ruskin's arrival, standing beside him. Her confederate, Mrs. Elizabeth Wagstaff, concurred in these visions. They had no idea who the girl was, they claimed. Ruskin, on the other hand, was sure it was Rose. "The truth is shown me," he wrote in his diary, "which, though blind, I have truly sought so long."

Yet at Broadlands the apparition itself remained visible only to others. A year would pass before he would have his own ecstatic vision. He was in Venice, then: having begged off his lectures at Oxford and summered at Brantwood, he extended his leave from the university to spend nine months in Italy. He had come with an intention to revise his *Stones of Venice*, but within days of arriving he returned to his obsession with Carpaccio. Two years before he had focused upon Carpaccio's three depictions of the life of St. George, the titular hero of his Guild of St. George. This time, he focused instead on Carpaccio's cycle of paintings depicting the life of the martyr St. Ursula, and upon one painting in particular: *The Dream of St. Ursula*, a serene depiction of the sleeping child-saint in absolute repose on a medieval bed in a medieval bedroom, the angel of God at her foot. That painting he found hanging in gloomy obscurity near the ceiling of a dark gallery of Venice's Gallerie dell'Accademia; Ruskin was an honorary member there and exercised his authority to have it taken down and brought to a private room, where, day after day, "I have a couple of hours tete-a-tete with St. Ursula, very good for me." For the next seven months he attempted as he had never done before to capture the soul of a painting, obsessively working and reworking, first creating a miniature copy of the whole in watercolor and bodycolor, and then focusing upon the painting's individual details: the sleeping girl's head and her hands, the pot of verbena on the windowsill, the girl's slippers. Just as often, he simply sat in rapt contemplation of painting. "There she lies, so real, that when the

room's quite quiet, I get afraid of waking her!" he wrote to Joan. He very much *wanted* to wake her, however, and as he allowed the scene to haunt him, the boundaries between art and life, living and dead, material and spiritual began to dissolve. Ursula, now familiarly his "Little Bear"—the young Celt, preternaturally wise and preternaturally pure, who shunned the world of matter for death and the spiritual triumph of a martyr—became one with his Rose.

As Christmas approached, and with it the anniversary of Rose's appearance at Broadlands, Ruskin begged God for another sign from her—and, on Christmas Eve, it came. That morning, two letters arrived for him. The first, from Joan, contained a note to Ruskin from Rose's mother. The second, from a botanist friend, contained a flower—a sprig of verbena. Earlier he had received a gift from a friend in Venice, Lady Castletown: a pot of dianthus. Verbena, dianthus: the two plants Carpaccio had placed in the room of the sleeping St. Ursula. That night, as he reported to his *Fors* readers, he had his vision: "Last night, St. Ursula sent me her dianthus 'out of her bedroom window, with her love.'" This was the first miracle of many over the next nine days, as, Ruskin truly believed, the veil lifted, and Venice became a numinous city, a place of walking spirits and revealed Truth, where Ursula and Rose—Ursula *as* Rose—spoke to him and guided him. "My duty was to yield to every impulse, the moment I felt it," he wrote. "*Resistance* only was the error." On Christmas Day, in a burst of revelation, Ruskin was given the answer to the most pressing political conundrum of the day: the Eastern Question, that calamitous struggle in the Balkans between Russia and Turkey. (Ruskin attempted to lay out this revelation in *Fors* that February, but all he managed was four indecipherable aphorisms.) That day, as well, he had a glimpse of hell in the form of a satanic gondolier, "a horrid monster with inflamed eyes, as red as coals." For three days, while outwardly appearing quite normal to all whom he met, Ruskin dwelled in this world of perpetual revelation; for a week after that, the visions came sporadically. To Joan back in London, to whom he recounted his experiences in detail, and to everyone else that heard his "Christmas Story," these revelations were of course nothing more than hallucinations,

dangerous signs of Ruskin's mental instability. But not to Ruskin—*never* to Ruskin. He had had hallucinations before and would have many more in the years to come, but those experiences, when he recovered, he always *acknowledged* to be hallucinations. His visions this winter in Venice, on the other hand, he always held to be Truth: Truth that obliterated his skepticism about the afterlife, that altered his thinking about the spiritual and the material, Truth about life—about art.

At 11:00 on the morning of January 2, 1877, according to Ruskin, Ursula-Rose stopped speaking to him, "leaving me again in this material world." His obsession with the painting, however, lingered: he continued to work on his studies of the *Dream of St. Ursula* until March, and then, although he shifted his focus to a different Carpaccio painting altogether—*Two Venetian Ladies*—his mind remained very much on his Ursula-Rose: "yesterday, for a companion to little Bear, I began painting the Doggie with the switch in his mouth and his paws on Carpaccio's name." Meanwhile, during these last days of what would turn out be his last productive trip to Venice, he busily drew sketches and took notes for later works: for the planned revision of *The Stones of Venice*—which he later published instead as *St. Mark's Rest*—and in his *Guide to the Academy of Venice*. Finally, at the end of May he started back to England.

He returned to Herne Hill on June 16 in a state of joy and optimism. "My old nursery feeling like true home," he wrote. "May I value and use rightly what hours remain to me in it!" He would only have three weeks in London, though, before heading for Brantwood, three busy weeks to see friends, Edward Burne-Jones chief among them, to take in a few shows—and to again take on the mantle of England's leading critic of art with a tour of all the galleries: the Royal Academy, the Dudley, the Fine Art Society, and the Grosvenor, a new gallery that had opened at the end of April. Edward Burne-Jones was one of the featured artists there. Another was James McNeill Whistler. Ruskin, finally, would have his own opportunity to see the *Falling Rocket*.

CHAPTER 4

DAMAGES

Sir Coutts Lindsay—baronet, painter, widely acclaimed benefactor of the arts, and according to writer Henry James "the handsomest man in England"—had with the ornate façade of his newly opened Grosvenor Gallery aimed to impress: to set the gallery apart from its fashionable Bond Street neighbors without and to hint at the aesthetic glories within. As centerpiece to that façade Lindsay had, at a cost that could only be imagined, imported from Venice an elaborate, three-hundred-year-old portal of Istrian limestone with jasper pillars—designed, Lindsay claimed, by the great Italian master Andrea Palladio himself: it was, apparently, the only genuine Palladio in all of Britain. Lindsay and his assistants had for months trumpeted the news of the doorway with full details about the gallery to the newspapers and journals. The public, then, knew that Lindsay had sunk a fortune into this gallery.

Actually, he had sunk *two* fortunes into it: both his own share of the Coutts banking fortune, and his wife Lady Blanche's share of the even more fabulous Rothschild fortune. In all, Lindsay spent at least £120,000—over £14 million today—to buy up a dozen choice Bond Street properties, raze them, and build in their place an expansive neo-Renaissance *palazzo*: grand vestibule and equally grand staircase, dining rooms and kitchen, billiard

and smoking rooms, a library—and four galleries, all sumptuously fitted out: painted ceilings, Genoa marble columns and Ionic pilasters, parquet floors, Persian carpets—and furnishings and bric-a-brac spread about in Victorian profusion. The Grosvenor opened on the last day in April 1877, and twenty-one-year-old Oscar Wilde, who had managed to get a ticket to that inaugural private viewing, was dazzled: "The walls are hung with scarlet damask above a dado of dull green and gold; there are luxurious velvet couches, beautiful flowers and plants, tables of gilded wood and inlaid marbles, covered with Japanese China and the latest 'Minton,' globes of 'rainbow glass' like large soap bubbles, and, in fine, everything in decoration that is lovely to look on, and in harmony with the surrounding works of art."

Lindsay had spent with abandon and purpose: to transform the very concept of modern art. He did that by providing a venue for exhibition apart from the conservative Royal Academy, which dominated London's and England's art establishment and which generally promoted the sentimental, the narrative, the strictly representational over the original and the innovative, the safe and sellable over the avant-garde. As all aspiring oil painters of the time knew, success and fame depended largely upon frequent and honorable participation in the Royal Academy's annual summer exhibitions. But, as many of London's and England's finest artists realized, attempting to exhibit with the RA often proved an exercise in frustration if not outright futility. Selection committees routinely favored the traditional and rejected the novel. And any work they did accept they could discredit by subjecting it to a humiliating spatial pecking order: the Academy's hanging committee, entrusted to fill every single square inch of wall space, routinely relegated less-favored works to Siberian exile by "skying" or "flooring" them. Sir Coutts himself had felt the sting of the Academy's rejection, and so had many of his most talented friends. James Whistler had run the gamut of Royal Academy humiliation when he submitted the portrait of his mother for the 1873 exhibition four years before. The selection committee rejected *Arrangement in Grey and Black No. 1* outright, only reconsidering when one of its members, William Boxall—the same

man who had painted Whistler as a child—threatened to resign if it was not accepted. Then, the hanging committee launched the painting into the stratosphere, skying it over a doorway, where it earned nothing but a few lukewarm reviews and the laughter of the public. This shabby treatment inspired in Whistler a simmering and lifelong resentment against the RA; he never submitted to them again.

He was not alone: by 1877 Ford Madox Brown, Dante Gabriel Rossetti, William Holman Hunt, and Edward Burne-Jones had also turned their backs on the Academy. Brown, still smarting from the skying of two of his paintings a quarter-century before, had shunned them the longest. Rossetti, always morbidly sensitive to public criticism, had never quite summoned the courage to submit to the RA, and after 1853 had, almost without exception, ceased exhibiting *anywhere*, relying instead on selling his art directly to dealers and to patrons—Ruskin, of course, among them. Burne-Jones, more proficient as a painter in watercolor than in oils, had throughout the 1860s exhibited not with the RA but with the Old Water-Colour Society, an equally conservative institution, where his strikingly original paintings contrasted glaringly with others' tame landscapes and genre pictures. Burne-Jones endured the resulting attacks upon his "diseased imagination" until 1870, when an anonymous complaint about the assertively nude male figure in his *Phyllis and Demophoön* resulted in the painting's abrupt removal from the exhibition. Burne-Jones then resigned from the Society, blasting them not simply for their prudery but also for their complete lack of sympathy with his talents. In the eight years since then, he had not exhibited a single painting in public. The public had, for the most part, forgotten him. Lindsay vowed with the Grosvenor to bring him back, and to return to the fore *all* of the artists he thought the most creative, the most novel—or, as he put it in an interview, the most *strange*: "There are several thoughtful men in London whose ideas and method of embodying them are strange to us; but as I do not think strangeness, or even eccentricity of method, sufficient excuse for ignoring the works of men otherwise notable, I have built the Grosvenor Gallery that their pictures, and those of every other man I think worthy, may be fairly honestly seen and judged." Seen and judged, in other

words, as art for its own sake: with his gallery Lindsay gave the Aesthetic movement a local habitation and a name.

Ensuring that the best in modern art could be seen and appreciated involved both wealth and planning. Lindsay abandoned the RA's method of selection by jury altogether, instead relying solely upon his own taste and issuing personal invitations to artists he thought worthy, allowing them to submit whichever works they chose and to submit as many as they liked. He rejected the Royal Academy's standard practice of cramming paintings together haphazardly, from floor to ceiling. Instead, he separated all paintings, usually by at least a foot, and hung them all in one or at most two easily viewable lines. Tom Taylor, writing for the *Times*, was delighted with the effect, which "gives rest to the eye and mind, and enables us to complete the survey of the exhibition with a freedom from fatigue unparalleled in our experience of picture-seeing." In another break with tradition, Lindsay hung the works of each artist together as a group, allowing viewers greater insight into each artist's development, style, and vision. Finally, Lindsay aimed, with great skylights and moveable drapery, as well as with strategically placed gaslight, to show every work in literally the best light possible. The overall effect, as Lindsay saw it, was to simulate the return of fine art to its natural habitat: the urban mansion or country estate of the wealthy connoisseur, as opposed to the chaotic warehouses the other galleries had become.

Lindsay's grand plan—to exhibit works of art in what was, in effect, a work of art—defied convention. But it was not unprecedented. Three years before this James Whistler, for one, had anticipated him. Completely lacking Lindsay's wealth but graced with truer, finer taste, Whistler rented a defunct gallery in Pall Mall and transformed it, painting the walls a muted yellow-grey, covering the floors with matting of much brighter yellow, furnishing the room with light-maroon upholstered sofas, and adorning it all with plants and flowers, as well as the by-now obligatory blue and white china. All of it served as the elegant backdrop for his portraits, nocturnes, drawings, and etchings, well separated and easily viewed. *Mr. Whistler's Exhibition* was hardly a financial success, but it did earn him positive

reviews, so that, as Anna wrote a friend, her son "at least acquired fame tho not yet money in proportion to the expenses attendant upon it." "The visitor is struck, on entering the Gallery," one reviewer gushed, "with a curious sense of harmony and fitness pervading it, and is more interested, perhaps, in the general effect than in any one work. The Gallery and its contents are altogether in harmony—a *symphony in colour. . . .*" Whistler would in years to come use this exhibition as a model for his many one-man shows. Coutts Lindsay almost certainly drew inspiration from it.

While the Grosvenor underwent finishing touches, Lindsay put out his call for artists. Two—Dante Gabriel Rossetti and Ford Madox Brown—refused him. Rossetti's fear of public criticism had only intensified with time and had indeed intensified pathologically six years before with Robert Buchanan's essay "The Fleshly School of Poetry," which viciously attacked Rossetti's poetry as being sensual to the point of the pornographic. "It is a simple fact," Rossetti's brother William noted, "that, from the time when the pamphlet had begun to work into the inner tissue of his feelings, Dante Rossetti was a changed man, and so continued till the close of his life." Prickly Ford Madox Brown refused for a far pettier reason, his vanity mortified when he was not the very first to be asked to exhibit. Burne-Jones, Whistler, Holman Hunt, Albert Moore, and Alphonse Legros, on the other hand, jumped at the chance. So did several Royal Academicians, including Millais, George Frederick Watts, Frederick Leighton, Lawrence Alma-Tadema, and even the Academy's president Francis Grant. Lindsay made it a point to invite members of the Academy not only because he wished to avoid any appearance of open warfare against that institution, but also because he knew that some of them were genuinely talented. Lindsay's decision, incidentally, to include them when they had their own walls upon which to display their works provided Rossetti with the excuse he needed to bow out. But even without him the 1877 Grosvenor Gallery exhibition was indisputably an unprecedented bringing-together of all that was new, progressive, *strange*, and beautiful in art.

It was highly successful. The cream of London society attended the opening on April 30. Among that throng of bishops, duchesses, and

artists were Prime Minister William Gladstone, composer Arthur Sullivan, Robert Browning, George Eliot, George Henry Lewes, and Henry James, as well as Oscar Wilde, who, by seeking out and conversing with Whistler that day, initiated their famous love-hate relationship. At the public opening the next day an astounding seven thousand people crammed the galleries. Then, a week later—a delay occasioned by the Prince of Wales's schedule—artists, aristocracy, and celebrities reassembled at a grand inaugural banquet at which the prince and three of his siblings were guests of honor. Whistler was there, though surprisingly Burne-Jones was not. Tom Taylor was there, as were John Millais and his wife, Effie.

But John Ruskin, then still in Venice and captive to Carpaccio and St. Ursula, had missed it all. Now, on June 23, he made amends: if he did not get in the first word about the collection, he would get in the last—and the most authoritative. So, under broken clouds resolving themselves into "the old black evil sky," Ruskin made his way to Bond Street, where he gazed upon Lindsay's much-touted Palladian portal.

He was not impressed. Fools who had not read or understood Ruskin's writings on architecture might admire the works of Andrea Palladio, but Ruskin loathed the architect and his works. He had condemned those works in *Modern Painters* as "wholly virtueless and despicable," as the epitome of the cold, formulaic, godless Italian Renaissance style that had replaced the warm, imaginative, spiritually infused Gothic he adored. Equally deplorable, as far as Ruskin was concerned, was that the stones of this doorway, Palladian or not, had once been sacred stones *of Venice*, a part of the church of Santa Lucia on the Grand Canal, which in 1860 and 1861 had been deconsecrated and razed in order to make way for that vilest of all symbols of modernity, a railway station. Salvaged, bought by Lindsay, shipped to London and wedged among the shops, the doorway now served not God, but art—and Mammon.

That was Ruskin's first disappointment. His second almost certainly followed moments later, as he made his way into the vestibule, and there above the turnstiles saw the single painting that Lindsay had hung downstairs,

as if to epitomize the treasures above. It was a Whistler. And it was of Ruskin's revered second *papa*: Thomas Carlyle.

In the late summer of 1872, a Chelsea neighbor of both Carlyle and Whistler had brought the two together, accompanying Carlyle to Lindsey Row specifically to view the *Mother*, freshly returned from its skying at the Royal Academy. Carlyle was impressed—impressed enough to agree on the spot to sit for a portrait in the same style. Whistler, eager for the publicity such a celebrity portrait would bring him, quickly had Carlyle upstairs in the studio. He sat Carlyle in the same chair his mother had sat in, flat against the same grey wall and black dado, in a similar but more relaxed pose. "And now, mon, fire away!" Carlyle is said to have exhorted him. But it didn't work that way. Instead, Carlyle endured Whistler's frequent, interminable, tyrannical sessions, suffering Whistler's screams of "for God's sake, don't move!" if he showed the slightest sign of shifting position. The result, after several months, was *Arrangement in Gray and Black No. 2*, admirably similar to the Mother in its restriction of palette, its balancing act of color and form, its Japanese flatness, its compelling grasp of character. Carlyle might have complained that Whistler seemed much more obsessed with depicting his coat than his face, but Whistler's rendition of that face is a marvel, fully grasping the loneliness and the mightily weary intellect of the seventy-eight-year-old widower. Oscar Wilde, for one, had been captivated by the portrait, declaring it Whistler's one undeniably great submission to the exhibition and proving "Mr. Whistler to be an artist of very great power when he likes." But if John Ruskin sensed any value in this portrait of *papa*, he kept that sense to himself: neither in recounting his visit to the Grosvenor nor in any of his voluminous writings about art does he mention *Arrangement in Grey and Black No. 2.*[*]

As Ruskin made his way upstairs and toured the galleries his disappointments multiplied. The costly décor he found shoddy and distracting, "poor in itself; and grievously injurious to the best pictures it contains, while its

[*] Nor does Ruskin say anything, anywhere, about the *Mother*: *Arrangement in Grey and Black No. 1*.

glitter as unjustly veils the vulgarity of the worst." Particularly distracting were the costly scarlet damask hangings: Ruskin was not alone in thinking that they clashed horribly with the bright colors of the paintings. He was disgusted, as well, by Lindsay's shameless hanging of his own works among his superiors', deriding Lindsay in his account of the visit as "an amateur both in art and shopkeeping." (About the equally amateurish watercolors and oils of Lindsay's wife Blanche, on the other hand, Ruskin preserved chivalrous silence.) He deplored Lindsay's innovation of hanging each artist's works in one group, which, he considered, emphasized "the monotony of their virtues, and the obstinacy of their faults." But most of all he was disappointed by the poor quality of nearly all the 216 works of art on display. If this was the best of modern art, the exhibition only indicated the depths to which modern art had fallen.

In his account of his visit to the Grosvenor Ruskin pointedly mentioned by name only five of the sixty-four artists who exhibited. He was, after all, committed to writing a brief account, for he had written most of his *Fors Clavigera* letter for that month—on the subject, appropriately enough, of art exhibits for working men—and was limited to a six-page postscript on the Grosvenor. But there is much more to Ruskin's reticence about naming the Grosvenor's artists than that. He made clear that he did not mention most of them because they did not *deserve* mentioning. He did offer up a half-sentence of praise to two French painters he nonetheless thought "minor": Ferdinand Heilbuth and James Tissot. John Millais did earn from him honorable mention for meticulous rock-painting in his *The Sound of Many Waters*, but this mention turned out to be most damnable faint praise: not only was *The Sound of Many Waters* not at the Grosvenor,* but Ruskin noted that Millais's skill in that painting only gave the barest hint as to the glorious artist he would have been had he only remained true to the Pre-Raphaelite principles he had held years before when, say, he had dwelled with Ruskin and Effie among the rocks of Glenfinlas.

* Rather *The Sound of Many Waters* was on exhibit at the Royal Academy, which Ruskin had visited the day before.

Every other artist—save two—and nearly all modern art, Ruskin dismissed curtly: "their eccentricities are almost in some degree forced; and their imperfections gratuitously, if not impertinently, indulged." Forced eccentricities; gratuitous imperfections. Of the two remaining artists that Ruskin did mention, one was entirely free from these vices—and one was wholly a slave to them. Edward Burne-Jones was the very best modern art had to offer; James Whistler the very worst.

Coutts Lindsay, it was clear, had considered Burne-Jones the star of his exhibition; he had given Burne-Jones the entire south wall of the Grosvenor's finest gallery. There, the eight paintings Burne-Jones had submitted hung in two lines: above, five full-sized allegorical portraits, and below, three magnificent, oversized dreamscapes: *The Beguiling of Merlin*, *The Mirror of Venus* (this one, incidentally, commissioned by Frederick Leyland), and the six-part *Days of Creation*. Flanking these works on the adjoining walls were works by Burne-Jones's disciples Walter Crane, John Strudwick, and John Stanhope: courtiers to their king. This was the one instance at the exhibition of grouping by *school*, and Ruskin did not like that sort of grouping either, but only because those feeble echoes of the master served to diminish his greatness. Burne-Jones had obviously chosen his eight paintings to impress upon the public both the incredible breadth of his imagination and the profound improvement in his abilities since he had ceased exhibiting seven years before. Ruskin, as a frequent visitor to Burne-Jones's studio, was familiar with all these works. But the critics and the public were not, and to them they were a stunning revelation: their brilliant colors, their pronounced but ultimately enigmatic symbolism, their aethereal arrangements, all signaled the seemingly spontaneous emergence of an extraordinary artistic talent. "Since painting was an art," raved Sidney Colvin in *Fortnightly*, "it is probable that no poetry so intense as this, no invention so rich and so unerringly lovely, was ever poured into form and colour." The critic for the *Examiner* agreed: "we deliberately reckon Mr. Burne Jones as the greatest and most original painter of our time." The Grosvenor exhibition had quickly catapulted Burne-Jones to the top rank of British artists. From the exhibition's first day, his wife Georgiana realized,

"he belonged to the world in a sense that he had never done before, for his existence became widely known and his name famous."

But, Ruskin knew, Burne-Jones's works hardly resembled the art he had promoted and venerated in *Modern Painters*, where adherence to nature—spiritually infused nature, but nature nevertheless—was the essential quality of all great art. Truth to nature had been Turner's great achievement; it had given a temporary greatness to Millais, to Holman Hunt, and to a lesser extent to Rossetti. But although Ruskin did think highly of Burne-Jones's technical ability in capturing nature—he considered him, for example, the only living artist truly capable of drawing a leaf—the paintings themselves, with their otherworldly figures outside of any history and landscapes outside of any known geography, were decidedly removed from everyday reality. Burne-Jones knew it; he was proud of it. As he later put it, "I mean by a picture a beautiful romantic dream of something that never was, never will be—in a light better than any light ever shone—in a land no one can define or remember, only desire—and the forms divinely beautiful." Art, that is, not unnatural, but *supernatural*. Ruskin agreed: Burne-Jones captured, he would write not long afterward, "the more perfect truth of things, not only that once were,—not only that now are,—but which are the same yesterday, today, for ever;—the love, by whose ordaining the world itself and all that dwell therein, live, and move, and have their being." Burne-Jones, then, above all others, presented higher Truth in defiance of ever-growing and ever-deadening industrial materialism. And he did it while paying homage to the great spiritual painters that Ruskin had come to love—Giotto, Fra Angelico, Carpaccio—homage obvious not simply in the aethereal compositions but also in each and every one of the faces he painted, rapt and serene, reflecting perfect repose, that quality essential to Ruskin's aesthetics as the truest signifier of God's existence in nature. As far as Ruskin was concerned, his greatest protégé had become the nation's, if not the world's, greatest painter.

For years, Ruskin had kept his admiration for Burne-Jones largely to himself. But now that Burne-Jones's paintings had become the talk of society, and now that critics and public had on their own begun to perceive

his greatness, the time had come to exercise his authority to propel Burne-Jones into the pantheon of the great artists of all time.

And so, in the next issue of *Fors*, he offered up his unstinting praise.

> His work, first, is simply the only art-work at present produced
> in England which will be received by the future as 'classic' in its
> kind,—the best that has been, or could be. I think those por-
> traits by Millais may be immortal (if the colour is firm), but only
> in such subordinate relation to Gainsborough and Velasquez, as
> Bonifazio, for instance, to Titian. But the action of imagination
> of the highest power in Burne-Jones, under the conditions of
> scholarship, of social beauty, and of social distress, which neces-
> sarily aid, thwart, and colour it, in the nineteenth century, are
> alone in art,—unrivalled in their kind; and I *know* that these
> will be immortal, as the best things the mid-nineteenth century
> in England could do, in such true relations as it had, through
> all confusion, retained with the paternal and everlasting Art of
> the world.

So much for the best of artists. For the worst, Ruskin did not have to go far. Fifty feet away in the same gallery, squeezed between Lady Lindsay's amateur oils and a doorway, they were hung: seven paintings by James Whistler, set like Burne-Jones's in two lines: three portraits above; four nocturnes below. The portraits—one of a man, two of women—were all visibly unfinished: that in itself another disappointment to Ruskin, who had complained three decades before that "one of the most morbid symptoms of the general taste of the present day is, a too great fondness for unfin-ished works." The one man portrayed, in *Arrangement in Black No. 3*, was recognizable, for this was, like the *Carlyle*, another celebrity portrait: the actor Henry Irving, dressed for the stage as Philip II of Spain. Unfinished as it was, it was the product of yet another hard slog: Whistler had begun it confident he could finish it in two sittings or so but was still at it after at least twenty—after which he maddened Irving by scraping the canvas bare.

Irving eventually gave up sitting and refused to buy the portrait, even at a discount. The two women were far less recognizable. The subject of *Arrangement in Brown** was the then-twenty-year-old Maud Franklin, the cabinetmaker's daughter who had for a good five years been Whistler's favorite and most assiduous model, both as stand-in for some of his more easily exhaustible sitters, and more and more as a subject in her own right: she had by this time supplanted fellow redhead Jo Hiffernan as Whistler's principal muse as well as his lover and business partner. In this painting, begun the year before and not yet finished, Whistler with a dark and limited palette depicts Maude as in danger of being consumed by the night: the furs on her upper body melt into the blackness about her while her skirts melt into the brownness below. Her face, by contrast, remains well-defined, glancing backward toward the viewer with a haunting melancholy. The subject of the other portrait, *Harmony in Amber and Black*, might have been Maud as well—critics at the exhibition noted similarities between the two faces—or it might have been the Leyland's daughter Florence, or it might have been someone else altogether. Because of Whistler's compulsion to rub down and repaint his works, and his habit of retitling the same paintings for different exhibitions, the identity of the painting itself, to say nothing of the identity of its sitter, is not at all certain. William Rossetti in his review described the portrait as "a blonde lady in white muslin with black bows, and some yellow flowers in the corner," but no existing painting by Whistler quite matches that description.** Whatever work it actually was, one thing it clear: it was as enshrouded in gloom as its sister and brother portraits: the three of them together the murkiest that Whistler ever exhibited at one time. "Mr. Whistler's full-length arrangements suggest to us a choice between materialized spirits and figures in a London fog," noted Tom Taylor, and

* Later *Arrangement in Black and Brown: The Fur Jacket*.

** A couple come close. Either *Portrait of Miss Florence Leyland* or *Harmony in Grey and Peach Color* might be the present and fully transformed incarnation of this painting. (Merrill, *Pot of Paint*, 40; YMSM 79.)

Oscar Wilde, who now dubbed Whistler the "Great Dark Master," agreed, describing the two women as "evidently caught in a black London fog."

The nocturnes, of course, matched the portraits in their exploration of darkness. What amazed the more sensitive and sympathetic viewers of them, however, was not their inky sameness but rather their astounding variety in color, form, and effect. Of the four, one of Whistler's earliest nocturnes provided the greatest surprise. *Nocturne in Blue and Silver*—one of several paintings by that name—Whistler had given as a gift to Frances Leyland soon after its creation, and it had never been exhibited—until now. Painted in soothing pale-blue monochrome, it depicts the Thames from Lindsey Row, looking across to the utterly quiescent industry, the slag heaps and chimneys, of the Battersea shore. William Rossetti, almost certainly the *most* sensitive and sympathetic critic of Whistler's work at the Grosvenor, described this as "among the loveliest of the painter's works of this class." He certainly saw, if Ruskin certainly did not, that in this nocturne Whistler had captured repose to a degree that matched any number of Burne-Jones's angelic faces.

The other three nocturnes had all been exhibited three years before. His Ukiyo-e flavored *Nocturne in Blue and Silver (Old Battersea Bridge)* Whistler had shown at the 1875 Brighton exhibition. Priced there at 300 guineas, it had found no buyers then or since. But within weeks of the Grosvenor exhibition Whistler would virtually foist it upon William Graham, the would-be patron who had six years before paid Whistler £100 for *Annabel Lee*, the painting Whistler had abandoned when its model had abandoned him, forcing him to turn instead to painting his mother. Exactly a month after Ruskin's visit to the Grosvenor, Graham would finally write Whistler about *Annabel Lee*, "not for the purpose of pressing you to complete what I presume you now no longer care for, but simply to ask you if it would be agreeable to you to let me have it unfinished." This, however, was *not* agreeable to Whistler, who claimed to have destroyed it. Instead, Whistler—without asking—sent Graham the Battersea Bridge in its place. Graham, either recognizing the nocturne's beauty or realizing that he could not hope to get more from Whistler, accepted the exchange.

The other two nocturnes—*Nocturne in Blue and Gold* and *Nocturne in Black and Gold*—had been displayed side-by-side three years before at the Dudley Gallery.* *Nocturne in Blue and Gold* contains precious little of either of those colors. Light grey with a hint of violet dominates the sky above and far darker grey the river below; even darker vertical forms to the right—the lifeless and lightless Houses of Parliament—contend ominously against the horizontals of river and horizon. It was Whistler's successful selling of this painting at the Dudley that led at the time to his ecstatic self-congratulatory "butterfly flippancy" sniping at Tom Taylor. *Nocturne in Black and Gold* had been on sale at the Dudley as well, priced at 250 guineas. But it also failed to sell and had failed to sell ever since. Now at the Grosvenor, Whistler, discounting the price to 200 guineas, tried again. Of the eight paintings Whistler exhibited at the Grosvenor, this was the only one listed in the catalogue for sale. John Ruskin consulted the catalogue, saw its price—and remembered it.

Whistler had by now been turning out nocturnes in large quantities for some time; the critics and the public had had six years to make sense of them. Nevertheless, besides William Rossetti's largely favorable review in *The Academy* and others' recognition of the talent shown in this or that specific nocturne, the general reaction was again bafflement—bafflement that extended to the portraits, which seemed little more than chaotic nocturnes with human figures. His paintings, declared the critic for the *Art Journal*, "are simply conundrums." The critic for the *Daily Telegraph* agreed: they were "enigmas sometimes so occult that Oedipus might be puzzled to solve them."

* Whistler's habit of renaming his paintings makes it easy to confuse three of these four Grosvenor nocturnes with one another. While one *Nocturne in Blue and Silver*—Frances Leyland's—retained that name, the other *Nocturne in Blue and Silver*, soon to be William Graham's, is now known as *Blue and Gold—Old Battersea Bridge*. The nocturne *then* known as *Nocturne in Blue and Gold*, however, is now *Nocturne: Grey and Gold—Westminster Bridge*. At least the fourth of the nocturnes is clearly distinguishable from the other three. It was exhibited at the Grosvenor as *Nocturne in Black and Gold*. Its title before that was, and presently is, *Nocturne in Black and Gold: The Falling Rocket*.

Others might be baffled by these seven visions of obscurity. John Ruskin was not. He instantly saw through them and instantly detested them.

He had, of course, the crushing weight of his aesthetic theory to set against them, beginning with the bedrock principle of *Modern Painters*, the single test of any work of art: its reflection of the spiritual beauty of the works of God. To him the connection between God and light was something more than symbolic; these seven chaotic masses of darkness were seven aesthetic sins, hiding nature and shunning the spiritually pure. What little nature *was* visible was deformed and degraded with the smokestacks, the derricks, the detritus of industry. "No art," Ruskin had argued three years before, "nor any high moral culture, is possible in filth of soot." A true work of art, by Ruskin's definition, conveyed a great number of great thoughts. These dark and discernibly unfinished messes conveyed nothing but physical and spiritual emptiness. They were nothing but variations upon the plague cloud. All of this might have occurred to Ruskin as he contemplated these paintings—but might not have. His written reaction to them is less intellectual, much more visceral: overwhelming, instinctive contempt and disgust. He had his *Theoria*, but did not need it: in this case, *Aesthesis*—sensation alone—was more than sufficient. He *loathed* these poor excuses for art.

One painting of the seven stood out as worst of the bad: the darkest, most chaotic painting of the lot. Not only was *Nocturne in Black and Gold* a meaningless blob; it was also an effortless one—clearly the work of an hour or two. To ask a couple hundred guineas for this—this nothing: it was an obscenity.

Ruskin left the Grosvenor Gallery with rage in his heart and soul, surely mulling over the thunderbolt he would hurl at the two men responsible for this affront to culture: Sir Coutts Lindsay, for thinking this thing art, and James Whistler, for thinking himself an artist. Within a few days he had it: brief, pointed—combustible. "For Mr. Whistler's own sake, no less than for the protection of the purchaser, Sir Coutts Lindsay ought not to have admitted works into the gallery in which the ill-educated conceit of the artist so nearly approached the aspect of wilful imposture. I have seen,

and heard, much of Cockney impudence before now; but never expected to hear a coxcomb ask two hundred guineas for flinging a pot of paint in the public's face."

In the evening after his visit to the Grosvenor, Ruskin crossed London through Whistler's Chelsea and past Cremorne Gardens to Fulham to dine with Edward and Georgiana Burne-Jones. It can be assumed that much of their conversation was congratulatory, celebrating Burne-Jones's sudden conquest of London's art world. But just as surely, given Ruskin's earlier horror, that conversation flowed with dark undercurrents of anger and ridicule toward Whistler and his miserable works. While Ruskin likely introduced the subject, it was one to which Burne-Jones, with his own long-simmering disdain for both the man and his art, must have contributed eagerly.

Nine days later—on July 2, 1877—Ruskin's attack upon Whistler first reached the public, or at least that segment of the public most sympathetic to Ruskin. *Fors Clavigera* was not sold in shops, its two thousand copies instead sent directly to subscribers: the few workmen of England who could afford the stiff price of ten pence an issue, the fans (of all classes) of Ruskin's predictable onslaughts against orthodox political economy, and in particular the members of Ruskin's utopian Guild of St. George, for whom *Fors* had become house organ. Had Ruskin's corrosive words gone to them alone, Whistler likely would never have seen them, as he had missed Ruskin's attack upon him in an Oxford lecture room four years before. But *Fors* had another vigilant readership: editors and journalists on the lookout for Ruskin's purple passages, his prophetic thunderings, his crotchets and eccentricities, all of it good copy for their newspapers and journals. From this issue they mined the choicest nugget of all. The attack first reappeared in the *Sheffield Independent* on the 9th—exactly a week after *Fors* was published. Over the next few days it appeared in a number of provincial papers. On the 14th *The Architect*, a weekly journal which despite its title covered

fine art almost as extensively as it covered architecture, devoted almost a full page to all of Ruskin's remarks about the Grosvenor. And on the 19th the influential *Leeds Mercury* actually misquoted Ruskin's attack, having him call Whistler "an impudent coxcomb who throws a pot of paint against his canvas, and then asks the public to give him two hundred guineas for it." That misquote was requoted in newspapers across the country, and—in Victorian fashion—Ruskin's attack went viral.

Even before Ruskin's thunderbolt reached the wider public it had struck its target, when on a quiet evening in the middle of the month, James Whistler and a friend, fellow artist and fellow American George Henry Boughton, slipped into the empty smoking room of their club—the Arts Club, in Hanover Square—for a cigar and a read. The Club provisioned that room with leading art journals, including *The Architect*. It was Boughton who first snatched up that periodical, hit upon Ruskin's review, and read on, quite likely wondering whether Ruskin had anything to say about Boughton's own single contribution to the Grosvenor exhibition. (Ruskin didn't.) When Boughton came upon Ruskin's venomous lines about Whistler he faced a dilemma. He knew Whistler usually "rather enjoyed adverse criticism and made sport of the writers." But he realized that this attack far exceeded any of the others in virulence, and so he hesitated to show the excerpt to Whistler at all—for a moment. Then he passed it over to Whistler and watched him read.

"I shall never forget the peculiar look on his face," Boughton later remembered, "as he read it and handed the paper back to me with never a word of comment, but thinking, furiously though sadly, all the time." Furious, sad—and, to some extent surely puzzled, at least by the reference to Whistler's *Cockney* impudence. He and Ruskin of course had never met, but Ruskin knew full well that Whistler was an American—and Whistler knew that he knew. What Whistler almost certainly did not know—not being much of a reader at all, and certainly not a reader of Ruskin—is that when Ruskin used the term "Cockney," as he often did, it often had little to do with birth proximity to the Bow Bells and much more with blunted sensibility, with removal from nature, with spiritual dullness. But even if

Whistler did not know that, he could not miss the obvious connotation of the term, a connotation Ruskin intended here: low-class—in every sense of the term. And nothing could be more insulting to Whistler. As for the rest of Ruskin's attack, that was clear enough. Ruskin was accusing him not of creating bad art, but of creating *no art*. He was a fake, a pretend artist, a fake but not quite a fraud, for Whistler only "*approached* the aspect of wilful imposture." What kept Whistler from crossing that line to unqualified immorality, however, was something in itself deplorable: he was an idiot with an "ill-educated conceit" that blinded him to the valuelessness of his own work.

All this might have been bearable if Ruskin was just another art critic, his criticism just one more jab at the fogginess of Whistler's canvases and the awkward novelty of his titles. Boughton was right: Whistler could make sport of that sort of thing. Ruskin, however, had for decades been the undisputed arbiter of art, a man whose power to make or break had long made Royal Academicians tremble. The one man in England—in the world—who had the power to destroy Whistler's reputation as an artist had with this passage, Whistler thought, aimed to do exactly that.

"It is the most debased *style* of criticism I have had thrown at me yet," Whistler uttered to Boughton.

"Sounds rather like libel?" Boughton asked.

"Well," Whistler replied, "that I shall try to find out." He jumped up, lit a cigarette, and rushed from the room and the club. Given the powerful agitation driving him on, the cigarette he lit was likely still smoking in the gutter by the time Whistler had made his way either to the Strand and the office of his solicitor, James Anderson Rose, or across the river to Southwark and Rose's home.

Rose could not have been too surprised to see him. Not only had the two been friends for over a dozen years, but during that time—and even more frequently, recently—Rose had handled Whistler's various legal affairs and crises. He had drawn up Whistler's will before Whistler set out for Valparaiso. He had defused the situation when Whistler's brother-in-law Seymour Haden threatened to sue for defamation in the wake of the

Burlington Fine Arts Club brouhaha. In 1863 Rose had saved Whistler from a £10 fine for skipping jury duty by having Whistler declare the American citizenship that exempted him. In 1874 he had negotiated down the stiff charges billed to him by the landlord of the Pall Mall Gallery—site of his one-man show—for unauthorized changes to the property. And within the last few months Whistler had kept Rose busy dealing with his burgeoning crowd of creditors. Less than two weeks before, one of these had gone to court for redress, causing officers to descend upon Lindsey Row and prompting Whistler to send a panicked note to Rose seeking his help. It was not the first time bailiffs had descended upon his home, and it would not be the last.

Rose then had been Whistler's faithful defender for years. But now, for the first time, Whistler asked him to go on the attack, with a case that must have appeared to him on its face a daunting one: to sue England's most formidable critic—for his criticism. But if there is any possibility that Rose, with his cooler head and far superior knowledge of English civil law, might have hesitated and attempted to dissuade Whistler from taking on the case, he did not hesitate for long; within days he would set the legal machinery in motion. In the voluminous record documenting his role in the case over the next months, Rose never showed himself to be anything but a staunch advocate to Whistler and a true believer in his cause.

Almost certainly, as the two discussed the possibility of suing Ruskin that evening, they considered what Whistler might actually get out of this action. From the start Whistler must have considered winning the battle of ideas and seeing his views about art triumphing over Ruskin's to be of incalculable value in itself. But Whistler could not have been so blinded by his rage at Ruskin's attack upon him not to see the spectacular opportunity Ruskin offered to salvage his fortunes along with his reputation—to respond to the debts and disappointments of the past years with a single substantial judgment for the plaintiff. Damages in a civil defamation suit, Rose knew, even if Whistler did not, were (then, and still) divided into *special* and *general* ones. Special damages involved specific and quantifiable losses incurred by the defamation: the loss to Whistler, for instance,

if the sale of one of his paintings fell through because of Ruskin's attack. But nothing of that sort had happened yet—at least, nothing that could be proven—and might never happen. General damages were compensation for the overall damage done by the defamation—pain and suffering, loss of reputation. That amount, ultimately incalculable, was not necessary to prove. A claim of general damages therefore could suggest, more than anything else, the most a plaintiff hoped to get. Although Whistler and Rose hesitated for some time before committing their assessment to a legal document, in the end the two settled upon damages of a thousand pounds—and the costs of the action.

A thousand pounds: this might simply have been a tidy, round number signifying Whistler's highest hopes. But it might have been much more than that. Of the many frustrations and disappointments of the past few years, one loss had haunted Whistler more than the others put together—the loss that mortified him by its unfairness and its denial of his talents, and that he was sure had brought him to the brink of catastrophe. That loss was of a thousand pounds—or perhaps of a thousand guineas: even that was in dispute. That devastating loss had nothing to do with John Ruskin, and everything to do with Whistler's once-greatest patron, but now his bitter enemy: Frederick Leyland.

———

Whistler's great aesthetic breakthrough at the end of 1871—his creation of the *Mother* and of the first of his steady stream of nocturnes—had hardly resulted in a corresponding *financial* breakthrough. He had not sold the *Mother*, for one thing. He *could not* sell that, for its sentimental value far outweighed any price he realized he could get for it. As for the nocturnes, they continued to perplex the public and failed to attract many buyers. True, his first London nocturne, then titled *Harmony in Blue-Green—Moonlight*,[*] was a success, selling quickly upon its first exhibition for the full asking

———

* Now titled *Nocturne—Blue and Silver: Chelsea.*

price of 200 guineas. Since then he had only found similar success with one other nocturne: his *Nocturne in Blue and Gold* sold in 1874 for the same price. Besides these, Whistler only managed to sell three other nocturnes, all of them at a deep discount, and all of them to the same enthusiastic if frugal buyer, Liverpool industrialist Alfred Chapman. In 1874, Chapman had bargained to obtain two nocturnes at 200 guineas for the pair; for one of these alone—*Nocturne: Blue and Gold—Southampton Water*—Whistler had originally asked 300 guineas. Whistler later asked that same amount for his *Nocturne—Blue and Silver—Bognor*, but Chapman drove an even harder bargain for it, citing the then-current economic recession and offering only 60 guineas: "times are too bad at present to allow me to think of going in wholesale for things of beauty tho' they be a joy forever." That Whistler immediately and gratefully accepted that paltry offer demonstrates both his desperation for ready cash and his awareness that he could not hope for more.

Besides these, he had found owners for only two other nocturnes—but only because he had given them to Frances Leyland and Albert Moore as gifts.

Portraits seemed to offer Whistler a surer income. Certainly, he had gained enough portrait commissions to keep him busy for years, thanks largely to Frederick Leyland and his commission in 1869 to paint individual portraits of his family, and to William Cleverly Alexander, who after 1871 similarly wished Whistler to paint portraits of his six daughters. The problem for Whistler, though, was not in obtaining commissions, but in completing them. His relative ease at completing the *Mother* was exceptional. More commonly with portraits Whistler still faced—and would face until the end of his life—the old frustrations of building up and scraping down—and all too often, to giving up altogether. In the eight years since he had agreed to paint portraits the Leylands, he had not completed a single one. With the portrait of Leyland himself, Whistler had come close: three years of Leyland's "martyrdom" as well as the assistance of a nude model named Fosco had led to the evocative *Arrangement in Black*, completed, Whistler admitted, to the point of public approval—but not to the

satisfaction of his own artistic scruples; it therefore remained in Whistler's studio rather than on Leyland's wall. He made similar slow progress, as well, with his portrait of Leyland's wife, Frances. Frances Leyland posed for it for two years, which included a particularly grueling two-month stint in 1872 when she stood daily for Whistler for hours: she had "never known an artist to be more conscientious." Unlike her husband, Frances Leyland enjoyed these sessions: as a sitter she was indefatigable, and during them she and Whistler drew closer to one another, Whistler speaking to her freely, sharing his troubles with her, seeking her sympathy—and happily sporting about town with her in her husband's absence. Frances Leyland had envisioned her portrait as a black-on-black complement to her husband's portrait, but Whistler instead insisted upon a study in contrasts. He dressed Frances in a loose pale pink gown of his own devising, set her against a similarly colored wall beside a spray of almond blossoms, and posed her with her back to the viewer and her head in profile. After the usual brutal and cyclical process, Whistler achieved—or *almost* achieved—the *Symphony in Flesh Colour and Pink: Portrait of Mrs. Frances Leyland*. It too remained in his studio, a hostage to his scruples. As for the portraits of the four Leyland children, Whistler would never complete any of them.

Nor had he progressed much further with the Alexander girls. In 1872 he had begun to paint the eldest daughter, Agnes Mary. But the girl bored him and he soon abandoned her. "If you will not think me too capricious," Whistler wrote her mother, "I wish that tomorrow you would bring the little fair daughter instead of her elder sister." And so eight-year-old Cicely became in her own word Whistler's "victim," enduring more than seventy sessions standing before the familiar black dado and grey wall of Whistler's studio, suffering from his relentless demands to stand still and from his frequent broken promises of lunch or an early release. "I know I used to get very tired and cross," she remembered, "and often finished the day in tears"—tears she thought he never noticed. But Whistler did notice, and from her suffering came magnificent art: *Harmony in Grey and Green*, a delicate interplay of green and grey, black and white, capturing with striking absence of sentimentality the child's sullen anger shading into despair.

Of all of Whistler's paintings, this is the one that reveals most clearly his enormous debt to the great Diego Velázquez. It is, undoubtedly, a stunner. But it was Whistler's sole success among five failures; Cicely was the only one of the Alexander sisters whom Whistler managed successfully to paint.

Whistler executed one more commission at this time, the most profitable portrait of all. It had come from Louis Huth, the insurance magnate and collector who already owned two Whistlers, including the Albert Moore–influenced *Symphony in White No. 3*. In 1872, while Whistler was busy working on the Leylands, the Cicely Alexander, and the (uncommissioned) portrait of Carlyle, he agreed to paint Huth's wife Helen. Whistler posed her in a pitch-black velvet dress and against a black background, therefore making her portrait (and not Frances Leyland's) the female counterpart to the Frederick Leyland *Arrangement in Black*. Helen Huth found sitting for Whistler exhausting—but he managed to complete her portrait relatively quickly with the help of a model, probably Maud, standing in. By early 1873, the *Arrangement in Black No. 2* was done—done to Whistler's satisfaction and to Louis Huth's, who happily (and probably naively) paid Whistler 600 guineas for it: it was by far the most Whistler had earned until that moment for any of his works. But it was not even close to the amounts the most popular painters were making at the time: William Holman Hunt, for example, earned an unprecedented sixteen times as much and more that year—£10,500—for his *The Shadow of Death*.

All of Whistler's completed and near-completed portraits of the previous three years—the Helen Huth and the Cicely Alexander, the Frederick and the Frances Leyland, the *Mother*, the *Carlyle*, and one other portrait, apparently one of his earliest paintings of Maud Franklin—featured prominently at Whistler's 1874 one-man show. Clearly, Whistler had hoped by displaying them to sell himself as an exemplary society portraitist. In that respect, the exhibition was a failure: for four years after the exhibition he would not obtain a single portrait commission. The divide between Whistler's expenditure and his income could only grow. A more practical and less ambitious artist might have done his best to curb his spending, and in September 1876 Whistler wrote his mother to assure her that he was

doing exactly that: "Matters at home are getting better—I have managed to pay off many of my debts and am making careful economies—so that soon, with my new works I hope to be in comparatively . . . smooth water." But Whistler was lying. Careful economies would hardly sell his work or make his name. What was needed, rather, was further spending upon ever-more-ostentatious self-promotion.

Ever since Whistler had moved into 2 Lindsey Row in 1867, he had promoted himself and his art through his frequent dinners for fellow artists, for social luminaries, and, most importantly, for prospective buyers. His menus were often elaborate, one in 1873 promising *Truite Saumonée Hollandaise, Côtelettes d'Agneau Glacées Soubise, Aspic de foie gras, Filles de Boeuf à la Marsaillaise, Jambon braisé*, as well as *Babas au Rhum*—and something called *Crème Oncle Tom*. Other times, the fare was simpler: fried sole, mutton, macaroni. That fluctuation in quality must have been dictated at least in part by what Whistler or his cook could squeeze out of the long-suffering shopkeepers of Chelsea. As for the wine, it was generally cheap, although often shifted to finer bottles. Whistler's dinner parties he considered as works of art, harmonies of form and color. He was known to dye the butter green to harmonize with the china, and for one dinner he pureed the chicken and dyed it pink: *Purée de Volaille Magenta*. His décor was, like his paintings, understated but carefully thought-out: simple floral arrangements, goldfish swimming in a glass bowl at the table's center, and, of course, exquisitely tempered walls and ubiquitous blue and white. At one early party, Frances Leyland remembered, she prevented a disastrous disruption of the formal harmony when she stopped one nearsighted guest from plopping herself down into a "sort of Japanese bath" that she had mistaken for a divan. (Whistler, who didn't like the woman, wished that Frances had let her go ahead and douse herself.)

When Whistler's mother shared his home, Whistler rarely held these dinners on Sundays: "my Mother exerts her influence over me," Whistler told one friend while rescheduling a dinner for midweek. All that changed in the summer of 1875 when Anna left London and her Jemie for good. Her recurrent and ever-worsening bronchitis had reached a crisis point that

April, causing her to collapse and nearly die; she attributed her survival to "the tender mercy of the Lord in answer to my children's prayers." Her doctors—including her son Willie—advised her to leave London immediately; the fogs there might inspire her son, but they were killing her. Willie found her ideal lodgings in Hastings with a kindly landlady, a salubriously elevated location on a hill outside of town, extra rooms for her visiting children, and a view from her window suggestive of Jemie's nocturnes: "at night the gas lights through its streets a brilliant illumination, but moonlight shining on the sea beyond is far more attractive." Anna would spend her remaining four years there.

Freed of his mother's chastening Sabbatarianism, and with Maud taking Anna's place, Whistler quickly began to devote Sundays to his whimsical goddess, instituting his soon-to-be famous regular Sunday breakfasts. He called them breakfasts, but they never began before noon and often much later than that, more than once delayed as guests waited until Whistler finished his leisurely and noisy bath in the next room. As with his dinners, meals varied greatly both in quantity and in delicacy; there was the usual French cuisine, of course, but just as often Whistler, using the "family Bible," the recipes his mother had left behind, personally cooked American dishes. Buckwheat cakes were a specialty. During leaner times, the pickings could be slim, slim enough to disgust at least one guest, an Italian landscape painter by the name of Martini, who complained of Whistler "he ask me a leetle while ago to breakfarst, and I go. My cab-fare two shilling, 'arf-crown. I arrive, very nice. Gold fish in bowl, very pretty. But breakfarst—one egg, one toast, no more! Ah no! My cab-fare, two shilling, 'arf-crown. For me no more!"

But Martini was the exception. Most guests to Whistler's breakfasts, no matter how frugal the meal, could not get enough of the host, his *mots* and anecdotes, his "ideas on art unfettered by principles." One self-declared "constant guest," the artist Louise Jopling, summed it up. "One met all the best in Society there—the people with brains, and those who had enough to appreciate them. Whistler was an inimitable host. He loved to be the Sun round whom we lesser lights revolved. He ignored no one. All came

under his influence, and in consequence no one was bored, no one was dull. Indeed, who could be when anywhere near that brilliant personality?" "Though short and small," wrote the Pennells, guests at later breakfasts, "his was the commanding presence. When he talked everyone listened. At his table he had a delightful way of waiting upon his guests. He would go round with a bottle of Burgundy in its cradle, talking all the while, emphasising every point with a dramatic pause just before or just after filling a glass." As it happened, on the Sunday after Whistler had decided to sue Ruskin, he would give the finest breakfast performance of all. When a guest asked to see him paint, Ruskin turned to Louise Jopling to pose, and within two hours had produced a full-length portrait, *Harmony in Flesh Colour and Black*. "An almost awful exhibit of nervous power and concentration," noted a fellow guest.

Whistler's breakfasts, "as original as himself or his work, and equally memorable," captivated society and elevated him to new heights of celebrity. "Lindsey Row was lined with the carriages of Mayfair and Belgravia. Whistler was the fashion," wrote the Pennells. (But they added "his pictures were not.") The *beau monde* loved to eat Whistler's buckwheat cakes and drink in his monologues. But it did not buy, and by 1877 most of his creditors had lost their patience. Few could afford to be as agreeable as John Charles, the fishmonger who continued to allow Whistler to run up an enormous bill and whom Whistler praised as "not merely the only tradesman who can afford to deal with me" but also "one of the few gentlemen I know." Shipwreck, it was clear, was looming.

But in the spring of 1876 Frederick Leyland seemed to show Whistler a way out of his troubles. At first Leyland offered him a modest commission, painting the dadoes of the grand staircase at 49 Prince's Gate, the house hard by Hyde Park which Leyland had acquired, gutted, and then refurbished into a palace to house his enormous collection of classic and modern art. Whistler's friend Alan Cole observed Whistler there that March painting the dadoes a "very delicate cocoa colour and gold." A month after that, Leyland asked Whistler to offer advice to his fellow artist

Thomas Jeckyll upon the redecoration of Leyland's dining room, which Jeckyll had designed as the grand repository both for Leyland's collection of blue and white china and for Whistler's own painting *La Princesse du Pays de la Porcelaine*. When soon after this Jeckyll abruptly abandoned the project—apparently because he was slipping into a state of madness from which he would never recover—Whistler took over. At that point Jeckyll had largely completed the room, having covered the walls with costly gilt leather and installed shelving for the porcelain as well as a ribbed ceiling with newfangled (and undeniably ugly) stalactite-like electric fixtures. It would seem that Whistler had little more to do. But Whistler did not see it that way. Instead, he planned to put a summer's work into the room, earn enough to slip over to Venice that September, and there to produce with a new set of etchings a new source of income.

The costly gilt leather on the walls, Whistler knew, was sacred to Leyland, something he could not change—beyond retouching its red flowers with yellow, the better to harmonize with his *Princesse*. The rest of the room—doors, dadoes, windows, ceiling—he felt free to alter completely, and he went at that task as if possessed. He brought in the Greaves boys and together they coated the room with metallic leaf "so frantically that it seemed to be raining gold." Over this Whistler painted in blue. He began with a "wave pattern" which soon morphed into the glorious repetition of the curves and markings of peacock's feathers. "I was up at 6, and it was striking the quarter to 9 o'clock in the evening as I walked away from my ladders and paint!" he wrote to Frances Leyland that August. "It is most lovely—but I wouldn't do it again for any one alive." It was exhausting; it was also euphoric. At that point Whistler was sure he was nearly done: "three or four days more," he assured Frances.

He was wrong. Instead, he turned to the room's three substantial shutters, covering them all with magnificent oversized peacocks, which Whistler's young son Charles Hanson later remembered he had based upon careful and repeated observation of the birds at the zoo. At around this time, a critic who had seen the room published a glowing account about it in *The Academy*. Obviously savoring the publicity, Whistler began to invite

the public to view what he now called the *Peacock Room*. The date he had set for his flight to Venice came and passed.

All this time Leyland had been away in Liverpool. In mid-October he returned, and was shocked: he had not asked for this and he did not want it. He asked Whistler's price, and was even more shocked by the answer: 2,000 guineas, more than half of that for the shutters alone. And with that, Leyland's patronage and friendship collapsed and the two became bitter enemies. "I can only repeat what I told you the other day that I cannot consent to the amount you spoke of," Leyland wrote Whistler on October 21. "The peacocks you have put on the back of the shutters may possibly be worth (as pictures) the £1200 you charge for them but that position is clearly a most inappropriate one for such an expensive piece of decoration; and you certainly were not justified in placing them there without any order from me." Leyland suggested Whistler take the shutters away. "Put not your trust in Princes," Whistler shot back, leaving the shutters where they were but settling for half of what he had asked: "I pay my thousand guineas as my share in the dining room, and you pay yours." Leyland sent Whistler instead a check for £600, paying him not with the guineas due to a professional but with the pounds due to a common tradesman, subtracting the £400 he had already advanced Whistler from the total. Whistler was mortified. "Shorn of my shillings I perceive!" he responded.

Without the hope of earning another penny from his work on the *Peacock Room*, Whistler nevertheless worked on. Inexplicably, Leyland allowed him to. All through the autumn and winter of 1876–1877, while Leyland remained in Liverpool, Whistler pursued his obsession. Freed in his mind from the need to please Leyland, freed from everything beyond the need to serve his whimsical goddess, Whistler began anew and completely reversed his color scheme, covering the gilt walls—including, this time, the no longer sacred gilt leather—with peacock blue, turning the sunny room into something nocturnal. Again, Whistler felt the exhaustion and the euphoria; by November, "mad with excitement," he was covering and recovering every square inch with his peacock patterns. "I just painted as I went on," he later remembered, "without design or

sketch—it grew as I painted. And towards the end I reached such a point of perfection—putting in every touch with such freedom—that when I came round to the corner where I had started, why, I had to paint part of it over again, or the difference would have been too marked. And the harmony in blue and gold developing, you know, I forgot everything in my joy in it!" Finally, he covered the wall opposite his *Princesse du Pays de la Porcelaine*—space he had hoped to fill with his never-to-be-finished *Three Girls*—with an allegorical depiction of his enmity with Leyland: two fighting peacocks—the artist-peacock, with its magnificent plumage, reeling, while the ruffle-breasted patron-peacock jealously guards the shillings at its feet. Whistler gave that to Leyland to swallow with his dinners.

All the while visitors' carriages clogged Prince's Gate. Millais, Poynter, and Alma-Tadema came; so did the Queen's daughter Princess Louise and the Marquis of Westminster. And so did the critics, including Tom Taylor, who in the *Times* praised Whistler's "artistic feeling," the individuality of his design, the brilliant execution. To assist the public appreciation of his achievement Whistler had printed up a descriptive broadside, and—according to Maria Stillman, sister of the model for *La Princesse du Pays de la Porcelaine*—actually produced tickets of admission, available in a bowl on the counter at Liberty & Co. The attention delighted Whistler. It mortified Leyland. "At the time so many newspaper puffs of your work appeared," Leyland later wrote him, "I felt deeply enough the humiliation of having my name so prominently connected with that of a man who had degenerated into nothing but an artistic Barnum." In mid-February, Leyland prohibited Whistler from inviting the public into his house. Whistler ignored him. A week later, Frances Leyland slipped unexpectedly into Prince's Gate and overheard Whistler dismissing her husband to guests as a *parvenu*. She threw Whistler out. He managed to sneak back over the next couple weeks for finishing touches, and at two in the morning on March 5, 1877, with some final brushstrokes upon the peacock shutters, his *Harmony in Blue and Gold: The Peacock Room* was done.

Whistler was not, however, done with Fredrick Leyland, who was now not only his principal creditor in England, but also his most ferocious social

antagonist. That July, while crowds filled the Grosvenor Gallery and while the news of Ruskin's attack spread across the country, the two engaged in a war of letters. Frances Leyland's ejection of Whistler from Prince's Gate that February had not prevented her and Whistler from promenading about London together that spring and summer while Leyland attended to business in Liverpool. When in July stories got back to Leyland he was livid, and he wrote vilifying Whistler for "the meanness of your thus taking advantage of the weakness of a woman to place her in such a false position before the world" and forbidding both servants and family from having any more to do with him. But Frances Leyland had other ideas. Two weeks later, learning that she and Whistler were seen together at Lord's Cricket Ground, Leyland threatened violence: "if ever after this intimation I find you in her society again I will publicly horsewhip you." That threatened attack reached Whistler at around the same time as he became aware of Ruskin's actual one—possibly on the very same day.

As Whistler conferred with his solicitor about Ruskin, then, his battle with his bitterest enemy raged on—and the thought of the sum Leyland had denied him, and the damages that had done him, still rankled. "All of this annoyance is the result of that confounded Peacock Room," he wrote around this time to another one of his creditors, Arthur Lasenby Liberty. That thousand guineas—or, shorn of the shillings, that thousand pounds—he would never get back from Leyland.

But he might be able to get it from Ruskin. In the matter of *Whistler v. Ruskin*, then: damages of £1,000. And costs.

CHAPTER 5

"RUSKIN WOULDN'T GO"

Within a fortnight of Whistler's discovery of Ruskin's attack, James Rose had set *Whistler v. Ruskin* in motion. After directing his clerk to purchase three copies of *Fors Clavigera*—a necessary legal step to prove the libel had occurred—Rose drew up a writ summoning Ruskin or his lawyer to answer to the charge of libel at the Court of Queen's Bench at Westminster. That writ went out on August 3 but never reached Ruskin, Rose mistakenly sending it to Oxford instead of Brantwood. Rose then drew up a second copy, which reached Ruskin on the 8th. Though Ruskin might have been surprised by the suit, he was not at all shaken by it, seeing instead a great opportunity to reach out to and educate the public—*his* public—more widely than ever before: the opportunity, in other words, for a grand teachable moment. And so, in contacting his solicitors, Messrs. Walker, Martineau, and Co. of Grays Inn, he made it clear that he fully intended to seize that moment by taking personal command of the case. So instructed, senior partner at the firm John Martineau quickly assigned junior partner Robert Loveband Fulford to the case. Fulford quickly made his way to Westminster and the Court of Queen's Bench to declare Ruskin's willingness to answer the charge—with Ruskin acting as his own counsel.

And if the Court of Queen's Bench had with similar promptness brought the case to trial Ruskin might very well have had his moment. But the trial would not begin for months, and Ruskin's exuberance at the thought of crushing Whistler would be tested all that time by a protracted battle against exhaustion and depression. "I am nearer breaking down myself," he had written to his American confidante Charles Eliot Norton at the end of July, "owing to the extreme need for doing all I could at Venice this winter—and I have reduced myself nearly to the state of a brittle log." His diaries over the next few months chart a deterioration from there. In August: "Totally discouraged about all powers and plans"; "a quite frightful fit of depression"; "Tired and blind." In September: "Too despondent to think of anything since I left Venice"; cryptically and yet typically "modernism doing its worst on me"; "Worse and worse. Fog,—confusion and discomfiture reigning everywhere." Confusion and discomfiture continued through October when the gloomy weather competed in its darkness with his gloomy moods, Joan Severn's painful miscarriage that month only augmenting that depression.

But Ruskin's resolve and his relish for taking on Whistler held, and showed itself clearly at the beginning of November when he responded to Edward Burne-Jones's eager offer of his—and William Morris's—assistance in the case. "If that advertising Yankee quack teazes you I'll kill him," Burne-Jones wrote. "I'll help in any way that I am told—turn up in court like Mr. Winkle if you like—so will Morris. . . ." "You're a *couple* of darlings," Ruskin replied, "and perhaps I may want you, but I don't think so. It's mere nuts and nectar to me the notion of having to answer for myself in court, and the whole thing will enable me to assert some principles of art economy which I've never got into the public's head, by writing, but may get sent over all the world vividly in a newspaper report or two." His only fear at that time, apparently, was that Whistler might come to his senses, drop the suit, and deny Ruskin his grand opportunity.

By this time Ruskin was back in Oxford, and, for the first time in two years, back to university teaching. He had originally planned to create this time an entirely new and full course of lectures, possibly on Turner. But

realizing he lacked the energy, he instead decided simply to read passages from *Modern Painters* while adding extempore commentary. These lectures turned out to be a stunning success: "the most important course I have ever yet given in Oxford," Ruskin thought. For three weeks he again became the University's most popular professor. "I gave yesterday the twelfth and last of my course of lectures this term," he wrote his Coniston neighbor Susie Beever, "to a room crowded by six hundred people, two-thirds members of the University, and with its door wedged open by those who could not get in; this interest of theirs being granted to me, I doubt not, because for the first time in Oxford I have been able to speak to them boldly of immortal life."* But his obvious delight in his performance was tempered by underlying exhaustion: "it has taken all my time and strength. . . ."

From Oxford Ruskin traveled to London to spend the weeks before Christmas at Herne Hill with the Severns. As it happens he came to London just when his solicitors and Whistler's were engaged in the legal process of submitting pleas. First Rose submitted to Walker, Martineau and Co. Whistler's claim of libel, for the first time noting damages of a thousand pounds and costs. Robert Loveband Fulford then submitted to Rose a Statement of the Defence, claiming Ruskin's words to be "fair and bonâ fide criticism." Finally, Rose submitted Whistler's reply: "the Plaintiff joins issue." In January all three pleas would be submitted to the Court of Queen's Bench and a date set for trial. Ruskin's own involvement in this legal dance was minimal, likely limited simply to approving of the statement drawn up by his solicitor, something he could easily have done from Brantwood or Oxford. But he was in London, and so perhaps he used the opportunity to meet Fulford and discuss *Whistler v. Ruskin*. Perhaps: there is no clear evidence that he did so, or even cared to.

On Christmas Eve Ruskin left London for Oxford, wishing to seclude himself as he had done the year before in Venice, and desperately hoping

* Among those turned away from one of these lectures was the dean of Christ Church Henry Liddell's twenty-five-year-old daughter Alice, whom Lewis Carroll has made famous as the protagonist of his *Alice* books. "Alice couldn't get into Wonderland a bit, nor the Dean neither," Ruskin noted. (Ruskin, *Works*, 22.xlii)

for a recurrence of his supernatural communion the previous Christmas with his Rose/St. Ursula. That didn't happen. "Very lifeless compared to this time last year," he noted in his diary. After that he made two low-spirited expeditions. On New Year's Day he journeyed to nearby Windsor Castle as guest of Prince Leopold, his former student and still his disciple, now ailing and confined to bed. "I'm horribly sulky this morning," Ruskin wrote on the morning after he arrived, "for I expected to have a room with a view, if the room was ever so little, and I've got a great big one looking into the Castle yard, and I feel exactly as if I was in a big modern county goal." Soon afterward he traveled north to Hawarden to visit William Gladstone for the first time. (The invitation came from Gladstone's daughter Mary, who knew Ruskin through Burne-Jones.) Gladstone thought Ruskin the epitome of geniality and wit: "in some respects an unrivalled guest, and those important respects too," he wrote in his diary. But Ruskin in *his* diary could only note his continuing distress: "I have seldom been more ill without serious illness"; "thoroughly ill and anxious"; "don't feel sure I'm right." And one perceptive houseguest detected desolation beneath the congeniality. "His talk at dinner was altogether delightful. Nevertheless there was an utter hopelessness; a real, pure despair beneath the sunlight of his smile, and ringing through all he said. Why it does not wholly paralyse him I cannot make out."

By mid-January Ruskin was back at Brantwood, where during the next month his moods cycled as frequently as—and usually in conformity with—the weather. "Morning entirely divine and I and my work in more order than for some time," he noted in his diary on January 17. But more typical was his entry two days later: "*Eyes very dim too* this morning[.] Sky grey & cheerless[;] table in litter after all my work at tidying, *brains in litter too*." Darkness and despondency creep into his writing during that time. He faced three deadlines during those weeks. Two were for his *Fors* letters for February and March. The first of these letters culminates in foul acrimony with Ruskin's publication of private correspondence with his erstwhile friend and fellow philanthropist Octavia Hill. Hill, Ruskin had learned third-hand, had disparaged Ruskin's ability to carry out any of his many projects. When Hill learned that Ruskin intended to publish

the correspondence, she wrote to warn him that this "would injure you, and could not injure me." She was right. Her own letters show her to be patient, charitable, respectful; his letters, in which he blasts Hill for her rank betrayal, show him to be insensitive, paranoid, unbalanced by rage. A similar rancor found its way into the *Fors* for March, which Ruskin managed to complete early, by February: even though Ruskin laced that letter with repeated promises to restrain himself from taking "the seat of the scornful," he broke that promise on the very first page with an argu- ably libelous denunciation of the writer Harriet Martineau as an "infidel," "vulgar and foolish."

His one other deadline at that time was to fulfill an agreement with Marcus Huish, director of the Fine Art Society, which like the Grosvenor was a brand-new though far less ostentatious gallery on Bond Street. Huish had agreed to show Ruskin's unmatched collection of drawings by Turner, and Ruskin had agreed to write a descriptive catalogue in time for the early March opening. That deadline proved too much for him, and the first edi- tions of that catalogue were published incomplete.

Ruskin by February 1878 was careening toward collapse. The usual content of his diary—reports of the weather, his moods, his activities, and increasingly, his nightmares—gave way by mid-month to long, fitful, semi-coherent passages detailing the strewn wreckage of his mental inventory: fragmentary thoughts of Shakespeare and the Bible, Keats and Blake and Carlyle, Turner and Tintoretto, girl-saints, Rose, and the Devil, as he desperately and ineffectually tried to make sense of it all. On the night of February 20/21 Ruskin began to hallucinate. "Enter ye in—R[ose] of course—did'nt say that—it was said to both of us R[ose] very quiet—saying nothing it seemed to me I fell asleep—woke at 3—Understood by thinking—that even in the Heavenly love—when the first time is—and thoughts meet thoughts." Later that day, he jubilantly proclaimed in a letter to George MacDonald the realization of his greatest desire: "we've got married—after all after all—but such a surprise!"

The next day—Friday, February 22—Ruskin quite appropriately called his "*Good* Friday," even though the actual holy day was still eight weeks off.

For that night Ruskin experienced his own private harrowing. Convinced that the Devil had come to seize him, he later remembered "I felt convinced that the only way to meet him—if efficient way there was—was to remain awake waiting for him all through the night, and combat him in a naked condition." He threw off his clothes and paced the frigid room until dawn, when finally, he thought, the devil in the form of a black cat leapt at him from behind the mirror. Ruskin grabbed the cat, "flung it with all my might and main against the floor," and collapsed onto his bed. His servants found him later that morning, naked and delirious.

Over the next five weeks Ruskin's mind was, in the words of his friend Henry Acland, "utterly gone." Local doctor George Parsons was quickly called in and attempted to subdue Ruskin's violent ravings with chloral hydrate. The Severns were telegraphed and soon arrived; they were followed a few days later by John Simon, Ruskin's friend and president of the Royal College of Surgeons, who took over Ruskin's care just as it was reaching its worst crisis. The chloral hydrate reduced Ruskin to a stupor; he had for days refused all food and by the end of February he was sinking: "we gave up all hope," Joan wrote. He rallied, but then relapsed, shouting, jerking, obsessively clapping hands, remembering his "long dream" afterward as a ceaseless contention with the devil, who, he thought, spoke to him in the "ugly croaking voice" of the angry bird in the yard—a *peacock*, of all creatures—impelling him to commit terrible wrongs and triumphing with Ruskin's every transgression. Meanwhile, the Severns had engaged several burly nurses to hold Ruskin down in his ravings and to force-feed him; to Ruskin, of course, these were the Devil's agents. Joan, too, he thought an agent of the Devil, and as she kept watch over him, he tortured her with accusations: she had set everyone against him; she was out to get his money and his property; she had conspired with Queen Victoria to shoot him, decapitate him, or kill him with poison that the queen had sent up from Windsor Castle. By mid-March Ruskin's boiling agitation had subsided to a simmering; Dr. Simon relinquished him to Dr. Parsons's care and returned to London. The delusions continued. Ruskin endlessly dodged cannonballs fired by the Devil, and frantically grasped hold of and

ceaselessly babbled the same phrases: "Rosy Posy" one day; "Everything white! Everything black!" another.

All the while, the nation followed the slow progress of his illness through bulletins sent from Brantwood to Marcus Huish and the Fine Art Society, where the exhibition of Ruskin's Turners was underway—and proving very successful. From there, the newspapers carried the reports nationwide. The public, therefore, was able to learn in something close to real time of Ruskin's surprisingly rapid recovery during the first week of April. On the first, he was able to give Joan a coherent account of the onset of his illness. On the fourth, he began reading on his own. On the seventh, he walked outdoors and, more importantly, made his way down to his study and—very tentatively—back to his work. Arthur Severn spoke with him there and claimed, "I never heard him speak better"; he "was quite J. R. of old, only a little more calm and sad."

Marcus Huish took the lead in commemorating Ruskin's recovery with an incredible show of support. Having learned that of all of Turner's drawings, the one that Ruskin had since the 1840s coveted the most and had failed to gain was *Splügen*, at that moment up for auction, Huish got up a subscription, and, through the generosity of friends and admirers quickly collected the needed amount—a thousand guineas—to buy it. When it arrived at Brantwood on May 14, Ruskin was delighted. "I would be well content," he wrote gratefully to Dr. Simon's wife Jane, "to go through a worse illness than that . . . to receive the tenth part of the witness it has won for me of manifold kindness which I had not before understood or conceived." One imagines that Whistler, who surely knew about this gift, reacted with a mixture of awe, envy, and concern to this outpouring of public affection toward his enemy.

Ruskin's illness had changed him forever, and Ruskin knew it. "While my illness at Matlock encouraged me by all its dreams in after work," he wrote to Thomas Carlyle that June, "this one has done nothing but humiliate and terrify me." His doctors entirely blamed overwork as the cause of his illness, but Ruskin knew better: it was not overwork, but "acute mental suffering or misfortune." (To his confidante Norton, he was more specific

and claimed that the cause was his Ursula/Rose: "I went crazy about St. Ursula and the other saints—chiefly young-lady saints.")* He did agree with his doctors Parsons, Simon, and Acland that he needed to avoid any work that would excite or distress him. No more *Fors Clavigera*; no more work for the Guild of St. George; no more politics or political economy; no more lecturing at Oxford. Instead, botany, geology, and "a *little* Turner work." The Turner work came first, as within a month of his recovery he had completed the catalogue for the Fine Art Society; by June he had managed to put out a new installment of *Deucalion*, the work on geology that he had begun three years before; and he returned to work on his work on flowers, *Proserpina*, eventually putting out one more part of that at the beginning of 1879.

Beyond that Ruskin produced nothing over the next few months. Largely heeding his doctors, he remained ensconced at Brantwood, in effect submitting himself to what was, in effect, an extended rest cure. His one attempt to break from this routine, with a trip to London to oversee the transfer of 250 Turner drawings from the National Gallery to Oxford University, so alarmed Dr. Simon that he demanded the Severns carry him away from the city's commotion. Arthur obliged, accompanying Ruskin north to Yorkshire for a leisurely sketching tour. By autumn, Ruskin was ready for tentative steps back into society, ready enough, at least, to make a pair of country house visits. That October he returned to Hawarden, where Gladstone noted in him "no diminution of charm." But the journey he had taken a month before was the more inspiring of the two. At the invitation of Frances Graham, a young woman whom Ruskin considered a "pet," Ruskin traveled to the Perthshire home of her father, the collector William Graham: the same William Graham to whom Whistler, failing to paint *Annabel Lee*, had recently sent his Battersea Bridge nocturne. Quite possibly

* Scholars of the twentieth and twenty-first centuries have offered a number of more creative diagnoses of Ruskin's illness: morbid depression and "brain fever," extreme bipolarity, schizophrenia, and—most recently—Cerebral Autosomal Dominant Arteriopathy with Subcortical Infarcts and Leukoencephalopathy. (Cook, 1:220, 2:406; Bragman; Wilenski, 31; John Dixon Hunt, 370; Kempster and Alty, 2523.)

John Ruskin therefore saw that nocturne for the second time during this visit. But if he did, it apparently did not interest him. What *did* interest him were a trio of Pre-Raphaelite paintings there: Rossetti's *Ecce Ancilla Domini*, Millais's *Blind Girl*, and Burne-Jones's *The King's Wedding*. These works inspired him to write an extended essay praising the genius of the paintings' creators: a faded genius, perhaps, in the cases of Rossetti and Millais, whose paintings dated from the 1850s, but a living and triumphant genius in the case of Burne-Jones, "the greatest master whom the school has yet produced." Touting Burne-Jones's shining glory, unsurprisingly, gave Ruskin occasion to bemoan, as he had in *Fors*, most of the rest of modern art as a "Cockneydom" blind to spiritual truth. This essay, "The Three Colours of Pre-Raphaelitism," appeared in the November and December issues of *Nineteenth Century*—appeared, that is, right before and right after *Whistler v. Ruskin*, and therefore it helped, in its own small way, to restore Ruskin to his authority as arbiter of art at a crucial time.

All this time *Whistler v. Ruskin* was delayed—delayed without Ruskin's active involvement, but certainly with his approval. The case was originally scheduled for trial in April 1878, but James Anderson Rose, following the bulletins on Ruskin's illness then in the papers, agreed with Ruskin's solicitors to postpone for a month. Whistler must have been livid at the delay but bowed to the inevitable. After that Ruskin's solicitors, armed with a medical certificate from Ruskin's Coniston doctor Parsons, declaring Ruskin's unfitness to appear in court, twice sought and obtained postponements, shifting the trial date from May to June, and finally to November. That last delay was particularly mortifying to Whistler, who needed some mollifying from Rose before he would agree. "The result of the trial may turn on a small matter," Rose wrote him, "and I think it would be unwise to let Ruskin's Counsel have a chance of making a grievance by being able to say you had forced on the trial knowing that Ruskin was ill and unable to attend." Whistler agreed. Worse than any delay was the prospect of going to trial without Ruskin to spar with.

—⁓—

Whistler had good reason to chafe at this fifteen-month delay: he desperately needed the money that winning the case might give him. In the last half of 1877 the torrent of bills grew so overwhelming that Whistler had begun simply to forward to James Rose, as if his solicitor could magically make them go away.* "Enclosed another torpedo!" he wrote Rose that August; "put off the people!" But the torpedoes multiplied and the "people"—the cheesemongers and fishmongers, poulterers and bakers, bootmakers and haberdashers, coal dealers, photographers, and art suppliers—grew more impatient and more aggressive. That autumn a coal dealer named John Johnson sued Whistler for £23 and costs—and won. Whistler, with obvious reluctance, paid off the debt in four installments.

Despite his ever-growing troubles, Whistler continued to disdain the thought of economizing. Instead, convinced that extravagant self-promotion offered him a way out of his financial hole, he spent more lavishly than ever before. His weekly breakfasts continued uninterrupted and his dinners, if anything, increased; during the last four months of 1877; the *côtelettes de mouton*, the oysters *Kramousky*, the *compote de poire* continued to flow from his little kitchen to the plates of the chosen few, as he threw over two dozen of them.

At the same time, Whistler embarked upon both the riskiest financial gamble and one of the greatest attempts of self-promotion of his life, with the construction of a custom-built home to match in style, if not in expense, those of the great celebrity painters of the day such as Leighton and Millais. In it he would have an expansive, well-lit studio that would put his present one to shame, and would serve not simply as a workspace, but as an attractive showroom for the crowds of potential buyers, as well as an atelier for the students—the *paying* students—all of whom he was certain would come.

At the time of the 1877 Grosvenor exhibition Whistler and his good friend, architect Edward Godwin, began to consult upon the design of

* They soon overwhelmed Rose as well, and Whistler began sending them to a second solicitor, Theodore Allingham, whom he knew through Howell.

what they would soon be calling the White House. Inside, besides the larger studio, would be another smaller one and a separate etching room, as well as separate dining and breakfast rooms. Outside, their design would eschew ornament altogether, in keeping with Whistler's and Godwin's shared aesthetic principles, and in affront to those of Ruskin, who equated architecture with ornament. They opted for an apparently haphazard placement of doors and windows, exterior form dictated by interior function, and—Godwin deferring to Whistler in this—opted for broad masses of color: white bricks (in startling contrast to Chelsea's ubiquitous red ones), blue detailing, and a sweepingly expansive green roof that took up two-thirds of the façade. Godwin described their plans as one would a Whistler painting: "in effect it was to be a simple colour harmony of white, green, and blue."

That October Whistler signed an agreement for an empty double-plot of land on nearby Tite Street. The rent was cheap—just £29 a year—but it came with a catch: its owners, the Metropolitan Board of Works, had to approve of any design before they transferred the lease. Whistler simply ignored that stipulation, ordering his builder, Benjamin Nightingale, to commence work on the house before the Board approved Godwin's plans. By the time the Board's chief architectural adviser visited the site he was stunned to find that walls "had gone up ten to twelve feet." Meanwhile the Board, with its more Ruskinian perspective toward architecture, rejected Godwin's and Whistler's unadorned design outright. "That it was not *Gothic*, nor *Queen Anne*, nor *Palladian*, was probably its crime before the Board of Works," Godwin surmised. Whistler then found himself locked in yet another battle for art, one that extended from the end of 1877 to the summer of 1878. The Board demanded fuller ornamentation. Godwin submitted revised plans with minor changes. The Board rejected them. Whistler ordered Nightingale to build on. Godwin again revised his plans; the Board agreed to approve of the White House—if Whistler's builder incorporated the embellishments that Godwin proposed. By May the White House was essentially done, its façade retrofitted at some expense with sculpted pediments and lintels. Still, it fell short of Godwin's design,

and the Board refused to approve it. Whistler proceeded to pepper the Board with angry letters, in one threatening to sue them for the suffering they had caused him. Finally, by the end of July, Nightingale had installed just enough ornamentation; the Board gave Whistler his lease, and Whistler moved into his "triumph of Art and ingenuity." The house had cost over £2,700 but Whistler paid almost none of it. To cover the original estimate, he had taken out two mortgages he could not hope to repay. And when Benjamin Nightingale presented a bill for the additional hundreds of pounds expended upon the changes in design, Whistler simply refused to reimburse him, instantly creating another substantial creditor—and a relentless one.

Whistler mulled over some grandiose plans to handle these alarming new debts. Before construction commenced, he had blithely laid them out to a friend, Stephen Tucker. "I am going to build—and want a couple thousand. . . . I propose now in the 'little season' to paint heads of blokes—business you perceive—portraits bon marché—say from 30 to 50 guineas. Now fellows about town would never dream of coming to Whistler for full length pictures at 400 or 500—would be glad enough to have a head at 30 to 50—You know army chaps—ensigns—cornets! and Field Marshals in their uniforms!—the embroidered collar at least—or their pet ballet dancers!" He looked to Tucker for help: "you will manage it for me of course." But Tucker did not manage it. The field marshals and their ballerinas did not come. Equally disastrously, Whistler's substantial stock of older paintings, long lying unsold in his studio, remained unsold.

In the end it was Whistler's indefatigable if shady friend Charles Augustus Howell who managed it. After latching himself firmly over the past dozen years to the affairs of Ruskin, and Rossetti, and Swinburne, Howell now latched himself even more firmly to Whistler's, convincing Whistler to turn for his income from his generally unsellable paintings to his highly sellable if less remunerative etchings. "I was sitting looking out of the window in Lindsey Row," Whistler remembered, "and there was Howell passing, and Rosa Corder was with him. I called out to them and they came in, and Howell said: 'Why, you have etched many plates,

haven't you? You must get them out, you must print them, you must let me see them—there's gold waiting." The next day Whistler, Howell and Rosa Corder—Howell's primary mistress and reputedly his partner in crime, the two apparently complicit in creating and selling Rossetti forgeries—set to work at the press. "There we all were . . . and Howell pulling at the wheel, and there were basins of water and paper being damped, and prints being dried, and then Howell was grinding more ink, and with the plates under my fingers, I felt all the old love for it come back." It did not take long for Whistler to realize that Howell was pilfering from the prints to make his own profit. But Whistler didn't care, for Howell was "so superb," running in the afternoons to negotiate with printsellers, "and there were orders flying about, and cheques—it was all amazing, you know!" Whistler earned well over £500 from his etchings in the last half of 1877 alone. Success with the old plates motivated Whistler to create new ones and motivated him as well to turn to lithography: drawing images upon a printer's stone rather than scratching them into plates. He created seventeen of these and published two in a magazine, but his lithographs sold far less successfully than his etchings.

Throughout 1878 and beyond, Howell became deeply involved in virtually all of Whistler's moneymaking schemes. It was Howell, for one thing, who gave Whistler the only portrait commission he completed that year: not of a field marshal or a ballerina but of his mistress Rosa Corder: another magnificent black-on-black full length, for which Corder remembered sitting forty times, occasionally fainting, until she refused to sit further. Howell records paying a hundred guineas for this *Arrangement in Brown and Black*, but Whistler remembered that Howell got it for nothing, giving him only £70 in money that turned out to be Whistler's own. Howell found ways to squeeze money out of Whistler's older paintings as well. Dealers might be unwilling to buy these—but several were more than willing to take them as security for a loan. Howell negotiated his first deal of this kind with a hapless collector by the name of Walter Blott, who agreed to advance Whistler £150 while taking the *Carlyle* as security. Howell, however, botched that deal to serve his own interests, bamboozling both Blott by failing to deposit

the *Carlyle* with him, and Whistler by skimming from the money Blott had paid. Blott threatened to sue before Whistler and Howell managed somehow to placate him—for a time. Howell made sounder arrangements with Jane and Urban Noseda, art dealers in the Strand, who advanced an amount now forgotten for several Whistlers, including, for a short time, the *Mother* and at least four other paintings—two of which, *Arrangement in Brown* and the now-notorious *Nocturne in Black and Gold*, Whistler had exhibited at the 1877 Grosvenor. It was with the printsellers Graves and Co., however, that Howell made by far his most lucrative deal, for not only did they advance loans for the paintings they held, they realized further profit by engraving them and selling mezzotint copies. They first reproduced the *Carlyle*, overcoming several problems to create a product that, according to Howell, delighted Whistler. Later—after the trial—Graves and Co. would reproduce both the *Mother* and the portrait of Rosa Corder.

The success of the *Carlyle* mezzotints prompted Graves and Co. to make a stunning offer to Whistler: a thousand guineas for a full-length painting, with reproduction rights, of Prime Minister Benjamin Disraeli. The problem, of course, lay in obtaining Disraeli's agreement to sit. In that, Whistler failed. According to Whistler's own account, he pursued Disraeli to his estate at Hughenden, where Disraeli promised him he would sit for Whistler—if he sat for anyone. "And then," Whistler remembered, "he sat to Millais!" Another account has Whistler cornering Disraeli in St. James's Park, where Disraeli met his request with an icy stare and the murmur of "Go away, go away, little man." In any case, Whistler's chance to earn a thousand guineas melted away.

Charles Augustus Howell proved to be Whistler's indispensable man during the sixteen months between the Grosvenor exhibition and the trial, always prepared to ferret out cash somehow when Whistler needed it the most. At times Howell borrowed from mutual friends for Whistler's (and his own) benefit, for example borrowing, according to Howell's own diary, twenty shillings from "Alice" and giving fifteen to Whistler. Or Whistler borrowed from him directly: "lent ten pounds to Whistler, eight pounds to Maud, good girl Maud" reads another entry. Another time when Whistler

asked twenty shillings of Howell, Howell made a mistake of taking from his pocket a half-crown with the shillings, and Whistler took that as well. "I walked home, damn him," Howell wrote. Howell kept track of his transactions; he, too, became one of Whistler's many creditors—in time, one of the most substantial. All the while Howell, aware as few others then were that Whistler's paintings could not but appreciate in value, found personal opportunity in Whistler's desperation. On February 22, 1878, he purchased from Whistler for £50 a number of odds and ends from the studio: a painting with apple blossoms, a sketch for the portrait of Cicely Alexander and another for one of the Greaves brothers, two nocturnes, and eight frames. At another, later time—obviously one of extreme need for Whistler—Howell got the portrait of Irving from him for "ten pounds and a sealskin coat."

Howell, then, was instrumental in preventing Whistler from being swallowed up by his debt. But Howell could do little to prevent that debt from growing ever larger. *Whistler v. Ruskin*, on the other hand, *could* turn everything around with its chance both to salvage his reputation and give him a much-needed thousand pounds. One can only imagine how much Whistler ached for his day in court, and how much he chafed at each delay.

⁓

One evening in mid-November 1878, not long before the long-awaited commencement of *Whistler v. Ruskin*, Frederick Leyland threw a dinner for his artist friends at 49 Prince's Gate—in the Peacock Room. Surrounded by Whistler's golden whorls and nocturnal tones, under the passive gaze of the *Princesse du Pays de Porcelaine* on one wall and the endless battle between artist-peacock and critic-peacock on the opposite one, they sat: Burne-Jones and his brother-in-law Edward Poynter, Thomas Armstrong, Walter Crane, Val Prinsep, Joseph Comyns Carr, and others, including the American George Henry Boughton—the man who sixteen months before at the Arts Club had placed Ruskin's attack in Whistler's hands.

James Whistler, of course, had not been invited.

At some point during that dinner, the conversation quite naturally turned to the artist whose work encompassed them. Walter Crane, sitting beside Burne-Jones much as his paintings had hung beside Burne-Jones's at the 1877 Grosvenor, asserted his admiration for the artistic quality of Whistler's work—and realized immediately that he had blundered. Burne-Jones turned upon him with a tirade against that pretend artist and his pretend art. "I was rather surprised to find," Crane remembered, "that Burne-Jones could not, or would not, see his merits as an artist, or recognise the difference of his aims. He seemed to think there was only *one* right way of painting, and after a little discussion, he said, with some emphasis, 'This is the only time we ever had a difference and—it shall be the last!'"

No one after that dared defend Whistler. Not Whistler's friend Boughton, not his one-time comrades in bohemian Paris Armstrong and Poynter, and certainly not Frederick Leyland. Every one of Leyland's guests that evening knew full well what Walter Crane belatedly grasped: "that the libel case of *Whistler v. Ruskin* was about to come on, in which Burne-Jones was an important witness for the defendant, and, in fact, though much against the grain, and only under the strongest pressure from Ruskin, he undertook to appear in court for him. Under the circumstances he could hardly afford to allow any credit to Whistler."

Crane, remembering this scene years after the fact, if anything understated Burne-Jones's role in the coming trial. Burne-Jones was not simply to be an important witness; he was to be the *most* important witness for the defense, John Ruskin's hand-picked surrogate. For John Ruskin himself had finally opted out. His doctors' admonitions and certificates had given him the excuse he needed, but the final decision had been his. His nuts and nectar of sixteen months before had now become ashes and poison. Arthur Severn, who had been with him at Brantwood much of that time, put it simply: "Ruskin wouldn't go." On November 9, with the trial set to begin on the 18th, Ruskin's solicitors informed James Anderson Rose that Dr. Parsons had once again declared Ruskin unfit to appear at trial. Whistler, still wishing above all a personal battle with Ruskin, called for yet another postponement—and threatened to compel Ruskin to appear

with a subpoena if one wasn't given. Ruskin's solicitor Robert Loveband
Fulford, who had previously welcomed every postponement, objected to this
one. On November 15, three days before the trial was scheduled to begin,
Fulford announced that Ruskin had ordered his lawyers to proceed without
him and without delay, adding that, given Ruskin's medical condition,
Whistler's threatened subpoena was bound to fail. With that Whistler
and Rose admitted defeat, asking instead for a delay of a week to prepare
for trial without Ruskin. Fulford opposed even this, but a judge approved.
The trial would commence on Monday, November 25.

While Ruskin refused to appear, he did his best to control his defense
from afar, submitting to his lawyers a detailed set of instructions for fighting
his case. For a man whose authority and whose reputation depended upon
promulgating truth—Truth—in all he wrote, he now urged his counsel
to argue for him that everything he had said about Whistler was abso-
lutely true. "Ill-educated and conceited?" That was obvious both from the
ridiculous prices Whistler asked for his works and from the idiotic musical
titles he gave them; "the public would at once recognize the coxcombry
of a composer, who advertised a study in chiaroscuro for four voices, or a
prismatic piece of colour in four flats, and I am only courteous in supposing
nothing worse than coxcombry in an artist who offers them a symphony in
green and yellow for two hundred pounds." Flinging a pot of paint in the
face of the public? That too was true, for Whistler's works were nothing
but matter without thought, "ornament rather than edification," in blatant
opposition to the principle that Ruskin had stated thirty years before in
estimating an artwork's value: "their preciousness depended ultimately on
the greatness and justice of the ideas they contained and conveyed." "It is
a critic's first duty," he explained, "to distinguish the artist's works from
the upholsterer's." Absence of ideas devalued Whistler's works. So did the
absence of labor. For Ruskin, the concept of a fair day's wage for a fair
day's work applied to the artist as it applied to any workman. Whistler's
hasty, unfinished work was bad art—or, rather, no art at all. He hardly
deserved 200 guineas for it, but richly deserved censure for charlatanism,
for "approaching" imposture. Ruskin hoped, as well, to bring political

economy as well as aesthetics into the argument, by sending via Arthur Severn additional instructions to his lawyers: "I should like you to express to whichever of our Counsel listens best, the *one main* difference between me and other economists—that I say, all economy begins in requiring and teaching every craftsman to give as *much* work as he can for his money, and all modern economists say you must show him how to give as *little* as he can for his money."

In exhorting his lawyers to establish the absolute truth of his words, Ruskin expected them to win his case with a legal plea of *justification*. For one whose reputation relied upon his sagacity it was the only plea that made sense. But to his solicitor and his barristers, who aimed not to teach but to win, it made no sense at all—and might be the surest way to a loss. Charles Bowen, who would serve as Ruskin's junior counsel at trial, concluded as much when he first considered the facts of the case, noting "it would . . . be hopeless to try to convince a jury that Mr. Ruskin's view of Mr. Whistler's performance was right: they never could or would decide on that." Far easier to argue and to win would be a plea of *fair comment*: that Ruskin's words were not demonstrable truth but credible opinion, opinion delivered without malice: the kind of opinion that any reasonable person might hold. From the start, Ruskin's solicitor Robert Fulford had preferred this defense. Indeed, he had committed to it ten months before, declaring in his plea to the High Court that "the alleged libel is privileged as being a fair and *bonâ fide* criticism upon a painting which the Plaintiff had exposed for Public view."

Given their obvious differences with their client, Ruskin's lawyers were surely relieved to have Edward Burne-Jones and not Ruskin himself as their chief witness. Burne-Jones, too, submitted a statement to Ruskin's lawyers, and in it made it very clear that he was more than willing to take on the role of his *papa*'s St. George, battling the Whistlerian dragon with his own low opinion of Whistler's art, reflecting Ruskin's own criticisms, but able to heap several more of his own upon this man he clearly despised. "The point and matter seems to me to be this," Burne-Jones wrote,

that scarcely any body regards Whistler as a serious person. For years past he has so worked the art of brag that he has succeeded in a measure amongst the semi-artistic part of the public, but amongst artists his vanities and eccentricities have been a matter of joke of long standing. Now when he first went before the public there was sufficient excellence in his work to make all artists look forward to his future with some interest, but the qualities he possessed appeared soon to be exhausted and it is long since there has been any expectation of further fulfillment. In fact, he lacks certain qualities *necessary* to the making of a *real* picture.

Whistler, he thought, was well aware of his shortcomings and resorted to selling his work through sheer puffery, "without any shame at all in proclaiming himself as the only painter who has lived." (In other words, Whistler *was* nothing more than an "artistic Barnum.") Whistler, Burne-Jones thought, could never produce more than sketches—sometimes clever, often stupid, "sometimes sheerly insolent." He could finish nothing, and therefore attempted to make a virtue of incompleteness while decrying qualities of art "that all mankind, ancients and modern, have striven for and demanded."

At dinner at the Peacock Room, then, Walter Crane had done Burne-Jones a favor by providing him with an occasion to rehearse his lines—to practice releasing years of pent-up rage against this hated man and his hated art.

On the weekend before the trial, James Whistler had not one but two occasions to rehearse his own lines. That Saturday evening, the 23rd, at the White House, he entertained his lawyers—solicitor James Rose, senior counsel John Humffreys Parry, junior counsel William Comer Petheram—with a dinner at the White House of *filets de sole, côtelettes purée*

d'or, Poulet à la Baltimore, as well as a tour of his studio, to show off and to explicate on the merits of the retrospective collection of paintings he had assembled there before they were hauled to Westminster on Monday morning to be put on display for the jury. Among these paintings were the *Carlyle* and the *Mother,* the portraits of Cicely Alexander and Henry Irving, the Japanese-styled *Balcony,* a single nocturne (now unidentifiable), and a seascape, quite likely the *Harmony in Blue and Silver,* his depiction of Courbet on the beach. It was a memorable evening for John Parry, but memorable not for the fine cuisine or for Whistler's crowing. Rather, he was flabbergasted at Whistler's coercing officers of the court into serving as his waiters—and deeply concerned that his host's eccentricities, if shown in court, might cost them the case.

The next morning, Whistler threw a special, pre-trial Sunday breakfast, his special guest this time the one man who could arguably contend with Whistler for the title of London's greatest wit. William Schwenck Gilbert had long been renowned for his comic verse and plays, but in the autumn of 1878 was enjoying unprecedented celebrity, thanks to the success of HMS *Pinafore,* his smash comic opera collaboration with Arthur Sullivan. Until that Sunday morning, Whistler and Gilbert had kept a guarded distance from one another.* Although Gilbert would attend the trial the next day, this Sunday was quite possibly not only the first time but also the last that the two met face to face. The timing could not have been coincidental, for suddenly each man had something to offer the other. In Gilbert, with his barrister's training and his exceptional eye for human, social, and institutional folly, Whistler had found the perfect witness for his upcoming performance. In Whistler and his trial, Gilbert found the prospect of great entertainment and perhaps of great inspiration: a real-life, topsy-turvy comic opera,

* "Wits have one thing in common with bores: they recognise at sight and avoid one another, fearing competition," wrote biographer Hesketh Pearson with the two of them in mind. (Pearson, *Lives,* 191.)

a second *Trial by Jury*,* with Whistler in the lead role, supported by a fractious chorus of lawyers and witnesses, judge and jury.

Whistler, then, could not have had a better audience for yet another declamation of his genius. But Whistler convened this gathering with another purpose in mind, as well—to prepare, inspire, and embolden the upcoming performance of Albert Moore, also at the breakfast that day: his friend, the only English artist he truly respected, and his chief supporting witness at the trial. "Moore my dear brother professor," Whistler had written him a few days before, "I want you now . . . On Monday next my battle with Ruskin comes off—and I shall call on you to state boldly your opinion of Whistler generally as a painter—colorist—and worker—In point of fact what I gather is that I must have with me some of my own craft to state that what I produce is *Art*—otherwise Ruskin's assertion that it is *not*, remains." Over buckwheat cakes and coffee, then, Whistler, Moore, Gilbert and his wife Lucy, Theodore Watts-Dunton, and the rest hashed out these matters, and then Whistler led them all upstairs to admire his art. As breakfast broke up and the Gilberts departed, Whistler's lawyers returned, not to dine, but to work. There was the brief to amend and to review. There were Ruskin's writings to examine for vulnerabilities. And there were several witnesses, both actual and potential, to consult with.

For Whistler's lawyers, finding witnesses willing to testify had proven a trial in itself. Fearing, as Whistler put it, that Ruskin had amassed "an army of volunteers ready to swear that Whistler's work is mere impudence and sham," they proposed to counter with "as many witnesses as possible of position and of known taste": dealers and critics, as well as artists. While Whistler provided them with a list of possible witnesses he questioned their strategy, arguing that "my art is quite apart from the usual stuff furnished to the mass and *therefore* I necessarily have *not* the *large number of*

* Gilbert and Sullivan's one-act *Trial by Jury*, its subject a breach of promise case at the Court of Exchequer, had opened three years before. It was their first true operatic collaboration, and their first hit.

witnesses." Three would be enough, he thought: himself, Moore, and the sculptor Joseph Edgar Boehm.

Whistler was sure that Boehm would agree to testify. Not only was Boehm a friend; he was a friend for whom Whistler had just done an enormous favor. Earlier that month Whistler had written an effusive letter to George Washington Custis Lee, son of Confederate general Robert E. Lee, recommending Boehm for the lucrative commission of a colossal equestrian sculpture of Lee's father. But however grateful Boehm might be for Whistler's help, he quickly made it clear that he had no desire to testify. Rose could of course compel him to with a subpoena, but neither Rose nor Whistler wanted to put a reluctant artist in the witness box.

Nearly all the other artists on Whistler's list, including Frederick Leighton, Frederic Burton, Edward Poynter, and James Tissot, proved equally reluctant to testify. Leighton, at least, had an excellent excuse: he had just been elected president of the Royal Academy and on the Monday would travel to Windsor to be knighted by the queen. Tissot, on the other hand, had no excuse except his timidity, which prompted Whistler's enmity, expressed in a sarcastically threatening letter: "My poor Tissot—I believe I am carrying out my final duty of friendship by letting you know that despite my efforts you are perhaps still at the mercy of the law—and with the possibility of spending several days in prison!—My solicitor's clerk is ready to affirm that he had served you with a summons—which still holds, despite my having done everything in my power to excuse you—by explaining to these gentlemen that in your pitiable state you would have been of no help at all."

Desperate to find an artist besides Whistler and Moore to testify, James Rose turned not to one of Whistler's friends, but to one of his own. William Gorham Wills had gained some fame as an artist, particularly with his pastel portraits of children. He had gained a greater fame as a prolific playwright. But his writing fulfilled him far less than his painting did, his brother and biographer noting that "he would freely have given all his dramatic laurels for one success as a painter, and . . . he fretted out his heart at his life-long failure." He would hardly carry the clout of a Leighton or

a Tissot in the witness box. But having just returned to London from his Paris studio, Wills was available—and more to the point, Wills was willing.

As for obtaining a critic to testify, there was one obvious choice: William Michael Rossetti, who had written the year before in *The Academy* the most positive review of Whistler's work at the Grosvenor. On the Friday before trial Rose had served Rossetti with a subpoena, accompanying it with a letter reminding him of his praise for Whistler's art at the Grosvenor. He then sought out Rossetti in person at the Excise Office at Somerset House, where Rossetti kept his day job, to exhort him further. Rossetti pleaded to be let go, writing to Rose that "Ruskin is an old and valued friend of mine . . . and, though I don't either agree in his ill-opinion of Whistler's pictures or approve of the phrases he uses, still I should be very sorry to take a personal part in getting him mulcted in damages." But, Rossetti concluded, "if I don't hear from you . . . I shall of course attend, and give my sincerely felt witness to the excellences of that picture." That—and Rossetti's documented appreciation of Whistler—was enough: despite his reluctance, he would appear.

Whistler, Moore, Rossetti, Wills: they would be the witnesses for the plaintiff. At least three others were subpoenaed and would be in court in case they were called: two dealers and a little-known artist and a friend of Whistler's named Matthew Elden. Another potential witness, however—Charles Augustus Howell—was considered and then dropped. No one had a better knowledge of Whistler's business affairs than Howell. No one could better spin a tale. Both these things could present problems for Whistler's side. After the trial, Howell had boasted to Whistler that his testimony alone, had he given it, would have won the case. "Yes," retorted Whistler; "had you been a witness you would have won and we would all have been in Newgate!"

The "army of volunteers" that Whistler's lawyers feared Ruskin had assembled, in the meantime, had failed to materialize, a failure that Ruskin's solicitor attributed to "a disinclination to appear and give evidence against an artist, however bad." The painter Henry Stacy Marks, who had apparently proposed to humiliate Whistler in court by painting a nocturne

of his own in five minutes, now backed out. So did George Dunlop Leslie and Ruskin's friend George Richmond, both eminent Academicians. Burne-Jones, who had earlier that month assured Joan Severn that "hundreds of us are eager to do something," now realized to his serious dismay that he alone among artists seemed willing to testify. From Brantwood, Ruskin did his best to deal with the problem. He could ask Arthur Severn to appear, of course, but not only was Severn—virtually his son-in-law—too close to Ruskin to testify, he was reluctant as well: "I knew Whistler and admired his work," Severn remembered; "I also thought Ruskin's criticism about flinging a pot of paint in the face of the public, ill judged." But if Ruskin could not get Severn into the witness box, he could employ Severn to coax another into it. Before Severn left Brantwood for London to assist in the case, Ruskin asked him whether he knew the artist William Powell Frith well enough to solicit him to testify. Severn replied that he did.

Frith was an inspired choice. He was at the time by far the most popular and the highest-paid painter in England, his teeming genre paintings such as *The Derby Day* and *The Railway Station*, with their Dickensian social sweep and narrative energy, able to draw the masses to the galleries as no other artwork could. He carried the authority of twenty-five-years' membership in the Royal Academy. He despised Whistler's work, and, equally importantly, he disliked Ruskin's, and that gave Frith a distance from Ruskin to counterbalance Burne-Jones's closeness to him. Frith, then, would testify. Frith, however, loathed courtroom appearances, and was enraged to be asked to testify now. At trial, he would make it very clear that a subpoena alone, not Arthur Severn, had gotten him into the witness box.

As a final witness for the defense Ruskin's lawyers, like Whistler's, looked for a critic, and for this they made the obvious choice of England's second-most renowned one: Tom Taylor of the *Times*. Taylor, like Rossetti, had gone on record about Whistler's paintings at the Grosvenor. But unlike him, Taylor's review was entirely disparaging, blasting the paintings for their nonsensical fogginess and "entire absence of details." Reluctant to testify or not, therefore—and there is no evidence that he *was* reluctant—Taylor promised to be a safe witness for the defense.

In the weeks before trial, Ruskin's lawyers scrambled as much to assemble exhibits for the trial as they did to find witnesses: they, too, wanted Whistler's art to be shown. But while Whistler had assembled a set of paintings that he hoped would impress upon the jury his aesthetic depth and breadth, Ruskin's lawyers sought the opposite: those paintings they thought would perplex and annoy the jury, specifically the seven paintings that had annoyed Ruskin so deeply at the Grosvenor exhibition.* More than this, they sought to *control* those paintings for the duration of the trial, and to decide the way that they would be presented to a jury. Whistler for his part was adamant that his paintings be hung for the jury as he had always aimed to hang them for the public: clearly visible, and in a tasteful setting. (He had arranged for the finest room of the St. Stephen's Club, ten minutes' walk from the courtroom, to hang the collection in his possession.) The paintings that the defense controlled, on the other hand, could be shown in the far-less-favorable conditions of the courtroom itself. Earlier that month, Whistler had anticipated and resisted exactly that sort of haphazard presentation when Fulford had asked to examine Whistler's work not in his studio, but in James Rose's gloomier chambers. "Certainly not!" Whistler complained to Rose: "Your client most determinedly objects to whatever pictures there may be of his being shown in any accidental and promiscuous manner. . . . Pictures may not be handed about like samples of butter to be inspected by chance experts in the market place—They are to be shown properly hung as they were *originally when first seen by Mr. Ruskin*."

A month before trial, Robert Fulford had commenced his battle to obtain Whistler's Grosvenor works, demanding that Whistler reveal their present whereabouts, and to allow him to examine all of them. Whistler refused, and Fulford took the matter before a judge, who ruled in his favor; Whistler then, grudgingly, complied. Three of the four nocturnes at the exhibition, he disclosed, he had sold or given away; the first of the two *Blue and Silver* nocturnes—the one of Battersea Reach—he had given to

* *Seven* Grosvenor paintings, not eight: the portrait of Carlyle was not listed in the catalogue and not among the paintings Ruskin wrote about. Ruskin's defense had no desire to bring that painting before a jury.

Frances Leyland; the second one—the Battersea Bridge—Whistler had given William Graham in place of the unfinished *Annabel Lee*; and the *Nocturne in Blue and Gold*, depicting Parliament and Westminster Bridge, Whistler had sold to Percy Wyndham as a gift for his wife, Madeline. The one remaining nocturne, the all-important *Falling Rocket*, he had deposited with the art dealers Jane and Urban Noseda as security for a loan. Of the three portraits, Whistler claimed to have only one—the portrait of Henry Irving—in his possession. The *Harmony in Amber and Black* he claimed he had painted over and thus destroyed. And the *Arrangement in Brown*—the portrait of Maud—he had also deposited with the Nosedas.

Fulford subpoenaed all seven, and he succeeded in getting four: The two *Blue and Silver* nocturnes from Leyland and Graham, and the two paintings, including the *Falling Rocket*, that the Nosedas held. (As Madeline Wyndham was out of the country, her nocturne remained out of reach; the "destroyed" *Harmony in Amber and Black* was unrecoverable; and Whistler somehow managed to hang onto the portrait of Irving for his own showing.)

Early on the morning of Monday November 25, then, an outstanding collection of fine art converged upon Westminster from all directions. From Chelsea and the White House came Whistler's retrospective collection, packed in the van of Whistler's frame-makers Foord and Dickinson. From the Strand came the Whistlers that the Nosedas held.[*] From Fulford's chambers at Gray's Inn came the two nocturnes Fulford had subpoenaed from Frances Leyland and William Graham. And from Herne Hill came Arthur Severn in a cab, having on that inclement day—or so he claimed—strapped to its roof the *Portrait of the Doge Andrea Gritti*, a painting owned by Ruskin and thought to be by the great Titian. (It was not.[**]) By showing that painting in court, Ruskin hoped to put Whistler to shame, and to illustrate the sorry decline of Whistler's brand of modern art.

[*] The Nosedas were actually subpoenaed to bring *four* paintings to the trial that day. Presumably, Fulford got the two he wanted, including the *Falling Rocket*—and Whistler added the other two to his collection. (*Correspondence*, James Anderson Rose to Urban Noseda and Matthew Elden, Nov. 22, 1878, GUL 13738.)

[**] *Portrait of the Doge Andrea Gritti* is now attributed to Vincenzo Catena.

Fulford's and the Nosedas' Whistlers as well as Ruskin's *Gritti* made it to Westminster without any problem. Not so the paintings sent from Whistler's studio; the workmen hauling that cargo pulled up to the St. Stephen's Club only to learn that the arrangement to hang them there had fallen through. To handle this complication, not Whistler but James Rose was called upon. Having been up most of the night scrutinizing Ruskin's works, Rose found himself that morning rushing about Westminster desperately searching for suitable walls upon which to hang Whistler's paintings. He finally found them at the Westminster Palace Hotel, a building within sight of the Westminster Hall courtroom—a far more convenient venue than the St. Stephen's Club. Whether the judge in *Whistler v. Ruskin* would actually allow the jury to cross the street and view Whistler's work there was still an open question.

That day John Ruskin remained at Brantwood, practicing the enforced inactivity he considered necessary for his recovery. To his friend Charles Eliot Norton he wrote "I keep fairly well—on condition of doing only about two hours real work each day. But that, with the thoughts that come in idleness, or as I chop wood—will go a good way yet—if I live a few years more." His two hours' work that day he devoted to botany and his *Proserpina*, work he considered unlikely to excite him. And as for the trial, Ruskin did his best to pretend to Norton that it meant little to him: "today . . . I believe the comic Whistler law suit is to be decided."

James Whistler, Edward Burne-Jones, Albert Moore, Tom Taylor, William Michael Rossetti, William Powell Frith, William Gorham Wills, Arthur Severn, and W. S. Gilbert would be there. John Ruskin would not.

WHISTLER V. RUSKIN

J ohn Walter Huddleston was, after his death, largely remembered for four reasons. First, he was the very last person to be given the ancient legal title Baron of the Exchequer, and therefore he called himself "the last of the Barons." Second, he had markedly improved his standing in society and politics in 1872 by marrying Lady Diana Beauclerk, daughter of the 9th Duke of St. Albans. Third, he had gained a reputation as a "strong" judge—that is, a judge who quickly drew his own conclusions in a case and usually induced a jury to draw them as well. And finally, he had a morbid antipathy to drafts in his naturally drafty Westminster Hall courtroom. By the mid-1880s that aversion, aggravated by the chronic illness that would end with his death, provoked Huddleston to declare total war against the outside atmosphere: besides stiflingly overheating the court, he surrounded himself with muffling curtains and ordered doors shut, window-sashes papered over, and all ventilation grates stopped up. (The report that he also had every keyhole plugged might have been an exaggeration.) When a fellow judge complained his actions were likely to produce asphyxia, Huddleston retorted that he preferred suffocation to drafts. On November 25 and 26, 1878, however, as Baron Huddleston presided over *Whistler v. Ruskin*, the onset of his

chronic illness was still a year away, and he was far less vigilant about the irruption of climate into the courtroom. And so for the duration of *Whistler v. Ruskin*, the outside made its way in: the drafts—and also the darkness. The weather was dismal on both days: "cloudy and showery" on Monday; "gloomy, dull and foggy" on Tuesday. The Whistler paintings that Fulford had brought into the badly gaslit courtroom, some of which he had propped up before the judge's bench, were therefore doubly dark, nearly invisible.

By 10:30 A.M. Monday morning the lawyers had taken their places. Whistler sat with his counsel; Arthur Severn, poor substitute for Ruskin, sat at the defense table equipped with all five volumes of *Modern Painters*, which he had borrowed from Burne-Jones. His plan, or rather Ruskin's lawyers' plan, was that he would look up relevant examples of Ruskin's aesthetic authority during trial—a task, Severn admitted, for which he was hardly qualified. Crowds now crammed the courtroom beyond capacity and spilled into the hallways. Baron Huddleston entered, bowed to counsel (who bowed back), took his place upon the bench, and proceeded to swear in the twelve jurors one by one.

Both sides in the case had agreed to deliberation by special jury—a jury, that is, consisting of men (no women) who met a substantial property qualification. Special juries were commonly employed at the time in libel cases, the assumption being that a higher class of juror would be better equipped to deal with the legal, the rhetorical, the financial—and, in this particular case, the aesthetic—issues that might arise. Their assumed higher awareness came at the price of higher court costs: special jurors were paid the professional amount of a guinea a day, far more than the shilling or eightpence paid common jurors.

Without doubt paying careful attention, reading the face of each juror as he was sworn, were the senior counsel for both sides. Both Whistler's counsel John Humffreys Parry and Ruskin's counsel Sir John Holker were renowned for their ability to connect with and to sway juries. But their approaches to that task could not have been more different. Serjeant Parry, not particularly distinguished for his knowledge of the law, excelled rather

in passionate advocacy, ready when the occasion called for it—and sometimes when it didn't—to appeal with polished and eloquent rhetoric to the jury's emotions: "as a winner of verdicts in cases where the feelings of juries co-operated, or perhaps occasionally conflicted with their reason, he had few equals, and hardly any superiors," noted one newspaper of him. Sir John Holker, by contrast, was highly distinguished for his knowledge of English law, and with it had reached the pinnacle of his profession: he was then the attorney general for England and Wales. (At the time, holding that position did not preclude private practice, and Holker had an extensive and lucrative one.) *His* way with juries, however, was methodical and commonsensical, pedestrian rather than passionate. Ponderous in body, lethargic in manner, and with a face that had earned him the nickname "Sleepy Jack Holker," he had made a virtue of his slowness, avoiding high-handed displays of eloquence or brilliance but instead by speaking frankly and genially, presenting himself to jurors as if he were one of them. "To lay a plain case before a jury," noted the *Telegraph*, "there never was or could be a better barrister." Parry excelled in having juries feel as he did; Holker, at having them think as he did.

The two junior counsel in the case—William Comer Petheram for the plaintiff, and Charles Synge Christopher Bowen for the defense—were also barristers of stellar reputation; neither Whistler's solicitor nor Ruskin's had stinted in their choice of advocates for their clients. Petheram, James Anderson Rose had assured Whistler, was "a Gentleman, of good presence, popular, and an excellent Lawyer, in large practice and therefore of great experience." He would in time become chief justice of Bengal, the highest justice in the Raj. Bowen, despite chronic illness, had found great success as a barrister not because of any way with juries—on the contrary, he tended to be hesitant and overly deferential with them—but because of his superior knowledge of the law and his obsession with assiduous preparation: "cases," he once said, "are won at chambers." Within a year his talents would earn him both knighthood and judgeship.

The jury sworn, Serjeant Parry stood to open the case. Whistler, Parry knew, had very definite ideas about how he expected his lawyers to conduct his case, and had emphatically made his instructions clear to them two days

before. "I am *known* and *always have been known* to hold an Independent position in Art and to have had the Academy opposed to me—That *is* my position and this would explain away the appearance of Academicians against me. . . . and I fancy it would be a good thing for Parry to take the initiative and say this. . . . Again I don't stand in the position of the *popular* picture maker with herds of admirers. . . . In defending me it would be bad policy to try to make me out a different person than the well known Whistler—besides I think more is to be gained by sticking to that character." Whistler, then, expected his lawyers to administer to the court an unadulterated dose of genuine Whistler, enemy both to the stale art of the past and to the worn-out artists of the Royal Academy who continued to practice it. Everything that was strange about Whistler and his art—his innovative formalism, his unconventional methods, his seemingly bizarre nomenclature, his striking, eccentric, rebellious personality: that was what Whistler wanted the jury and the world to see.

Parry and Petheram, however, disagreed with Whistler on this completely. Both had become well acquainted with the "well known" Whistler. The two could of course not hide Whistler's oddities—in art if not in personality—from the jury; Ruskin's lawyers were sure to bring it up. They considered these aspects of Whistler as things to be handled delicately rather than assertively. The Whistler they planned to sell to the jury was a very different one: not the rebellious outsider but the distinguished insider, the respectable artist who through years of study and hard work had taken his rightful place among the top rank of artists. To prove that Ruskin had done irreparable damage to Whistler's reputation, they had, they knew, to establish that Whistler had earned a lofty reputation in the first place.

Parry's opening, then, amounted to a spoken curriculum vitae: the eminent family background and apprenticeship in Paris, the skills and successes as an etcher, the widespread and illustrious exhibition of his art in England (particularly at the Royal Academy) and throughout Europe. Having established all that, Parry touched guardedly upon Whistler's independent ways, defending his client's singularity by cloaking him in sound Victorian virtue:

He occupied a somewhat independent position in art, and it
might be that his theory of painting was, in the estimation of
some, eccentric; but his great object was to produce the utmost
effect which colour would enable him to do, and to bring about a
harmony in colour and arrangement in his pictures. Although
a man adopted such a theory and followed it out with earnest-
ness, industry, and [utmost] enthusiasm, yet it was no reason
why he should be denounced or libelled.

After laying out Ruskin's "injurious and hurtful" libel, Parry turned
to the crucial question of where and how the jury would view Whistler's
work. Hoping to head off the defense's attempt to render Whistler's art
ridiculous by displaying it in the "impossible" conditions of the court-
room, Parry instead proposed a proper viewing of the paintings Whistler
himself had assembled at the Westminster Palace Hotel. This led to the
first of several discussions upon the subject. Baron Huddleston thought it
"exceedingly desirable" that the jury should see Whistler's retrospective but
balked at the idea of the jury actually leaving the courts to see it: surely
a place could be found to exhibit them in Westminster Hall? Holker, on
the other hand, objected to the jury seeing these pictures at all. The only
relevant Whistlers—and therefore the only ones the jury should see—were
the seven Grosvenor paintings that "Mr. Ruskin had in his mind" when
he wrote his alleged libel.

The opportunity to swipe at Ruskin's non-appearance—and his mental
instability—was too great for Parry to resist. "We don't know what
Mr. Ruskin had in his mind," he replied, "and probably we never shall."

The question was for the moment shelved. Parry yielded to his junior
Petheram, who called Whistler to the witness box and proceeded to
lead him over the ground that Parry had already covered: his origins,
his studies, his sales and successes. For the most part Whistler cooper-
ated in fleshing out these details. But this was not the Whistler that
Whistler wished the world to see: he champed at the bit to assert his
superior artistry, to separate himself from the academic herd. He also

wished to romanticize himself, an urge that can be detected behind the glib lie he uttered in the first words of his testimony, claiming birth in St. Petersburg, Russia. Even less acute observers would have noted that Whistler's repudiation of his actual beginnings in gritty Lowell, Massachusetts, flatly contradicted Serjeant Parry's assertion, moments before, that Whistler had been born in America.

Petheram, like Parry, dealt with the tricky subject of Whistler's unconventionality with caution. Beyond touching upon his "independent work" while at Paris, Petheram only allowed Whistler at the end of his testimony to explain his methods and his intent:

> "Will you tell us the meaning of that word 'nocturne' as applied to your pictures?"
>
> "By using the word nocturne I wished to divest the pictures from any outside anecdotal interest. The picture throughout is for me a problem which I attempt to solve, and I make use of any means, any incident and object in nature which will bring about such a symmetrical result if possible."
>
> "What do you mean by arrangement?"
>
> "I mean an arrangement of line and form and colour."

It was a start. But it was only a start, and hardly enough. Years later, when Whistler published his embellished, brazenly self-serving account of the trial in *The Gentle Art of Making Enemies*, he reduced Parry's opening to a single expository paragraph and he cut out Petheram's examination altogether. A tepid performance with little animation and little wit, it was no great loss. To bring out the real Whistler, the artistic genius, Whistler needed not an advocate but an opponent, a target, a foil, someone who espoused all the tired attitudes toward art that Whistler had challenged and therefore seemed blind to Whistler's talents. He needed someone whom he could battle and vanquish, thereby vindicating his art. Ruskin, of course, was supposed to fill that role; Whistler had fought hard to make that happen, but he had lost. Whistler needed another sparring partner.

He needed attorney general John Holker.

Holker was no Ruskin. He lacked Ruskin's encyclopedic aesthetic knowledge and theoretical depth, and neither the potted precepts in Fulford's brief or Arthur Severn's inadequate presence in the courtroom could supply these. Moreover, Holker altogether lacked Ruskin's antipathy toward Whistler and his art. Holker was a connoisseur and a collector who regularly patronized the galleries and exhibitions. He had almost certainly attended the 1877 Grosvenor exhibition and had appreciated the works there. He was a very close friend to Whistler's old friend Thomas Armstrong, and, according to Armstrong, he had an affection for Whistler as well. Two weeks after the trial, Armstrong remembered teasing Holker about his role in it, asking if he had helped ruin any more artists. "I was bound to do the best I could for my client," Holker protested, but maintained he would have preferred taking Whistler's side. "Why didn't Jimmy have me?" Holker asked Armstrong, and when Armstrong told him his fees were too high, Holker contended "I would have done it for nothing for Whistler."

Holker, however, was far too good a lawyer to allow affection to stand in the way of winning a case. He saw his best chance in winning this one was to leap beyond the defense's stated plea of fair comment and toward the far more challenging one of justification. He aimed not to have the jury allow that a reasonable person *might* agree with Ruskin—but that, with his guidance, that they *did* agree with Ruskin. His strength in swaying juries, he knew, lay in his approaching them as one of them, and that is what he proposed to do now, impugning Whistler's newfangled ideas about art not as much with Ruskin's esoteric ones, but with the traditional and commonsensical notions of art he assumed to be native to the jurors: that pictures by definition *depicted*, and told stories, that clarity and finish gave a work value while unfinished, nonrepresentational, unexplainable art was bad art—or no art at all. By adopting the guise of a philistine, Holker sought to get the jury to think as he thought—or rather to think as he seemed to think.

He began by attempting to put Whistler on the defensive by stressing his failure. "You have sent pictures to the Academy which have not been received?"

"I believe that is the experience of all artists," Whistler parried, an answer that earned him for the first time, but hardly the last, the laughter of the court.

Holker pressed on, turning to the *Falling Rocket* and peppering Whistler with questions calculated to force admissions of its inferiority by any traditional standard: slipshod and hurried in method, possibly immoral in subject, nonrepresentational in result, and hardly worth the price Whistler asked for it. Whistler parried them all.

> "What is the subject of the *Nocturne in Black and Gold*?"
>
> "It is a night piece, and represents the fireworks at Cremorne."
>
> "Not a view of Cremorne?"
>
> "If it were called a view of Cremorne it would certainly bring about nothing but disappointment on the part of the beholders. [Laughter.] It is an artistic arrangement."
>
> "You do not think that any member of the public would go to Cremorne because he saw your picture? [Laughter.]"
>
> "I do not know how to describe the picture. It is simply an arrangement of colour. That was for sale, and the price marked was 200 guineas."
>
> "And 200 guineas was the amount you thought a fit and proper price for it?"
>
> "Yes."
>
> "Is 200 guineas a pretty good price for a picture of an artist of reputation?"
>
> "Yes."
>
> "Is it what we who are not artists should call a stiffish price?"
>
> "I think very likely it would be so."

It was certainly so to Ruskin, Holker suggested, by quizzing Whistler on two of Ruskin's principles—one aesthetic, the other economic.

"You know that Mr. Ruskin's view is that the artist should not allow a picture to go from his hand when he, by any labour he can bestow upon it, can improve it?"

"Very likely."

"And that his view that an artist should give good value, and not endeavour to get the highest price?"

"Very likely . . . I am glad to see the principle so well estab-lished. [Laughter.]"

Holker then explored the oddities of Whistler's work in general. First there were those foolish titles. "Why do you call Mr. Irving an *Arrangement in Black*?" Baron Huddleston rather than Whistler did his best to clarify here, interjecting that "It is the picture and not Mr. Irving who is the arrangement." (He earned his own, surely unwanted, laughter for this.) Then, there was the overall strangeness of Whistler's work.

"I suppose you are willing to admit that your pictures exhibit some eccentricities. You have been told that over and over again?"

"Yes; very often. [Laughter.]"

"You sent them to the Gallery to invite the admiration of the public?"

"That would be such a vast absurdity on my part that I don't think I could. [Laughter.]"

"You don't expect your pictures not to be criticized?"

"Oh, no, certainly; unless they are overlooked."

For Whistler, of course, that would be a far worse fate. Finally, there were the shoddy methods:

"Did it take you much time to paint the *Nocturne in Black and Gold*? How soon did you knock it off? [Laughter.]"

"I beg your pardon—"

"Well, I am using a term that applies rather, perhaps, to my own work."

"Thank you for the compliment. [A laugh.] I knocked it off possibly in a couple of days—one day to do the work, and another to finish it."

"After partly painting it, did you put it up to mellow? [Laughter]: do you ever hang these pictures up on the garden wall?"

"I [did] not put up the 'Nocturne' or any other picture to mellow: I should be grieved to see my paintings mellowed [laughter]: but I do put my paintings in the open air that they may dry well as I go on with my work."

"And that was the labour for which you asked 200 guineas?"

"No; it was for the knowledge gained through a lifetime."

The applause was immediate, thunderous, and so disturbing to Baron Huddleston that he threatened to clear the courtroom if that sort of thing happened again. For Whistler, it was the witticism of the trial—perhaps the witticism of his life.

Holker did his best to recover by invoking the critics.

"You know that many critics entirely disagree with your views as to these pictures?"

"It would be beyond me to agree with the critics. [Laughter.]"

"You don't approve of criticism?"

"I should not disapprove in any way of technical criticism by a man whose life is passed in the practice of the science that he criticizes; but for the opinion of a man whose life is not so passed I would have as little respect as you would have if he expressed an opinion on the law. I hold that none but an artist can be a competent critic. It is not only when a criticism is unjust that I object to it, but when it is incompetent."

It was a clever reversal—a shot at Ruskin's abilities both as artist and as critic, and a reinforcement of Whistler's abilities as both. The argument here that true artists were the only legitimate critics of art would quickly become a central tenet of Whistler's own aesthetic theory. He would refine it within days and promulgate it widely for years.

Holker decided at that moment to allow Whistler's works—the ones in possession of the defense, anyway—to speak for themselves. He proposed that the *Falling Rocket* be brought forward for the jury to inspect. Serjeant Parry objected immediately, again arguing the unfitness of the setting. Baron Huddleston agreed: "it would be scarcely fair that an artist's pictures should be shown in a bad light." Holker persisted, asking that the jury see *Nocturne in Blue and Silver*—the Battersea Bridge nocturne—instead.

Parry objected again, and again recommended that the jury see all of Whistler's pictures in another room. To this Holker objected: since Ruskin had not seen most of those paintings, they were entirely irrelevant to the case. Not so, countered Parry: "inasmuch as the plaintiff's character was attacked, and he had been almost charged with being an imposter, he had the right to show to the jury what his works had been." Baron Huddleston agreed. And the jury made clear their perfect willingness to walk to the Westminster Palace Hotel to see them. It was settled; the jury would view them after lunch. The pictures now in the courtroom—including the *Falling Rocket*—would be hung there with the rest.

It was settled—and then it wasn't. After a further discussion between counsel and judge, one that reporters in the courtroom either couldn't hear or didn't see fit to record, Huddleston changed his mind, Holker got his way, and the paintings Ruskin's defense had subpoenaed were allowed to be brought forward for inspection.

A comic confusion ensued. "Once," remembered Arthur Severn, "when one of Whistler's 'Nocturnes' was held up to be looked at, he was asked if it was his work. 'I can't see at that distance,' said he. 'Hand it over to Mr. Whistler,' said Parry. As it was going over the heads of the people, some clumsy person let the corner of the frame fall on the bald head of an

elderly gentleman who wasn't pleased. But the Court was delighted. Then as it went on, it showed signs of falling out of its frame. Counsel called out: 'Is that your work?' Whistler, with his eye-glass in his eye and that extraordinary expression he could put on, said: 'Well, it was once. But it won't be much longer if it goes on in that way!'"

William Graham and his entire family were among the spectators in the courtroom that day, and so were there to witness the manhandling of their Battersea Bridge nocturne. "When the nocturne was brought in," Graham's daughter Frances remembered, "it was handed to the judge upside-down, but he did not perceive this, and said to the jury: 'Gentlemen, it is quite evident that this beautiful picture is—a view of Chelsea Church with its spire.' Then hurriedly someone whispered to him, and the picture was turned the right way up and Huddleston said: 'At least, not exactly Chelsea Church spire; but you see the buttress of Battersea Bridge in the foreground.' And everybody laughed."* Whistler's monition to Huddleston—"Your lordship is too close at present to the picture to perceive the effect which I intended to produce at a distance"— did nothing to stop this painting, and others, from being passed from juror to juror for similarly faulty inspection.

Holker took aim at the nocturne's apparent lack of coherence.

> "Do you say this is a correct representation of Battersea Bridge? . . ."
>
> "I did not intend to paint a portrait of the bridge. As to what the picture represents, that depends upon who looks at it. To some persons it may represent all I intended; to others it may represent nothing. . . ."
>
> "Are those figures on the top of the bridge intended for people?"
>
> "They are just what you like."
>
> "That is a barge beneath?"

* According to newspaper accounts, Huddleston's reaction to the painting was less complimentary and more bewildered: "Which part of the picture is the bridge?"

"Yes. I am very much flattered at your seeing that. The thing is intended simply as a representation of moonlight. My whole scheme was only to bring about a certain harmony of colour."

Holker then had Mrs. Leyland's nocturne passed about. He pressed Whistler on its hurried composition. "I completed the work of that in one day after having arranged the idea in my mind," Whistler replied.

With that, Holker ceded to Serjeant Parry, who allowed Whistler to elaborate upon this answer and contend haste to be a virtue in his art: "All the hand work is done rapidly; the proper execution of the idea depends greatly upon rapidity. The pictures would not have the quality I desire if I did not go on hammering away." Parry also had Whistler describe the paintings he had on display at the Westminster Palace Hotel. Huddleston then adjourned—for lunch, but also so that the jurors, flanked by officers of the court, could see the collection for themselves.

Court recommenced for a final confrontation between Holker and Whistler. The attorney general ordered *Falling Rocket* be brought forward and did his best to belittle it. "This is Cremorne?" Holker asked Whistler dubiously and dismissively—and got the laughter that he had obviously sought.

"It is a *Nocturne in Black and Gold*."

"How long did it take you to paint that?"

"One whole day and part of another. That is a finished picture. The black monogram in frame was placed in its position so as not to put the balance out."

"You have made the study of art your study of a lifetime. What is the peculiar beauty of that picture?"

"I dare say I could make it clear to any sympathetic painter, but I do not think I could to you any more than a musician can explain the beauty of a harmony to a person who had no ear."

"You offer that picture to the public as one of particular beauty, as a work of art, and which is fairly worth 200 guineas."

"I offer it as a work which I have conscientiously executed, and which I think worth the money. I would hold my reputation upon this as I would upon any of my other works."

With that, and after a couple inconsequential and anticlimactic questions by Parry, Whistler stepped triumphantly from the witness box, having charmed his audience, declared his genius, and soundly defeated Holker in their battle of wits. And he knew that, thanks to the press, his performance was guaranteed an international broadcasting. He had, in other words, achieved much of what he had hoped for in suing Ruskin. Much—but not everything. In so brilliantly defending his artistry, he might—just might—have done much to convince the jury that Ruskin had been wrong in his scathing assessment of Whistler's art. But he had done next to nothing to convince them that Ruskin's words were not an honest (if mistaken) opinion rather than a malicious attack—and were, therefore, libel. He and his lawyers would not earn him his thousand pounds until they did that. And while Whistler's active role in all this had now come to an end, John Holker's efforts to foil him had just begun.

———

William Michael Rossetti, next in the box, demonstrated the dangers to the plaintiff's side both of the reluctant witness and of the man of integrity. He had indeed written the most favorable review of Whistler's work at the 1877 Grosvenor, but his praise there was not unqualified: he had, for instance, dismissed the portrait of Irving as "a rather strong experiment upon public submissiveness." Had Whistler's counsel John Parry studied Rossetti's review more carefully, he would have had a better idea about the works he should focus upon in his questioning—and which to avoid. But he had not, and made the mistake of turning from the start to the *Falling Rocket*.

"You have seen the *Nocturne in Black and Gold* before?"

"Yes, and I am well aware of the nomenclature of Mr. Whistler's pictures, and I appreciate their meaning."

"As regards this particular picture in black and gold, did you criticize it?"

"I criticized the pictures in the Grosvenor Exhibition of 1877, and I suppose I must have said something about it."

He had in fact said nothing whatsoever about it. On the other hand, he *had* rhapsodized over the beauty of the *Nocturne in Blue and Silver* Whistler had given Mrs. Leyland, and when Parry next asked his judgment of Whistler's nocturnes in general, Rossetti pointed to that work, still on display in the courtroom, and commended its "artistic and beautiful representation." Parry directed Rossetti's attention to Graham's Battersea Bridge nocturne: "to that I apply nearly the same observation." Parry then returned to the *Falling Rocket*—but Rossetti's reaction to that was more descriptive than laudatory: "The *Nocturne in Black and Gold* is an effort to represent something of an indefinite kind. Being a representation of night, it must be indefinite. It represents the darkness of night mingled with and broken by the brightness of fireworks."

Parry sought safer ground, asking Rossetti his general assessment of Whistler as an artist. Holker objected: Ruskin's criticism, and not Whistler's art, was on trial, and testimony should focus upon the works Ruskin actually saw at the Grosvenor. Huddleston sustained the objection. Parry asked about one of the Grosvenor paintings: the portrait of Carlyle. Holker again objected, since this was not among the paintings Ruskin wrote about. But it had been exhibited at the Grosvenor, and so Huddleston overruled him. "I think it a very fine portrait, treated with a certain amount of peculiarity. It is a very excellent likeness to the best of my judgment," Rossetti testified. Parry again asked him his general assessment of Whistler's art. Holker objected; Huddleston sustained. Parry suitably rephrased the question:

"What is your judgment of the works in the Grosvenor Gallery exhibited by Mr. Whistler?"

"Taking them all together, I admired them much, but not without exception."

"Do you, or do you not, consider them the works of a conscientious artist desirous of working well in his profession?"

"I do, decidedly."

Which works Rossetti did *not* admire, exactly, Rossetti did not say. But attorney general Holker obviously had an inkling, and in cross-examination homed in on the *Falling Rocket*.

"What is the peculiar beauty of the *Nocturne in Black and Gold*—the representation of the fireworks at Cremorne? Is it a gem? [Laughter.]"

"No."

"Is it an exquisite painting?"

"No."

"Is it very beautiful?"

"No."

"Is it eccentric?"

"It is unlike the work of most other painters."

"Is it a work of art?"

"Yes, it is. It is a picture painted with a considerable sense of the general effect of such a scene as that, and it is painted with a considerable amount of manipulative skill."*

Having successfully elicited the paradox that such a limited and unaesthetic painting could nevertheless somehow be art, Holker turned to price, asking Rossetti whether he thought 200 guineas "stiffish." Rossetti hesitated to answer this question, apparently considering, as Ruskin did not, questions of cost lay outside the province of the critic. Holker appealed to

* Another transcription of this interchange provides another reason—a curious one—why Rossetti thought this painting art: "Is anything a work of art that produces a startling effect?" "Yes, I think so." (*Leeds Mercury*, Nov. 26, 1878, 6.)

the judge, and Huddleston compelled Rossetti to answer. "I think it is the full value of the picture," he replied. That the courtroom burst into laughter suggests that Rossetti heavily stressed the word "full," intimating that the painting might be worth that—but not a penny more.

Parry in reexamination made a final, valiant attempt to squeeze praise from Rossetti for the *Falling Rocket*, but should not have bothered: while Rossetti admitted cryptically that he did not look upon the picture indifferently, he could only end his testimony by disparaging it. "I have often seen fireworks represented before in pictures, but I do not think it is a good subject."

If Rossetti's tepid performance disappointed Whistler, Albert Moore, appearing next, gave him everything he could have wished for in a supporting witness. After eliciting Moore's eminent qualifications, Serjeant Parry, as he had done with Rossetti, turned to the *Falling Rocket*. Moore's praise was ardent and unqualified:

> The picture produced, in common with all Mr. Whistler's works, have a large aim not often followed. People abroad charge us with finishing our pictures too much. In the qualities aimed at I say he has succeeded, and no living painter, I believe, could succeed in the same way with the same qualities. I consider them to be beautiful works of art. There is one extraordinary thing about them, and that is, that he has painted the air, especially in the Battersea Bridge scene. The picture in black and gold I look upon as simply marvellous. I call it a most beautiful work of art.

He then offered the ultimate compliment one artist could give another: "I wish I could paint as well." Two hundred guineas he thought a fair price for the nocturnes—"if I were rich I would buy them myself"—and deftly endorsed Whistler's argument that skill and experience rather than sheer labor gave an artwork value, positing Whistler's professionalism on a level with that of any barrister in the room: "Regarding Mr. Whistler's position as an artist, you can't expect him to work very long for £100, any more than you gentlemen would. [A laugh.]" Holker in cross-examination could do

nothing to shake Moore. Whistler was no follower of others, Moore assured him; "the practice of art as he follows it is not very common in England." If he was indebted to anyone's style, it was that of the great Velázquez. He scorned the insinuations of Holker's question as to whether Whistler's art displayed eccentricities: "I should call it originality. What would you call eccentricity in a picture? [Laughter.]"

Moore's testimony, brief but glorious, was followed by the lesser artist William Gorham Wills's: briefer—and ridiculous. In answer to Parry's questions, Wills dutifully provided the expected praise. Whistler was a genius whose works showed "great consideration and knowledge," as well as a "native" sense of color. But under Holker's cross-examination his value as a witness evaporated. Wills had visited the 1877 Grosvenor exhibition, he recalled, and had seen the two blue and silver nocturnes there. But what of the nocturne that had hung right beside them, the painting at the heart of the case? "I have never seen the *Nocturne in Black and Gold* before," he confessed. And handing him the *Falling Rocket* to examine did not help: "it is too dark for me to see it now." After this, and Parry's perfunctory re-examination, William Gorham Wills was dismissed from the box and, surely, from the minds of everyone in the room. On that feeble note Parry rested for the plaintiff.

Holker immediately moved for a summary judgment and an immediate end to the trial, arguing that Serjeant Parry had done absolutely nothing to prove malice on Ruskin's part. Holker was right; though Parry had alluded in his opening to Ruskin's unfair and hurtful language, in his—and Petheram's—examination of witnesses both had been so set upon establishing Whistler's talents as an artist that both failed to pay much attention to Ruskin's deficiencies as a critic. But Holker obviously knew that unless Baron Huddleston suffered an appalling lapse in judgment his motion was doomed to fail. For in a libel trial, as Huddleston proceeded to point out, the burden to prove that a comment is a fair one, without malice, falls not upon the plaintiff, but upon the party that entered the plea of fair comment in the first place—the defendant. "Surely this is a question for the jury," Huddleston ruled. The trial continued.

Holker's motion might have failed, but it did serve a purpose: now he could blame Parry and absolve himself from extending the trial for another day. He had hoped, he told the jury, "to spare the court the examination of any witnesses on behalf of Mr. Ruskin, but the course which his learned friend had taken rendered that impossible." Now he would have to call his own witnesses to testify to the value—or lack of value—of Whistler's art. But before that, possibly taking note of Baron Huddleston's reminder that the defense had pleaded fair comment and not justification, Holker veered from his focus upon his Whistler's art to focus upon Ruskin's criticism. "The real question," he told the jury, undercutting the entire day's proceedings, "was not as to whether these pictures were pictures of great merit or of no merit, but whether Mr. Ruskin had criticized them fairly, honestly, and *bonâ fide*." Critics, he reminded the jury, provided an essential cultural service. "[I] should like to know what would become of literature, of poetry, of oratory, of politics, of painting, if critics—competent and able men—were to be extinguished? If there was to be nothing but praise there would be no incentive to excel." And of critics Ruskin, with his love and reverence for art, his forty years of study, his voluminous writing, his position as Slade Professor at Oxford, was one of the most competent and able of all. Holker then set out three principal standards to which Ruskin held all artists. They should be devoted to their profession—and possess "something more than a few flashes of genius." They should give the buyer work worth the money paid. And they should let no work capable of improvement out of their hands. By every one of those standards, was it any wonder that Ruskin gazed upon Whistler's works, and found them valueless? It was not only Ruskin's right but his duty to say so.

Having thus advanced the defense's stated plea of fair comment, Holker veered away from it—this time virtually for good—for the more entertaining if more challenging territory of justification: doing his best to prove that Ruskin was absolutely correct in his claim that Whistler was a terrible artist. "A picture to which a high price is demanded should show adequate labour and study, whereas Mr. Whistler painted a picture in a day, put it out to dry, and then said, 'Here is a beautiful work of art.'" He

dismissed Graham's Battersea Bridge Nocturne as a "meagre and worthless affair"—as much like "Mahomet's coffin or Jacob's ladder" as a bridge. Surely, he thought, the jury would agree: "the picture was a fantastical extravagance, and not worth 200 guineas."

Here Baron Huddleston stopped him. It was 4:00; the courtroom was "becoming a nocturne." He adjourned for the day.

———

At 10:30 A.M. the next morning, with the small courtroom again filled uncomfortably beyond capacity, Holker recommenced. Whistler had rejoined his solicitor and barristers; Arthur Severn had again taken his place as Ruskin's placeholder. Beside Severn sat junior counsel Charles Bowen, who to this point had not spoken a single word. Baron Huddleston had taken his place on the bench; sitting beside him—as she often was—was his wife, Lady Diana Huddleston—and next to her, the attorney general's wife. Returning to the gallery once more to see his nocturne manhandled and insulted was William Graham, again with his entire family. William Schwenck Gilbert, however, did not return to the court on this day. That was truly unfortunate, for Gilbert of all people would have found the conclusion of Holker's speech immensely amusing and surely inspirational, as Holker, taking to the subject with exceptional gusto and wit, broadened his target, ridiculing the sensitive vacuity of the Aesthetic movement in order to suggest the ridiculousness of its most conspicuous adherent. Holker, in other words, pioneered the same parodic terrain that Gilbert himself would so successfully traverse three years later with his and Arthur Sullivan's own comic opera take upon the Aesthetic movement: *Patience*.

Holker introduced the jury to the Aesthetic world by taking them on an extended mental voyage to the 1877 Grosvenor exhibition. After imaginatively feeding them at the gallery's restaurant "an artistic chop served in a plate of ancient pattern, and some claret in a Venetian glass," Holker led them upstairs to Whistler's works.

They would, of course, have some difficulty in getting near them, for there was an intense admiration of his pictures among the votaries of art who principally frequented the Grosvenor Gallery. They would find "nocturnes," "arrangements," and "symphonies" surrounded by groups of artistic ladies—beautiful ladies who endeavoured to disguise their attractions in medieval millinery, but did not succeed in consequence of sheer force of nature [laughter] and [I dare] say they would hear these ladies admiring these pictures and commenting upon them. For instance, a lady, gazing on the moonlight scene representing Battersea Bridge, would turn round and say to another "How beautiful: it is a nocturne. Do you know what a nocturne means?" "No: but it is an exquisite idea. How I should like to see Mr. Whistler, to see what it means." Well, [I do] not know, after having received the explanation which Mr. Whistler gave the Court yesterday, the young lady would be any the wiser. But it would be said, "How delightful it is that Mr. Whistler has discovered that there is such a sympathy between the two great arts, music and painting, for he has given us not only "nocturnes," but "symphonies," "arrangements," and "harmonies." Only fancy a moonlight in E minor, or a chiaroscuro in four flats [Laughter]. And the ladies would admire and adore, and after they had all poured out incense upon the alter of Mr. Whistler, other people would be able to get near the pictures.

These amusingly witless acolytes could make no sense of Whistler's art—because it made no sense. Of the Battersea Bridge nocturne, Holker joked, "they would ask, 'What is it? Is it a telescope or a fire escape? Or is it the great tubular bridge over the Menai Straits which has escaped and become Battersea Bridge? [Laughter.]" As for the *Falling Rocket*, "Mr. Whistler did not see things which other people saw; he heard artistic voices which others could not hear [laughter]; and a rocket coming down in sparks was not a rocket to him, but represented some fantastic and

mysterious forms which he depicted for the entrancement of the British public." Holker admitted Whistler capable of "exceedingly good things," but dismissed all of the Grosvenor works as "strange fantastic conceits, having some merit, but not worthy to be called works of art."

Aestheticism, then, and particularly Whistler's brand of it, was nothing more than a scam and an imposture upon the public—a "mania" that Ruskin rightly discouraged with the truth of his criticism. That naturally brought the attorney general to Ruskin's specific language in *Fors Clavigera*, which he now proceeded to deconstruct, offensive word by offensive word, demonstrating each one to be entirely truthful. Ruskin called Whistler a coxcomb? Holker:

> had looked the word up, and found that it came from the old idea of the licensed jester, who wore a cap with bells on his head with a cock's comb on it, who went about making jests for the amusement of his master and family. If that were the true definition, then Mr. Whistler should not complain because his pictures had afforded a most amusing jest. He did not know when so much amusement had been afforded to the British public as by Mr. Whistler's pictures.

Whistler approached wilful imposture? "If Mr. Whistler's reputation as an artist was to be founded upon these pictures, he was a pretender to the accomplishment of painting, which he did not possess, and was worthy of the name of coxcomb."

Holker completed what the *Pall Mall Gazette* called his "satirical and amusing" performance with a dire warning about the future of criticism, should the jury deliver a verdict against the defendant. "Mr. Ruskin would cease to write, but it would be an evil day for art in this country when Mr. Ruskin should be prevented from indulging in proper and liberal criticism, and when all criticism would be reduced to a dead level, and nothing was to be said of artists but what was couched in the language of fulsome admiration." Upon that culturally apocalyptic note, Holker was done. Ceding all further questioning and ceding the summation for

the defense to his junior, he left the Exchequer Chamber for another courtroom, and another case.

To Charles Bowen, then, fell responsibility for questioning every defense witness as well as closing the case for the defense. He called Edward Burne-Jones to the box.

For Burne-Jones, this was "Tuesday the Horrible-th." Gone was the self-righteous bellicosity of days before, replaced by a morbid awareness of his embarrassing position: he, the one who had most profited by Ruskin's criticism in *Fors*, had been called to vilify the one who had suffered from it the most. Though his disdain for Whistler as an artist had not abated in the least, he was now haunted by the feeling that attacking any one of his fellow artists amounted to betraying them all. He had done his best—"moved earth and hell"—to back out of testifying, but his loyalty to Ruskin and the pressure put upon him by Ruskin's lawyers had compelled him to appear. William Morris had "carried me metaphorically in his arms to the door of the court," where the "wigs and sterile faces" alarmed him. He trembled; his tongue clung to the roof of his dry mouth. He was mortified to see friends of his in the gallery*: he was sure they had come only to witness his humiliation. And in short, he was afraid. Now desperate to avoid speaking any evil of Whistler, he had begged Ruskin's lawyers to restrict their questioning to two subjects: Ruskin's reputation, and the benefits of free criticism. But Burne-Jones's own fiery comments attached to the defense brief proved impossible for Bowen to ignore. With his first question, Bowen took aim at what Burne-Jones had posited as Whistler's greatest flaw.

"In your opinion what part do finish and completeness bear to the merit of a painting?"

"I think complete finish ought to be the object of all artists," Burne-Jones replied.

Bowen asked him to assess, one by one, the three nocturnes still on display in the courtroom. All three, Burne-Jones maintained, showed a deplorable lack of finish. For the first two, however—Mrs. Leyland's *Battersea Reach* and Mr. Graham's *Battersea Bridge*—Burne-Jones felt

* Including his good friend Helen Graham, William Graham's daughter.

compelled to balance censure with praise.[*] The first he thought "masterly in some respects, especially in color," although lack of form and finish rendered it only a sketch. Of Graham's nocturne, the color was even better, while in its lack of form it was even more bewildering: Burne-Jones was sure that Whistler himself never thought of it as finished. Both works he admitted to be art, if not very good art. For the *Falling Rocket*, however, he could not manage to muster the slightest compliment.

> "I don't think it has the merit of the other two at all."
>
> "Is it in your opinion a finished work of art?"
>
> "It would be impossible for me to say so. I have never seen any picture of night which has been successful; and this is the only one of the thousand failures which artists have made in their efforts at painting night."
>
> "Is that picture, in your judgment, worth 200 guineas?"
>
> "No; I cannot say it is, seeing how much careful work men do for so much less."

The time had come, Bowen decided, to shame Whistler by juxtaposing his ambiguous nocturnes with the finished work of a master. He moved to admit the supposed Titian, *Portrait of the Doge, Andrea Gritti*. Serjeant Parry objected: Whistler had never claimed to be Titian's equal and a comparison between them was unfair. Huddleston agreed with him, thinking the comparison "going a little too far," and cautioning Bowen that he would first have to establish the painting's authenticity. Bowen was confident he could do that, but Huddleston was not so sure, and citing the dubious (but for spectators highly amusing) case of an "undoubted" Titian rubbed down to reveal a full-length portrait of George III. Parry reiterated his objection—and then, surprisingly, decided not to press it. The *Gritti* was brought forward, and Burne-Jones declared his unstinting admiration: "I believe it is a real Titian. It shows finish. It is a very

[*] "I said harmful things of him which I believed, and qualified it with all the praise I could think of," Burne-Jones wrote later that day to Joan Severn.

perfect sample of the highest finish of ancient art. The flesh is perfect, the modelling of the face is round and good. That is an arrangement in flesh and blood." From that aesthetic zenith, Whistler's work represented a distinct devolution, and a dangerous one for modern art in general: "Mr. Whistler gave great promise at first, but I do not think he has followed it. . . . The danger is this, that if unfinished pictures become common we shall arrive at a stage of mere manufacture, and the art of the country will be degraded."

In cross-examination Parry quizzed Burne-Jones about the price of the supposed Titian ("a mere accident of the sale room," Burne-Jones told him), elicited from him a fuller praise for Whistler's sense of color and atmosphere, and finally challenged him with a question that touched for once not upon the merit of Whistler's art but upon the fairness of Ruskin's criticism: "You would not call a man a wilful imposter for exhibiting these pictures?" Burne-Jones, having admitted to Whistler's artistry, could hardly agree with Ruskin here. But Bowen immediately objected to the question, and before Huddleston could rule, Parry inexplicably withdrew it—and was done. Burne-Jones left the witness box still trembling, now tormented by the thought that he had failed his master utterly. "They wouldn't ask me the questions I wanted them to ask," he wrote Ruskin soon afterward. "They would not ask me about you and what you'd done as I wanted—and I don't know *what* I said and their counsel turned all I said so that I didn't know it again & I never spoke out louder than one does to a friend in my life, and I dare say I was most unwise—and I was very nervous and it all felt dreadful. . . ."

William Powell Frith, succeeding Burne-Jones, might have been equally reluctant to testify against a brother artist, but he was not at all troubled by any compulsion to sweeten his censure with compliments.[*]

"You have seen the pictures of Mr. Whistler which were presented yesterday?"

[*] Burne-Jones—who had remained after his testimony to watch the trial—admitted to a friend that Frith had come nearer to the truth about Whistler than he had. (E. Burne-Jones, *Burne-Jones Talking*, 70n)

"Yes."

"What is your opinion as to the merits of those pictures; are they works of art?"

"I should say not."

"Take the *Nocturne in Black and Gold* representing the fireworks at Cremorne; is that a serious work of art?"

"Not to me."

"Take the two others."

"There is a beautiful tone of colour in the picture of *Old Battersea Bridge* but the colour does not represent any more than you could get from a bit of wall paper or silk. I should say exactly the same in regard to the other picture. I have heard it described as a good representation of moonlight; but it does not convey that impression to me."

Parry in cross-examination, fishing for any hint of Frith's approval of Whistler's art, asked him whether he admitted Whistler's "unrivalled" power in creating atmosphere. He did not.

James Anderson Rose in his brief had advised Parry to discredit Frith's testimony with a full-bore attack upon Frith's immorality, both in his art, filled with the "commonplace of vulgarity and crime" and in his personal life. "He seduced his own ward in his own house where lived his own wife and his own numerous family," Rose had written, adding that now Frith divided his time between *two* numerous families. Parry, realizing that Frith's moral failings had nothing to do with his aesthetic judgment of Whistler, refused to bring any of this up. Instead, he questioned him about J. W. M. Turner's later art, generally considered his least finished and least representational, and once criticized much as Ruskin had criticized Whistler's art, clearly hoping to have Frith acknowledge its quality. Frith, however, refused to take the bait.

"We know that Turner is an idol of Mr. Ruskin?"

"I think he should be an idol of all painters."

"Have you seen Turner's picture of the *Snowstorm?*"

"Yes."

"Are you aware that it has been described by a critic as a mass of soapsuds and whitewash?"

"I am not."

"Would you call it a mass of soapsuds and whitewash?"

"I think it very likely I should. [Laughter] When I say Turner should be the idol of everybody I refer to his earlier works, and not to his later ones, which are as insane as the people who admire them. [Renewed laughter]"

Frith's testimony petered out as he and Baron Huddleston—Frith's very good friend, by the way—shared memories of droll dismissals of Turner's later work. "Lobster salad," remembered Huddleston. "Salad and mustard," remembered Frith. "Without the lobster," joked Serjeant Parry.

Frith stepped away. Tom Taylor replaced him and quickly demonstrated that the defense, like the plaintiff, had saved its least important and least effective witness for last. In response to Bowen's questions about the *Falling Rocket*, Taylor simply pulled out and read his *Times* review from four years before, in which he had claimed that the *Falling Rocket* and works like it "only come one step nearer pictures than delicately graduated tints on a wall paper would do." As for Whistler's portraits at the Grosvenor, Taylor could only repeat his witticism from the *Times* of over a year before about "materialized spirits and figures in a London fog." Parry in his cross-examination got Taylor to admit to Whistler's high artistic merit; Bowen in his re-examination simply had Taylor repeat his opinion that the nocturnes were little more than wallpaper. So much for England's second-most renowned art critic.

—⁂—

Attorney general Holker had a way with juries, but his junior did not. Charles Bowen, as a former pupil of his put it, "was rarely very successful with juries,

on account of the great difficulty he felt in letting his mind run on the same line with theirs, or in understanding the views and mode of reasoning of an ordinary juryman." Holker, then, would have been the natural choice to sum up the case for the defense. But since Holker had bowed out of *Whistler v. Ruskin*, the task fell to Bowen. And Bowen faltered. For two days, the defense had focused squarely upon Whistler and his deficiencies as an artist. Holker, with pointed questioning, with ridicule, with the intentionally shambolic display of Whistler's nocturnes, had done his best to steer the jury to the belief that Ruskin was absolutely right, fully justified in dismissing Whistler as a bad artist. Bowen had largely played along. But now, instead of summarizing and bolstering that defense, Bowen essentially abandoned it.

The true issue of the case, Bowen told the jury, had little to do with whether Whistler's paintings were good or bad, and not whether the *Falling Rocket* was worth 200 guineas or not—little to do, that is, with most of the substance of two days' testimony. In adopting that focus, Bowen now admitted, "both sides had wandered from the field." Now, he wandered back. Of Holker's work of the past two days he had nothing to say. His own questioning of witnesses he now reframed not as an attempt to substantiate the truth of Ruskin's comments, but as a sidelong attempt to suggest the fairness of his opinion, by showing that other artists had their own fair opinions—opinions that bore similarities to Ruskin's. After that, finally, belatedly, he turned to the defense of fair comment and the specifics of Ruskin's criticism. The line between fair and unfair criticism, he told the jury, "was clear and sharp":

> The critic must not descend into a man's private life, he must not rake up dirt to cast at his name. He must not, if he criticized a man's public performance, indulge in personal malice; but, beyond that, whether the matter be literature, art, or politics, the critic was not bound to speak with bated breath. He might say what he liked and what he chose, provided he did so honestly, without travelling out of the subject-matter before him.

Ruskin had done exactly that, Bowen maintained. There was no evidence in this case—"not a scintilla"—that Ruskin had written with any malignant motive. There was no evidence that Ruskin knew Whistler personally or that he did anything besides perform his duty to the public and to the art he loved. He concluded with a paean to the importance of free criticism, and a plea to the jury with their verdict to do nothing to fetter it and thereby do irreparable harm to the future of art.

Bowen was right: Whistler's lawyers had done next to nothing to prove that Ruskin's criticism had been driven by malice toward Whistler. But missing from his summation was any mention of the fact that he and Holker had themselves largely failed to prove that Ruskin's criticism had *not* been driven by malice toward Whistler—had failed, that is, to prove Ruskin's criticism fair comment. And their failure was by far the greater of the two. For as Baron Huddleston had made clear the evening before, the burden of proof in this matter lay not with the plaintiff but with the defense. Bowen, of course, had every reason not to call attention to this fact. Serjeant Parry, in his summation, would not be as reticent.

Parry began his summation by playing to his own strengths, launching into a passionate appeal for his client. Assuming outrage, he laid into attorney general Holker, who had "given an additional sting" to Ruskin's original libel with "exaggerated" and "out of place" remarks about Whistler's works, and with his disgraceful attack upon Aesthetic womanhood: "When the honorable and learned gentleman sneered at a group of young ladies admiring Mr. Whistler's paintings he must have forgotten that there were women's names in art which were entitled to the greatest consideration and respect." He then turned upon Ruskin, portraying his attack upon Whistler in starkly melodramatic terms, with Ruskin as the heartless monster—and Whistler as the abject victim. Ruskin was corrupted by his own power. "Sitting on the throne of art—great as a writer, but not as a man—Mr. Ruskin cared not whether his decree injuriously affected others or not." He had brought his formidable influence to bear to "crush and ruin" Whistler—"a comparatively struggling man." Ruskin's

language toward Whistler was obviously malicious: there was little if any difference between the accusation of "approaching imposture" and the stigmatizing one of actual imposture. The term "Cockney" as applied ·to Whistler, was not only illogical, it was grossly insulting, meaning "something dirty and disagreeable." Whistler was hardly Ruskin's only victim; Parry pointed out Ruskin's attacks upon several others within the offending issue of *Fors*.

That the court responded with laughter to this passionate diatribe against Ruskin suggests that Parry did not have quite the effect upon the jury that he wished. Undeterred, he concluded with an image of Whistler as Victorian hero—"conscientious, hard-working, and industrious,"[*] and one last plea to the jury to save Whistler from Ruskin's villainy: "Was he to be expelled from the realm of art by the man who sits there as a despot? I hope the jury will say by its verdict that Mr. Ruskin has no right to drive Mr. Whistler out by defamatory and libelous accusations."

Parry's characterization of Whistler, of course, bore little resemblance to the confident, spirited, and utterly unbowed man that the jury and the court had seen in the witness box the day before. The reporter for *The Spectator* could not have been the only one to find Parry's emotional appeal faintly ridiculous: "Mr. Serjeant Parry put the case for Mr. Whistler in the tone and way which he employs with so much success in behalf of a starving widow and five young children, made orphans by a wealthy railway company; but that, we may take it, did not convey precisely his client's view of the matter. Mr. Whistler is not to be knocked over by a few hard words, and it is much less likely that he came to Westminster Hall to obtain a salve for his wounded feelings, than to get some sort of judicial recognition of the value of his 'nocturnes' and 'symphonies.'" But amid this thicket of overblown indignation Parry did manage to draw attention to the weakness of the defense's case. The defense, he pointed out, had not once questioned any of their witnesses about the specifics of Ruskin's libel. (He might have

[*] Burne-Jones remembered Parry's words here as "humble, industrious and gifted"—and was dumbfounded that anybody could seriously apply any one of them to Whistler. (Ruskin, *Brantwood Diary*, 424–25.)

added that the one time that *he* had tried to do this, Bowen had objected
to the question.) If the witnesses *had* been asked, Parry was sure, "they
would have expressed their decided disapproval." And given that all three
of them had acknowledged Whistler as an artist, however flawed, at least
one of Ruskin's claims had been discredited: "after the evidence of
Mr. Burne-Jones, Mr. Frith, and Mr. Tom Taylor, the jury could not say
that they thought Mr. Whistler an impostor."

<center>———</center>

Baron Huddleston, instructing the jury after a midday recess, seemed to live
up to his reputation as a strong judge, pushing the twelve toward a verdict.
"No one would entertain a doubt that those words amounted to a libel,"
he bluntly informed them of Ruskin's remarks. He had, in other words,
examined Ruskin's comments and determined that any reasonable person
would conclude that they held Whistler up to contempt and ridicule. Since
Ruskin's words were libelous on their face, Huddleston explained, the law
presumed them to be malicious. But Ruskin in his defense had pleaded that
they were fair comment, and now it was for the jury to determine whether
Ruskin's defense had met its burden and had proven Ruskin's words to be
fair. And for the rest of his instructions, Huddleston refrained completely
from pushing any opinion of his own upon that matter. Instead, for the
better part of an hour, he expounded upon the relevant principles of law
upon which the jury should base their decision.

It was of the "last importance," Huddleston told them, that the critic have
"wide margin" to express honestly formed judgments, and therefore "there
was no reason why he should not use ridicule as a weapon." He explained at
some length that by law the critic's privilege extended to the actual works
criticized and to the qualities of the artist revealed in the work. But there
that privilege ended: "reflections of a personal character were, however, a
different thing and any attack upon character, unconnected with author-
ship, ought to be punished." He briefly and impartially reviewed witness
testimony in the case. He read from *Fors Clavigera* Ruskin's attack upon

Whistler—and upon others. He did his best with Johnson's *Dictionary* to make sense of Ruskin's use of the terms "cockney" and "coxcomb," but only managed to render them more confusing than ever. He dismissed the defense's introduction of the supposed Titian as entirely unfair: "nobody ever had equaled, and probably never would equal, Titian."

And after each point, Huddleston reiterated to the jury the single question it must answer: "whether Mr. Ruskin's criticism of Mr. Whistler's pictures is fair and *bonâ fide*." Or: "*honest* and *bonâ fide*." Or: "*fair, honest, and bonâ fide*." Fair, honest, *bonâ fide*: Huddleston employed these three terms variously, interchangeably and—apparently—synonymously. Not once did he define any term or attempt to explain the difference between them. As defining terms they sometimes operated as a set or as pairs, repetition apparently providing emphasis, or they operated individually and self-sufficiently, as when Huddleston told them, "Mr. Ruskin undoubtedly called a spade a spade, and, indeed, called it something stronger; and the question was whether he expressed honest convictions . . . if he honestly believed what he wrote [I] would be very much inclined to give full license to it." Honesty alone, then, indicated fair comment.

Having hammered its duty into the heads of the jury, Huddleston turned to the one other question they might need to answer: the question of damages. Whistler might have put own price upon the damage done him by Ruskin's words, but in the end, if the jury rendered a verdict for Whistler, it was they who would decide the amount. Now Huddleston revealed that this gave them real power—a power of incredible nuance in expressing their own opinions about the plaintiff, the defendant—the case itself. They could assess damages in any one of three ways. If they thought the insult offered in the libel was of a "gross character," they could award substantial damages. If they thought, rather, that "the case was one which ought never to have been brought into court," they could award "contemptuous damages to the extent of a farthing, or something of that sort." Finally, they could take the middle ground and award a more moderate sum, indicating "that the defendant had gone beyond the strict letter of the law." Huddleston, in laying out their options, cannot be accused of pushing the jury to any specific decision

on the question of damages. But he certainly must have sent their twelve minds racing with possibilities as, with a final iteration of their duty to decide whether Ruskin's criticism was "honest, fair, and *bonâ fide*," he sent the jury to be locked into another room to deliberate.

They were out for over an hour.

Exactly what they spoke about can never be known in full, but from the clues they offered and from the results of their deliberation, one thing is clear: unlike the lawyers in this case, they did not wander from the field. All the witnesses' carping about Whistler's lack of finish and sniping about the worth of the *Falling Rocket*, or Holker's imaginary tour of the Grosvenor Gallery, or Parry's melodramatic reframing of the case, had little if any bearing upon their verdict. This might have been the matter of the trial, but Ruskin's plea was fair comment and not justification, Huddleston's instructions had focused upon fair comment, not justification, and they too concentrated less upon the merits of Whistler's art and much more upon whether Ruskin's words were fair. Or honest. Or *bonâ fide*. They deliberated until they reached an impasse, one that they could not overcome without clarification from Baron Huddleston. They sent him a message saying so; he sent one back asking them to put their questions to him in writing.

Within minutes he was handed their second message, read it, and announced to the still-crowded courtroom: "The jury had agreed that the defendant spoke his honest opinion." With that, many in the courtroom—Whistler's solicitor Rose among them—were certain Ruskin had won. Hadn't Huddleston repeatedly stated that honest opinion was fair comment? But Huddleston continued, with a pronouncement entirely at odds with his own instructions: ". . . but that was not enough. It must be fair and *bonâ fide* criticism."

He ordered the jury back into the courtroom, told them that their verdict did not go far enough, and repeated his mantra, only this time with the omission of *honest*: "the question for them was whether the criticism was fair and *bonâ fide*."

The jury was, not surprisingly, flummoxed by this sudden distinction without an explanation. They huddled, whispered, and then revealed more

specifically their grounds for disagreement: they could not decide, the foreman told Huddleston, whether the word "imposture" referred to the artist—or to the man. Huddleston's own instructions had thrown them into a quandary, for he had made clear to them that a personal attack upon a man by a critic—an attack unconnected with the work criticized—was malicious and not fair comment. But he had also stated that honest opinion *was* fair comment.

This was a quandary that Huddleston might have resolved in seconds by clarifying—or, rather, amending—his instructions, now making clear that a personal attack by a critic, unconnected with the work criticized, was *always* unfair, whether that attack was honest opinion or not. But Huddleston either could not explain or refused to, and could only repeat—and repeat again—his mantra: "look at the words and say whether they came within the meaning of the term fair and *bonâ fide* criticism. It was for the defendant to show that the criticism was fair and *bonâ fide*."

One juror angled for more than this: "The way the case is put by some jurors is that . . ." and Huddleston cut him off, protesting "I am afraid I must not be admitted to your secrets." Another took a different tack, asking, hypothetically, "if there was no reflection upon the man and the words applied simply to his works, they would come within *bonâ fide* criticism." Huddleston agreed that this would be so. But that offered no solution to their quandary, in which some jurors considered that Ruskin *was* reflecting upon Whistler and that his words did *not* apply to Whistler's works. And so, more perplexed than ever, the jury returned to its deliberations.

They were not gone long. In short order they came to one of two conclusions. Possibly, they decided that Ruskin had attacked Whistler personally and with no connection to his art, that this outweighed what they agreed had been his honest opinion, and therefore that Ruskin was guilty of libel. Equally possibly, they quickly realized that they were confronted with a Gordian knot they could not untangle, and decided to cut through it with a compromise verdict that dealt out censure and reward to both sides in nearly equal measure. In either case, they were almost certainly unanimous in their annoyance that they had had to deal with this question, these legal

absurdities, this ridiculous case in the first place. The law offered them a way to express exactly that. They returned to the courtroom.

Verdict for Whistler.

Damages: one farthing.

Before Whistler could make any sense whatsoever of his quarter-penny award, Ruskin's counsel Charles Bowen leapt up to move that his client Ruskin not be held liable for the costs of the trial. By awarding contemptuous damages, the jury had made clear that Whistler should never have brought the suit. More than this, he pointed out, they had made clear (with their message to the judge if not with their verdict) that Ruskin's criticism was honest. Whistler's counsel Petheram leapt up to disagree. Whistler had won, and the law should follow its usual course: Ruskin should pay costs.

Huddleston agreed with Bowen and followed the lead of the jury: judgment for Whistler. Without costs: that is, with each side saddled with its own costs.

At that moment, legally victorious but facing inevitable financial ruin, James Whistler stood baffled, according to George Washburn Smalley, his American friend reporting the case for *New York Tribune*. Then his face began to clear. "That's a verdict for me, is it not?" he asked his crestfallen senior counsel.

"Yes, nominally," Serjeant Parry answered.

Whistler quickly understood what the verdict meant to him—or, rather, what it *should* mean to him. "Well, I suppose a verdict is a verdict," he said to Parry. He then called out to Smalley: "It's a great triumph!"

And then, significantly, he added: "*tell everybody it's a great triumph.*"

CHAPTER 7

THE SHOW

aving seen *Doge Andrea Gritti* safely returned from Westminster to Herne Hill, Walter Severn rushed from London's fogs to Coniston's snows in order to bring Ruskin news of the trial. In his memoir of Ruskin he suggests that he hoped to minimize Ruskin's loss by emphasizing the trial's comic aspects. There was the elderly gentleman who was cracked in the head by one of Whistler's nocturnes as it was passed around the courtroom, and the juror mistaking the *Andrea Gritti* for a Whistler and exclaiming "Oh, horrid thing! I entirely agree with Ruskin." There was the attorney general, in Severn's mind a fish out of water and "the furthest remove from anything 'Ruskinian' or 'Whistlerian.'" And there was Severn's own hapless performance as Ruskin's substitute.

Edward Burne-Jones, writing to Brantwood at around the same time, adopted a similar strategy. He recounted Serjeant Parry's ludicrous characterization of Whistler ("yes—he said *humble* & he said *industrious*"), as well as his own conflicted testimony about Whistler's work: "my oldie [Ruskin] will laugh when he sees me discourse on atmosphere and praise Whistler for it." He enclosed in the letter a quarter-part of

a halfpenny stamp—that is, half-a-farthing's worth—to compensate for any damage he might have done to Ruskin's cause. He speculated that his own conflict with Whistler would now have to play itself out with a duel on a Calais beach, in which Ruskin would act as second, and pots of paints be their weapons: "I select Prussian Blue as the most effective weapon I know."

But Ruskin was in no mood for laughing. He might himself have just hours before declared the trial comic, but the verdict changed everything. He had lost: his words had been judged a libel, and the state had penalized him for publishing them. That the penalty was a contemptable farthing, and that the contempt had been largely directed toward Whistler and not toward him meant nothing to someone with Ruskin's morally absolute view of the world. The guilty verdict was to him a crushing rebuke, a challenge to his integrity and authority, a crippling blow to his hard-won reputation as sage and prophet. His right to speak freely to his public had been denied.

His initial response was to seclude himself even more fully from his public: he would resign his Slade Professorship. The next day he wrote not one but two letters to that effect to Dean Liddell at Oxford. "The result of the Whistler trial leaves me no further option," he asserted in the first; "I cannot hold a Chair from which I have no power of expressing judgment without being taxed for it by British Law." In the second he made plain his bitter disappointment both with the verdict and with the ignorance of his public:

> It is much better that the resignation of the office should be distinctly referred to its real cause, which is virtually represented by this Whistler trial. It is not owing to ill-health that I resign, but because the Professorship is a farce if it has no right to condemn as well as to praise. It has long been my feeling that nobody really cared for anything that I *knew*; but only for more or less lively talk from me—or else drawing master's work—and neither of these were my proper business.

His disgust was real. But his insistence that the trial alone had forced this decision was disingenuous. Actually, he had been contemplating resigning for months because of poor health, and just a week before the trial he had written Liddell, "I can't be Professor any more." Certainly, however, disappointment about the trial added urgency to his resolve, and, more than that, allowed him to present it to the world as a matter of high principle.

Still, he knew that total withdrawal from public life was impossible. The trial was certainly a loss to him, but not, he hoped, a permanent one. While he still had his life and his sanity, study, writing, and teaching were as breathing to him. *Whistler v. Ruskin* had given him a nasty shock. But it was not the end. On the very same day he wrote his two letters of resignation, he wrote one more letter to his publisher George Allen, teeming with plans to republish *The Stones of Venice* and to produce new works: "I will knock off the fourth *Fésole*"; "I am at work just now on the long promised *Prosody*"; "The 5th and 6th *Proserps* [that is, *Proserpina*] will be very interesting." He would devote himself, in other words, to writing upon drawing, versification, and botany: a varied agenda, but a carefully limited one: there would be no writing upon political economy, no more *Fors Clavigera*, and certainly no criticism of contemporary art. "Though I think I can draw and write nearly as well as ever on subjects that do not excite me," he admitted to a friend soon afterward, "I fear I am past all emotional and historical work." Still, he had not given up the hope—the *expectation*—of returning to all of that work and of triumphing through it. He had no thoughts of appealing the verdict; getting back at Whistler meant nothing to him; getting back his public meant everything. "Comic enough, the whole trial, the public may think" he vowed to Allen, "but I'll make them remember it, or my name's not mine."

Ruskin's most pressing problem in the wake of the verdict was paying the costs of the trial, which amounted to roughly £400. Coming up with that amount would not be nearly as difficult for Ruskin as it would be for Whistler. Although Ruskin had largely frittered away his

inheritance upon dubious projects and sometimes-questionable charity,[*] he had made up for it by taking full control of the publication of his many works. In that way, he had guaranteed himself sizeable annual income, which Dante Gabriel Rossetti around this time estimated at £800. Ruskin certainly could pay his own costs. But he quickly learned that he would not have to.

"I suppose you know that people aren't going to let you have one penny to pay over this business," Burne-Jones wrote to him after the trial; he and William Morris had determined to cover them. But another champion acted first. Beginning that Friday, advertisements appeared in several metropolitan newspapers:

> Mr. Ruskin's Costs.—A considerable opinion prevailing that a lifelong, honest endeavour on the part of Mr. Ruskin to fur-ther the cause of art should not be crowned by his being cast in costs to the amount of several hundreds of pounds, the Fine Art Society have agreed to set on foot a Subscription to defray his expenses arising out of the late action. Any one wishing to co-operate will oblige by communicating with the Society, 148, New Bond-street, London.

Marcus Huish, the Society's director, who had months before orches-trated the magnificent gift to Ruskin of Turner's *Splügen*, now became Ruskin's benefactor for a second time. Within two weeks, with Burne-Jones heading the list, donations reached £150. Five months later, Huish sent Ruskin news that 118 contributors had paid his costs in full. Ruskin's response was not generous. Indeed, for seven years Ruskin did not respond at all, and when he did, his thanks were highly qualified: "I am grateful to them, but would very willingly have . . . paid my own law costs, if only

* "I heard the other day that Ruskin has only £9000 left & lives on his capital, out of which he pays 2000 a year to helpless incapables whom he has on his back, having never all his life aided any man who was worth his salt but idiots only," wrote a distinctly uncharitable Dante Gabriel Rossetti in July 1879. (D. Rossetti and Morris, 103–4)

they would have helped me in the great public work which I have given certainly the most intense labour of my life to promote." The financial burden of the trial: that, others could handle. The moral burden: that was his alone to bear.

Two decades after *Whistler v. Ruskin*, James Whistler found himself in Paris, crossing the Seine in a cab with the American sculptor Augustus Saint-Gaudens. "Well, Saint-Gaudens," Whistler asked him, "how are you, how are you?"

"Cocky," Saint-Gaudens told him, flush with confidence about a work he had just submitted for exhibition.

"That's the way to feel!" Whistler cried; "that's the way!" Gripping and energetically shaking Saint-Gauden's thigh, he added, "If you feel otherwise, never admit it. Never admit it!"

Whistler revealed much about himself at that moment. Projecting outwardly an unshakeable belief in himself and his art in spite of all inner doubts or private difficulties: this was the essence of Whistler's relationship with the wider world, and the practice of his entire adult life. That attitude had prompted him to sue Ruskin in the first place; it inspired his command performance in the witness box. And it compelled him, in the days after the trial, to represent the verdict as an absolute triumph of himself and his art. As he wrote to James Rose, "Nothing could have been finer—Morally, and in the judgment of the world—all the world with whom high tone has weight—it is a complete victory." He would never admit otherwise. The farthing winnings he took from Ruskin and attached to a watch chain, one quite possibly unattached to a watch, for Whistler had little use for one of *those*. For years afterward he flaunted the farthing as ocular proof of his triumph. In 1890 the American poet Harriet Monroe witnessed the "historic farthing" at a party in Whistler's studio, where he revealed it at the climax of a gleeful reenactment of *Whistler v. Ruskin*, complete with his crowd-pleasing impression of a stuttering and confused Burne-Jones.

The world, however, could not interpret the verdict as Whistler did. While Whistler gamely announced to Rose that he had returned home from the trial "to find my table strewn with letters of congratulation and sympathy," the sympathy was real. But the congratulations existed largely in his imagination. Algernon Graves, son of the print seller who at that time held the *Mother*, declared himself "very grieved at the very insignificant sum awarded," though he did allow that the verdict "saves your name." Elisabeth Lewis, wife of the famous solicitor, told him "we are annoyed at the result of your action. Your case would abundantly prove, if proof were warranted, that there are really no limits to the ignorance & folly of a British Jury." George Washburn Smalley agreed: "what can you expect when a lot of cheesemongers & pastry cooks are allowed to sit in judgment on works of rare & delicate art?" Others offered compensation for Whistler's loss: Joseph Comyns Carr proposed to contribute his "mite" to cover costs, and painter and collector John Postle Heseltine sent him a check for twenty-five guineas "as a mark of sympathy with you and as a protest against what seems to me an illogical verdict." (It was a gesture not completely disinterested: Heseltine expected Whistler to send him an etching or two in return.)

The newspapers and journals, on the other hand, offered neither sympathy nor congratulation to Whistler. Only the *British Architect* accorded him anything close to a win, emphasizing the complete collapse of Ruskin's defense. But that commentator was almost certainly Whistler's good friend and artistic collaborator Edward Godwin. Even Godwin could see no triumph in the derisory damages, dismissing them as "wholly incomprehensible if it had not come from a British jury." As for other commentators, several saw Whistler the clear loser and Ruskin the victor, despite the verdict. The writer for the *Art Journal*, for example, saw in the farthing damages a symbolic victory for the critic's freedom to criticize: "if [Whistler] had obtained the damages he asked for, or forty shillings of them, the business (so to speak) of an Art critic would have been at an end; we could have written nothing in condemnation without perpetual dread of consequences."

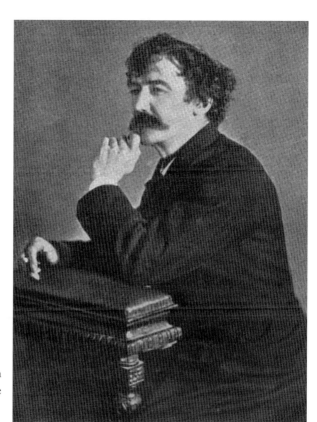

James Whistler, right, and John Ruskin, below, at around the time of *Whistler v. Ruskin*.

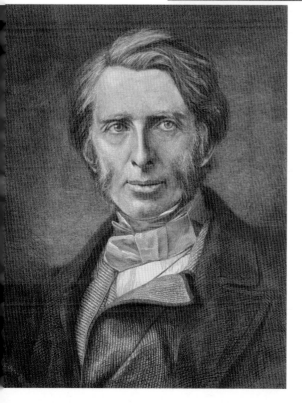

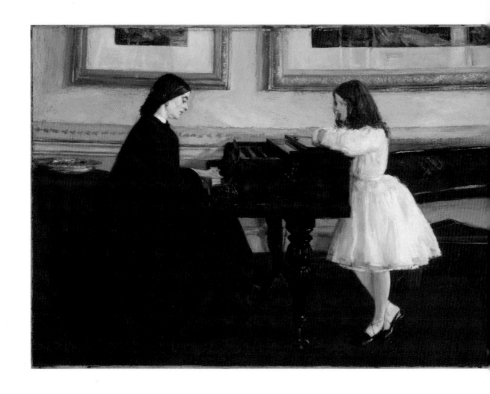

ABOVE: *At the Piano* (1859). The masterwork of Whistler's early years, its careful arrangement of forms and its color harmonies anticipated much of what was to come. BELOW: *Wapping* (1860–64), Whistler's early depiction of the Thames and of his mistress, Jo Hiffernan.

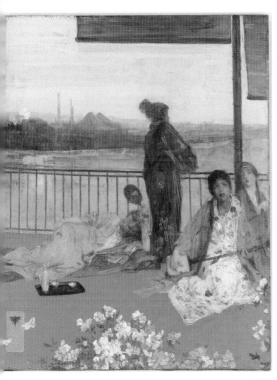

LEFT: *Variations in Flesh Colour and Green: The Balcony* (finished 1870). Its evocative background offers a hint to Whistler's artistic future. BELOW: *Symphony in White, No. 1: The White Girl* (1862). This portrait of Jo became the talk of the 1863 Paris *Salon des Refusés*.

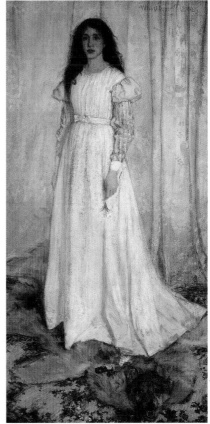

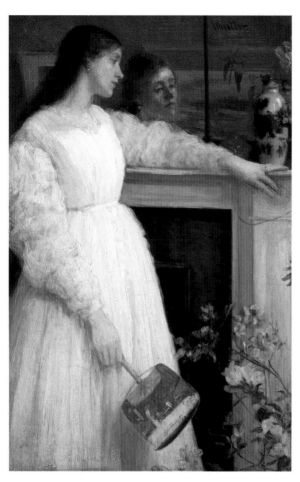

LEFT: *Symphony in White, No. 2: The Little White Girl* (1862). The portrait of Jo inspired Algernon Charles Swinburne to write his poem "Before the Mirror." BELOW: Albert Moore, *The Marble Seat* (c. 1865). Whistler was mesmerized by this painting at the 1865 Royal Academy Exhibition and was compelled to study and emulate Moore's methods—for a time.

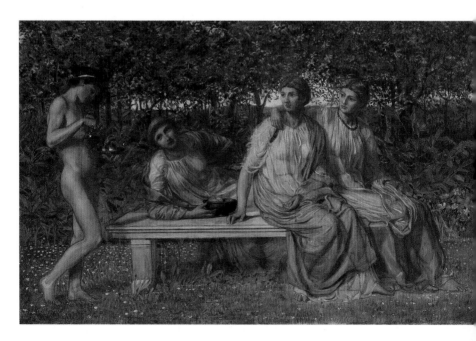

ABOVE: Study for *The White Symphony: Three Girls* (c. 1868). Whistler agonized over this project for years—and never completed it. BELOW: *Arrangement in Grey and Black: Portrait of the Painter's Mother* (1871): the miraculous product of Whistler's restored confidence in his art.

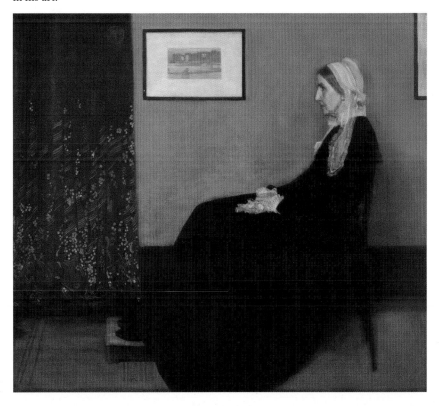

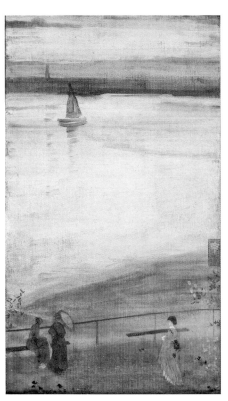

Variations in Violet, left, and *Green Blue and Silve[r:*
Chelsea, below, were painted on the same night [i]n
the summer of 1871. The first is a prelude to t[h]e
second, Whistler's first London nocturne.

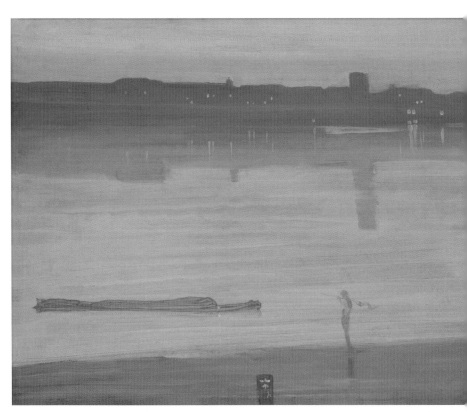

ABOVE: J. M. W. Turner, *Juliet and her Nurse* (1836). When the critic John Eagles savaged this and two other paintings in *Blackwood's Magazine*, seventeen-year-old John Ruskin wrote an impassioned reply that, on the advice of Turner himself, he did not publish. BELOW: *Snow Storm—Steam-Boat off a Harbour's Mouth* (exhibited 1842). When Turner exhibited this and four more paintings at the 1842 Royal Academy Exhibition, critics responded with incomprehension and ridicule. Ruskin resolved again to defend him, publicly, this time, with what became his monumental *Modern Painters*.

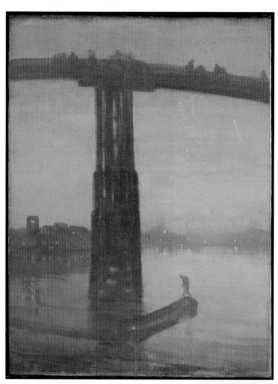

LEFT: *Nocturne in Blue and Silver: Old Battersea Bridge,* later titled *Nocturne in Blue and Gold: Old Battersea Bridge* (1872/3?) Whistler's synthesis of explorations of the Thames with Japanese Ukiyo-e prints such as the one below. BELOW: Hiroshige, *Bamboo Yards, Kyōbashi Bridge* (1857).

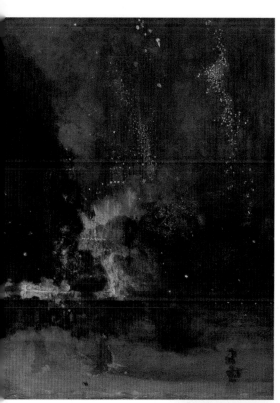

Nocturne in Black and Gold: The Falling Rocket (1875): Whistler's journey to the verge of abstraction.

The Palladian entrance to the Grosvenor Gallery at the time of its May 1877 opening.

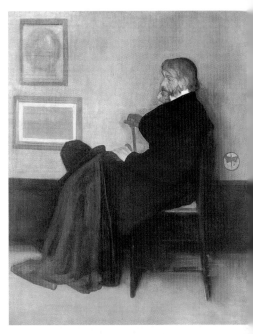

In addition to his *Nocturne in Black and Gold: The Falling Rocket* and his *Nocturne in Blue and Silver (Old Battersea Bridge)*, Whistler had six paintings on display at the 1877 Grosvenor Exhibition, five of which can be identified. *Arrangement in Grey and Black, No. 2,* top, his portrait of Thomas Carlyle. *Arrangement in Black, No. 3,* bottom left, a portrait of the actor Henry Irving, and *Arrangement in Brown,* bottom right, one of his mistress Maud Franklin. Facing page, TOP: another *Nocturne in Blue and Silver.* BOTTOM: *Nocturne in Blue and Gold.*

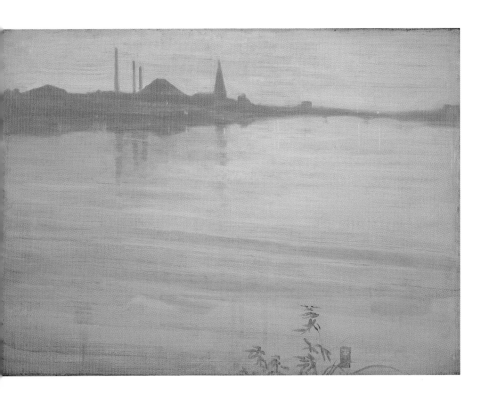

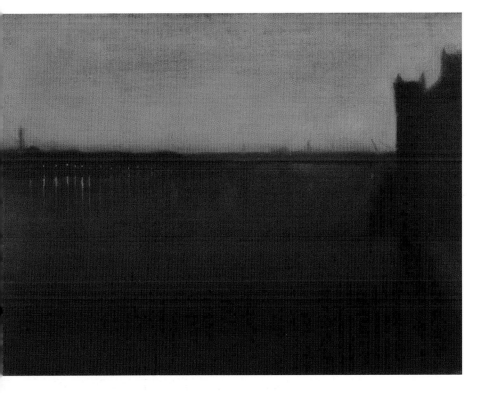

ABOVE: *Portrait of the Doge, Andrea Gritti* (probably 1523–31), supposedly by Titian but actually by Vincenzo Cartena, and in 1878 owned by John Ruskin. This painting was introduced in *Whistler v. Ruskin* to suggest by comparison the complete lack of finish in James Whistler's paintings. BELOW: *Punch* magazine's verdict on *Whistler v. Ruskin*: as a draw—or, rather, as a loss for both sides.

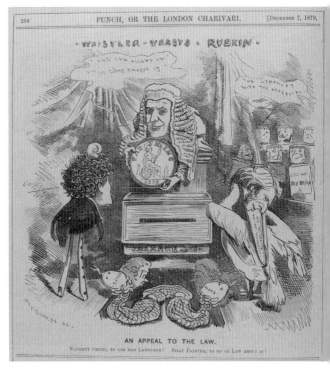

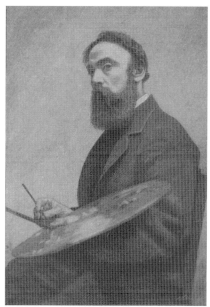

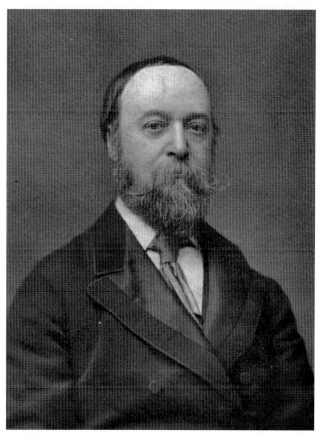

The witnesses for the plaintiff (besides Whistler himself) in *Whistler v. Ruskin*. From top: William Michael Rossetti, Albert Moore, William Gorman Wills.

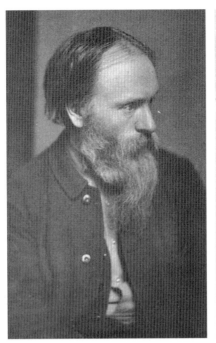
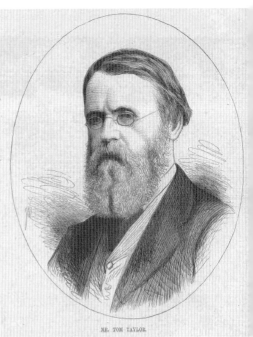

MR. TOM TAYLOR.

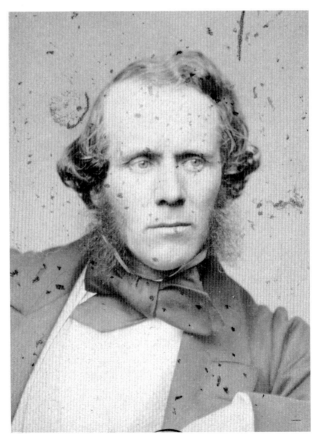

The witnesses for the defense. From top: Edward Burne-Jones, Tom Taylor, William Powell Frith

ABOVE: The White House, Tite Street, Chelsea, designed by Whistler and the architect Edward Godwin. Whistler had hoped the house would improve his finances. Instead, its cost only hastened his insolvency. BELOW: Brantwood, the Lake District estate that John Ruskin bought sight unseen in 1871 and that for most of the rest of his life became his haven from the world.

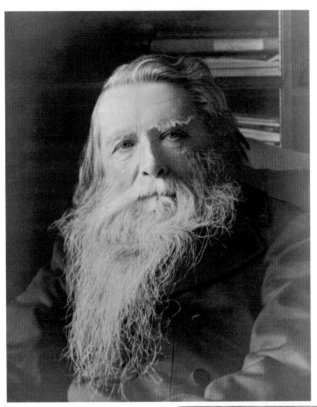

Ruskin in twilight, Whistler in decline: John Ruskin at Brantwood in 1894, left: James Whistler in Ajaccio in 1901, below.

The overwhelming consensus, however, was there had been no victor at all: that the trial had resulted in "something very like a drawn battle" or, worse, in mutual defeat and a "censure on both." Whistler, most agreed, had been a fool to bring the suit. Ruskin's offending words had been buried in the obscurity of *Fors Clavigera*—"a periodical which only six people in all the universe are allowed to see," joked one writer—and if Whistler hadn't forced them into the world's consciousness, very few would have seen them at all. While many commentators agreed that Ruskin might have crossed the line in the personal nature of his attack, several also considered that Whistler's Grosvenor paintings *were* awful—hardly art at all—and that therefore Whistler deserved the abuse and the damaged reputation. In any case, going to the law to settle aesthetic questions had been a mistake. "Mr. Whistler is clever and original," noted *The Spectator*, "but he will never hit upon anything more original in art than the device of settling abstruse artistic questions by an appeal to an intelligent British jury." "We do not remember any occasion when the inherent limitations of the [jury] system have been so emphatically expressed," seconded *The Saturday Review*. Henry James, reporting for the American journal *Nation*, scorned the entire trial as "a singular and most regrettable exhibition." "If it had taken place in some Western American town," he wrote, "it would have been called provincial and barbarous; it would have been cited as an incident of a low civilisation. Beneath the stately towers of Westminster it hardly wore a higher aspect."

Press and public did realize, however, that the trial had had its saving grace: It had been immensely amusing and "kept dinner-tables supplied with animated conversation for a fortnight." *Punch* magazine captured both that sense of amusement and the prevailing sentiment about the verdict in its December 7, 1878, issue, which contained both a hilarious parody of the trial, in which judge, lawyers, and "Penny Whizzler" vie to outgun one another with wit, [*] and a cartoon depicting the moment of judgment.

[*] *"Sir John Joker, Q.C. (cross-examining Mr.* Penny Whizzler, *A.A.A.). And I dare say you thought that with one of these* Nocturnes *you would* Knock Turner *out of the field? (Chuckles from Juniors; smiles from Jurymen; laughter of Spectators; gravity from the Judge, who does not approve of any jokes being laughed at except his own . . .)."*

In it, Whistler and Ruskin stand to either side of Baron Huddleston, who clutches an enormous farthing and proclaims "The Law allows it. The court awards it." Whistler, gazing raptly at the farthing, is recognizable by his curly black hair and prominent white forelock, but is otherwise depicted as a strange bird with an ostrich's plumage (to emphasize head-in-the-sand folly?) and with pennywhistle legs. Ruskin, oblivious to all, turns his head away and stares at the floor. He, too, is a bird: drawn and labeled as an "old pelican in the art wilderness," the emblem of solitary desolation adapted from the Old Testament.* In the background sits the jury, block-headed tubes of paint. A two-headed snake labeled "COSTS," emerging from the well in which the lawyers sit, hisses at both Whistler and Ruskin. "Naughty critic, to use bad language," reads the caption. "Silly painter, to go to the law about it!"

The creator of that cartoon, Edward Linley Sambourne, was hardly a friend of Whistler's, but he *was* concerned enough about Whistler's reaction to write him ahead of publication to offer sympathy "in what must be a most trying and irritating time," to play down the cartoon as a "little bit of nonsense," and to shift the blame for its existence to another: "I am in a manner *obliged* to take up any subject the Editor points out": that editor being none other than England's second-most renowned critic, Tom Taylor. Whistler replied to Sambourne cheerfully, professing to be charmed and flattered by the cartoon, and—for the time being—good-humored about Taylor's role in the affair. "If Punch in person sat upon me in the box—Why should not the most subtle of his staff have a shot?" If anything annoyed him, it was Sambourne's misplaced sympathy. "You must not grieve over what you call this 'trying time'—To have brought about an 'Arrangement in Frith, *Punch* & Ruskin with a touch of Titian' has been a joy—and sufficient in itself to satisfy even my own craving for curious combinations!" Whistler then sent the correspondence to the *World* to trumpet his own magnanimity and sense of triumph. Edmund Yates, the *World*'s editor, had published a flattering interview with Whistler seven months before, and

* Psalm 102:6: "I am like a pelican of the wilderness: I am like an owl of the desert."

Whistler saw in him an ally, and in his weekly column the perfect place for publicly airing his grievances and views. He was right: Yates published nearly all the many things Whistler sent him over the next decade.

However triumphant he might profess to be, Whistler was well aware that *Whistler v. Ruskin* amounted to the first skirmish in a larger war. "The question at issue," he explained to Rose, "has really been not merely a personal difference between Mr. Ruskin and myself, but a battle fought for the painters in which for the moment Whistler is the Quixote!" He and not Ruskin had shone at trial, and in that respect, he was sure he had scored a victory. But there was much more to do. It remained to him to vindicate all art—all *true* art—in the face of the critics who had shown themselves incapable of understanding it. He had refrained from taking on the critics in this way during the trial: he had even refrained from questioning Ruskin's critical abilities. "To have said that Mr. Ruskin's pose among intelligent men, as other than a *littérateur* is false and ridiculous, would have been in invitation to the stake; and to be burnt alive, or stoned before the verdict, was not what I came into court for," he claimed. But his work now—and, as it turned out, his life's work—was to do exactly that: to dethrone Ruskin and his tribe as arbiters of art, and to set himself, with his aesthetic ideals, in their place. The trial had confronted the world with the question "what is art?"—but had done little more than that. In the years to come, through creation, through promotion, through force of personality, Whistler intended to win the war that had begun with this battle, by an extended campaign to convince not a jury, but the wider public, of the value and validity of his aesthetic.

He considered, at first, that the next battle would take place in the court-room as well. "Now about the war—" he wrote James Rose three days after the verdict, "it is rumored that either we or they might still appeal—How is this?" He suggested they get a better lawyer—and he had just the man in mind: his countryman Judah P. Benjamin, once secretary of war for the Confederacy, now in exile a London barrister with a particularly lofty reputation for winning appeals. Rose, obviously horrified by the very idea of appeal, did his best to strangle it at birth with not one but two speedy

replies. They could never excel the case they had already made, Rose was certain. Parry and Petheram could not have been better. The witnesses for Whistler (including, apparently, William Gorham Wills) were "first rate." Even Ruskin's witnesses had praised Whistler's work—all except Frith, whom Rose once again disqualified as an authority because of the immorality of his works. Finally, Baron Huddleston, Rose assured him, had been in Whistler's favor "from beginning to end." And yet with all of those advantages, they were lucky they had not lost: once the jury proclaimed Ruskin's criticism "honest," Rose believed, Huddleston should have directed them to find for Ruskin. Ruskin, then, had far stronger grounds for an appeal. "This of course," Rose cautioned him, "you must be wise enough to keep to yourself."

Whistler, apparently convinced, dropped altogether the thought of appealing. He therefore gave up any chance of Ruskin paying his costs. Instead, he considered having others pay them. When Rose brought to Whistler's attention the public campaign to pay Ruskin's costs, Whistler decided that a similar campaign to pay his own costs would be, as he told Rose, "quite in keeping with our dignity," and directed him to contact Comyns Carr—who had promised his "mite"—to arrange matters. (For his own part, Whistler magnanimously declared "*I also will subscribe* my mite to the general fund.") A subscription was duly established at the London offices of the French journal *L'Art*, where Comyns Carr was editor. It was established—and it languished. No one contributed, and Whistler gained from it only a hard lesson in the limits of his support within the English art world.

By then Whistler had fired his next salvo in what he now called the war "between the brush and the pen," ironically putting down his own brush and taking up his pen to do it, with a polemic assault not just upon Ruskin, but upon *all* critics of art. While Whistler was a natural wit, he was hardly a natural writer, and this verbal assault, like all his public writing, came slowly and awkwardly, with inspired fits but also false starts. He filled pages with *mots*, runaway alliterations, erudite allusions, and subjected them to a tumultuous process of deletion and addition, gradually forcing something close to coherence upon his text. The result was a style of

calculated *insouciance*, something distinctly and inimitably Whistlerian. As Henry James put it, "Mr. Whistler writes in an off-hand, colloquial style, much besprinkled with French—a style which might be called familiar if any one encountered anything like it." By December 18, he had a "most rattling" twelve-page article. "You will be delighted with it," he assured Rose, "and perhaps as pleased with me again as you were when I was in the box!" He planned to send it to the journal *Nineteenth Century*, whose editor James Knowles, he claimed, had seen it and "is most hungry for it." But he apparently misjudged Knowles's appetite, for the essay did not appear there. Instead, Whistler turned to Chatto & Windus—Swinburne's publishers—to produce it as a pamphlet. *Whistler versus Ruskin: Art and Art Critics* appeared at the very end of December 1878.

Whistler's argument was simple. Art critics, by and large men of letters and not at all artists themselves, were therefore entirely unqualified to judge art. Proximity to or even the study of art was not enough: "a life passed among pictures makes not a painter—else the policemen in the National Gallery might assert himself." Ignorant of the logic and the technique of painting, such critics must rely upon questionable taste rather than expertise to judge, and upon eloquence rather than true awareness to persuade their public. "The Observatory at Greenwich under the direction of an Apothecary! The College of Physicians with Tennyson as President! and we know that madness is about. But a school of art with an accomplished *littérateur* at its head disturbs no one! and is actually what the world receives as rational, while Ruskin writes for pupils, and Colvin holds forth at Cambridge."* "Poor Art!" Whistler proclaimed, "what a sad state the slut is in, an these gentlemen shall help her"—while the truly knowledgeable artist "remains unconsulted." The solution? "Let there be no critics! they are not a 'necessary evil,' but an evil quite unnecessary, though an evil certainly."

Not surprisingly, John Ruskin, *littérateur* among *littérateurs*, received the brunt of Whistler's abuse. With breathtaking—and surely willful—blindness

* Sidney Colvin was the Slade Professor of Art at Cambridge and an art critic for a number of London journals.

to Ruskin's abilities as an artist, Whistler concentrated upon his writing alone, turning his renown in that respect against him:

> quite alone stands Ruskin, whose writing is art, and whose art is unworthy his writing. To him and his example do we owe the outrage of proffered assistance from the unscientific—the meddling of the immodest—the intrusion of the garrulous What greater sarcasm can Mr. Ruskin pass upon himself than that he preaches to young men what he cannot perform! Why, unsatisfied with his own conscious power, should he choose to become the type of incompetence by talking for forty years of what he has never done!

As for other English critics, Whistler dismissed them as mediocre nonentities, hardly worth naming, with the significant exception of one: upon Tom Taylor Whistler heaped nearly as much personal abuse as he did upon Ruskin. "Tough old Tom" Whistler posited as the "busy City 'Bus" among critics, "its steady, sturdy, stodgy continuance on the same old much worn way, every turning known, and freshness unhoped for; its patient dreary dullness of daily duty to its cheap company . . ." As *coup de grâce* to Taylor's critical pretensions, Whistler quoted from an article that Taylor had written over a dozen years before declaring a Velázquez painting "slovenly in execution, poor in colour—being little but a combination of neutral greys and ugly in its forms." Those *were* Taylor's words—but Whistler deliberately neglected to mention that they were a part of a passage in which Taylor actually glorified Velázquez. The attack was, therefore, a low blow. Whistler had no problem with that.

The first printing of *Whistler versus Ruskin: Art and Art Critics*—five hundred copies—sold out in three days. Before a month had passed it had gone through six more printings. The critics excoriated it. "His facts are hazy and his reasoning illogical," insisted one; it was "the excess of bad taste," complained another. Even Whistler's friend Edward Godwin acknowledged that his attack "overshoots the mark." Joseph Comyns Carr,

offering Whistler another "mite" of a very different kind, was merciless: "We presume that this is its author's first literary production; for his own sake, we sincerely hope it may be the last, as, to tell the truth, we have seldom come across a more silly production. Whatever may be Mr. Whistler's talents and capabilities as an artist, he seems unable to write plain English and generally ignorant of the subjects of which he treats or to which he alludes." Whistler, prepared for this critical onslaught, was undaunted. He crowed to anyone who would listen about the pamphlet's popularity with the public. And at a shilling a copy, *Art and Art Critics* made Whistler a tidy profit at the beginning of 1879—though hardly enough make much difference in his now-massive debt.

"Let work, then, be received in silence," Whistler enjoined the critics. In response to Whistler's assault, one critic at least obeyed. John Ruskin had actually written the perfect answer to Whistler's pamphlet even before Whistler wrote it. His instructions to counsel amounted to a full justification of himself as a critic of art and a critic of Whistler. In the days after the verdict Ruskin had taken up these instructions, edited them, and retitled them, "My Own Article on Whistler." He clearly intended to publish. But something stopped him—and that something was almost certainly Whistler. With his pamphlet Whistler had managed to fire the first shot, and after that Ruskin's instructions would be perceived as nothing more than a counterattack, indicating his willingness to embroil himself in Whistler's endless war. But he was not willing. He set his article aside. It would not be discovered until after his death.

Where Ruskin refused to tread, however, Tom Taylor rushed in. Whistler had sent a copy of his pamphlet to Taylor, inscribing it "sans rancune": no hard feelings. "'Sans rancune,' by all means, my dear Whistler," Taylor replied, "but you should not have quoted from my article . . . on Velasquez, in such a way as to give exactly the opposite impression to that which the article, taken as a whole, conveys." As for the central argument of *Art and Art Critics*, Taylor dismissed it: "God help the artists if ever the criticism of pictures falls into the hands of painters! It would be a case of vivisection all round."

Whistler dismissed him. "Dead for a ducat, dead! My dear Tom; and the rattle has reached me by post." With his pamphlet, as far as he was concerned, Whistler had scalped and slaughtered Taylor as well as the rest of his critics; they were now dead—to him. Taylor shot back: "Pardon me, my dear Whistler, for having taken you *au sérieux* even for a moment. I ought to have remembered that your penning, like your painting, belongs to the region of 'chaff.'" To which Whistler: "Why, my dear old Tom, I never *was* serious with you, even when you were among us. Indeed, I killed you quite, as who should say, without seriousness, 'A rat! A rat!' you know, rather cursorily." Whistler then publicized his kill by sharing the entire correspondence with Edmund Yates, who shared it, in the *World*, with the world.

All the while, Whistler fought frantically against an overwhelming tide of debt. His own solicitor Rose was now officially a substantial creditor; Rose had sent Whistler his bill for £261 that December. But Rose posed little threat. Not only was he at that time the most patient of creditors; he remained Whistler's staunch ally against all the others. Those others, by 1879, had become a multitude of over five dozen. Some, to be sure, were remarkably quiescent. Whistler's largest creditor, for example, longstanding American patron Thomas Winans—or rather the Winans family, for Thomas had died the year before—did nothing to recover the £1,200 that Whistler owed them. Frederick Leyland as well left Whistler alone at this time, probably wanting nothing to do with him. But many others were growing more anxious and less patient. In the wake of *Whistler v. Ruskin*, life for Whistler and for his agents—Maud, Charles Howell, James Rose, and Whistler's second solicitor, Theodore Allingham—had become an ever-intensifying nightmare of fending these creditors off with excuses, token payments, or fruitless negotiation. This harried existence Whistler had designated "the Show." The Show had of course been going on for some time, but it in the weeks after the trial it had grown, according to Whistler's letters, especially fierce: "shocking," "awfully hot," and in a "strangled state."

The most persistently aggressive among Whistler's creditors—although he certainly had competition—was a man named Louis Herrman, a dealer in classical art with a showroom close by the British Museum. Early in 1878 Charles Howell had apparently wheedled £225 out of Herrman, probably by repeating the trick he had played upon Walter Blott: promising a Whistler as security, taking Herrman's money, and delivering nothing. A grimly intent Herrman then pursued Howell and Whistler for months, generating an anxious communication between Whistler and Howell throughout 1878. Whistler to Howell, May 24: "really we must have *some* pounds for Herrman—Eight will do—or even perhaps *six*." June 19: "A note from Herrman—to say that I am to send him *immediately* the 30 shillings." August 15: "Herrman is hot! and things are verging upon hell!" In December, after Whistler failed to honor one and then another negotiated settlement, Herrman put the matter in the hands of his solicitors, who, surprisingly, simply oversaw a third settlement. New Year's Eve: "What *am* I to do about Herrman?"

By then, three other creditors had tired of this game and turned to the courts. Benjamin Nightingale, builder of the White House, struck first. His suit against Whistler was heard, coincidentally, on November 25, the first day of *Whistler v. Ruskin*. James Rose was of course busy that day; Theodore Allingham argued the case. He lost; Nightingale obtained the legal right to recover his £450—and costs. One week after this, the furnisher of Whistler's piano, Frederick Oetzmann, successfully sued for £23; one day after that one of Whistler's picture framers, George Tacchi, did the same for £26. The sheriffs did their duty and set bailiffs upon the White House.

In countless Whistler legends, the bailiffs seem to be nothing but harmless and thickheaded dupes, either distracted or drugged by Whistler while friends spirited Whistler's art from their control, or coerced into wearing livery and serving breakfasts. ("Your servants seem to be extremely attentive, Mr. Whistler, and anxious to please you," noted one guest. "Oh, yes," replied Whistler, "I assure you they *wouldn't leave me*.") In reality—though he would never publicly admit it—the bailiffs were a torment to Whistler, and his letters to Rose at this time betray terror upon their arrival and

enormous relief upon their departure. As officers of the court, bailiffs were empowered to do more than simply watch over Whistler's property; they could also seize and sell goods to realize the full amount of a debt. With smaller debts—Oetzmann's or Tacchi's—that would be an annoyance, but with his debt to Nightingale it would be a disaster, stripping the house bare of furniture and, worse, stripping the studio of his artwork. Once Nightingale won his suit he took steps to do exactly that, sending in an auctioneer to take inventory, then to draw up advertisements and post bills for a sale. "Do get me out of this mess," Whistler implored Rose in a panic: "the Philistines are upon me!"

Remarkably, Rose did get him out of that particular mess with the intervention of *deus ex machina* Charles Howell. Two days after *Whistler v. Ruskin*, Howell had fought his own lawsuit, *Howell v. The Metropolitan District Railway (Fulham Extension)*, seeking compensation for his well-appointed home, which the railway had marked for destruction. Edward Godwin appeared as an expert witness, testifying as to the immense value of Howell's home and collection. Whistler had given support simply by showing up at the trial, fashionably late. ("We must be careful now," Howell announced as Whistler sauntered in; "here is 'an arrangement in black and white,' the key-note of all true symphonies is in court.") The jury awarded Howell a whopping £3,650. Whistler was delighted by the windfall, which he considered extended to himself: "I trust myself also soon to bring you gold," he announced to a creditor soon afterward. With Howell agreeing to stand security, Rose negotiated paying back Nightingale's £450 in two installments: one due in January 1889, and the other in March. Whistler of course never paid either installment. Howell would, in the end, only pay the first.

At the same time Whistler managed, with shocking callousness, to extricate himself from another mess altogether. In 1878, Maud Franklin was pregnant. She was showing by the time of *Whistler v. Ruskin*, approaching term by the end of the year. She was therefore becoming nothing but a distraction to Whistler, and he fended her off by means of a ruse concocted with George Lucas, a longstanding American friend who lived in Paris.

First he removed Maud from the White House, apparently to a hotel. Then Whistler stayed put in Chelsea while pretending to be in Paris, sending letters to Maud within letters to Lucas, which Lucas returned to Maud with Parisian postmarks. This deception likely continued until February 23, 1879, the day Maud gave birth to a daughter, Maud McNeill Whistler Franklin. Maud then returned to the White House. Their daughter was farmed out—and apparently soon died. There is no evidence that Whistler ever met this child—or cared to.*

Throughout the winter of 1879 and well into the spring Whistler grappled with the Show, truly believing all the while that if he could have enough time to work free from distraction he could create magnificent art, sell it at the price it deserved, and emerge triumphant. "It is *all important*," he wrote to Rose in January enclosing an unopened summons, "that I should not be disturbed in the work that I am *finishing* and that will at last bring bank notes my dear Rose!! . . . Another week or two I shall be out of the wood!" Whistler actually did complete one painting at this time: *Nocturne: Grey and Silver—Chelsea Embankment, Winter*, a somber depiction of the Thames encased in ice. He quickly shipped it to Glasgow where it quickly sold at a knockdown price—enough, however, to stave off disaster. Just as Oetzmann's agents planned to auction off White House property and Rose was on the verge of filing bankruptcy papers, Whistler came up with the £50 he needed to ward Oetzmann off. (Whistler to Rose: "The man is out—hurah! we must never let him in again!") Rose set the bankruptcy papers aside.

Grey and Silver was, however, an exception: the only painting he had managed to sell during those months. He had come close with another, a 200 guinea commission from his neighbor, Algernon Mitford, for a full-length of his wife, Clementine. But that painting, Mitford remembered, Whistler destroyed with others "in a storm of mad fury lest they should fall

* Two—or possibly three or four—years before this, Maud had given birth to another daughter, Ióne, who was similarly farmed out and similarly forgotten by Whistler, but not by Maud: letters between Maud and Ióne in later years suggest a true mother-daughter bond. (Margaret MacDonald, "Maud Franklin," 23)

into the hands of the bailiffs . . . all for a miserable debt of thirty pounds."
Whistler did have very high hopes for another portrait that managed to
survive that massacre: *Harmony in Yellow and Gold—the Gold Girl*, a portrait
of thirteen-year-old Connie Gilchrist, a music-hall dancer, skipping rope.
Lillie Langtry, celebrated public beauty and royal mistress, had seen that
portrait in Whistler's studio in 1877 and had told him "nobody but you
could have done it so beautifully." Although hers was distinctly a minority
view, Whistler agreed with her, and would offer it for sale that May at the
Grosvenor for a cool £500.

He continued to have much better luck selling prints than paintings. The
Carlyle mezzotints, for one thing, remained popular. He resurrected some of
his old etchings, publishing one of them in *Portfolio* magazine early in 1878.
He managed to escape the pressures of the Show enough to create a few new
etchings, most of them views of the river that echoed the popular *Thames Set*
of two decades before. These he sold both by print and copperplate to several
dealers. One plate—*Old Putney Bridge*—he offered in March 1879 to Marcus
Huish at the Fine Art Society. Huish thought it too esoteric and rejected it,
but a month later, likely encouraged by his assistant Ernest Brown, Huish
changed his mind, bought it for eighty guineas, and appeared amenable
to buying more. It was the beginning of a profitable relationship for both;
Ruskin's benefactor was gradually becoming Whistler's.

Sales such as these might provide Whistler with fending-off money,
but by the beginning of 1879 bankruptcy seemed inevitable. In March,
when summons, judgments and threats of seizure fell upon Whistler in an
overwhelming deluge, Whistler and his solicitor Rose hatched a desperate
plan to salvage his property. The heavily mortgaged White House, they
knew, was beyond saving. But Whistler's moveable goods—including what
remained of his art—they could deny to all of Whistler's other creditors if
Rose sued Whistler and so became a substantial creditor himself, set his
own bailiffs upon the White House, arranged for a quick sale, and bought
everything of Whistler's that he could—presumably to hold in trust until
Whistler could pay him back. It was a plan that called for great secrecy
and as much haste as the legal system would allow.

On March 20, then, Whistler, at his brother Willie's house, happily accepted Rose's summons to appear in court to answer for a debt of £261—Rose's fee for *Whistler v. Ruskin*. Eleven days after that Whistler deliberately failed to appear and lost the suit by default. Rose quickly sent in bailiffs. For once they provided Whistler not with torment but with relief: Rose expressly directed them not to prevent Whistler from sending his art to the Grosvenor Gallery, and soon *The Gold Girl* as well as several prints and pastels were under Sir Coutt Lindsay's protection. Rose drew up a bill of sale for the rest. And then, he hesitated. He and Whistler had erred: the value of Whistler's property amounted to more than his debt to Rose, and Rose could at that point seize no more than that. On April 10, therefore, Rose served him with a *second* summons, this time claiming £210 for a decade's worth of loans. Eight days later, Whistler again defaulted. Then, as they were on the verge of salvaging nearly £500 worth of Whistler's property, they again hesitated, and both Rose and Whistler left town—Whistler with Maud, for Paris.

It was a disastrous mistake. In their absence the implacable Louis Hermann struck, obtained his own judgment against Whistler, set his own bailiffs upon the White House, and arranged his own auction of Whistler's goods. When Whistler got the news—sent by Rose's clerk to Willie, and forwarded by Willie to Paris—he was incredulous. "Now what absurdity can this all be!—How can the Sheriff put up bills for sale when *you are in possession*[?]" But the sheriff could, and did. Whistler dashed back to London to find the White House in chaos. "The show is so frightfully afire," Maud wrote to George Lucas on May 3. "The place is full of men in possession & the sale is fixed for the 13th. You had better come over and buy." Rose came to Chelsea that same morning for a meeting with Whistler. It was to be their last; both Whistler's trust in Rose, and Rose's extraordinary generosity toward Whistler, evaporated that day. Rose quit or was fired; the two were never known again to exchange a friendly word.

Whistler quickly found a replacement for Rose in George Henry Lewis, whose renown for efficiency and discretion had ensured him a booming practice in the highest society: he counted the Prince of Wales among his

clients. But there was little Lewis could do in Whistler's case to stave off the inevitable. Within two days he had drawn up the petition that Whistler, affecting buoyancy, submitted to the London Bankruptcy Court. Declaring debts of £4,641 against somewhat fanciful assets of £1,824, Whistler requested a "liquidation by arrangement"—that is, a convening of all of his creditors in order to divide his assets. By the law of the time, this was actually a way to *avoid* bankruptcy. But the effect was exactly the same: his petition was granted, a receiver was appointed to take possession of all of his property, and from that moment Whistler was technically penniless.

In fact, for the rest of that spring and summer Whistler's pauperdom was a relatively comfortable one. Declaring insolvency had put an end to the incessant clamoring of his creditors. Since the receiver of Whistler's assets, an accountant by the name of James Waddell, allowed Whistler full use of the White House until it went up for sale in September, Whistler continued to be able to paint in the studio, to turn out proofs on his printing press, and even to throw parties and breakfasts.

And having safely placed several of his works with Sir Coutts Lindsay, Whistler could still exhibit. Three of his paintings adorned the walls at the opening of the 1879 Grosvenor summer exhibition. Two that he had borrowed back from Howell—the thirteen-year-old Valparaiso crepuscule, and the portrait of Rosa Corder—received mixed reviews. But the one he sent from his studio—his portrait of rope-skipping Connie Gilchrist—the critics nearly universally castigated as "ludicrously muddy and ugly," "glaringly eccentric," and "aesthetically speaking, a deplorable error to depict." "That it is one of the most disagreeable and vulgar things we ever met with in an exhibition," sneered one critic, "is an opinion which not even the fear of farthing damages can hinder us from expressing." The critic from the *Morning Post* suggested Whistler give up painting altogether: "if he would keep to etching he would do good service to his own reputation and save the public much pain." Not surprisingly, the Connie Gilchrist remained unsold.

But that hardly mattered to Whistler at this point: if the Connie *had* sold, every penny would have gone to his creditors. Anything that Whistler produced *after* declaring insolvency, on the other hand, was his alone—in

order to profit, he needed fresh creations. But while he was busy in his studio that May, he produced nothing marketable. Misfortune had perverted his style; he abandoned any thought of capturing beauty and instead gave outlet to the overwhelming rage he felt for the man he held responsible for all his financial troubles: Frederick Leyland. The two paintings he did create that May were virulent lampoons of the man, hastily and crudely slapped onto the canvas. The first, *The Loves of the Lobsters*, appeared to one viewer "as if the artist had upset the inkstand, and left Providence to work out its own results." In it two lobsters, one with a frilled front to reflect Leyland's idiosyncratic taste in shirts, battle one another in an undersea parallel to the fighting birds in the *Peacock Room*. The second, *Mount Ararat*, depicts a gang of frilled rats besieging Noah's ark. While Whistler's symbolism might have been muddled, his resentment was clear—and potent.

That resentment boiled over on June 4, when Whistler's creditors met for the first time and Whistler joined them. Whistler's friend Thomas Sutherland, a major shipping magnate and a minor creditor, was elected to chair the meeting and took his place at the front of the room, flanked by Whistler and George Henry Lewis. As Sutherland quietly endorsed papers handed to him, one impatient creditor jumped up and demanded an explanation from Whistler. Whistler obliged, stunning his audience with a volcanic tirade against plutocrats and their millions. Sutherland and Lewis finally had to wrestle him back into his chair.

Whistler, having in this way relieved himself, sat while the meeting continued with the election of a three-man committee of inspection to superintend the liquidation of assets. Two of these men, Whistler was happy to see, were friends: his lithographer, Thomas Way—and his factotum, Charles Howell. But the third was Frederick Leyland. That his enemy had gained this new power over him inspired redoubled rage and renewed vituperation. "How charmingly characteristic of your own meanness," Whistler blasted him soon afterward, "that for vengeance you should have waited these years and having pocketed the horsewhip like a true Counting house rat should now turn up when you think the moment of the register has arrived to worry and work with accounts and punish with your pen the

[*sic*] who laughs and has always laughed at your pompous rage and impotent spleen." Again, hatred infected his art, this time in no fewer than four pen and ink caricatures. One depicted Leyland as a nonentity, nothing but a frill with a horsewhip. The others depicted him as a ghoul brooding over Whistler's assets.

Later that summer Charles Howell did his best to take advantage of his position on the committee to help himself while helping Whistler. "State 'distinctly and in writing,' Howell bluntly directed him, "what you will give in work if I secure for you—the Connie—The three girls—and the blue girl." Whistler wisely resisted this shady deal, though it meant that his entire income from painting during those months amounted to no more than £50 for a portrait of Ada Jarvis, whom he agreed to paint to repay a debt to her husband, Lewis. Whistler agreed to paint her—but he did not agree to paint her well. After a few hasty sittings the thing was done and, by Whistler's own admission, done badly. "The little head ought to have been far away more charming," he wrote Mrs. Jarvis, "but I did my best at the time which I am afraid is very poor."

Again, he was far more successful with his etchings. At the beginning of August Marcus Huish agreed to buy a second copperplate from him, this one of old Battersea Bridge, for £100. Emboldened by this deal, Whistler invited Huish to the White House to propose a far bigger one: that Huish and the Fine Art Society sponsor the trip to Venice he had long dreamed of. Huish was willing, and by September the two worked out an agreement: Whistler would go to Venice for three months and create a dozen etchings for which the Society would pay £700, with a £150 advance. Considering that the Society had, just a year before, paid Whistler's brother-in-law and enemy Seymour Haden £1,500 for just two etchings, it was not the most generous offer. But it offered Whistler an escape from his long sojourn in financial purgatory, and he was delighted.

The White House was scheduled for auction on September 18, and Whistler made plans to "vamoose the ranch" just before. These included taking one more swipe at Frederick Leyland with the most hideous and bitter caricature of them all. In *The "Gold Scab": Eruption in Frilthy Lucre* Whistler portrayed

Leyland as a frill-fronted half-human, half-lizard-like peacock, scabrously coated in coins, perched upon the White House and, surrounded by moneybags, dementedly playing piano. To this Whistler appended his signature butterfly, sporting a stinger this time, a feature common enough in his correspondence but unique to his paintings. To mortify Leyland further, Whistler set the work in the frame he had intended for the *Three Girls*, his failed commission from Leyland. Whistler intended to torment Leyland by leaving this painting behind to be publicly auctioned. As a final insult—as well as entertainment for the gawkers who were sure to swarm the White House on the day of the auction—Whistler reproduced the caricature as a mural upon his drawing-room wall.

Not long before his escape, while visiting his new patrons the Jarvises in Bedfordshire, Whistler took note of a three-hundred-year-old inscription chiseled over the central gable of their new home. In it he found "a lovely inspiration! A last Kick!" before leaving the White House forever. He returned to London and made final preparations, which included destroying much of his unfinished work by scratching copperplates and smearing paintings with glue, and on the evening of Sunday, September 14, after a final breakfast with Lillie Langtry as honored guest, Whistler, with his son Charles Hanson, emerged from the White House and set a ladder over the doorway. Whistler climbed it and painted the inscription he had seen: "Except the Lord build the house, they labour in vain that build it."* To this he added "E. W. Godwin, F.S.A., built this one." He apparently meant no offense to Godwin, but rather attempted to comment on the pointlessness of a White House without a Whistler. Though few who saw it could have made much sense of this, everyone agreed that it was an immensely clever witticism.

Whistler and Maud were off to Paris the next day, and three days after that Whistler set out on the night train to Venice. (Maud would follow in a month.) On that day, the White House went up for auction. As Whistler had assumed, the curious did swarm the house to be amused by what one

* Psalm 127:1.

newspaper called "the Whistlerian Derangement," the detritus left behind once the finer furnishings, the china, and the artwork had been removed for later sale at Sotheby's. Rusty spoons and a dilapidated piano. The sitzbath in which Whistler had splashed while guests awaited breakfast. The perplexing image upon the wall of a manic demon sitting on a house. Scraps of abandoned correspondence, including one from an aesthetic votary: "Will you do me the pleasure to come here on the afternoon of Thursday, the — July, to sit in the shade of a huge Japanese umbrella and eat strawberries?" Anyone seeking a beautiful bargain was disappointed: "there was literally nothing which the most enthusiastic Whistlerian would have given sixpence for as a memento," one reporter remarked.

The house itself, on the other hand, inspired spirited bidding and finally went for £2,700. The buyer, of all people, happened to be an art critic: Harry Quilter, who wrote for *The Spectator*. Quilter saw himself as a disciple of Ruskin, and earlier that year he had energetically defended Ruskin against Whistler's attack in *Art and Art Critics*, a pamphlet he thought "can only be laughed at, and not answered, for there is nothing to answer in it." Whistler then already found plenty not to like in Harry (or, as he called him, 'Arry) Quilter. But Quilter would soon do much more to annoy him. When in July 1880 Tom Taylor died—"Tommy's dead. I'm lonesome. They are all dying. I have hardly a warm personal enemy left!" Whistler pined—Quilter replaced him as the *Times's* critic. Once Quilter took over the White house, he made renovations that obliterated Godwin's and Whistler's design. (He also dared to erase Whistler's inscription.) Not surprisingly, Arry Quilter would soon become Whistler's chief whipping boy among critics.

To the world, Whistler's flight to Venice signified abject defeat, a fulfillment of the prediction that his ex-friend Dante Gabriel Rossetti had made upon learning the verdict months before: "Alas for Jemmy Whistler! What Harbour of Refuge now, unless to turn Fire-King at Cremorne? And Cremorne itself is no more! A nocturne Andante in the direction of the Sandwich Islands, or some country where tattooing pure and simple is the national School of Art, can now alone avert the long-impending Arrangement in Black on White." But Whistler refused to see it that way.

On the contrary, in a parting letter to his receiver James Waddell he construed his months spent contending with insolvency as a time of unqualified triumph. "I have fought the White House devilish well, holding out against a siege of unexampled rigor through the whole of the season most brilliantly with breakfasts—and now I march out with bands playing, (figuratively) colors flying and all the honors of War!" To him, the journey to Venice was not an abandonment of the field but rather the beginning of a new campaign—and a pivotal one.

CHAPTER 8

VENICE

A ll the while that Whistler struggled against the Show, John Ruskin did his very best to avoid involving himself with anything resembling one. Except for one stressful and unavoidable week in London, from the time of *Whistler v. Ruskin* until September of the next year Ruskin remained in semi-seclusion at Brantwood, restricting those around him to a safe, chosen few. Always with him was Peter Baxter, who had been his faithful valet since 1876 and who had watched over him during his madness. Another constant presence was Laurence Hilliard, Ruskin's "strange, bright, gifted," and universally liked young secretary. Joan and Arthur Severn with their growing family were often there as well, now dividing their time between Brantwood and Herne Hill. Ruskin grew closer to his Coniston neighbors—particularly to Susanna Beever, who lived across Coniston Water, and with whom he loved to take tea. There was a regular stream of visitors, old friends, and young disciples, whom Ruskin could and did treat as family.

Constance Hilliard, sister of his secretary, once a child-friend but now grown, was one of these visitors; she came to Brantwood soon after the trial and left record of Ruskin's routine at that time. "He is aged by this illness, more irritable, poor dear, and more sad; though he draws and works hard

every morning, chops for an hour in the wood till dinner, rests a good deal in the afternoon, and reads 'Sir Charles Grandison' or listens to music until bedtime." She saw, in other words, a man bowed by time and circumstance. But he was not broken by it: his thirst to observe, to study, to write, and to teach remained unquenchable.

His observations, for the first nine months of 1879, were almost exclusively limited to the little universe around Brantwood, and, to him, that was sufficient. The winter of 1878–1879 was an abnormally cold and enduring one, and Ruskin was then preoccupied with freezing and melting nature: the snow in "folded lace-veils" on the hills, the frost forming "miniature ranges of basaltic pillars" in his garden, and the thin crust of ice that shot—or was "*breathed*"—across Coniston water, spreading half a mile in ten minutes. What he saw naturally found its way into his writing, most of it into the final chapter of his geological work *Deucalion*. So entranced was he with these natural wonders that winter that, while it lasted, he largely forgot about the plague cloud. When the ice receded, however, his awareness and dread of that threatening darkness returned. "Fearful darkness yesterday at evening—Devil's weather entirely the last three weeks," he noted at the end of April, "the blackest evening the devil has yet brought upon us,—utterly hellish, and the worse for its dead quiet," in mid-July.

His studies and writings at the time were remarkably diversified, limited only by his need to avoid anything that might agitate him. He shifted from subject to subject not simply from day to day, but from hour to hour. Usually he began with the classics, which he found particularly soothing: setting Horace to music, burying himself in Plutarch, translating Plato's *Laws*. From there he generally turned to one of his several open-ended works: works, in other words, to which he could contribute indefinitely: his *Deucalion* on geology, or his *Proserpina* on plants, or his *Laws of Fésole* on drawing. (He published supplements to all of those works in 1879.) Or he might turn to editing the memoir of his soldier-friend, Sir Herbert Edwardes, or to rereading Sir Walter Scott with vague ideas of his own work of literary criticism.

At the end of March Ruskin's routine and his equanimity were marred by his reluctant trip to London. That January he discovered that someone had forged his signature on a check cashed at his London bank. Soon after that, a man by the name of James Burden, one of the earliest companions of his Guild of St. George, was arrested attempting to cash another forged check. Ruskin dreaded having to testify against him but had no choice: "the lawyers forced me," he claimed. After a week spent at Herne Hill avoiding the lectures, exhibitions, and entertainments of London, he appeared as a witness at the Old Bailey: visibly unhealthy, he was allowed to testify from the judge's bench. Burden was found guilty and sentenced to a year's imprisonment; Ruskin returned to Brantwood "good for nothing but thankful to be as well as I am." When a year later Burden was released, Ruskin helped set him up in a better career.

Venice was very much on Ruskin's mind at this time. In April and July he published chapters upon the mosaics of St. Mark's as an addition to *St. Mark's Rest*, the guide to Venice's basilica that he had written two years before. In May he published a traveler's edition of *The Stones of Venice* with new notes and a new preface. Though Venice might seem a safe subject, in taking it up at that moment Ruskin actually flirted with controversy. Plans were then underway to restore the basilica's finest parts: on the outside, the western façade, and inside, many of the building's finest mosaics. Ruskin considered this sort of restoration to be nothing short of wholesale destruction, and two years before he had composed a letter, translated into Italian and published in Venice, adamantly protesting the project. Now fearing the worst, he vowed to preserve record of the original before it disappeared and commissioned two artists to travel to Venice to do just that. Thomas Rooke, an assistant of Burne-Jones, would draw the mosaics, and John Bunney, once Ruskin's pupil, would record the western façade upon a large canvas. Meanwhile, Edward Burne-Jones and William Morris, who shared Ruskin's horror of the coming restoration, formed the Society for the Protection of Ancient Buildings to coordinate protests throughout England against the destruction. While Ruskin felt unable to participate in any of these, he did his best to keep public interest alive, both through

the reissue of his Venice books and through a circular exhorting the public to subscribe to his project to preserve a record of the basilica. This was enough to disrupt his Brantwood peace—at least a little. "Yesterday very dismal, working on St. Marks mosaics," he wrote on March 17; "my hand trembles with the excitement of the thoughts I have to deal with. Must do a little geology first to cool me down."

In the summer, Ruskin reluctantly added theology to his mix of subjects at the behest of Frederick Amadeus Malleson, the vicar of nearby Broughton-in-Furness. Malleson, having for years done his best with very limited success to engage with Ruskin in serious dialogue, finally that June convinced Ruskin to write several letters explicating, clause by clause, the Lord's Prayer, to be read at meetings of a local clerical society. Ruskin encouraged Malleson to restrict the dissemination of these letters to that little group, hoping to avoid the controversy wider publication would bring. But Malleson had other ideas, and that December published the letters in *Contemporary Review*. As a result, Malleson managed in time to drag Ruskin into the sort of writing he had done his best to avoid.

At the same time Marcus Huish again set Ruskin to work upon a far more agreeable project. For the Fine Art Society's 1879 winter exhibition Huish planned to show watercolors by Samuel Prout and William Henry Hunt, both of them great favorites of Ruskin as a child, but both now largely faded from public consciousness. The opportunity both to write about fairly recent art without engaging in any contemporary controversy as well as to share his memories of a happier past proved irresistible. By the exhibition's mid-November opening, he produced his benign and nostalgic *Notes on Prout and Hunt*.

By then Ruskin had broken his Brantwood seclusion. That September he set forth on a three-month tour, one he clearly designed to be safe: largely avoiding crowds and seeking out places of familial or near-familial comfort. After a few days with the Severns at Herne Hill he moved on to Canterbury and stayed with the Gale family, old friends and also in-laws to the Severns. Early that October he returned north to Walkley near Sheffield in order to sort and assemble the collection he had donated to the little museum he

had created there for the Guild of St. George. While after his madness he had suspended all work for the Guild as too dangerous, he now found this work of preparing his minerals, prints, and paintings for an appreciative working-class audience both appealing and salubrious, an indulgence of the feudal-utopian fantasy that had inspired the Guild in the first place. That fantasy he most fully realized on the afternoon of October 22 when, for half an hour, Ruskin proudly demonstrated the collection to his ex-pupil Prince Leopold while a massive crowd of locals cheered outside. Exhilarated by it all, he briefly considered relocating. "I am thinking of living as much there as possible," he wrote Charles Norton. "The people are deeply interesting to me—and I am needed, for them,—and am never really quiet in conscience, elsewhere." But that, too, was a fantasy.

After Walkley, and after a short visit to the Cowper-Temples at Broadlands, Ruskin returned to Herne Hill. There for the rest of November and the first half of December he kept himself busy with his memories of Prout and Hunt, and by sitting for a portrait by Hubert von Herkomer, as well as for a bust sculpted by Joseph Boehm, whose bust of Whistler Ruskin had seen at the 1877 Grosvenor. At least once he ventured into public and into the metropolis, taking in a lecture at the London Institution by—to Ruskin—a dangerous man upon a dangerous subject: Thomas Henry Huxley, Darwin's bulldog and to Ruskin one of the "schemers of physical science," lectured upon natural selection. "I heard one of the leading doctors explain to a pleased audience that serpents once had legs," Ruskin recorded, "and had dropped them off in the process of development." This troubling materialism prompted Ruskin to contemplate a spiritual rejoinder, which he would deliver three months later in the very same lecture room.

Ruskin returned to Brantwood in mid-December but found very little peace of mind there. At the same time that an illness left him with "more sense of declining vital power than I've ever been conscious of," Ruskin returned to the dangerous subjects that he had for nearly two years avoided, and to the voice—authoritative, admonitory, contentious, prophetic—that he had suppressed.

It was the bothersome Reverend Malleson, in a sense, who brought him back into the perilous territory of political economy. Years before when in *Fors Clavigera* Ruskin had challenged the bishops of England to state their views upon the subject of usury, he had singled out one of them: the bishop of Manchester, James Fraser. He did not know Fraser at all, but had focused upon him because his diocese happened to be the locus of the orthodox political economy that Ruskin deplored—the Manchester school. Nothing came of Ruskin's challenge at the time; few bishops read *Fors*, and Fraser remained unaware. But in one of his letters to Malleson Ruskin repeated the challenge, and when Malleson published that in the December 1879 *Contemporary Review*, Fraser did see it. Though completely baffled as to why Ruskin called upon him by name, Fraser quickly wrote to Ruskin a mild but thorough explanation of his views upon usury, maintaining that loans at reasonable rates of interest were socially useful and morally sound. To Ruskin, for whom any loan at any rate of interest was anathema, that called for a heated—and public—reply. This he began before Christmas. He was encouraged on New Year's Day of 1880 by a bit of bibliomancy, randomly coming upon the New Testament exhortation "these things speak, and exhort, and rebuke with all authority. Let no man despise thee."* "I'm nearly done toasting my bishop," he wrote Susie Beever later in the month; "he just wants a turn or two, and then a little butter." The result, "Usury: a Reply and a Rejoinder," juxtaposed the Bishop's temperate letter with Ruskin's own scathing replies in footnotes, excoriating Fraser's fallacies and fulminating against modern commercialism and industrialism. To these the Right Reverend Bishop refused to reply, considering them nothing more than "the ravings of a lunatic."

By that time Ruskin had taken up an even more dangerous project: he decided to revive *Fors Clavigera*. A member of the Guild of St. George provided the occasion, writing to Ruskin to inform him that the pro-tenant and anti-landlord Irish Land League counted Ruskin among their supporters. On Christmas Day Ruskin replied to this, noting his ignorance of the

* Titus 2:15.

Land League but advocating the private ownership of land—under proper authority. That reply Ruskin had earmarked from the start for a resurrected *Fors*, and it duly appeared nine months later, in September 1880. But long before this—on the first day of 1880—Ruskin began to write a *Fors* letter to be published before that one.

That *Fors* letter—number 88—picked up where the others had left off: with Ruskin's madness of 1878. That madness, he now claimed, had not been caused by overwork at all. No, rather, his readers were to blame:

> I went mad because nothing came of my work. People would have understood my falling crazy if they had heard that the manuscripts on which I had spent seven years of my old life had all been used to light the fire with, like Carlyle's first volume of the *French Revolution*. But they could not understand that I should be the least annoyed, far less fall ill in a frantic manner, because, after I had got them published, nobody believed a word of them.

Having in this way proclaimed the great danger that his public posed to him with its doubt and misunderstanding, Ruskin then courted that danger all over again by recommencing his thunderings, beginning with a denunciation of James Anthony Froude, his acquaintance and a fellow disciple of Carlyle, for his progressive view of history so opposed to Ruskin's regressive one, and by shifting to a lengthy passage by the French politician Jules Simon detailing stomach-turning poverty in the industrial districts of northern France. This *Fors* letter appeared in March.

That winter the plague cloud particularly beset him. January 4, 1880: "The want—for a whole winter—of one pure sunrise! unbelievable and horrible—but fact. How we bear it is the wonder—." January 9: "The hell-fog unbroken . . . fretful and despairing and can't go on with anything—but pull my lips, and stare at the pitch cloud—and wonder if it's the Devil—or the Bishop of Manchester or me, that it's sent for." February 29: "The Abyss of darkness in the *whole* sky today, without fog—is quite awful." March 12:

"But the curse on the sky is my chief plague—If only spring *were* spring! But it's too hard on me, this devil in the wind and clouds and light."

During this dark time Ruskin took dark pleasure in news from Glasgow. At the end of January 1880, a painting, *A Symphonie in Blue and White*, described in the newspapers not only as Whistler's work but as "the *Cause Célebre*" of *Whistler v. Ruskin*, was auctioned off and fetched a paltry twelve pounds and ten shillings. The painting was almost certainly a fake—and certainly not the *Falling Rocket*. If Whistler, then in Venice, learned of this sale, he would certainly have spoken up. Ruskin, too, should have known better. But when a correspondent sent him the details, Ruskin believed the painting he had condemned had in effect been condemned again. He was gleeful: "more pleased . . . than perhaps some of my friends would think it virtuous to be." Replying to his correspondent, Ruskin could not disguise his absolute disdain for Whistler:

> the principal annoyance in the whole matter to me was the way my best friends wrote as if Mr. W. was really something of a dangerous match and antagonist—and their expecting me to answer or debate with him—so that I need not expect my friends to sympathise with any dignities of mine; but they might expect me to express virtuous forgiveness and the like, of which there is no shadow (or light) whatsoever in my mind, but entire satisfaction in all that you tell me in its bearings.

These were to be his last written words about Whistler or about the trial.

Having toasted the bishop of Manchester and blasted Froude, Ruskin in mid-March responded to Thomas Huxley, delivering "A Caution to Snakes" at the London Institute. For once, he showed himself to be surprisingly amiable to his intellectual enemies, acknowledging from the start his respect for both Huxley's and Darwin's genius. It was not the truth of their ideas that he questioned, but rather the *significance* of them: "although it is not necessary for any young persons, nor for many old ones, to know, even if they *can* know, anything about the origin or

development of species, it is vitally necessary that they should know what a species *is*." To that end he looked for inspiration not to any Darwinian Tree of Life but to the Aristotelian Chain of Being, tracing the spiritual rather than the biological descent of the snake from nobler animals: besides being, as Huxley had noted, a lizard with its legs dropped off, a snake was also a bird missing wings, and a fish missing fins. To this Ruskin noted a form of spiritual *ascent* for snakes: "a serpent is a honeysuckle, with a head put on." "All these living forms," he explained to his overflowing audience, "and the laws that rule them, are parables, when once you can read; but you can only read them through love, and the sense of beauty; and some day I hope to plead with you a little, of the value of that sense, and the way you have been lately losing it." The lecture was a great success; "he held us in the hollow of his hand," remembered one spectator. A repeat lecture was quickly scheduled.

Having delivered that and taken a visit from both the elderly Carlyle and the errant Froude, Ruskin returned to Brantwood and his various studies, which that spring and summer grew ever more various. In April alone, he began writing letters to Marcus Huish upon the form and function of museums and picture galleries for publication that June and August; he recommended work upon a short study of poetic meter, for publication that October; he wrote a new preface for a reissue of a twenty-three-year-old work on the political economy of art; and he began his work of literary criticism, *Fiction, Fair and Foul*, to be published in *Nineteenth Century* from June onward. Besides that, there was the revision of his snakes lecture for publication, the setting of a Herrick poem to music, the daily Plato. His diary increasingly revealed the strain; on May 24 he noted "This morning my head so full of crowded thoughts about Museums—Prosody, Clergy, Snakes, Scott, & Byron—all in hand together—that I don't know what to do." Nowhere are the results of that strain clearer than in the several installments of *Fiction, Fair and Foul*. After an insightful chapter tracing the decline of the modern novel in the face of growing industrial squalor, the work quickly digressed from fiction altogether and devolved into a semi-coherent mess, with near-random close readings of Wordsworth,

Byron, and Shakespeare as well as bewildering amblings into medieval French verse and Venetian history. Ruskin cobbled together four chapters over six months, and then dropped the project for a year.

In June Ruskin was enticed, in a sense, into political life, when the president of the Conservative Club at Glasgow University wrote, asking him to stand as their candidate for the university's Rectorship—opposing the ultraliberal politician John Bright. Ruskin wisely declined, declaring himself "not in the least disposed myself to stand in any contest where it is possible that Mr. Bright might beat me." He then grudgingly and unwisely changed his mind and agreed to run. Then he scuttled his chances altogether that October when a hotheaded reply to a student's inquiry about his political views was made public:

> What in the devil's name have *you* to do with either Mr. D'Israeli
> or Mr. Gladstone? You are students at the University, and have
> no more business with politics than you have with rat-catching.
>
> Had you ever read ten words of mine you would have known
> that I care no more for Mr. D'Israeli or Mr. Gladstone than for
> two old bagpipes with the drones going by steam, but that I
> hate all Liberalism as I do Beelzebub, and that, with Carlyle,
> I stand, we two alone now [in] England, for God and the Queen.

Not surprisingly these choice crotchets found a wide circulation, and an embarrassed Ruskin soon found himself apologizing to his very offended friend Mary Gladstone. Three weeks later Bright trounced Ruskin, 1,128 votes to 814.

By that time Ruskin was in France. He had set out in August with his secretary Laurence Hilliard, as well as Hilliard's mother and sister. That comfortable, familial arrangement, as well as continually blessed weather, made for a pleasant tour of the cathedral towns of northern France. Ruskin had come with an ambitious project in mind: to write ten extended episodes of Christian history. In the end, he produced one, in *The Bible of Amiens*—a volume on Frankish history and culture, and its realization in the Cathedral

of Amiens. On October 17, in Amiens, he began to write that book. But before he did he had another work to finish, of a very different kind: his second *Fors* letter for that year, for which he had transformed his original thoughts upon the Irish Land League into a fairly moderate expression of solidarity with the aims of the trades unions, to whom he offered this issue free of charge. He thought the letter—"the most important *Fors* I have yet written"—incendiary, its copies "dainty packets of dynamite" that were sure to get him into trouble. But when the letter came out there was little reaction beyond some bafflement by the unions at his offer.

Ruskin had intended to return from France to Brantwood at the beginning of October but changed his mind. Instead, after a short visit to Canterbury, he returned to Amiens for another month, this time with Arthur Severn and two of his artist friends. While Ruskin professed to enjoy this bachelor's expedition, he returned to England at the beginning of November overexcited and drained. When he traveled to Eton on the 6th to give as a lecture the first chapter of his *Bible of Amiens*, Arthur Benson, the young Etonian assigned to look after him, was astounded by the lecture, "an inspiring, appealing, intensely moving performance." But Benson was acutely aware, as well, of Ruskin's profound inner darkness. "I felt that he was a great man, with great and beautiful beliefs passionately held, yet both oppressed and obviously unhappy. He was contending with something, perhaps a vulture gnawing at his heart, like Prometheus. There was never a sign of placid or easy mastery; no appearance of enjoyment, even of interest; it was a duty he had to perform, a service he might do; and at the end he looked old and weary."

After a few weeks in London, working on proofs of his *Bible of Amiens* and putting in a few hurried days of work at the National Gallery upon a new catalogue of Turner's drawings, Ruskin returned alone, "much beaten and tired," to Brantwood. Throughout December 1880 and January 1881 his diary entries reflect sadness, but also calmness and clear-headedness. On February 4, however, his writing abruptly breaks off, followed by a fully drawn *cross pattée*: ✚. This almost certainly marked the death of his *papa* Carlyle on February 5. While he did write ten days after this to Mary

Gladstone that Carlyle's death "is no sorrow to me," he was surely lying, to her and to himself. He recommenced his diary on the day he wrote her, and for five days lucidly recorded the events of placid days—but sleepless nights.

On the sixth day, his wild delirium returned.

———

No sooner had Whistler escaped the Show than he found himself desperately wishing to return to it. "I am bored to death after a certain time away from Piccadilly!" he complained to his sister-in-law Helen within weeks of arriving in Venice. "I pine for Pall Mall and I long for a hansom!" The Italian language he thought mean and unappealing, the food foul, the people insignificant. He saw himself as "struggling on in a sort of Opera Comique country when the audience are absent and the Season is over!"

Most hateful of all was the unrelenting cold. "No winter like this known for at least thirty years," he reported without exaggeration to Helen at the beginning of 1880, "and at last I am getting very much depressed." Bitter weather destroyed any chance of Whistler's fulfilling his contract to the Fine Art Society for twelve etchings in three months. When he was not actually trapped indoors suffering "the rage of the pent up painter," he found himself unable to hold copperplate or etching needle and was forced instead to draw in pastels. When Marcus Huish wrote Whistler in mid-January 1880 pressing him to hurry home with his plates before the market for them cooled, Whistler balked. "I can't fight against the Gods," he insisted, and attempting to do so—"standing in the snow with a plate in my hand and an icicle at the end of my nose"—had only made him ill with a severely ulcerated throat. Worse, his advance had run out: he was starving, he told Huish, or would be soon. "You had better send me fifty pounds at once and trust to a thaw which will put us all right."

Huish sent him the money—lent with interest, he made clear—and exhorted him again to "hurry back with all your trophies."

Whistler had no intention of hurrying back. The frigid weather, he eventually realized, had been a blessing in disguise, for "it has opened for me a

mine that I might otherwise have left undiscovered—simply rushing back to London with the etchings of infinitely less rare beauty that I doubtless should have completed in a few weeks had I not been made a prisoner by the ice and snow." By spring he had become dizzied with the abundance of beauty and was greedy to capture it all. "After the wet," he gushed in the last letter he ever wrote to his mother, "the colors upon the walls and their reflections in the canals are more gorgeous than ever—and with sun shining upon the polished marble mingled with rich toned bricks and plaster, this amazing city of palaces becomes really a fairyland—created one would think especially for the painter." Especially for *this* painter, he meant, telling Huish: "I have learned to know a Venice in Venice that others seem never have to perceived." He left to "the foolish sketcher" the hackneyed tourist scenes and genre pictures. He left to Ruskin's surrogates Rooke and Bunney the precise replication of the city's threatened monuments. *His* Venice was a purely Whistlerian one: "great pictures that stare you in the face—complete arrangements and harmonies in color & form that are ready and waiting for the one who can perceive."

He could not forget about London completely. He remained obsessed in particular with the circumstances of the artwork left in the hands of his creditors, and through correspondence with his sister-in-law as well as his friend Matthew Robinson Elden he learned in the early months of 1881 of the disappearance of several of his paintings, including *The Loves of the Lobsters*, *Mount Ararat*, and the *Three Girls*. He suspected that Leyland and Howell had conspired to purloin them, Leyland in order to destroy the first two as personal insults, Howell to profit from the last. This was the beginning of the end of his alliance with Howell.

Still, Venice had captured him. Altogether ignoring his deadline with the Fine Art Society, Whistler throughout the spring, summer, and autumn of 1880 threw himself into Venice's "entanglement of beautiful things." Accompanied always by his personal gondolier, he worked from dawn to dusk upon half a dozen subjects or more, shifting from one to another, from copperplate to pastel, as his mood and as the light moved him. For his etchings, he adopted a technique characterized by the striking

shortness of his lines and by the dramatic use of linear minimalism and empty space. Though this technique was not entirely new to him, while in Venice, capturing a canal scene, he realized that it was nothing less than "the secret of drawing":

> I began first of all by seizing upon the chief point of interest. Perhaps it might have been the extreme distance,—the little palaces and the shipping beneath the bridge. If so, I would begin drawing that distance in elaborately, and then would expand from it until I came to the bridge, which I would draw in one broad sweep. If by chance I did not see the whole of the bridge, I would not put it in. In this way the picture must necessarily be a perfect thing from start to finish. Even if one were to be arrested in the middle of it, it would still be a fine and complete picture.

He showed a similar sensibility with his pastels. Working always with colored paper—usually brown—to establish a prevailing tone, he sketched in the scene with finely sharpened black crayon with the precision of an etching needle, and then, generally restraining himself in both variety of color and extent of space, he would loosely rub in whites, blues, and reds, the roughness of the paper evoking the textures of the scene: coarse stucco, mottled sky, speckled water.

By the end of his stay he had created over fifty copperplates—and fully one hundred pastels. He loved every one of them. The etchings he thought "far more delicate in execution, more beautiful in subject and more important in interest" than anything he had done before. Not only were the pastels "complete beauties," they were revolutionary, "something so new in Art that every body's mouth will I feel pretty soon water": and soon, he was sure, everyone would be imitating them. Marcus Huish was convinced by Whistler's enthusiasm; sight unseen he agreed to devote a separate exhibition to them and set about procuring fifty frames for the purpose.

As for paintings that year, since neither Huish nor anyone else had commissioned them, Whistler produced few: the odd watercolor as well

as two finished oils, both of them nocturnes. The first of these, *Nocturne in Blue and Silver: the Lagoon, Venice*, echoes his earliest Thames nocturnes. The other, *Nocturne: Blue and Gold—St. Mark's, Venice*, is something quite new: a depiction of the basilica stripped of detail by looming darkness. Sculpted doorways become empty caves, amorphous cupolas fuse into the inky cobalt sky. Only the barest hints of human construction remain, including, significantly, in the lower left, the muted scaffolding that told of ongoing restoration.

It was that restoration, of course, that had prompted John Ruskin to pay John Bunney to capture, before it was too late, St. Mark's in photographic detail. Bunney according to Ruskin labored fully six hundred days on this project, and he was in 1880 a constant presence upon the Piazza San Marco. When Whistler came upon him there one day, he could not resist taking a palpable if juvenile swipe at Bunney's questionable artistic sensibilities—and by extension those of his sponsor. "I am totally blind," he wrote on a placard, and attached it to the unsuspecting Bunney's coattail.[*]

1880 was the most productive year of Whistler's life. It was also one of the least comfortable. Huish's £150 advance had lasted only until February and the additional £50 Huish sent him then could not have lasted much longer. Huish would not send another penny for another nine months. Whistler and Maud struggled, living on "cat's meat and cheese parings," he claimed. He at least found relief in trading wit for food at the homes of wealthy American residents of the city—his distant relative Katherine de Kay Bronson, for example, or the American Consul John Harris. Maud, barred for propriety's sake, was not so fortunate. Whistler also borrowed shamelessly and incessantly, complained fellow artist Henry Woods: "there

[*] Another curious run-in Whistler had that year was with Harry (or 'Arry) Quilter, his successor at the White House. When Whistler in his gondola came upon Quilter in his, sketching the doorway that became the subject of one of Whistler's finest etchings, Whistler stridently claimed the space and the subject as his own. Quilter suggested they share his gondola. Whistler agreed, and spent the rest of their time together pretending not to know who his companion was while excoriating that horrible excuse for a critic in London: 'Arry Quilter. (Quilter, 141)

is no mistake that he is the cheekiest scoundrel out. I am giving him a wide berth. It's really awful." Others, however, acknowledged that Whistler repaid his debts, and even managed to give back by hosting Sunday breakfasts, Venetian style: cheap fried fish and cheaper wine, as well as the landlady's polenta doused with syrup.

The revival of the breakfasts was a sure sign that Whistler's winter depression had passed: the season was in full swing—and now he had an audience, thanks to the arrival from Germany to Venice of American artist Frank Duveneck and his many pupils. The "Duveneck boys," as they were known, soon became Whistler's pupils as well, and provided him throughout the summer and into the autumn with satisfying companionship tinged with even more satisfying adulation. The boys lodged on the Riva San Biagio, which had a stunning view of the lagoon; Whistler visited them there in June, fell in love with that view, and moved in with Maud soon after. The Duveneck boys accompanied Whistler upon his creative expeditions. They fell into a routine of early morning bathing with him in the lagoon. They spent long bohemian evenings with at the Café Florian on the Piazza while Whistler held court "praising France, abusing England, and thoroughly enjoying Italy."

When in late August Whistler hinted he might soon return to London, they threw him an elaborate fête, with heavily festooned procession of barges and gondolas along the Grand Canal. The send-off, however, was premature: the boys left Venice long before Whistler did. By October Marcus Huish was pressing him again to return. Whistler was amenable—if Huish would advance him a further £100 for expenses. When Huish sent only £50 in the face of his board's objections, Whistler savaged them for their obtuse stinginess. Huish quickly sent the other £50. Still Whistler hesitated. He finally returned in late November. "Keep it dark and on the strict QT," he had directed Willie and Helen, "for I don't want anybody to know until I am in full blaze." He surprised everyone when, more flamboyant than ever, with a thin bamboo cane in one hand and a ribbon-leash connected to a little white Pomeranian in the other, he strolled into the Fine Art Society exhibition of great English etchers, screwed his monocle into one eye, and

scrutinized his peers' work: "'Dear me!' I said. 'Still the same old sad work! Dear me!'" His brother-in-law and fellow exhibitor Seymour Haden stood nearby, pontificating about Rembrandt; Whistler barked a "Ha! Ha!"—and Haden vanished.

Whistler was back. And this time he intended to conquer.

———

Setting up Maud in a Pimlico boardinghouse, Whistler moved into his brother Willie's home in Marylebone and immediately set to printing out his first Venice set of etchings, working at first upon a press that Huish set up at the Fine Art Society and then upon one in rooms obtained for him on Regent Street. At the same time, he began to gather up what would soon become a small army of supporters and adherents—the "followers" who would be instrumental in promoting his cause in the years to come. Tom Way was the first of these, as he and his father Thomas, Whistler's lithographer, assisted Whistler in his printing. The young Australian artist Mortimer Menpes soon joined them. Then a student under Edward Poynter at the National Art Training School, Menpes sought out Whistler within days of his return to London. "The moment I saw him," Menpes recalled, "I realised that I had at last come into contact with a master. I became conscious that I was meeting face to face one of the greatest painters living. From that hour I was almost a slave in his service, ready and only too anxious to help, no matter in how small a way. I took off my coat there and then, and began to grind up ink for the master."

Over the next few months they would be joined by Julian and Waldo Story, sons of American sculptor William Wetmore Story, by Harper Pennington, also an American and formerly a Duveneck boy, by Frederick Lawless, son of an Irish peer, and by Rennell Rodd, who had been encouraged by Burne-Jones to take up art, but would soon take up diplomacy instead. In 1882, Walter Sickert would flee Alphonse Legros's classes at London's Slade School to become—with Menpes—Whistler's chief worshipper and vassal. ("The Whistler Followers were privileged people," noted Menpes,

"but among them there were only two genuine pupils. These were Walter Sickert and myself.")

Whistler, intent upon creating individualized masterpieces of every one of his Venice etchings, refused to relinquish command of the process and was mortified when Marcus Huish, hoping to attract more visitors to the exhibition they were planning with a little showmanship, informed Whistler that he had engaged a printer to entertain spectators by churning out Whistler proofs upon presses set up in the Society's showrooms. "Look here my dear Huish," Whistler barked at him, "I have not taken all of this trouble for you in order that the public should 'be amused' by either any printing tricks or spun glass or meerschaum pipe making in the place . . . You had better *lose no* time in getting the *two presses out of the way* in order that there *may* be room for the people." Huish obeyed.

The exhibition opened at the beginning of December 1880. Preoccupied with printing, Whistler for once gave little thought to display—and it showed. Even his friend Edward Godwin chided him on slapdash appearance of the etchings, "arranged on a maroon-coloured cloth, with rough chalk numbers underneath, and not in sequence, possibly a quaint conceit on the part of the etcher, but not conducive to the convenience of the visitor." Still, crowds came, and so did the critics. Their reviews were mixed at best; for each one who admitted to "the great artistic value of his etchings," there were others who dismissed them as "clever though disappointing" and compared them unfavorably to his earlier work. Harry Quilter found them "interesting," but deplored them for not representing "any Venice that we much care to remember; for who wants to remember the degradation of what has been noble, and the foulness of what has been fair?" Sales of the etchings were slow, and it would be years before the Fine Art Society recouped its investment. But Whistler at least recouped *his* investment, for Huish paid him the remainder of his Venice commission that December.

For the exhibition of his pastels, which commenced at the end of January 1881, Whistler avoided the mistake he had made with his etchings and transformed the gallery into what Maud described as "an arrangement in

brown gold & Venetian Red," and set in it fifty-three pastels in carefully chosen frames of yellow, pink, and green-gold. The effect was stunning, and critics were appreciative. "The mere method of display is a triumph of 'tone,'" the writer for the *Telegraph* raved; "The arrangement of the room will be a lesson to aesthetic visitors, in the now favourite amusement of domestic decoration." Those aesthetic visitors came in droves. The pastels "are the *Fashion*," Maud rhapsodized in a letter to one of the Duveneck boys. "All the London World was at the private view—Princesses Painters Beauties Actors—everybody." Everybody, Maud was sure, was captivated by the pastels; "even Whistler's enemies were obliged to acknowledge their loveliness," and the critics "are one & all high in their praise." She was wrong—but not by much. True, many critics noted, as did the one for the *Pictorial World*, that the pastels had been "done with a swiftness and dash that precludes anything like care and finish." But rather than attack Whistler for his lack of finish, as they had done for years, most were finally beginning to realize that his ability to capture an impression quickly and confidently was an asset. "Venice," observed the critic for the *Standard*, "has not sat to Mr. Whistler for the portrait of its permanent features, but for its speedy seizure of its passing expressions. And though the work thus done is undeniably sketchy, is the very shorthand of art—it is yet generally, within the limits which it sets itself, faithful, significant, and vivid." Harry Quilter agreed, arguing that Whistler's method "commends itself to an impressionist, and conveys to us the feeling and perception of transient beauties which are too often missed in the more deliberate and less impulsive efforts of the orthodox student."

An astounding 42,830 people came to view Whistler's pastels.* And this time they came to buy. "Four hundred pounds' worth went the first day"

* Those numbers were certainly helped by the fact that the Fine Art Society, at the same time, was showing in the adjoining gallery a full retrospective of John Everett Millais's paintings, a retrospective, incidentally, that included *The Order of Release*, Millais's first painting of Effie—then Effie Ruskin, now Effie Millais. Millais attended the opening for Whistler's pastels, was charmed, and told Whistler so. "Magnificent, fine—very cheeky—but fine!" was his judgment. (*Belfast News-Letter*, Feb. 26, 1881, 3; Pennell, *Life* [1919], 203)

enthused Maud; "now over a thousand pounds worth are sold—the prices range from 20 to 60 guineas—and nobody grumbles at paying that for them." Nobody grumbled, that is, except perhaps Whistler, who chafed at the Society's policy of paying its artists only after an exhibition ended, and who solved that problem with characteristic aplomb, as he later recounted:

> The next Saturday afternoon, I came just when the crowd was thickest, and everything was going beautifully, Huish and Brown taking people round and showing them and explaining the pastels, on the point of selling many, and I stood in the little central gallery, and I said in a loud gay voice, Well, the Show's over. Huish and Brown rushed up and tried to quiet me. Everybody was in a fearful agitation. But I said again, The Show's over: Ha! ha! they will not give me any money and the Show's over. Finally, Huish promised to give me a cheque on Monday—I had first asked for two hundred pounds; now I made it three hundred, and so I said, All right, the Show can go on. And on Monday I had my cheque.

With *Mr. Whistler's Venice Pastels*, a taste at least of the success that Whistler had for so long promised his mother would come, had come. But his mother was never to know. On January 31—the day his exhibition opened to the public—Whistler received word that Anna was deathly ill. He and Willie rushed to Hastings but were too late. For a week Whistler suffered agonies of guilt; he had hardly written her while in Venice and had not seen her at all after his return. He was haunted again at the thought of giving up her God for his own whimsical goddess, lamenting "It would have been better had I been a parson as she wanted!" All of that, however, quickly passed when, after her funeral, he returned to London.

The windfall that the pastels had brought allowed Whistler to treat Maud more generously; "I've just been enjoying myself," she wrote that April, "and have managed to spend a hundred pounds on myself—what do you think of that, after the impecuniosity of Venice?" Whistler was able

to begin paying down his debt for both the *Mother* and the *Carlyle* to the dealer Henry Graves, though it would be years before he would regain any of the five paintings—including the *Falling Rocket*—then in Graves's possession. Whistler's success with the pastels, however, hardly entailed permanent wealth, and in the years to come dry spells with sales, as well as inveterate carelessness with money, would again lead Whistler into trouble. Still, he never again faced the distress he faced during the worst days of the Show. He had established a close connection with the Fine Art Society and would soon establish connections with French and American Galleries as well, guaranteeing him an income, if sometimes a sporadic one. Moreover, the disciplined productivity he had established in Venice remained with him after his return. Though still ambitious to score hefty commissions with large society portraits, his success with his pastels had impressed upon him the advantages of generating a profusion of smaller works. He was soon roaming London and further afield seeking inspiration for the plein air works he generally painted on surfaces smaller than a foot square. Shopfronts became a favorite subject. He painted and etched seascapes, street scenes, cottages, women's heads, and nocturnes. He worked now both in oil and in watercolor, a medium he had until now largely avoided. *Notes*, he generally called these works, and for a time he stockpiled them, expecting great things once he revealed them.

The summer after their return from Venice, Whistler and Maud moved back to Tite Street. Reclaiming the White House, of course, was now impossible, for not only did Harry Quilter possess it; he was in the process of altering its design beyond recognition. He had already gutted and renovated the building's interior, and would soon do the same to the exterior, tearing off the distinctive green roof and replacing it with a more conventional façade. Whistler instead moved into a home and studio next door, and so was witness to this desecration. "What of the 'Society for the Preservation of Beautiful Buildings?'" Whistler howled to the *World* in October 1883. "Where is Ruskin? . . . Shall the birthplace of art become the tomb of its parasite in Tite Street?"

Whistler quickly established his new studio as a hub of aestheticism. He redecorated, painting over the "execrable" walls with harmonious colors: a "sort of grey flesh-tint" in the studio, a "strangely vigorous blue-green" in the dining room, and yellow almost everywhere else, leading Charles Howell to joke that visiting Whistler felt "as if standing inside an egg." His followers flocked to his studio daily; he rarely painted there now without an audience. He began again to collect blue and white china. His recommended Sunday breakfasts became more the fashion than ever. Lillie Langtry graced one of the first of these and Whistler made the most of that opportunity: not only did he convince her to sit for a portrait, but he apparently persuaded her to entice her friend and erstwhile lover, the Prince of Wales, to visit. "You will be pleased to hear that H. R. H. smoked a cigar in the Studio this afternoon," Whistler boasted in September 1881 to his sister-in-law; "the 'Royal Boy' was of course most charming."

From across Tite Street came two more acolytes. Frank Miles had by then made a name for himself with his drawings of society beauties for *Life* magazine; Lillie Langtry credited Miles with launching her to fame. Miles's housemate, Oscar Wilde, had gained even greater celebrity. Thanks largely to a flood of popular cartoons by Whistler's old friend George du Maurier in *Punch*, and to a series of caricatures of him in the theatres, Wilde had become the very face of aestheticism. One caricature in particular—the languid, lily-loving Reginald Bunthorne in Gilbert and Sullivan's smash operetta *Patience*, which had opened that April—would propel Wilde to international fame when at the end of the year the show's producer Richard D'Oyly Carte would contract him for a speaking tour of the United States meant to drum up interest for the American production of the show. Until then, Wilde took his place among Whistler's devotees and commenced his widely reported battle of wits with the master: relatively benign at first, but ever tending to the caustic—especially on Whistler's side. From the first, Wilde in this way distinguished himself from Whistler's followers: they might dedicate themselves to fighting their master's battles—but Wilde remained squarely committed to fighting his own.

Two veterans remained among Whistler's young recruits—for a time. Matthew Robinson Elden, who had been subpoenaed for *Whistler v. Ruskin*—but didn't testify—and who had been Whistler's London eyes and ears while he was in Venice, had seemingly conjoined himself to Whistler after his return. "There was one man who was always there, all day long, and we just hated him. . . . He was Whistler's shadow," remembered one visitor to Tite Street. Another recalled him as a "sort of claque" cheering on Whistler's every brushstroke, or himself drawing pictures "often full of talent, but always mad." Elden lingered on until the beginning of 1883, but then according to Whistler he became "hopeless—domesticity and whisky having proved too much," and was carted off to Bethlehem Hospital. He died, "raving mad," two years later.

Charles Howell, on the other hand, fell away much more quickly. While still in Venice Whistler, convinced of his double-dealing, had soured upon him, and had returned to London "devoted . . . with the pertinacity of the Redskin to the scalping of Howell." His chance came in June 1881 with the discovery of yet another example of Howell's perfidy—one that stretched back to 1878. Whistler, then moving into the White House, had sold a Chinese cabinet to Sidney Morse, the man who moved into Cheyne Row after him. He left the transaction to Howell, who proceeded to break the cabinet into two parts, giving the bottom half to Morse and taking payment while pawning the top half and pocketing that money. Time passed; angry letters flew back and forth; Howell made excuses; solicitors got involved. For three years the Chinese cabinet remained divided—until that June Whistler somehow happened upon the pawnshop that contained the upper part, redeemed it, and delivered it himself to a grateful Morse. Whistler then gathered up the full correspondence of the affair and exposed Howell's deceit in a published pamphlet. With that, he considered Howell scalped and dead—to him.

Whistler's return to Tite Street came with renewed plans to "paint all the fashionables." The fashionables indeed flocked to his studio; they ate his breakfasts and marveled at his décor, admired his performances before the easel, and—perhaps—admired the results. But few were willing to buy,

and fewer still willing to sit for him. The suspicions about his paintings that Ruskin had voiced three years before had not disappeared; to sit for Whistler was to court notoriety. True, Lillie Langtry, the most in-demand sitter at the time, had allowed Whistler to paint her. But neither she nor her estranged and impecunious husband nor her royal ex-lover were willing to pay for that painting. And in the end, there *was* no painting: Whistler reached the same creative impasse with Langtry that he had reached so many times before, and their sessions lapsed. "What became of that unfinished picture and the yellow robe in which he was painting me?" Langtry wondered, four decades later; "both are still in existence I fancy." She might have been right about the robe. She was wrong about the painting.

Henry Cole, renowned as chief organizer of the Great Exhibition of 1851, and the father of Alan Cole, was another fashionable willing to sit—but not to pay.* That portrait, too, Whistler could not finish, but this time it was not his fault—or, perhaps, it was. From December 1881 until April 1882, Whistler had the seventy-three-year-old pose for him in evening dress and wearing a heavy cloak. In mid-April he became ill, but continued to pose, and on the 17th did so for an hour and a half while, Cole complained to his son, Whistler "merely touched the light on his shoes." Henry Cole died the next day, and Walter Sickert, for one, was certain Whistler had killed him.

With willing fashionables in short supply, Whistler turned to models. As usual, he painted Maud repeatedly. Three times he attempted to paint his sponger Matthew Elden—and three times gave up. He painted a young girl named Maud Waller—"quite a pet of Whistler's" at the time, thought her uncle—wearing a blue gown of Whistler's design. Despite agonies of painting and repainting, Whistler could never be satisfied with this *Scherzo in Blue*. Though it was obviously unfinished, he submitted it anyway to the 1882 Grosvenor exhibition—and then pulled it after one day. He tried showing it again two years later at a one-man show, and spent hours upon

* Whistler hoped that Cole would at least give him £30 for the copyright so that Cole could reproduce the portrait in his memoirs. Cole declined even that. (*Correspondence*, James Whistler to Henry Cole, Mar. 29, 1882, GUL 03571)

a ladder the morning before the opening, frantically attempting to get the girl's mouth right. ("It was terrible to watch him," remembered Mortimer Menpes. "He kept on painting the mouth, rubbing it out and repainting it; still it mocked and defied him.") Both times the critics assailed mercilessly this "scarecrow in a blue dress." Whistler then set aside the work for another two years. When he attempted to return to it, Maud Waller had grown too big for the dress.

Whistler even turned for a model to his erstwhile creditor, Walter Blott—quite likely to recover a painting he had given Blott as collateral before his insolvency. But not only did Whistler never finish painting Blott, quite possibly he never began. For no sooner had Whistler made arrangements with Blott than he began as before to fend him off, this time in order to make way for his one bona fide commission of 1881: a stunning 1,500 guineas for not one but three full-length portraits of Valerie Meux.

Valerie Meux was beautiful. Her husband, Henry Meux, was heir to a brewing fortune. He was also the son of a baronet and would become baronet himself, making his wife a lady, in 1883. But Lady Meux was hardly one of the fashionables that Whistler had dreamed of painting. She had been born Susan Langdon, daughter of a Devon butcher, and had been the mistress of a corporal in the Life Guards before Henry Meux met her in a Holborn casino, fell in love, and married her. The Meux family despised her. Polite ladies would have nothing to do with her. Valerie Meux didn't care. Nor did she care whether in sitting for Whistler she courted notoriety. She relished her status as an outsider, and in that way saw Whistler as a kindred spirit. "I suppose we are both a little *eccentric* and *not* loved by *all* the *world*," she wrote him years later. "Personally I am glad of it as I should prefer a little hate." With her husband's money she could have sat for any artist, but she decided that Whistler was the one to capture her beauty and her audacious spirit. She was right.

Whistler decided to paint all three portraits at once, each one designed in a different way to flaunt her wealth: one in pink silk, one draped head to toe in sables, and one in a black dress, stunning white stole, and the £10,000 in diamonds her husband had showered upon her. That last pose

Whistler, inspired, finished first. Julian Hawthorne, son of the American novelist, and his wife, Minnie, visited Whistler that summer; for a week they observed Whistler painting Meux. Minnie marveled at the results, and particularly at Whistler's uncanny ability to give depth to the total darkness of his background. "What he does," she was certain, "no other man can do." Julian, on the other hand, was dazzled less at the results than by Whistler's aggressive painting style:

> Whistler held in his left hand a sheaf of brushes, with monstrous long handles; in his right the brush he was at that moment using. His movements were those of a duellist fencing actively and cautiously with the small sword. The picture was his antagonist; but his eyes were on the dais. He advanced and retreated; he crouched, peering; he lifted himself, catching a swift impression; in a moment he had touched the canvas with his weapon and taken his distance once more.

By September 1881 Whistler had essentially completed this *Arrangement in Black*. His *Harmony in Pink and Grey*—Valerie Meux in silk—soon followed. But the third painting, *Portrait of Lady Meux in Furs*, gave him trouble. At least three years after Whistler began it, Valerie Meux was still posing for it, and losing patience. Their last session ended badly, with Meux reducing Whistler to fury and uncharacteristic helplessness with a threat that amounted to an aesthetic insult: "see here, Jimmy Whistler! You keep a civil tongue in that head of yours, or I will have in some one to *finish* those portraits you have made of me!" After that, Lady Meux sent her maid to pose for her; Whistler retaliated by painting the maid's face over the Lady's. In 1886 Meux had her furs altered, making further sittings impossible.

Soon after Lady Meux began to sit for him, Whistler had found another Lady he felt compelled to paint: "the Moon-Lady, the Grey Lady, the beautiful wraith with beryl eyes," as Oscar Wilde described her. Janey, Lady Campbell—or, to Whistler, "Lady Archie"—*was* a fashionable and a respectable, once ward and now daughter-in-law to the Duke of Argyll.

She was Whistler's friend and an aesthetic fellow traveler: she painted her own rooms in the spirit of Whistler's *Peacock Room*, she staged with Godwin's help Shakespeare plays outdoors at her country estate, and, in 1886, she would publish her *Rainbow Music*, in which she would attempt—awkwardly—to elaborate upon Whistler's ideas about the parallels between painting and music. She was also beautiful, and agreed to pose for a series of portraits. She did not agree to pay, however, making it clear at her first sitting that her husband refused to be considered as commissioning anything. ("Dear me, no," Whistler replied, "we are doing this for the pleasure there is in it.") Whistler first posed her in elaborate court dress but gave that up when she found that too fatiguing. He made a quick study of her playing Orlando in *As You Like it*. He then attempted to paint her descending a staircase: a "harmony in silver greys." She thought it a masterpiece of drawing, but he was not satisfied, and let it lapse. Finally, he posed her, as he had posed Lady Meux, for an *Arrangement in Black*—but posed her in a strikingly contrastive way. For while Lady Meux emerges boldly out of the darkness, Lady Archibald stands on the brink of plunging into it. Her back to the viewer, she turns her head for a haughty backward stare. In stepping away the hem of her skirt is raised, provocatively revealing the yellow-brown boot that eventually gave the painting its present title: *The Lady with the Yellow Buskin*. The painting certainly captured Lady Archie's independent spirit. Her family, however, thought it captured more—and less, dismissing it as depicting "a street walker encouraging a shy follower with a backward glance." They managed with their objections at least temporarily to shake Lady Archie's faith in Whistler's genius. The French art critic Théodore Duret, whom Whistler was also painting at the time, remembered her bursting into Whistler's studio to demand that he change the painting completely, leaving Whistler "utterly discouraged" at the corrosive power of uninformed opinion. It was up to Duret to chase Lady Archie to her hansom and convince her that if she did not return the world would lose a masterpiece.

Duret succeeded. Lady Archie returned. And, though it hesitated to acknowledge it, the world got its masterpiece.

CHAPTER 9

LA FORTUNE

n the autumn of 1881 and in the commencement of a decade-long campaign to win over the public on both sides of the Atlantic to his art through and ever-wider exhibition of his works, Whistler sent *Arrangement in Grey and Black No. 1*—his *Mother*—to the United States. It was an inspired choice. For though the American public had never seen the original, they were familiar with it both by reputation and by reproduction in a number of art magazines: it was, according to the critic for the *New York Times*, "famous" and "an old acquaintance." It hung at Philadelphia's Pennsylvania Academy of Fine Arts until the end of the year before moving in the spring of 1882 to the Society of American Artists' exhibition in New York City. In both cities the painting was universally held to be the greatest of the show, and Whistler himself acknowledged to be the greatest of American artists. "It is a very extraordinary performance," raved the *New York Times*. "No other painter has the distinctive quality that Mr. Whistler shows; he is thoroughly original, and at the same time handles his work in a way that may surprise painters, but is also certain to arouse their interest, if not their envy."

As he won over Americans with his *Mother*, he aimed to do the same with both the English and the French with Lady Meux, sending that spring

his painting of her in pink silk, with six other paintings, to the Grosvenor and his black and white portrait of her to the Paris Salon. Surprisingly, perhaps, the pink Lady garnered the better reviews, critics considering that painting "clever," "charming," and "delightful," if also eccentric and audacious. (Henry James, however, disagreed, deriding Whistler as "the buffoon of the Grosvenor" and ridiculing the depiction of Lady Meux for her ill-fitting hat and the unnatural skin tone.) Parisian critics, on the other hand, were confused by the dark Lady Meux, thinking it "strange," "dismal," "a premeditated error," and a muddle compared to Whistler's etchings, which, all agreed, were masterful. Parisian *artists*, however, were more impressed: "An astonishing Whistler," Edgar Degas thought it, if "over-refined."

For the rest of 1882, preoccupied with painting Lady Archie and then, in December, with creating "nocturnes—and various" on a working vacation in Amsterdam, Whistler refrained from exhibition. At the beginning of 1883 he began preparations for his most ambitious one-man show yet—not of paintings, but of a second set of Venice etchings. At that exhibition, which opened at the Fine Art Society that February, production arguably outshone product. Titling it *Arrangement in Yellow and White*, Whistler saturated everything in those two colors: walls, flowerpots and flowers, chairs, tables—even the horribly self-conscious attendant in livery handing out catalogues. Though press and public debated as to whether the resulting "practical joke for the amusement of the public" was a good or a bad one, Whistler himself was euphoric. "Great Shebang," he wrote; "all the world there—Lady Archie—the Prince—and Various!—especially Various!—great glorification—and the Butterfly rampant and all over the place!" The Whistlerian butterfly, equipped with stinger, was particularly rampant in the catalogues, into which, for the first time—and not for the last—Whistler aimed to humiliate his critics with their own words, flinging back at them over eighty of the choicest stupidities they had flung at him over the years: "Another crop of Mr. Whistler's little jokes"; "in Mr. Whistler's productions one might safely say there is no culture"; "form and line are of little account to him." The critics harrumphed about this assault upon them, and they generally dismissed his etchings as at best uneven and at

worst unpleasantly impressionistic. Whistler didn't care. The catalogue itself became a bestseller, the etchings gave him a guaranteed income for years, and—most importantly—he had again made himself the talk of London.

Meanwhile he did his best to become the talk of Paris as well. To the Galerie Georges Petit, a venue that, with its pleasant ambiance and its mission to show the strikingly modern in art, had become a Parisian counterpart to the Grosvenor Gallery, Whistler sent seven paintings, four of them nocturnes and one the *Falling Rocket*. Though the nocturnes generated the usual bafflement, they did gain the admiration of the noted French critic Alfred de Lostalot, whose praise of their ability to "express the inexpressible: form without form, color without color" indicates the beginning of a significant perceptual shift toward Whistler's most challenging works. But it was not with these that Whistler's greatest hope for Parisian acclaim lay that year but with the *Mother*, which he sent to that year's Salon hoping with it to win entry into the French *Legion d'Honneur*, a distinction regularly awarded to the Salon's outstanding foreign exhibitor. He might have won it: certainly, the *Mother* was one of that exhibition's most admired paintings. But he ruined his chances, apparently because of annoyingly dogged campaigning. He directed Walter Sickert, Oscar Wilde, and Waldo Story—all of them then in Paris—to badger the Salon's jury, to "move Heaven and Earth to show them . . . that the Amazing one alone should have the bit of red ribbon he requires!" He then traveled to Paris to exert his own pressure. The American artist Mary Cassatt, for one, thought that Whistler behaved "like a fool," and that the jury responded by punishing him with a lowly third-class medal.

After its perplexing showing in Paris, the *Falling Rocket* became Whistler's second painting to cross the Atlantic for exhibition, joining his exhibition of the year before—the *Arrangement in Yellow and White*—as it moved from Bond Street to Broadway, to open that October in the Galleries of Wunderlich and Co., Whistler's preferred American dealer. American reactions to the etchings and to the arrangements paralleled the British ones. The *Falling Rocket* garnered notice as well—less for any aesthetic value, and more for its notorious connection with the Ruskin trial as well as its

amusing impenetrability. As far as the critic for the *Chicago Tribune* was concerned, Ruskin had been right: "At first it suggests a saturated blotting paper perforated with pin-holes, and only after fifteen-minutes' study does the Philistine discover that smoke is smoke, and that buildings are not smoke, and even then he does not understand the 'Nocturne.'" Whistler had put the painting on sale, priced at $2,500. This, too, must have come off as one of Mr. Whistler's little jokes.

Whistler's widest-ranging year of exhibition of all was 1884, as his works not only traveled across the United States but also appeared in Brussels, Paris, London, Edinburgh, and Dublin. His *Arrangement in Yellow and White* took to the road after its New York run, showing—without the *Falling Rocket*, which returned to London—in Baltimore, Boston, and Philadelphia in 1883, and in Detroit and Chicago in 1884. Meanwhile, in February 1884, he exhibited for the first time with the Belgian avant-garde Société des XX, submitting a set of works clearly intended to show his range: his portraits of Cicely Alexander and Rosa Corder, his first London nocturne, his Albert Moore–influenced *Symphony in White No. 3*, and four of his etchings. The Belgian critics were entranced: "Adverse criticism must be silent in the presence of these powerfully original works," one declared in the *Echo de Bruxelles*. In May he had his portrait of Cicely Alexander sent from Brussels to the Paris Salon, sending the *Carlyle* to join it there. Both gained acclaim. "Two superb canvases," effused *Le Art Moderne*. The influential critic J. K. Huysmans proclaimed the *Carlyle* "astounding" and thought the Cicely Alexander even better.

To an international exhibition at the Crystal Palace in London that April, Whistler sent two paintings: the *Rosa Corder* (fresh from Belgium) and one of his blue and silver nocturnes. Both hung there from then until October while as many as three million ticket holders toured the exhibits. While more people than ever in this way now got their first-ever glimpse of a Whistler original, the silence of the critics was deafening. That same month Whistler sent two portraits to that year's Grosvenor exhibition—and was stunned when Sir Coutts Lindsay rejected one of them. Lindsay had no problem with the portrait of Lady Archie. But the portrait of Théodore

Duret he dismissed with a curt note: "I wish my dear Whistler that you would do yourself and me more justice and not send work that cannot do you or me credit." Whistler with uncharacteristic humility accepted Lindsay's rebuke, but to his friends he could not hide his mortification: "Sir Coutts has been too horrid—without meaning to affront me—which makes it worse!—One's enemies one can deal with—one's friends are most *dangerous*. . . ." The two remained on good terms, but this was the very last time Whistler sent a painting to the Grosvenor.[*]

Whistler was in any case preoccupied at the time with another one-man show, held this time not at the Fine Art Society but at Dowdeswell's, two doors down from the Grosvenor. This *Arrangement in Brown and Gold* featured the now-usual color-coordinated floors, walls, vases, flowers, and footman, and the usual clever catalogue, this time prefaced by "L'Envoie," a collection of Whistlerian maxims that assailed Ruskinian ideas about morality and finish in art.[**] Featured at this exhibition were the "little beauties" that Whistler had been working on since his return from Venice: sixty-seven oils, watercolors and pastels, all but one of them—the ill-starred *Scherzo in Blue*—small, even tiny: some no larger than the average-sized postcard. With these works Whistler was seeking a different market than he sought with his larger portraits. But he didn't find it: not, at least, with this exhibition. Mortimer Menpes later explained why. Convening with their master the night before the opening to drink cheap wine and set prices for his works, Whistler's followers vied with one another to inflate wildly the value of each one. "We were placing Whistler on a plane where he should be," recalled Menpes.

[*] He did, however, exhibit a few pastels at the Grosvenor in 1888.

[**] For example: "The work of the master reeks not of the sweat of the brow—suggests no effort—and is finished from its beginning"; "The masterpiece should appear as the flower to the painter—perfect in its bud as in its bloom—with no reason to explain its presence—no mission to fulfil—a joy to the artist—a delusion to the philanthropist—a puzzle to the botanist—an accident of sentiment and alliteration to the literary man." (Whistler, *Gentle Art*, 115, 116)

That summer Whistler sent the *Carlyle* to Edinburgh, again hoping for a sale. The exhibition exclusively featured portraits of Scottish national figures, as a preliminary to the formation of a Scottish National Portrait Gallery. Whistler set his price for the painting at 400 guineas, and at the beginning of October a newspaper campaign to purchase it by subscription was afoot. When, however, an otherwise enthusiastic supporter affronted Whistler with a public letter that noted Whistler's "unconventional methods and personal eccentricities," he upped his price to a thousand guineas. He might again have placed himself on the plane where he should be, but the Scots weren't willing to join him there—yet.

Within a month the *Carlyle* was off to Dublin, along with the *Mother* and—incredibly—twenty-four more paintings. Whistler had sent this aesthetic barrage to Ireland in response to a request from the hanging committee of Dublin Sketching Club to send one or two paintings, and, perhaps, to give one or two lectures. The committee, delighted by the Whistlerian windfall, gave his paintings pride of place on the Club's walls. The Club's more conservative members, outraged, demanded they be removed or hung less conspicuously. The committee simply ignored them. The Dublin press soon caught wind of these hostilities, flocked to the preview, and made the Club's private war a very public one. Whistler delightedly begged to be sent every report and review, particularly the "scurrilous" ones: "for it is a joy to me to see the loutish underbred method of mine enemies, who rave and tare [*sic*] their hair and blunder with their bludgeons and touch me never!" In the end, the Sketching Club turned a profit, but Whistler did not. While he did get an offer for the *Mother*, he refused it: "How can it ever have been supposed that I offered the picture of my mother for sale!"

As for the lecture the committee had asked him for, Whistler decided by that December to give one—but in London, not Dublin. Simmering in him for years had been the desire to explain his art—to explain art itself—more fully than he ever could in the courtroom, in a catalogue, or in acidic letters to the newspapers. But it was Oscar Wilde more than anything else who now pushed him onto the lecture stage. Whistler had for the past three years had witnessed Wilde, with his extensive lecture tours throughout

the United States and Britain, transform himself into the embodiment of the Aesthetic movement. As far as Whistler was concerned, he had done this by pilfering Whistler's own ideas. By the beginning of 1885, Whistler had decided the time had come to reclaim the thunder he was convinced Wilde had stolen from him.

In January, then, Whistler arranged with Helen Lenoir—assistant (and later wife) to Richard D'Oyly Carte, impresario to Gilbert and Sullivan—to speak that February 20, at Prince's Hall, Piccadilly. To ensure a fashionable audience, they priced the tickets at a steep half-guinea. Whistler decided to schedule the lecture at the unorthodox hour of 10 P.M. "Every dull bat and beetle spouts at eight o'clock, just as we are about to sit down to dinner," he explained. "I shall lecture at ten in order to dine myself, and let my victims get through with dinner." He therefore titled the lecture the "Ten O'Clock," which left the newspapers guessing about its subject. "Is he going to pulverize Oscar Wilde or Ruskin, or someone else?" wondered Henry Labouchère in *Truth*.

Whistler pulverized Wilde, Ruskin, and virtually everyone else, while defending and defining his own art: he delivered, in other words, a self-portrait with enemies. The artist, he argued, exists in a form of splendid isolation, not the product of any nation, or society, or era, but in mystical communion with Art, that "whimsical goddess"—the term he coined in this lecture—who shares with him her secrets, which he then applies to the elements of nature, not through imitating—"nature is usually wrong," he proclaimed—but through re-envisioning, rearranging, harmonizing: through *creating* beauty. "And when the evening mist clothes the riverside with poetry, as with a veil," he uttered in strikingly tender justification of his vocation in general and his nocturnes in particular,

> And the poor buildings lose themselves in the dim sky, and the tall chimneys become campanili, and the warehouse are palaces in the night, and the whole city hangs in the heavens, and fairy-land is before us—then the wayfarer hastens home; the working man and the cultured one, the wise man and the

one of pleasure, cease to understand, as they have ceased to see, and Nature, who for once, has sung in tune, sings her exquisite song to the artist alone, her son and her master—her son in that he loves her, her master in that he knows her.

While in this way glorifying himself, Whistler felled one by one the false idols of art. Though Whistler never named him in the lecture, Oscar Wilde was his first victim: not for his plagiarism, but for his misguided and relentless efforts to popularize art, which only served to degrade it. "If familiarity can breed contempt," Whistler charged, "certainly Art—or what is currently taken for it—has been brought to its lowest stage of intimacy." Then there were the critics of art, writers and not artists, who mistakenly went about reading pictures as literary texts; in always scrambling to find the story and its moral, they looked not *at* paintings, but *through* them, incapable of understanding beauty as an end in itself, but merely as some means to an illusory end. Ruskin—also never named—was of course the giant among these runts, and toward Ruskin in particular Whistler extended his attack, ridiculing the scholar-critic who "collecting—comparing—compiling—classifying—contradicting," obsessively attempted to explain everything—"establishing, with due weight, unimportant reputations—discovering the picture, by the stain on the back—testing the torso, by the leg that is missing—filling folios with doubts on the way of that limb—disputatious and dictatorial, concerning the birthplace of inferior persons—speculating, in much writing upon the great worth of bad work"—and, in the end, in proving . . . nothing.

Whistler's friends and followers, who packed the front rows of the theatre, loved the lecture; they showered Whistler with applause and the next day deluged him with congratulatory letters. The press—most relegated to the back rows—were not so sure. "Mr. Whistler could not be heard by nine-tenths of his audience," growled the writer for the *Telegraph*, and his ideas seemed "an undigested mass of pretentious platitudes and formulated fallacies." Most of the other reviewers were more charitable, admiring the bite of Whistler's wit and the poetry of his prose but questioning his logic.

Oscar Wilde did exactly that in his *Pall Mall Gazette* review, and, for good measure, goaded Whistler with his own claim that the poet, and not the painter, was the superior artist. That, of course, led to yet another highly reported tussle of wits between the two.

Whistler reprised the "Ten O'Clock" several times over the next few months. He continued to dream of eclipsing Oscar Wilde's tours with an extensive American tour of his own. In the end, he never returned to the States. That Helen Lenoir and D'Oyly Carte apparently convinced him that his reception there would be at best so-so likely had something to do with this. But, in the mid-1880s at least, affairs in England were simply too pressing to allow for an extended speaking tour. For at the same time as he anointed himself the quintessential outsider with his "Ten O'Clock," he was making the most sustained effort of his life to conquer the British art establishment from within.

He knew that membership in the Royal Academy was impossible: they shunned him; he shunned them. Rather, he set his sights upon the Society of British Artists—the SBA—which had been formed sixty-one years before as a rival to the Academy but had, with the years, become something of a junior partner, a haven for the many who could not hope to find a place in the that superior body, and a stepping-stone for the few who could. The Society consisted largely but not entirely of artists steeped in conservatism and known for their sentimental and anecdotal works, the kind that 'Arry Quilter had designated their "Ask Mamma" and "Don't Tease Baby" pictures. Reviews of their exhibitions in the early 1880s invariably harped upon their utter mediocrity. With two long-enduring exhibitions a year, their works crammed in the old style from floor to ceiling, the Society offered a reliable market to sell their wares. Most of its members considered Whistler's art as loathsome as he considered theirs, but when in November 1884 Whistler, with Walter Sickert's help, made his desire to join known to the Society, they agreed, knowing his celebrity would pull crowds into their exhibitions—and hoping he would steer clear of the Society's affairs.

That, of course, did not happen, for Whistler had joined the Society committed to gaining control over it and transforming it from the moribund

nonentity it was into a respectable and dynamic vehicle for himself and his art. Three years later, he divulged these aims to the Society in a parable. "You remind me of a ship-load of passengers living on an antiquated boat which has been anchored to a rock for many years. Suddenly this old tub, which hitherto has been disabled and incapable of putting out to sea, to face the storm and stress of the waves, is boarded by a pirate. (I am the pirate.) He patches up the ship and makes her not only weather-tight, but a perfect vessel, and boldly puts out, running down less ably captained ships, and bearing a stream of wreckage in her wake." From the start, then, he faithfully attended Society meetings. He persistently pushed to turn their warehouse-like exhibitions into something closer to his one-man shows. To butter up influential members, he invited them to Sunday breakfast at Tite Street, complete with a tour of his studio and a lecture upon his methods.* He dutifully served on the Society's committees, and by May 1885 was a member of the powerful executive committee. He cultured friendships with the Society's young Turks and energetically supported making members of his followers. Little by little, he built up a formidable voting bloc.

As the Society had wished, he did attract the crowds by contributing to their exhibitions. For a year after joining, Whistler exhibited at the SBA's galleries alone, with the single exception of the 1885 Paris Salon, to which he sent his portraits of Duret and Lady Archie. (They were well-received, but still Whistler grumbled when he was awarded no medals.) To the Society's 1884–1885 Winter Exhibition he sent two paintings. His 1873 painting of Helen Huth—one of his earliest black-on-black portraits—the critics generally praised as the spectacular work among a mass of mediocrity. They were less impressed by his second work, the impressionistic Dutch landscape *A Little Red Note* which, the *St. James's Gazette* joked, was remarkable, "chiefly for its price." To their 1885 Summer Exhibition he sent seven small watercolors and two large portraits, including his most recent *Arrangement in Black*, of the popular Spanish violinist Pablo de Sarasate,

* This was one of Whistler's last breakfasts there: money problems, apparently, forced him in 1885 to move into a cheaper cottage off the King's Road that he called the "Pink Palace," and into a separate studio in Fulham.

which the *Pall Mall Gazette* hailed as "certainly one of the most original and powerful portraits which have been painted in England for many years." The critics appreciatively noted the many works by followers at this exhibition. "Time was," claimed the *Standard*, "when its Exhibition was of the kind that the intelligent tourist of the picture galleries did wisely to omit to visit. But that day is gone. There is an element of strength now visible in the Society. There is new blood in its body."

That new blood was even more noticeable at the Society's 1885–1886 Winter Exhibition, to which Whistler himself submitted nine works, and in which, having found a staunch ally on the hanging committee, he made sure that his followers—Menpes, Sickert, Harper Pennington, William Stott of Oldham, Elizabeth Armstrong, and Philip Wilson Steer—were well-represented, each now listed in the catalogue as a "pupil of Whistler": a practice common enough in France, but until then unheard-of in England. The critics touted a revolution in progress, Harry Quilter proclaiming "there is now no gallery in London, probably none in the world, where can be so clearly seen as in this exhibition at Suffolk Street, the most conventional and commonplace of old fashioned work, side by side with the most eccentric and daring examples of modern impressionism."

Two of the many "pupils of Whistler" showing at that exhibition were listed as "Clifton Lin" and "Rix Birnie." "Lin" was actually Maud Franklin; "Birnie" was Beatrix Godwin. Both of them would exhibit frequently with the SBA between 1885 and 1888. Throughout those years, the two of them were locked in a grim battle for Whistler's attention. Maud, for years, had assumed the role of Whistler's wife, printing up her calling cards and signing her name as "Mrs. Whistler," adamant in demanding that all the local tradesmen and cabdrivers address her that way. The more rigid among society hostesses, however, she found harder to convince; entry into their world remained as difficult for her as it had been in Venice. But that was never a problem for Beatrix Godwin, daughter of a renowned sculptor and wife to an equally renowned architect. Whistler's friendship with Edward Godwin had for years extended to Beatrix, and when in 1884 Edward and Beatrix amicably agreed to separate, Whistler and Beatrix became even

closer. She became a regular visitor to Whistler's Fulham studio, comfortably distant from Maud and his Chelsea home. For two years she posed for Whistler's *Harmony in Red: Lamplight*, an experimental effort painted under the glare of "a sort of chandelier of argand burners." She was known to interrupt the sittings of others to carry Whistler off and into society, as, with her husband gone, Whistler became her escort when she was in London. The ménage between Whistler, Maud, and Beatrix became particularly awkward in early 1886, when Whistler somehow contrived to bring both women to Paris. Whistler's Parisian friend George Lucas recorded in his diary dinner with Whistler and Maud on the 4th of March—and dinner with Whistler and Beatrix on the 5th, 7th, and 8th. That autumn, soon after Edward Godwin died of complications after surgery for kidney stones, Beatrix moved to Chelsea and became a regular visitor to Whistler's home—and Maud's domain. Predictably, tensions soared; there were scenes, and even violence. Tinnie Greaves (Walter's sister), who had renewed her acquaintance with Whistler at this time, recalled one terrible row between Maud and Beatrix. "Jimmie threw them all into the street and shut the house. There was such a scene that Maud broke a blood vessel and Jimmie went off to the chemist and asked him to come and see her." For another year and more, the three of them would somehow endure this unendurable state of affairs.

"I *am* woefully busy," Whistler confessed to a friend in March 1886. He had already sent one painting—the *Sarasate*—to the Société des XX in Brussels, and was now working to show at five more exhibitions. To the SBA, which opened that month, he for once gave short shrift, sending only the *Harmony in Blue and Gold*, a decade-old nude that had somehow remained in his hands after his insolvency. His followers now gained more attention at this exhibition than he did. The critics openly deemed them "impressionists," their works "products of impulses and aesthetic systems wholly French." Much more important to Whistler that spring was another of his

one-man shows at Dowdeswell's: sixty-one oils, watercolors, and pastels. He promised that "it would be "the Artistic event of the season." In terms of gate, he might have been right: "so great was the crowd which filled his small exhibition room," noted one reporter of the opening, "that there was quite an undignified scrimmage to get in and out." In terms of gross, however, Whistler was wrong: the little beauties did not sell, and while Dowdeswell did send Whistler £50, he sent with it the news that that the show had been a total loss. Whistler blamed the poor economy—and never exhibited with Dowdeswell again.

One other of Whistler's paintings went on display in London that spring—without Whistler's blessing. William Graham, Ruskin's friend, and once Whistler's patron, had died the year before, and that April his magnificent collection of classic and modern art went up for auction at Christie's. The spectators cramming the courtroom treated the sale as sport, cheering as their favorite paintings were brought forth, and when they sold for record prices. Rossetti's *Ecce Ancilla Domini*, the painting that Ruskin had so admired when he saw it on Graham's wall, went for 800 guineas, the crowd giving an extra cheer when they learned that it was destined for the National Gallery. Millais's *Vale of Rest* fetched an astounding 3,000 guineas, and Burne-Jones's Arcadian *Chant d'Amour* 3,150.* After Graham's thirty Rossettis had been auctioned but before his thirty-three Burne-Joneses were, his one Whistler, the *Nocturne in Blue and Silver: Old Battersea Bridge*, was put up. It was the first public appearance of this painting since it had been manhandled during *Whistler v. Ruskin* eight years before. The crowd now gave it a feeble cheer that the *Times* designated "ironical" and then an angry hiss "such as has never been heard before in these solemn precincts." The painting fetched a meager 60 guineas. Whistler, who learned of the sale from that evening's *Observer*, presented himself as unruffled. "May I beg," he wrote to that paper's editor, "to acknowledge the distinguished, though I fear unconscious, compliment so publicly paid. It is rare that recognition

* Burne-Jones's *Days of Creation*, the hit of the 1877 Grosvenor exhibition, also sold that day, for an impressive 1,650 guineas. (*Morning Post*, April 5, 1886, 6)

so complete is made during the lifetime of the painter, and I would wish to have recorded my full sense of this flattering exception in my favour."

To Paris and the Salon that May Whistler forwarded the *Sarasate* from Brussels. Reviewers in both cities suggested a specific appreciation for Whistler quite different from any he got in London. "Whistler's portrait of Sarasate is full of subtleties. The whole has a most impressive strange aspect," wrote a critic for the Belgian *L'Emancipation*. "His portrait of Sarasate is a sort of apparition of the famous violinist evoked by a medium during a spiritualist session," observed the French critic Alfred de Lostalot. He was not alone in beginning to recognize Whistler, because of the suggestive dreaminess of his works, as precursor and prophet of the Symbolist movement then burgeoning across the continent.

That May, as well, he sent to the Berlin Academy of Arts both his *Lady Archibald Campbell* and his Carlyle—which he was again particularly ambitious to sell. (In Germany, Whistler told Graves, Carlyle "is held in great reverence—and they may wish to purchase the picture for a museum.") But they did not buy. Nor did they consider Whistler worthy of one of their gold medals, which they gave to Millais and von Herkomer instead. Finally, that month Whistler sent two of his darker portraits (the *Fur Jacket* and *Effie Deans*) as well as one of his darker nocturnes (quite likely the *Falling Rocket*) to the Edinburgh International Exhibition of Industry, Science, and Art. This was a waste of his time, for all three paintings were skied beyond the point of human comprehension. "In the case of all three pictures, the low tones employed, to say nothing of the standing of the artist, might have suggested a different kind of treatment," complained the critic for the *Glasgow Herald*.

That June Whistler launched a coup at the Society of British Artists, marshaling his forces and trouncing the conservative's candidate to become the Society's president. Though he would not officially take the position for another six months, he assumed it anyway and energetically set to "cleansing the Society." The results of his efforts were obvious at that year's winter exhibition, which resembled one of his one-man shows more than ever before, with its masses of gilt and brown-papered walls and Whistler's

innovation—his *invention*, he claimed—of an awning, or velarium, which softened the light from above into canary-colored crepuscule. By eliminating skying and flooring, and by increasing the space between pictures, he drastically reduced the number of works on display. He guaranteed that most of these works were by followers and not conservatives by placing Mortimer Menpes and Stott of Oldham on the hanging committee and by giving them strict orders to "never weary . . . of saying 'Out.' If you are uncertain for a moment, say 'Out.' You need never be afraid of rejecting a masterpiece. We want clean spaces round our pictures. We want them to be seen. The British Artists must cease to be a shop."

The Society *did* cease to be a shop. Nearly three times as many people came to this show than had come to the one the year before. But sales plummeted. When Whistler had joined the Society in 1884, revenues had approached £8,000; within three years, they had sunk to under £2,000. "In Suffolk-street the wail is loud, long, and piercing," according to the *Pall Mall Gazette*. As a salve, when Whistler became president he offered to loan £500 to the Society, raising that amount through some Howellian double-dealing: borrowing the money from D'Oyly Carte and offering as collateral three paintings, including two—the *Mother* and the *Carlyle*—that already served as collateral for Whistler's debt to Henry Graves.

The year of Queen Victoria's golden jubilee, 1887, was Whistler's own royal year. He convinced the Prince and Princess of Wales to visit the Society's summer exhibition and personally ushered them about the galleries, which he had personally repainted in a yellow dazzling enough to vex the conservatives. He vexed them even more by ensuring that the paintings he preferred—including seven of his own—outnumbered their once-ubiquitous banalities by two to one. Now he vexed them one more time when the prince asked him about the history of the Society. "Sir, it has none," Whistler replied; "its history dates from to-day!" At the same time he sent four of his best paintings—the *Falling Rocket*, the *Carlyle*, the *Mother*, and the *Lady Archibald Campbell*—to a Royal Jubilee Exhibition held in Manchester, and with them, apparently still smarting from the flagrant

skying of his work in Edinburgh the year before, he sent specific instructions to hang them "singly—with a space between each,—and everything on the line." Before the exhibition opened, though, Whistler, convinced that his instructions were being ignored, angrily telegraphed Manchester demanding the immediate return of his work.

The three portraits then returned to London, but the *Falling Rocket* went on to Paris, where it joined forty-one other paintings, most of them little beauties, at an exhibition at the Galerie Georges Petit. Claude Monet, who had personally urged Whistler to contribute, showed as well, as did Renoir, Sisley, Pissarro, and others, including the sculptor Rodin. Whistler exhibited, then, among the leading French impressionists—though not, technically, *as* one of them, even though English critics had long hailed him as one. Camille Pissarro, for one, writing to his son about this exhibition, noted a fundamental distinction between them: "Whistler, by the way, does not care for luminosity." Whatever their differences, Whistler clearly now enjoyed a level of respect and appreciation among his French peers still denied him by his English ones.

All that spring and summer Whistler plotted to elevate his society to the level of the Royal Academy—or rather, to a level above it: seeking to obtain from the queen, with a petition disguised as a Jubilee testimonial, permission to title his society the *Imperial* Society of British Artists. He secretly set to designing a testimonial to eclipse all others. He consulted with the queen's aesthetic daughter Princess Louise about proper protocol. Composing with difficulty—Whistler *always* composed with difficulty—he hammered out a florid text. He had a calligrapher set it down in Gothic script upon fine Dutch paper. He illustrated it with etchings of the queen's castle at Windsor and his own cottage in Chelsea. He submitted this to the queen in July, only to learn that while "Imperial" was out of the question, "Royal" was possible. He made the appropriate revisions and resubmitted. At the beginning of August the queen assented, and Whistler called a special meeting to announce the existence of the Royal Society of British Artists. That meeting began stormily, as they all did now, but ended with jubilation and champagne.

The joy was short-lived, shattered by Whistler two months afterward when he put forward a proposal banning members from his society from retaining membership in any other London art society and calling for the expulsion of any who did. It was, to many, a career-threatening proposal, and Whistler likely introduced it in hopes of purging the old guard. Instead, it roused and unified them. On the first of November angry members packed the meeting and forced the withdrawal of the proposal. A month later Whistler put forth a similar proposal that similarly failed. The rest of Whistler's presidency would be a hobbled one, his opposition now awaiting their opportunity to take him down.

Whistler exhibited for the last time with the RSBA at its 1887–1888 winter exhibition. His submissions were numerous but modest: a dozen etchings and four lithographs, a few tiny watercolors, and his *Symphony in White and Red*, an unfinished and unfinishable sketch from his frustrating *Three Girls* days two decades before. Gaining more attention than these were the paintings shown, at Whistler's urging, by Claude Monet and the Belgian Alfred Stevens—an unprecedented inclusion of foreign artists that further irritated the conservatives. Gaining the most attention of all—attention of the worst kind—was *The Birth of Venus*, a large circular painting by William Stott of Oldham, a follower to whom both Whistler and Maud Franklin had grown closer in 1887. Stott's painting refashioned Botticelli's quattrocento work of the same name, stripping away all the allegorical trappings to present a redheaded nude surrounded by the minutiae of a distinctly northern beach. These natural details might have impressed the critics, but Stott's depiction of the goddess appalled them: she was nothing but a "pert and puny" nude, a "knock-kneed, thoroughly drunk young woman," a "vulgar trollop." Stott's model for the painting had been Maud Franklin. Whistler too was appalled—not by the nudity itself, but by the thought of Stott's exploiting Maud's nudity to create something so miserable. The situation carried the same whiff of betrayal that had tainted Whistler's relationship with Jo Hiffernan after her erotic posing for Courbet twenty years before. If Whistler needed any further excuse to get rid of Maud, he certainly had it, and, indeed, before this exhibition ended Maud

was gone: an exile in Paris, living with Stott of Oldham and his family, selling Whistler prints to support herself, and finding consolation with George Lucas, now unquestionably Whistler's ex-friend, who noted in his diary for February 29, 1888, "visit from Maud . . . to relate her separation griefs." Later that spring Whistler abandoned the Pink Palace, the cottage he had shared with Maud, to return to apartments and a studio on Tite Street, where he recommenced his Sunday breakfasts—with Beatrix now his hostess.

Whistler himself traveled to Paris that winter to visit with Monet, now a close friend. At a luncheon that Monet organized, Whistler renewed his acquaintance with the Symbolist poet and influential critic Stéphane Mallarmé: the beginning of an even closer, and, for Whistler, deeply rewarding friendship. Hearing that Whistler, having given up plans for any American tour, planned instead to publish his "Ten O'Clock" lecture, Mallarmé offered to translate the lecture into French. Whistler accepted. British, French, and American editions all appeared in May that year.

The printed lecture attracted few reviews, but one that did appear, in that July's *Fortnightly Review*, cut Whistler to the quick. Algernon Charles Swinburne had largely faded from Whistler's and nearly everyone else's life since 1878, when alcoholism and physical debilitation had forced him into retirement in Putney. Swinburne had missed Whistler's lecture in 1885 and had declined Whistler's offer to come to Putney to read it to him personally. Now he made up for his neglect with a blistering attack upon Whistler's theory, which he dismissed as a hodgepodge of half-truths and questionable inferences. Making things worse, Swinburne attacked Whistler with Ruskinian logic. Swinburne was horrified that Whistler placed the art of the Japanese on a par with that of the Greeks; the former, Swinburne held, was merely decorative, while the latter was something far greater, appealing not simply to taste, but to the mind and the heart. In other words (though Swinburne did not use them) Japanese art was appreciable by the lesser faculty of *Aesthesis*; Greek art appreciable by the higher faculty of *Theoria*. Whistler, mortified by what he considered a rank betrayal, dispatched to Swinburne on the same day two bitter *Et tu, Brute?* letters, and then, to

make the break a very public one, shared one of these with the newspapers. Swinburne vowed never to speak to Whistler again—and never did.

On the day after the "Ten O'Clock" appeared in print, the resurgent conservatives at the Royal Society of British Artists made their first attempt to topple Whistler, calling a special meeting to force his resignation. Their motion failed—just: nineteen votes for Whistler, eighteen against him, six abstentions. But the writing was on the wall, and three weeks later, at that year's election for president, they tried again. "They brought up the maimed, the halt, the lame, and the blind—literally—like in Hogarth's 'Election,'" Whistler joked; "they brought up everything but corpses, don't you know." Whistler lost; he and two dozen of his followers immediately resigned. "So you see," Whistler summed up the situation, "the 'Artists' have come out, and the 'British' remain—and peace and sweet obscurity are restored to Suffolk-street."

Denied in this way his usual exhibition space in London, Whistler turned instead to Sir Coutts Lindsay, negotiating with him to include himself and his followers at that summer's Grosvenor exhibition. Whistler's demands were so exorbitant, however, that Lindsay quickly cut off negotiations. Many of the followers instead found a new home—and the new name of the "English Impressionists"—by showing with Walter Sickert at the New English Art Club. Whistler, on the other hand, looked to the continent for recognition, exhibiting only a single painting in Britain that summer—the *Carlyle*, at an international exhibition in Glasgow. (He again priced it at £1,000—and again failed to sell it.) That February, he had sent eight works to Brussels and the Société des XX. "As usual, you had the greatest success," its organizer told him. But it was the last time he exhibited there. He exhibited again with the impressionists in Paris that May and June sending three nocturnes and *The Fur Jacket* not to Petit's, this time, but to the Galerie Durand-Ruel. Though the exhibition was marred by Monet's pulling out at the last minute, according to the artist Berthe Morisot Whistler could consider his own contributions a success: she claimed that Whistler's and Renoir's works alone saved the show from disaster.

At the Munich Internationale Kunst-Austellung, which ran from June until October that year, he found far greater success, although it did not

seem that way at first. Rennell Rodd, his follower who had become a diplomat in Berlin, had coaxed him to exhibit there, and Whistler obliged with a deluge: thirty etchings, seven pastels, twenty watercolors, and thirteen oils—including the *Lady Archibald Campbell*, the *Cicely Alexander*, two nocturnes, and the *Mother*. The critics, again recognizing Whistler as seminal to the Symbolists, were impressed, and so, to an extent, was the exhibition's jury, which judged the *Mother* worthy of a gold medal—a second-class one. Whistler was affronted, writing sarcastically to their secretary "pray convey my sentiments of tempered and respectable joy to the Gentlemen of the Committee, and my complete appreciation of the second-class compliment paid me." He considered declining the medal, but instead accepted it while making his displeasure known through Rodd and others. His complaining paid off handsomely. "There is a great row about you," Rodd wrote him; the exhibition's organizer and other men of influence were furious with the Committee's meager award and determined to shower Whistler with higher honors. Whistler learned of these in November and was ecstatic. He managed in a letter to a friend joyfully, biblically, and a bit awkwardly to equate this triumph with his triumph over his nemesis a decade before: "They have made me Hon. Member of the Royal Academy of Bavaria—and conferred upon me the cross of St. Michael in holy & sympathetic wrath destroying the demon of dullness! even as I with indignant trifling have done, in the person of Ruskin!—wiping him with the floor—even as a man wipeth a dish—wiping him & turning him upside down!"

Whistler had just returned to London from France when this news reached him; there he and Beatrix had spent an extended honeymoon. They had married the previous August, in a tiny ceremony in a Kensington church. Louise Jopling was one of the very few guests and recalled Whistler's uneasiness during the ceremony: he glanced about the church, she thought, as if afraid of Maud's intrusion. If so, he needn't have worried. Maud was far away, still in French exile, [*] and still oblivious to her abso-

[*] "With Maud to market at Melun," George Lucas recorded in his diary on that day. (Lucas, 2.675)

lute abandonment. But that would quickly end; the *Pall Mall Gazette* had caught wind of the occasion and had sent a reporter to the church; his story of the "yoking of the butterfly" was out by that evening and spread quickly.

—⁓—

In 1889, as in 1888, Whistler's triumphs lay outside of Britain. He did submit the *Mother* that February to Glasgow's Institute of Fine Arts, but the little positive attention it got there was for Whistler entirely eclipsed by his discovery that a Whistler forgery, *A Dream of Morning Off Gravesend*, was hanging near the *Mother*, leading the critics to make the case that Whistler produced good works—and atrocious ones. Whistler fired off an indignant telegram to the Institute: "Shameful imposition . . . critics ridiculous . . . how could your painters look at Portrait and believe the other possible . . . please send photograph and deny officially in papers immediately . . . Whistler."

The fake was pulled. So, in April, was the *Mother*, shipped back to London to join a stunning collection of Whistler's works, including the *Carlyle* and *Rosa Corder*, as well as a trove of pastels, watercolors, and etchings, in an unusual venue: the College for Working Men and Women, in out-of-the-way Queen's Square. Not surprisingly, few people found their way there to see them. Two who did, though, were the Americans Joseph and Elizabeth Pennell, who in a few years would become Whistler's closest companions, his fiercest protectors, and his first biographers. Indignant when they saw the pitiful turnout, they in a sense took up their defense of the master with this exhibition, chiding the public in the London *Star*: "if there were as many as half a dozen people who cared for good work, they should go at once to see this exhibition of the man who has done more to influence artists than any modern." Few, if any, heeded them, and the show was a flop.

Showing at around the same time, at Wunderlich's in New York, was Whistler's first major exhibition of paintings in the United States: sixty watercolors, pastels, and oils—including *Falling Rocket*. While reviews were

mixed, sales were good, and it was this exhibition that provided Whistler with his first glimmer of the fact that the surest source of his income for the rest of his life was not to be Britain or Europe, but his home country. One small watercolor at the exhibition, *Grey and Silver: Liverpool*, was purchased by Detroit railway tycoon Charles Lang Freer: the first Whistler painting acquired by the man who would in time become the world's most fanatical collector of them.

America gave Whistler money that year, but Europe gave him honors. That spring, Whistler submitted his *Lady Archibald Campbell*, his Japanese-tinctured *Balcony*, and twenty-seven etchings to hang in the American section of the great Paris Exposition Universelle—the world's fair for which the Eiffel Tower was created. He was stunned, however, when the American commissioner, fellow West Pointer General Rush C. Hawkins, informed him that ten of his etchings had been rejected by the jury and ordered him to remove them immediately. Whistler rushed to Paris, withdrew all of his works, and submitted them instead to the British section, even though the British would accept only nine of his etchings, eight fewer than the Americans would. The maneuver salved his self-esteem—at a price. When Whistler learned that July that he had been awarded a first-class medal for the portrait of Lady Archie, he was far from pleased, for not only had the jury ignored his etchings completely, they had awarded his hated brother-in-law Seymour Haden the higher honor of a *grand prix* for his and, worse, had awarded both John Singer Sargent and Edward Burne-Jones not only *grands prix*, but also entry as chevaliers into the French Legion d'Honneur. Had Whistler simply remained in the American section, Théodore Duret informed him, he certainly would have been similarly decorated, "since at the moment, in Paris, the Americans are very well regarded and people cannot do too much for them." His own medal, then, he viewed as something like a snub. Duret, realizing this, promised to use his own connections with the French government to do something more for him.

The municipal exhibition in Amsterdam that autumn proved much more satisfying. The ten etchings and three paintings—including the

Mother—that he sent there earned him the exhibition's highest honors; "they have given me a *Grande Medaille d'Or* at the Dutch Salon," he crowed to a friend. He and Beatrix had traveled there for the opening and stayed for two months; Whistler, enjoying lionization by the Dutch the entire time, sketched, painted, and created a new series of etchings, the *Amsterdam Set*, which demonstrated that that city's canals inspired him to the heights that Venice's had a decade before. After a quick swing through Paris the Whistlers returned to Tite Street to learn that Duret had apparently succeeded in his intervention: Whistler, too, was to be made a chevalier in the Legion d'Honneur. Not only did this news instantly efface any sense of jealous disappointment; it caused him to give serious thought to abandoning London for Paris, sending a friend to seek out a suitable studio for him there. In the end, he would remain in London for another two years, quite likely more for Beatrix's sake than his own.

In England, the only notable accolades he would get would be secondhand ones—specifically, at a grand dinner that May at a Piccadilly restaurant, celebrating the honors he had won in Munich the year before. He earned much more attention in London, it seemed, for his secondary art of making enemies, taking—to use his way of putting it—three notable scalps during this time. The first belonged to William Stott of Oldham. Stott, having stewed in France for months over Whistler's despicable treatment of Maud, finally, at the very beginning of 1889, confronted him at the Hogarth, their mutual club, publicly denouncing him as a liar and a coward. Whistler then—according to Whistler, anyway, though denied by Stott—leapt up, slapped the larger man's face, and kicked his backside. Afterward, he demanded that Stott apologize or be forced to resign the club, and proceeded to enlist friends and newspapers in a concerted campaign to blacken Stott's name. Stott's attempts to defend himself were drowned out, and, in the end, he resigned.

Mortimer Menpes was Whistler's next victim. Whistler's quarrels with Menpes had begun two years before, when Menpes dared to sneak off to Whistler's beloved Japan without obtaining Whistler's blessing. They intensified when Menpes resigned from the Royal Society of British Artists

a month before Whistler did: "the early rat who leaves the sinking ship," Whistler called him. They reached the breaking point with what Whistler saw as Menpes's pilfering his own ideas about home decoration, first in the *Pall Mall Gazette* at the end of 1888 and, again, in a Philadelphia newspaper, in March 1889. Whistler sent a clipping of the latter article to Menpes with the instructions "You will blow your brains out—of course . . . Goodbye" and immediately shared the letter with the press. From then on, Menpes was dead to him.

Whistler's final showdown with Oscar Wilde, long in coming, finally came at the very beginning of 1890, when Whistler discovered an article in the *Sun* claiming that Wilde was again stealing ideas and phrases from Whistler for his own work, specifically pilfering Whistler's *mot* "Oscar has the courage of the opinions . . . of others!" for his own essay "The Decay of Lying." While a glance at that essay would have proved that particular claim ridiculous,* Whistler didn't hesitate to fire off a strident denunciation to Wilde personally, and a more detailed one to the *Truth* newspaper. "You have stolen *your own scalp*," he accused Wilde, "and potted it with more of your pudding." Wilde, fed up with Whistler's relentless accusations of his plagiarism, in his reply went for one of Whistler's own vulnerabilities: "as for borrowing Mr. Whistler's ideas about art, the only thoroughly original ideas I have ever heard him express have had reference to his own superiority as a painter over painters greater than himself." To this Whistler responded with a sarcastic *mea culpa* and a reiteration of his charges. With that, the most celebrated repartee of the nineteenth century died.

Having by then accumulated enough evidence of his enmity to fill a book, Whistler resolved to publish one—or, rather, was convinced to do so by someone who was to prove a worse pilferer and truer enemy to him than either Menpes or Wilde ever were. Sheridan Ford, American, sometime journalist and first-class opportunist, had with his lover and then-wife

* In the sentence—apparently—in question, Wilde attacks modern novelists for having "not even the courage of other people's ideas." This sentiment, Wilde rightly pointed out to Whistler, was far too old even for Whistler to claim it. (Qtd. Whistler, *Gentle Art*, 239)

Mary Bacon Martin for the past three years been doing his best to insinuate himself into Whistler's affairs. In the autumn of 1888 Whistler had fended off their attempt to manage him on an extensive creative and lecturing tour of the States by rejecting their plan as hopelessly exploitative: "now—for the first time do I clearly perceive, that you have harboured the possibility of absolutely possessing yourselves of my ambition and prospects at the very height of my Artistic Career." Unfazed, Ford returned to Whistler in the spring of 1889 with a new proposal: to edit Whistler's correspondence with the press over the past two decades. Whistler would get the recognition; Ford, the profits. Whistler agreed and Ford set to work, poring over the letters Whistler had, unearthing others in the British Library, annotating, compiling anecdotes, composing a substantial introduction. But that August, when Ford "was measurably within sight of the promised land of printer's proofs," Whistler "sweetly" asked Ford to hand over all he had done, saying he had decided that Théodore Duret should edit the work instead. He followed this up with a letter enclosing 10 guineas and stating his intention to postpone the project. Both Duret and delay were ruses, for Whistler, very likely at Beatrix's urging, had decided to take on the project (and the profits) himself. Ford refused to be dismissed. He scorned Whistler's payment and absconded with his text, seeking publishers in London and New York. One London publisher got as far as typesetting the work—but refused to print when he caught wind of Whistler's objections. Ford then fled to Antwerp and found a printer to produce two thousand copies; Whistler learned of this, set his solicitor Lewis on the case, and got Belgian authorities to confiscate them and to charge Ford with copyright infringement. Ford slipped away to Ghent, found another printer, and published four thousand more copies, many of which he managed to get to bookstores on both sides of the Atlantic. Whistler himself came upon a copy in a Chelsea bookstall.

All this time Whistler had been diligently at work upon his own edition. Beatrix assisted him, and so did his son Charles Hanson, who, since Whistler's marriage had become his father's much put-upon dogsbody. Whistler found an invaluable collaborator in his new publisher, William Heinemann,

who soon became a fast friend—one of the very few who never became his enemy. Whistler's own *Gentle Art of Making Enemies*—its title stolen from Ford—came out in mid-June 1890.

Whistler's edition excelled Ford's in every way. It was, for one thing, a visual delight, a product of the same aesthetic sensibility Whistler had applied to all of his catalogues and pamphlets. It was, moreover, superior in structure and scope. Ford, attempting (in vain) to stay on the safe side of copyright law, largely restricted himself to Whistler's newspaper correspondence; his edition is largely a chronicle of Whistler's public belligerence. Whistler's edition is much more than that. Because he was free to include his personally published writings such as his *Art and Art Critics* and his "Ten O'Clock," his *Gentle Art* became the fullest expression of his aesthetic vision. To give that vision its structure, Whistler opened the work with the single statement that best encapsulated the assumptions about art that he had for decades fought with every work painted or printed, every aesthetic utterance, and many scalps taken: Ruskin's attack upon him in *Fors Clavigera*. This he followed with a personal retelling of *Whistler v. Ruskin*, culled from newspaper reports but embellished to emphasize his own brilliance—and his opponents' idiocy. He also festooned the margins with snippets from Ruskin's works which, stripped of context, appeared equally idiotic.* In this way, Whistler managed to do what he could not do in 1878: bring Ruskin into the courtroom—and make him the loser. This was, of course, grossly unfair. It was also hugely entertaining.

Steeped in this literary work, Whistler did not exhibit anywhere for the first half of 1890. For the rest of the year he looked exclusively to the continent. To the Salon that year he submitted two paintings—not the usual portraits this time, but two of his most challenging nocturnes: his very first one, the *Nocturne in Blue and Gold: Valparaiso Bay*, and the *Nocturne: Black*

* Snippets such as this one, from *Modern Painters*, volume 4: "The Butcher's Dog, in the corner of Mr. Mulready's 'Butt,' displays, perhaps, the most wonderful because the most dignified, finish . . . and assuredly the most perfect unity of drawing and colour which the entire range of ancient and modern art can exhibit." (Whistler, *Gentle Art*, 15n.; Ruskin, *Works*, 4.336)

and Gold—the Fire Wheel, a Cremorne companion to the *Falling Rocket*, which similarly took formal representation to the verge of pure abstraction. It was as if Whistler, confident that Paris appreciated his portraiture, now challenged them to accept *all* of his work, including his most revolutionary. Though one of the paintings was badly skied—"ridiculously perched in paradise," as one critic put it—they were indeed well-received.

From that exhibition Whistler had the *Fire Wheel* shipped to Brussels where it joined the *Falling Rocket*, the *Lady Archibald Campbell*, and two other paintings at the Exposition Générale des Beaux-Arts. The jury there first impugned Whistler's abilities by rejecting both nocturnes outright, before paying homage to his reputation by realizing they were his and taking them back. The critics on the other hand were enthusiastic about them "They are perfect," rhapsodized one.

The only Whistler paintings seen in public in London that year were those shown that November at a sparsely attended Christie's auction—this one to sell off the estate of Charles Howell, who had died that spring. Among the works sold were two magnificent Whistlers: the haunting Valparaiso painting, *Crepuscule in Flesh-Colour and Green*, and the early black-on-black portrait of Rosa Corder. Both were snapped up by the young artist W. Graham Robertson for what he thought were laughably tiny bids.* Whistler, delighted to discover a Londoner who actually would buy his paintings, sought Robertson out at his home. After Whistler spent some time caressing his *Rosa Corder*, murmuring "*Isn't* she beautiful?" he and Robertson marveled at Howell's talent for appropriating others' things: Robertson described some of the auctioned items; Whistler responded "That was Rosetti's—that's mine—that's Swinburne's. . . ."

Whistler's one true exhibition in London at the time was not of his work, but of himself. Having discovered in *The Hawk*, a scurrilous weekly newspaper, rumors of a fraud supposedly committed by Edward Godwin some years before, Whistler on the evening of September 6, attended the

* The paintings might have been bargains, but not laughably so: newspapers reported that the *Rosa Corder* went for 230 guineas and the *Crepuscule* for 120. (*Globe*, Nov. 19, 1890, 6; *London Evening Standard*, Nov. 17, 1890)

premier of *A Million of Money* at the Drury Lane Theatre specifically to confront that newspaper's editor, Augustus Moore—the brother of the novelist and art critic George Moore. Between acts in the foyer, Whistler fell upon Moore, slashing at him with his cane while screaming *"Hawk! Hawk! Hawk!"* with every blow. Moore claimed that he fought back, sending Whistler sprawling onto the floor. Whistler denied it, claiming that the gathering crowd had momentarily forced him to a knee. The story spread across the nation and abroad overnight. For the next two months Whistler, again employing his formidable network of friends and friendly journalists, and setting his solicitors upon any paper that dared contradict his version of events, did his best to present the scuffle as another triumphant scalping. As an appreciative Mallarmé put it, "The second volume of the *Gentle Art* is starting!"

And then, in 1891, came the breakthrough, when Whistler made the two most important sales of his life.

The first was the realization of his seven-year-long desire to sell his *Carlyle* in Scotland, to a museum—and at the price he had always demanded. By 1891 he had gained strong support for this goal among Scotland's artists, and particularly among the Glasgow Boys, the progressive group of painters deeply inspired by Whistler's formal and tonal harmonies. At least two of their leaders, Edward A. Walton and James Guthrie, had wanted the *Carlyle* permanently in Glasgow since they saw it on exhibit there in 1888. In January 1891 they acted, drafting a petition to city officials to obtain it. Walton sent this first to Whistler to make sure that it was still for sale. It was, Whistler replied, dropping, to hurry things along, hints about nonexistent American offers to buy it. The Boys put out their petition, which soon gained an impressive number of signatures, while Whistler quickly settled his fourteen-year-old debt for the painting with Henry Graves, borrowing the £220 he needed from his solicitor, George Lewis, and as a compensation of sorts, allowing the Lewises to hang the freshly cleaned, varnished,

and reframed painting on their wall—until it was needed elsewhere. "The picture has come & fits into its place," Elisabeth Lewis wrote Whistler on February 15. "It is too beautiful & a great joy to behold. It will always be a precious recollection to me to have lived with it if only for a while."

Only for a very short while, it turned out: a fortnight later, Walton and his fellows presented their petition to the city corporation's subcommittee on galleries and museums. The subcommittee granted it on the spot, and—Walton having discreetly asked Whistler his price—set aside 1,000 guineas for its purchase. But they hoped Whistler would give them a discount and sent a delegation to London to coax one out of him. Whistler later recounted their visit.

> I received them, well, you know, charmingly, of course. And one who spoke for the rest asked me if I did not think I was putting a large price on the picture—one thousand guineas. And I said, "Yes, perhaps, if you will have it so!" And he said that it seemed to the Council excessive; why, the figure was not even life-size. And that was all. It was an official occasion, and I respected it. Then they asked me to think over the matter until the next day, and they would come again. And they came. And they said, "Have you thought of the thousand guineas and what we said about it, Mr. Whistler?" And I said, "Why, gentlemen, why—well, you know, how could I think of anything but the pleasure of seeing you again?" And, naturally, being gentlemen, they understood, and they gave me a cheque for the thousand guineas.

Whistler resolved to give the *Carlyle* a brief farewell showing in London, and chose a new venue in which to show it: the Goupil Gallery, the London outpost of the Parisian Boussod, Valodon & Cie. The French connection certainly appealed to him. So did the Goupil's director, David Croal Thomson, whose boundless admiration for Whistler's work, and his ability to work effectively and efficiently with the artist himself, would make

him Whistler's principal London dealer throughout the 1890s. Thomson displayed the painting with "a simple dignity which satisfied even 'the Master,'" watched as patrons came to laugh, but remained to admire, and concluded that the great turning point had come: the world finally recognized Whistler's true greatness. He advised Whistler to "'rub in' this sentiment" with a bold move: selling the *Mother* to Paris's Luxembourg Museum, which would almost certainly mean, ten years after Whistler died, enshrinement in the Louvre itself. Whistler agreed immediately, resolving upon a price of 75,000 francs—roughly three times what he had been paid for the *Carlyle*. Thomson promised to consult with his Parisian counterpart, Maurice Joyant, about the prospects for this sale.

Joyant's answer would not come for another six months, which gave Whistler the opportunity to exhibit the *Mother* once more in London: he paired it with the delicate portrait of Cicely Alexander and sent them to hang at the inaugural exhibition of the Society of Portrait Painters, alongside works by Millais, Leighton, Watts, Herkomer, and others—and, according to the critics, to outshine them all. The most effusive review, by far, came from George Moore, who demonstrated that Whistler's recent pummeling of his brother Augustus did nothing to impede his appreciation of Whistler's "wholly original and supremely beautiful" genius. Whistler, Moore argued, stood alone among the artists of his decadent age, and he called for the British public to give him the honor he deserved by subscribing to buy either the *Mother* or the *Cicely Alexander*, or both, for permanent exhibit in the National Gallery.

No one heeded his call.

In Paris, meanwhile, Whistler exhibited that year not as usual at the Salon at the Champs-Élysées, but at a new, upstart Salon on the Champ de Mars, geared toward more youthful and more progressive art, showing the two paintings from Howell's estate, the *Rosa Corder* and the *Crepuscule in Flesh-Colour and Green*. Whistler himself traveled to Paris in June to stand rapt before his own works—and to deplore heartily the works of all others. "Bad—so jolly bad!" he complained of them in a letter to Beatrix. "it is really stupendous how everything is not only bad, but going on to the

bad!" On the same day he stopped by the Galerie Durand-Ruel, where he was equally aghast at works by Renoir (*"childish"*) and Degas ("absolutely shameful!!"). This did not prevent him from visiting Degas on this trip. On the same trip he visited two others who would be crucial to him in selling the *Mother* to the Luxembourg: Stéphane Mallarmé, who with his loyalty and his extensive cultural and political connections would serve as an aide-de-camp in any sale, and Robert de Montesquiou, comte de Montesquiou-Fezensac, the aristocrat and aesthetic maven to whom Henry James had introduced him six years before. It had been Montesquiou more than any other who had ushered Whistler into the highest circles of French society, and it would be Montesquiou, more than any other, who could guarantee the success of any subscription to buy the *Mother* for the state.

Soon after Whistler returned from Paris to London, he learned of yet another potential—and potent—ally to the cause. Having seen Whistler's paintings at the Champ de Mars, the influential critic Gustave Geffroy was inspired to compose a panegyric to Whistler, hailing him, with his "works of such fine psychology, of such proud truth, of such haughty strangeness," as a Symbolist master. While Geffroy's enthusiasm matched Moore's, Geffroy had far more political clout: his homage to Whistler appeared in the July 1, 1891 issue of *La Justice*, the newspaper established by Geffroy's mentor Georges Clemenceau, leader of the Radicals in the government—and future prime minister of France. If Whistler did not then realize the importance of this connection, he would in time.

While his *Crepuscule* and *Rosa Corder* got all the attention in Paris that summer, his two Cremorne nocturnes, the *Fire Wheel* and the *Fallen Rocket* (both, like the *Mother*, newly redeemed from Henry Graves) were also on display there, but much more quietly: displayed to potential buyers at the galleries of Boussod, Valodon & Cie. Joyant did find a buyer, who was willing to buy either nocturne if Whistler was willing to accept £300 for it. David Croal Thomson, learning of this offer, considered it so embarrassingly low that he hesitated to relay it to Whistler. Whistler apparently agreed with him, and the nocturnes remained unsold.

Finally, in mid-October, Maurice Joyant jolted the Luxembourg campaign into motion with his enthusiastic reply to Thomson's inquiry. Prospects for a sale, Joyant was sure, were excellent. If the state did not buy the *Mother* directly, an illustrious committee of "painters, literati and amateurs" would be sure to purchase it, for "an evolution has taken place in the minds of amateurs and the public in the direction of the modern school of which Mr. Whistler is one of the leaders." The only sticking point, he thought, was Whistler's price of 75,000 francs. Not only did the French government operate with an extremely limited budget in these matters, Joyant assured Thomson, but any public subscription for that amount would fail as well. Whistler understood, and dropped any demands about price. Within days the *Mother* was in Paris, on show at Boussod, Valadon & Cie.

At the end of October, after a swing through Antwerp to testify in and win his piracy case against Sheridan Ford, Whistler followed the painting to Paris. He consulted with Mallarmé, who delighted him with the news that Henry Roujon, a good friend of his willing to advance the sale, had become a member of the Ministry of Public Instruction and Fine Arts: "the Luxembourg," Whistler then wrote Beatrix, "is I really believe not so far off." He and Mallarmé then visited Joyant, who had significant connections of his own. He made the social rounds, and he met with Gustave Geffroy, obviously with hopes of promoting the sale with a press campaign.

Geffroy was eager to oblige. On November 4, the *Gaulois* carried on its front page his worshipful assessment of Whistler's work in general and of the *Mother* in particular, concluding with an exhortation to France to obtain the painting. The government should consider it an honor to do this themselves, Geffroy declared, but if they failed to do so, the Parisian public should do it for them. Whistler, who had returned to London by the time the article appeared, found it a little too enthusiastic and a little too specific, fearing that Geffroy's ultimate appeal to the public might deter the state from making an offer at all. "If you see Roujon," Whistler wrote Mallarmé, "you can soften all that . . . making it clear that the quiet and official steps would be much more pleasant to me."

But Mallarmé could not see Roujon, for Roujon had fallen suddenly, seriously ill, and had departed to the south of France to convalesce. Mallarmé therefore recommended to Whistler that they delay their campaign until he returned, perhaps in a month. Whistler agreed, and asked Mallarmé to have the *Mother* removed from display at Bassoud, Valadon & Cie. The next day, however, Mallarmé wrote Whistler proposing "something new, something very new." A committee had formed to buy the *Mother*—an illustrious committee, headed by a former Minister for Public Instruction and the Fine Arts, and not, Mallarmé assured Whistler, the sort of "mediocre and vulgar subscription" that they wished to avoid. He now counseled Whistler to forget about any purchase by the state, which would only delay matters. But then, learning from Joyant that the government might make an offer, Mallarmé suggested that they consider it but take the committee's offer if the government's was too small. By now Whistler had heard from Joyant that the government *did* intend to make its own offer. At this point honor meant everything to him and price nothing, and his only question now was which was the more prestigious: a high-priced purchase by the committee, or a low-priced one by the state. "Consult with Joyant," Whistler urged Mallarmé.

That was good advice. Mallarmé that evening met not only with Joyant but with the cabal he had assembled, which included Duret and Geffroy, as well as Roger Marx, a functionary within the Ministry of Public Instruction and Fine Arts. It was now clear that not only was the Minister himself, Léon Bourgeois, enthusiastically in favor of the purchase, but so was Geffroy's mentor Georges Clemenceau. (And that, Mallarmé later told Whistler, "hastened everything.") The deal was essentially done; both Mallarmé and Duret, now committed to purchase by the state, wrote Whistler to spell out the formalities. On that Friday, November 20, Clemenceau would visit the gallery to marvel at the *Mother*. Bourgeois would then tender Whistler a formal offer to buy the *Mother* for the state. He would ask Whistler to name his price, but Whistler was instead to leave that decision entirely up to Bourgeois, even though his offer, Duret made clear to Whistler, would certainly be "very petty, even ridiculous." Whistler agreed, under one

condition: the absolute assurance that the painting would eventually hang in the Louvre. Both Mallarmé and Duret quickly responded to deflect that impolitic request. "Let's not talk about that for the moment as no one of us wants to outlive you and personally see the painting in the Louvre," Mallarmé wrote, and dangled before him the prospect of another honor that the purchase would almost certainly bring: promotion from *chevalier* to *officier* in the *Legion d'Honneur.* (This "means also everything—it means *guarantie*—money—it means *la fortune!*" Charles Drouet would later assure him.) Whistler dropped his condition.

In the end, the visit by Clemenceau and Bourgeois to see the painting, while "enthusiastic," was superfluous, for Bourgeois actually sent his formal offer to Whistler the day before. Whistler replied with deference and grace. Bourgeois then set a price for the *Mother* even more meager than Whistler's supporters expected: 400 francs, or roughly £160. Mallarmé advised Whistler to accept immediately. "ACCEPTE LA SOMME DICTEE," Whistler telegraphed back that night. On the last day of November, Bourgeois officially ordered the purchase of "the portrait of an elderly lady" for immediate exhibition at the Luxembourg.

The months that followed were the happiest of Whistler's life, the culmination not simply of two weeks' campaigning in Paris, but of the aesthetic war he had fought his entire career, against convention and the art establishment, against the obtuse public, against the pestiferous critics—and against the most formidable and obstructive critic of all. "Well well I think do you know the Whistlers are bound to win," he wrote to his brother Willie the next February from Paris, which he was now, finally, in the process of making his home. ("Now that France takes the Mother forever, it seems to me that she has to adopt the son a little too!" he had told Mallarmé.) "After all those black and foolish years in London among the Pecksniffs and Podsnaps with whom it is peopled, you can fancy the joyous change!—Amazing! Just think—To go and look at one's *own* picture hanging on the walls of the Luxembourg!—remembering how it was treated in England—to be met every where with deference and treated with respect and vast consideration—to be covered with distinction . . . and to

know that all this is gall & bitterness and a tremendous slap in the face to the Academy and the rest! Really it is like a dream!—a sort of fairy tale—"

A week after the sale of the *Mother* George Washburn Smalley, who had been Whistler's American mouthpiece after the verdict in *Whistler v. Ruskin*, now played the same role in announcing in the *New York Tribune* his triumph in Paris. Reminding his readers of Whistler's decades of struggle in London, he turned to—and turned upon—the man whom he considered the fountainhead of all antagonism to the master. Noting the "curious coincidence" that the *Falling Rocket* was now on show in a London gallery—now priced at 600 guineas rather than 200—Smalley considered that "it would be interesting to hear what [Ruskin] now has to say of Mr. Whistler as an artist." Two weeks after this George Moore reminded his readers in *The Speaker* of his plea for the British people to buy the *Mother* for the National Gallery. They had lost that chance now—though, he pointed out, the *Cicely Alexander* was still available, and the National Gallery should obtain that. (Again, nobody heeded him.) In his anger at the stupidity that had led to this loss, Moore lashed out at Whistler's critics, including the most formidable of them. "I wonder what the Press thinks to-day of all its odious attacks on this great man. And Mr. Ruskin; I wonder *what* he thinks, and I wonder what his admirers think."

What did Ruskin now think about Whistler? Nothing. Nothing at all.

CHAPTER 10

GHOSTS

John Ruskin still had eight years to live in 1891. But he was no longer a part of the world: Brantwood had become his entire universe. Joan Severn, once his ward, was now his warder, assiduously fending off anything she thought might excite him. The few visits by outsiders that she allowed, she monitored and limited. The "old dragon sat opposite and never budged an inch," complained Ruskin's frustrated publisher, George Allen, who had made his way to Brantwood that autumn. Joan was unapologetic about what she herself acknowledged as her "dragonizing," certain it was responsible for whatever awareness and equilibrium that Ruskin had.

Though Ruskin still spent most of his days in his study, it was in a hollow mockery of industry: his reading was now confined to the simplest books, and both his desire and his ability to write had vanished. "The Coz shuns pen and ink and paper as a child the fire who has been burnt," Joan assured Charles Norton, "and a good thing too." Once or twice a day he would walk outside, always accompanied by Joan, by her husband Arthur, or by his servant Peter Baxter. When the weather was bad, he would play inside: shuttlecock and battledore with the Severn children. The children would bring dinner to him in his study, where he ate alone. In the evenings

he would play chess or tiddlywinks with the family, or Joan would read to him. He generally spoke in simple sentences—or not at all. He had "little glimmers of consciousness in which he *almost* seems to be himself and then lapses in a vague blank state again," Joan told Norton: "It is a sort of calm drifting of life."

Ruskin had not succumbed to this twilight existence without a tremendous struggle. For more than a decade he had endured the same Sisyphean cycle of events: crushing, incapacitating, attenuating bouts of madness, followed by chastened recovery and a slow return to work, "safe" work at first, but in time more wide-ranging, more reckless—until madness brought him down again. That was the cycle he had endured at the time of *Whistler v. Ruskin*. He would endure it seven more times in the 1880s.

The insanity into which he fell after Carlyle's death in February 1881—catatonia alternating with hallucinations, nonsensical babbling, destructive rage—lasted until the end of March. "I must be very cautious in using my brains yet, awhile," Ruskin wrote Norton, and he was. He promised Joan, for one thing, that he would give up his taxing work as master of the Guild of St. George. But he soon reneged on that promise and cast off caution altogether: by the end of April, though deeply irritable and unable to focus upon any subject for long, he claimed to be "quite afloat again in my usual stream." His restiveness continued through the end of the year, leading by September in his diary to the sort of confused, excited jottings that presaged madness and then to physical collapse for a week in October. And yet he produced. "I begin the last twelfth of the year," he recorded on the first of December, "in which I proceed, *D.V.*,* to finish *Amiens* ii. And *Proserpina* vii.; and in the year I shall have done, in spite of illness, three *Amiens*, one *Proserpina*, and the Scott paper for *Nineteenth*, besides a good deal of trouble with the latest edition of *Stones of Venice*." It was not enough, he thought: "alas, what a wretched year's work it is!" That November Ruskin claimed to be the darkest and saddest he ever passed: the resurgent plague cloud without and crippling depression within causing

* *Deo Volente*: God willing.

a "loss of motive and spirit which makes progressive work hopeless." That torpor persisted: "Dismal—Dismal—Abysmal—all day long and every day alike," he lamented in his diary on January 14, 1882. Six days later his entries ceased altogether, not to resume for another seven months. That March he left Brantwood for London, where his attempt at the National Gallery to sketch a Turner painting came to nothing: "Bothered away from it, and never went again," he inscribed on the back of the unfinished work. Early in March he wrote in desperation to his old friend Georgina Cowper-Temple, now Lady Mount-Temple. "I'm afraid I'm going off the rails again—and it looks to me more like a terminus than the other two times." The inevitable collapse soon followed, this time in London: it was in the room that was once his nursery that he saw "the stars rushing at each other" and the lights of the city "gliding through the night into a World Collision." Joan, pregnant at the time and unable to provide her usual care, brought in a professional nurse, and brought in as well Sir William Gull, one of London's most eminent physicians.

This time recovery was swift, and within two weeks Ruskin, though "alarmed and stupefied," was back at work. Gull prescribed a tour of the continent, but for months Ruskin disregarded him and remained in London, hard at work: instituting a May Day festival at Whitelands, a women's college in Chelsea,* sorting and cataloging his collections for the Sheffield Museum, producing two more parts of his *Proserpina*. He also pursued a surprisingly active social life. He attended at the Oval that year England's momentous loss in cricket to Australia.** He saw (and despised) his first Wagner opera: *Die Meistersinger*. He gave a short speech at a dinner in honor of Africa explorer Richard Burton. He spent a great deal of time in Hyde Park admiring the little girls. "I *am* very naughty about Tinys & Rosalinds," he admitted to Joan, "and I've less and less hope of mending." Joan was alarmed—not by any impropriety, but because of the effect that this excitement was sure to have upon her Coz.

* The festival continues to this day.

** This was the match that gave rise to the Ashes series.

That August, finally heeding Gull's advice, Ruskin set out for Europe, accompanied by an assistant, William Collingwood, and by his servant Peter Baxter. Their route was the same as the one Ruskin had taken so many times before: through France and Switzerland to Italy and back. But everything was different, this time, as the plague-wind haunted him, diminishing both cities and mountains. "The Mont Blanc *we* knew is no more," Ruskin lamented to Norton; "All the snows are wasted—the Eternity of Being—are all gone for it." Nonetheless, he found the old activities—sketching his way across the continent, comprehending again the great vistas, measuring the stones of Italy and France—deeply invigorating. He began to ponder new projects and to develop the confidence that he could complete them. In Florence that October, he discovered in the American artist Francesca Alexander a new protégé and a new aesthetic heroine: so smitten was he with a book of her writing and drawing that he bought it on the spot for 600 guineas; he would later edit and publish it. As he was making his way back to England, he resolved upon a far more ambitious project: the resumption of his Oxford professorship. He was needed at Oxford more than ever, he thought, given recent, pernicious developments in art—in particular, the rise of the Impressionists. "The recent errors of the French schools have made it desirable that I should restate the principles for which I have so long contended," he wrote while making his intentions known to Alexander Macdonald, master of Oxford's Ruskin School. Macdonald conveyed those intentions to the right people; William Richmond, Ruskin's successor as Slade Professor, selflessly stepped aside, and early in the new year Ruskin, now back at Brantwood, got the news in a telegram from Henry Acland: "Dear Friend, may all good attend you and your work in this new condition; once again welcome to Alma Mater."

Ruskin soon set to work on "Recent English Art,"* six lectures that he would deliver, sporadically, throughout 1883. Every one of them was a resounding success, at least in terms of attendance: his celebrity as a lecturer, now at its height, guaranteed that. At the first one, early that March,

* Later published as *The Art of England*.

undergraduates and other admirers filled the University Museum's five-hundred-seat theatre to overflowing: hundreds were turned away. After that a ticket system was instituted, and Ruskin reprised not only that lecture, but all of them. (He promised as well to deliver each lecture a *third* time, in London—but that was a promise he could not keep more than once.) But though the crowds continued to come in droves, those expecting the master of old to deliver an insightful examination of contemporary English art and artists were surely disappointed—for Ruskin was now losing touch with that world. Of the few major artists he did bring up—Leighton, Alma-Tadema, Watts—he had very little to say. His assessments of the original pre-Raphaelites (from which he excluded Millais entirely) was now nostalgic, as was his assessment of the English landscape painters George Robson and Copley Fielding, who had died in 1833 and 1855, respectively. Even his praise for Burne-Jones was retrospective, as his new work—which he examined in Burne-Jones's studio in preparation for his lecture, only "vexed" him. Now, figures peripheral to high art got most of his attention: *Punch* cartoonists Du Maurier, Leech, and Tenniel, the sentimental watercolorist Helen Allingham, and, most effusively of all, his two latest protégés: the American Francesca Alexander, and Kate Greenaway, illustrator of saccharine little girls, one of whose Christmas cards Ruskin now thought "a greater thing than Raphael's St. Cecilia."

Ruskin had returned to Oxford resolving to finish everything he had left unfinished when he had resigned in the wake of *Whistler v. Ruskin* five years before—which meant, in particular, resuming his mastership at the drawing school and imposing an order upon the formidable but chaotic collection of artwork he had lent it. But he was no longer physically capable of that sort of devotion. Of the twenty-six months of his resumed professorship he would spend no more than four, all told, in residence. These were not Oxford years but Brantwood ones, for it was there that he spent almost all his time: alone, with Joan, and, frequently, with visitors. Kate Greenaway was now a favorite. So, again, was Maria La Touche, Rose's mother; Ruskin had reconciled with her in 1881. Charles Eliot Norton visited twice in 1883, and again in 1884. He hadn't seen Ruskin in eleven years and was

shocked at the change: "I had left him in 1873 a man in vigorous middle life, young for his years, erect in figure, alert in action, full of vitality, with smooth face and untired eyes. I found him an old man, with look even older than his years, with bent form, with the beard of a patriarch, with habitual expression of weariness, with the general air and gait of age."

Ruskin himself kept a watch upon these physical and psychological shifts, chronicling them in his diaries as obsessively as he chronicled the comings and goings of the plague cloud. Indeed, these concerns often merged. "Black fog and cold—I shivery and valueless," he wrote on February 15, 1883, "horrible 'plague-and-fury' wind . . . I cant think or set myself to anything" on January 21, 1884. He noted, it seemed, every restless night, and the rarer restful ones, as well as the dreams and nightmares that populated them. He noted the aches and pains that plagued him—of head, stomach, hand, and groin. He noted his relentlessly and rapidly fluctuating state of mind, from "good heart" and the will to work to overexcitement to hopeless depression—and utter lassitude. His literary output thus suffered during this time. But it did not end: besides his lectures, he added to his geology with more *Deucalion* as well as catalogues of his minerals. He revised his *Modern Painters* to expunge his youthful evangelicalism and to insert some jibes against the Impressionists. Ominously, he resurrected *Fors Clavigera* after a three-year hiatus: six letters, which largely concentrated upon the education of children, and in particular upon the sociology of little girls. Not surprisingly, perhaps, but still jarringly, Kate Greenaway illustrated five of them.

In the midst of all of this—in February 1884—he produced his most prophetic work, lecturing to a London audience upon "The Storm-Cloud of the Nineteenth Century," finally revealing to the public his vision of tainted environment—a vision that no one else seemed to share. Largely confined to evocative descriptions culled from his diaries, the lecture did not dwell upon causes: the belching smokestacks causing the dire change he only touched on. But his moral absolutism and prophetic fervor burst forth as he blamed the darkness within his listeners for the darkness without:

Remember, for the last twenty years, England, and all foreign nations, either tempting her, or following her, have blasphemed the name of God deliberately and openly; and have done iniquity by proclamation, every man doing as much injustice to his brother as it is in his power to do. Of states in such moral gloom every seer of old predicted the physical gloom, saying, "The light shall be darkened in the heavens thereof and the stars shall withdraw their shining" I leave you to compare at leisure the physical result of your own wars and prophecies . . . that the Empire of England, on which formerly the sun never set, has become one on which he never rises.

As so often before, this audience found Ruskin's singular vision highly entertaining—but not at all convincing. "We cannot swallow the 'plague-cloud,'" wrote the writer for *The Graphic*. "It no doubt has a real existence—in Mr. Ruskin's own bodily sensations."

Ruskin spent nearly all the spring and summer of 1884 at Brantwood, not returning to Oxford until October and Michaelmas term, when he planned to lecture upon "the Pleasures of England," a sweeping survey of English culture from Saxon times until his present. But that summer was one of ever greater languor and mental confusion: "my work now a mere breccia, like to decompose into sand" in June; "so many thoughts—so few powers, and hours" in August. He was able to prepare the first two of his lectures but had to leave the others to improvisation. The results were disastrous. He remained as popular a lecturer as ever, but only because students now flocked to witness, in his chaotic if energetic digressions, the sadly entertaining spectacle of a great intellect unraveling before their eyes. The painter Hubert von Herkomer that November witnessed Ruskin's fifth lecture, and was aghast: "How shall I describe that painful performance? And painful it was to his friends who loved and revered him, who so plainly saw how he played to the gallery, how the perversity of spirit that sometimes overtook that brilliant mind, he seemed only to wish to arouse hilarity amongst the undergraduates, who *did not know*

him." Afterward, Herkomer recalled, Ruskin, "a man of infinite sorrow and sadness," begged Herkomer to take over as Slade Professor—which, a few months later, he did. Ruskin's Oxford friends, including Henry Acland, fearing what he might do on his final two lectures—on atheism and mechanism—convinced him to shift his subjects to less controversial ones, and so he finished the term with lectures upon patience, birds, and landscape. "Badly off the rails," he noted just after the last of these that December, "but keeping well, and hope for an upspring again." The upspring did not come. Christmas at Brantwood was solitary and miserable. "I must never stir out of quiet work more," he vowed on the 23rd— and for the most part, he kept to that vow. Oxford was finished—though it would be another three months before he officially resigned, using the university's growing support for animal vivisection as his excuse. On Christmas Day, he completed his ninety-sixth and final *Fors Clavigera* letter. And on New Year's Day 1885 day he began, in brief daily installments, to record the memories that would form *Praeterita*, his autobiography.

Praeterita was indeed "quiet work" for him, limited, at least at first, to daily meditations of half an hour or so in his diary: a generally-soothing daily return to better the better world he inhabited before the coming of the plague cloud, when beauty was absolute and Ruskin was its prophet. His recollections were entirely, and therapeutically, selective: "I have written," he made clear in his preface, "of what it gives me joy to remember . . . passing in total silence things which I have no pleasure in reviewing." In Ruskinian terms, he focused upon the *wealth* of his life—childhood and young manhood—and ignored the *illth*. Dominating the work was his holy trinity of self, mother, and father: he dwelt lovingly upon the havens his parents created for him at Herne and then Denmark Hill, and upon the worlds they opened to him with their travel. Largely missing are the conflicted relationships with others. The Pre-Raphaelites barely got a mention, and Effie Gray none at all—except for the passing notice of an anonymous little girl for whom Ruskin once wrote a fairy tale. Though, ignoring the advice of others, Ruskin did write of his blissful early days with Rose La

Touche—it became the climactic episode of the work—the anguished later days with her are not there.

Praeterita was Ruskin's miraculously sweet swan song. Composed between 1885 and 1889, the most turbulent years of his life, filled with recurrent madness, with growing instability, with depression and with rage, *Praeterita* defies it all. It is the most lucid, tranquil, intimate, and genial of all his works.

His next collapse, long-anticipated, finally came that July, spurred, by two "contrary and exciting elements": visitors to Brantwood Kate Greenaway and Maria La Touche. The confusing and intoxicating presence of another young Rose—granddaughter to Maria La Touche and niece to Ruskin's love—could only have contributed to his excitement. When Ruskin's delirium commenced, Joan asked his visitors to leave; Maria and Rose complied, but Kate Greenaway, following Ruskin's frantic orders, did not. While Joan considered this bout the worst one Ruskin suffered, it was at least brief, lasting only three weeks. But this time Ruskin's recovery was partial. "This last illness," Ruskin wrote Norton afterward, "is entirely irremediable—it has taken all hope out of me, and with hope, all pride. I feel nothing but the opportunities that I have lost and the follies I have done." Empty, chastened, he now yielded total control to Joan, summoning a lawyer to Brantwood to sign over the estate to her and to Arthur, and submitting himself entirely to her decisions over the duration and the direction of his work: her dragonizing now commenced in earnest.

For the next two years Ruskin remained largely cloistered at Brantwood, confining his writing, as Joan desired, almost exclusively to *Praeterita*. But by the spring of 1886 his willing submission to Joan had passed and his resentment of her power over him intensified to the point of paranoia. "The sweet Joan," he wrote Norton that May, "is at this moment lodged in this house of Brantwood in defiance of my sternest orders—endeavouring by every artifice in her power to shut me, for insane, into my bedroom—as she did last year, and the year before. I hope, this year, to retain my power of managing my own servants, and walking in my own woods." It was, however, a hope for some time unrealized, for less than two months later

Ruskin fell into yet another delirium, this one conspicuous by a violent and helpless rage against Joan and her husband. "The present phase is *most trying*," Joan wrote that July, "and consists in the vilest abuse of Arthur and me—every crime we are accused of, including plots to murder him." Since the very sight of her precipitated Ruskin's fury she avoided him, leaving his care—and his restraint—to the male nurses she brought in.

In a month the madness passed. Ruskin's resentment against Joan and Arthur did not. For the next year he and the Severns were locked in a battle of wills. "The poor Coz," Joan complained to Norton toward the end of 1886, "hardly sleeps at all—declares himself to be in splendid health and is at intervals very sweet and like himself—but as a rule *most* irritable and unreasonable—and won't have the slightest contradiction or advice and says and does all sorts of harsh and wrong things—and if anyone dares to oppose him he becomes furious." Yet Joan did, increasingly, oppose him, as his desperate need to prove himself master of his household and of his affairs led him into extravagant spending: capriciously doubling his servants' wages, for example, and spending a fortune upon books that he would impulsively order from Bernard Quaritch, his London dealer. It was not his spending, however, but his involvement with several little girls from the local school that led to the most serious rupture between them. Every Saturday for months, and generally during Joan's absence, Ruskin had been inviting the girls to Brantwood for games and lessons, followed by tea and dancing in his private study. ("He's a foony man is Meester Rooskin," claimed one of them, "boot he likes oos to tek a good tea.") In May 1887, not long after Ruskin startled one girl's parents with an offer to adopt her, Joan confronted Ruskin about the parties. Ruskin responded so vehemently and threateningly that Joan fled to her room, locked herself in, and collapsed on her bed, while Ruskin rushed to his room, snatched up a few of his favorite Turners, and took flight to a local hotel, refusing to return while the Severns remained there. They soon left for London. Within days, after trying and failing to find a neighbor to replace Joan as housekeeper, Ruskin was begging her to come back. At the beginning of the summer, she did.

But by then he concluded that *he* would have to leave. Steeped in depression, tortured by the false notions that his life had been an utter failure and that he had with his extravagance lost his fortune, and convinced that he had become a burden upon the world in general and upon Joan in particular, he was now driven to hide himself away. That August he ceded his checkbook to Joan, instructed her to keep his whereabouts a secret and retain letters sent to him, and, with vague notions of eventually crossing the channel and again finding renewal in Europe, he departed with his servant Baxter for the seclusion of the Kentish coast, where they took rooms at the Paris Hotel in Folkestone.

Ruskin found no peace there. Instead, his depression cycled to a manic excitement that found outlets in verbal and physical abuse of Baxter, in rages toward strangers, and in inappropriate acts of generosity toward the hotel staff, such as giving sherry to the porters and champagne to the chambermaids. "He is simply the laughing stock of the people about," Baxter complained to Joan; "Mr. Severn ought to come at once and bring a keeper for him and take him from here at once." Baxter pleaded to be allowed to return to his wife and child at Brantwood, and Joan agreed—but otherwise refused to intervene. Ruskin, then, on his own found a replacement for Baxter: a "horsey, boozy, boaty—a little billiardy" local by the name of Edwin Trice, who promptly moved Ruskin out of the Paris Hotel for not one but two residences in the nearby village of Sandgate: a room at the Royal Kent Hotel where he could sleep and take his meals, and the front rooms of a house by the shore where he could in sad solitude sit before a bow window to observe the shore and the channel, the smoke-obscured sunsets and sunrises, the moon and the storms—and do little else. "I'm alone in a room about the size of a railway carriage," Ruskin wrote to a friend in February 1888. "I can't walk about in it (and wouldn't care to, if I could). I've no books that I care to read (or even would, if I cared to). I'm tired of pictures, and minerals, and the sky, and the sea." He would later remember the "misery of Sandgate" as a ten months' purgatory—"the most terrific year of illness and despondency I have yet known."

From time to time visitors relieved the monotony. Joan and Arthur often came down from London, as did Kate Greenaway, and, at the beginning

of 1888, a new disciple, Sydney Cockerell, with his sister Olive. Ruskin also made several flying visits to London, generally shunning society for the company of a few close friends and shunning Herne Hill for Morley's Hotel in Trafalgar Square, from where he could more easily haunt again the galleries and museums, particularly the National Gallery. It was there, in October 1877, that he found a new friend in twenty-year-old Kathleen Olander, an aspiring artist who had a particular love for *Modern Painters*. At their first meeting Ruskin convinced her to become his pupil. They had further meetings and initiated a brief but abundant correspondence. She was deeply flattered by the attention and was from the start devoted to him—but, from the start, he wanted more. Young, pretty, virginal, saintly, Kathleen, Ruskin quickly convinced himself, was his second Rose La Touche, actually sent to him by the first. His addresses to her between the autumn of 1887 and the spring of 1888 progressed from "Dear Miss Olander" to "My dear Kathleen" to "Very dear Kathleen" to "Dearest Kathleen" to "Darling Kathleen." That Christmas, Ruskin surprised Kathleen's father by requesting he bring her to Sandgate; Mr. Olander refused. When, that April, they learned that Ruskin had offered their daughter a suspiciously exorbitant 20 guineas to copy a Turner for him, her parents thought the worst and demanded that the correspondence come to an end. It did—for two months.

Ruskin remained at Sandgate from October 1887 until June 1888, enduring long periods of depressive torpor punctuated by briefer ones of volatile excitement. Joan was in Sandgate for one of these in March, but soon abandoned him, believing he would be better served by the therapeutic properties of "humdrum Hotel life" supplemented with the services of local doctor Robert Leamon Bowles and, when necessary, a platoon of minders that included two burly male nurses as well as the proprietors of both Ruskin's residences. That Joan, fearing her Coz's indiscretion, left standing orders for intercepting his mail could only have heightened Ruskin's feelings of oppressive paranoia.[*]

[*] Ruskin's attempt to subvert this restraint by forwarding letters through Kathleen Olander failed when Olander, bewildered to be getting mail addressed to people such as Cardinal Manning, refused to send them on. (Ruskin, *Gulf of Years*, 39)

Finally, at the end of May, Joan, convinced now that Ruskin would be better off anywhere besides Sandgate, swept down from London, sacked the dubious Edwin Trice and recalled the loyal Baxter, obtained Ruskin's promise that he would eventually return to Brantwood, and arranged a short trip for him, accompanied by Baxter and her husband Arthur, to France. On June 10, the three men arrived in Abbeville and settled into the *Tête de Boeuf* inn. The change of scene did nothing to alleviate Ruskin's morbid depression. Arthur quickly grew bored, annoyed, and desperate to return: "I am keeping abroad as long as I can stand it—to be of service to you," he wrote to his wife. After a fortnight of mutual misery, relief came with the arrival of two young men: Ruskin's new disciple Sydney Cockerell and Cockerell's friend, architecture student Detmar Blow. The two, having no idea Ruskin was in France, had come to make their own tour with Ruskin's *Bible of Amiens* as their guide. Having by coincidence chosen to stay at the *Tête de Boeuf*, they were stunned to see Ruskin at breakfast the next morning. Their presence rejuvenated him. For the next week and more the four men toured Abbeville, Amiens, and Beauvais, until Arthur, relieved to be able to leave Ruskin in more capable hands, hurried back to England to join a yachting expedition. Ruskin, Cockerell, and Blow continued on together for another week, until Cockerell—who remembered these days as "perhaps the happiest of my whole life"—was compelled to return home. With Blow and with Baxter, then, Ruskin, set out upon a wildly ambitious journey across the Alps to Venice, and back.

Their journey proved, at first, to be as revitalizing as Ruskin hoped it would be. His ability and his energy to write returned, and, between Paris and the Alps, he managed to create both a new epilogue to *Modern Painters* and a crucial new chapter of his *Praeterita*, dealing with those blissful early days with Rose La Touche. At the same time, as Kathleen Olander had convinced her parents that cutting off Ruskin would irreparably harm her career as an artist, he now inundated her with letters. That these letters were clearly unbridled declarations of his love would have been obvious to anyone besides Olander herself, who later admitted her painful naivete about "ordinary life." From Sallenches on September 10:

"for the present you belong altogether to me—heart—wits and will. . . ."
A week later from Chamonix he hinted at marrying her in the Sainte Cha-
pelle: "in Paris—you shall enter—a world—not wicked—in which God's
will shall be done—as in Heaven, and in which—we both shall be His
servants with one heart and mind." Finally, in Milan on September 25,
he jolted the young woman into awareness with the use of the word *wife*:
"and you *will* be happy with me, while yet I live—for it was only love
that I wanted to keep me sane—in all things—I am as pure—except in
thought—as you are—but it is *terrible* for any creature of my temper to
have no wife—one cannot but go mad."

Olander, bewildered and horrified, wrote to fend him off, and then showed
his letters to her parents, who ended contact between the two permanently.
Her letter reached him in Bossano, where he was staying with his protégé
Francesca Alexander. His gloom had by then returned; the vivacious company
that had assembled at Alexander's palazzo oppressed him, and now, Olander's
rejection crushed him utterly. He would have no wife—and he could not but
go mad. The next day he continued on to Venice, where he was nearly inca-
pable of communicating with old friends, and could find no joy in sharing
his beloved stones with Detmar Blow. The two had planned for three weeks
there but left after ten days, then lingered in Switzerland for nearly seven
weeks, Blow and Baxter desperately hoping that the mountains would charm
and strengthen Ruskin, as they had so many times before. They hoped in
vain. Ruskin sunk deeper and deeper into guilt, despair, and plaintive longing
for Joan and Brantwood. At Berne, at the end of November, they admitted
defeat and resolved to bring Ruskin home as quickly as possible. Within
two days they got him to Paris where, sure he was dying, they telegraphed
Joan, who came to find him delusional, weeping, and trembling uncontrol-
lably. She brought him back to Herne Hill where, without her family, they
spent a harrowing Christmas, before returning at the beginning of 1889 to
Brantwood, Ruskin all the while having no idea where he was. Joan feared
his condition might be permanent.

She was wrong—but not by much. By the spring, in spite of Joan's
anxiety, Ruskin was back at work, desperate to finish one more, culminating

chapter of his *Praeterita*, and he succeeded with perhaps the most tender and benign one of all: a final homage to Walter Scott, to Thomas Carlyle, and especially to Joan herself. On June 19 he finished with an exquisitely impressionistic—one might even say *Whistlerian*—prose nocturne that, half a century later, Virginia Woolf would judge among his best writings, "surely more beautiful than those more elaborate and gilded ones which we are apt to cut out and admire":

> How things bind and blend themselves together! The last time I saw the Fountain of Trevi, it was from Arthur's father's room—Joseph Severn's, where we both took Joanie to see him in 1872, and the old man made a sweet drawing of his pretty daughter-in-law, now in her schoolroom; he himself then eager in finishing his last picture of the Marriage in Cana, which he had caused to take place under a vine trellis, and delighted himself by painting the crystal and ruby glittering of the changing rivulet of water out of the Greek vase, glowing into wine. Fonte Branda I last saw with Charles Norton, under the same arches where Dante saw it. We drank of it together, and walked together that evening on the hills above, where the fireflies among the scented thickets shone fitfully in the still undarkened air. *How* they shone! Moving like fine-broken starlight through the purple leaves. How they shone! through the sunset that faded into thunderous night as I entered Siena three days before, the white edges of the mountainous clouds still lighted from the west, and the openly golden sky calm behind the gate of Siena's heart, with its still golden words. 'Cor magis tibi Sena pandit,' and the fireflies everywhere in sky and cloud rising and falling, mixed with the lightning, and more intense than the stars.

They were his last published words. A month later, on a miserable beach holiday in nearby Seascale, Ruskin tried to write again. But the ability was gone. "He seemed lost among the papers scattered on his table,"

remembered his disciple and future biographer W. G. Collingwood, who was then with him; "he could not fix his mind upon them and turned from one subject to another in despair. . . ." A month later came the seismic collapse that put an absolute end to any further attempts to write, and an end to all life outside of Brantwood.

For months he was confined to his bed, not raving but stunned and unaware, not resistant but pliable: the burly nurse brought in at first was not needed. From then on, Joan's control over him was absolute, and it was almost exclusively Joan who shaped the world's image of him during this time, assuring unexpected callers and sympathetic enquirers of his good spirits—but of an exhaustion too great to allow visitors. It was a diagnosis borne out by the accounts of the very few visitors who did manage to see him, who cumulatively detail a dying of the light so lengthy as to be imperceptible: the slow slippage of memory, of language, of physical activity. Sydney Cockerell, as it happens, visited him at the beginning of this period, and then visited him at the end. In April 1892, he found Ruskin "looking not unlike his old self—more feeble, more bent, his beard longer and a little whiter, his hair still dark steel grey and very abundant, his smile subdued, his eye less bright. He took my hand and spoke of Beauvais." In November 1899, he found him "tranquil, rather wistful, shrunken, but very little change in face"—but also vacant—not so much not there as *elsewhere*, buried within himself. Now, the past was gone: rather than chat about Beauvais, he denied ever being there, denied knowing any Detmar Blow. Quite likely, he did not know Sydney Cockerell. "It was like interviewing a ghost," Cockerell thought. By then, he had largely lost his ability to speak in sentences, or to communicate at all with anyone besides Joan or Baxter. He had also stopped his walks, and was now almost exclusively confined to his bedroom and to the adjoining turret; there he would now sit, "silently and for long intervals together gazing," according to his old friend Frederic Harrison, who visited in 1898, "with a far-off look of yearning, but no longer of eagerness, at the blue hills of the Coniston Old Man." *Theoria* had by then long abandoned him. *Aesthesis*, however, remained with him until the very end.

That end came at the beginning of 1900 when an influenza that had sickened several of the Brantwood servants spread to him. On Thursday January 18, Baxter put him to bed after Joan discovered his sore throat and pains "all over." On Friday, he revived enough to dine upon sole, pheasant, and champagne. But on the early afternoon of the next day—the 20th—he collapsed into unconsciousness. While Joan held his hand as Baxter moistened his lips with brandy and cooled his forehead with eau-de-cologne, his breathing faded almost imperceptibly into nothingness.

James Whistler, a man seemingly with a *mot* for every occasion and hardly one to let slip the great opportunity of burying the hatchet into the ribs of a lifeless enemy, met the news of Ruskin's death with uncharacteristic silence. For him—for nearly everyone—Ruskin had been long dead to the world, had, with his long withdrawal, become the ghostly relic of a bygone age. But ghosts can haunt—and James Whistler, particularly sensitive to that sort of thing, had by 1900 been haunted by Ruskin for years.

Certainly John Ruskin had been on Whistler's mind in the months after the sale of the *Mother*. Indulging all that time, with Montesquiou as his Mephistopheles, in daily and nightly lionization by the Parisian *bon ton*, Whistler did not lose sight of the fact that he still had the public and the critics in London—the Pecksniffs and the Podsnaps—to win over to his art. At the end of 1891 David Croal Thomson had suggested to him the means to that end: a magnificent retrospective exhibition of his paintings at London's Goupil Gallery, followed by the possibility that, with a word in the right ear, the British government might be induced to confer its own immortality upon Whistler by purchasing one of his paintings for the National Gallery. By March 1892, through doggedly wheedling Whistler's past patrons, Thomson and Whistler had assembled an unparalleled collection of his finest canvases—including his *Falling Rocket* and *Battersea Bridge* nocturne, as well as the *Carlyle* and portraits of Jo and Maud, Cicely Alexander, Rosa Corder, Lady Archie, and Lady Meux. (The *Mother*, of

course was now unavailable, but they made up for that by displaying a photograph of the original.) In preparing the catalogue for the exhibition Whistler, as he had done eight years before, planned to mock his critics by flinging back at them the absurdities they had once flung at him. This time, however, he expanded his attack to take in Ruskin's surrogates at the trial—and Ruskin himself. He opened his catalogue with attorney general Holker's dismissive, "I do now know when so much amusement has been afforded to the British public as by Mr. Whistler's pictures," followed through with a substantial amount of Burne-Jones's testimony and a snippet of Frith, and did his best to savage Ruskin not only with the *Fors Clavigera* tirade that started it all, but also with three passages culled from *Modern Painters*, two of them calculated to make Ruskin look ridiculous, and one encapsulating Ruskin's opposition to the notion of art for art's sake, and thus his desecration of Whistler's own goddess: "Painting, or art generally, as such, with all its technicalities, difficulties, and particular ends, is nothing but a noble and expressive language, invaluable as the vehicle of thought, but by itself nothing."

Nocturnes, Marines, and Chevalet Pieces, showing that March and April, was a popular sensation. Six thousand viewers crammed the gallery on opening day, and after that the crowds continued to come, setting an attendance record for the gallery that would not be broken for another twenty years.[*] Edward Burne-Jones came, paid his shilling, viewed every work at length, and finally appreciated Whistler's genius: "he is a bigger minded man than one would have thought," Thomson reported to Whistler, further reporting him "much vexed to see his old opinions come to daylight again" in the exhibition's catalogue. Taunting Burne-Jones in this way must have delighted Whistler, but taunting Burne-Jones's master would have been more delightful still, and though this was now impossible, Whistler tried anyway. "*Ruskin*," Whistler wrote Thomson; "did you send him by the way a Card?—You certainly ought to post him a season ticket *at once!*"

[*] That record, curiously enough, was to be broken by Whistler's one-time pupil Walter Greaves, whose own work, long ignored, was suddenly and dramatically rediscovered in 1911. (Anderson and Koval, 352)

But as successful as it was, the exhibition left Whistler unsatisfied. The critics' reviews, for one thing, were mixed. Worse than that, however, the exhibition failed to prompt the government to buy a Whistler for the nation. This implicit rejection so soon after his incredible success in France stung, and from that time on Whistler vowed that no painting of his would ever hang on the walls of *any* English museum. He now delighted to see his works migrate away from the hands the English patrons of his early years, who had been able, Whistler thought, thanks to "Mr. Ruskin, Mr. B. Jones and the Attorney genl of England," to buy their treasures at absurdly low prices, and into the hands of new and more generous patrons outside of England. That migration began in earnest with the Goupil exhibition itself, which many of Whistler's earlier patrons had used to showcase their works before putting them on the now-skyrocketing market for Whistlers and generally realizing immense profits. Before two years had passed, Whistler estimated that most of the paintings at the Goupil had in this way left the country. As pleased as he was to see them go, he was livid at their sellers both for putting profit before love of his art and for what he saw as nothing less than theft in accepting money for the products of "*my* labour—*my* brain—*my* name!!" while he got nothing. "It is intolerable," he fumed to one patron, "that all of you in England should under my nose, in this sly way—turn these pictures of mine over and over again, and without a word to me pocket sums that properly you should offer to me on your bended knees saying behold the price we are at last able to obtain for these valuable works we have had the privilege of living with all these years for eighteen pence!"

He had no problem, on the other hand, profiting personally from the few older paintings *he* had kept hold of. That summer he sold his *Fur Jacket* and his portrait of Lady Archie to a Glasgow dealer for £400 apiece and a share in the profits of future sales. Then, in October, came a sale in its own way as deeply satisfying to him as the sale of the *Mother* had been, when Samuel Untermyer, a wealthy New York lawyer, bought *Falling Rocket* for 800 guineas. "Let Mr. Untermeyer [*sic*] know," Whistler directed Sydney Starr, his follower who had brokered the deal, "that *he* possesses

the famous Nocturne that was the destruction of Ruskin the immaculate!" From Paris he directed his allies to spread the news that "the 'Pot of paint flung into the face of the British Public for two hundred guineas,' has now sold for four pots of paint, and that Ruskin has lived to see it!!" The sale, he thought, provoked the English on a level they could understand, being a "*commercial* slap in the face of their high priest I think that the people of the land will be much more deeply affected by—than by all honours or artistic achievements possible."

With that sale, Whistler virtually exhausted his own supply of older paintings, and for profit now relied largely upon new works. That the market for Whistler portraits had shot up as well had been demonstrated at that time by his commission for full-lengths of the Duke and Duchess of Marlborough for 2,500 guineas. (That commission, however, came to nothing when in November 1892 the forty-two-year-old Duke unexpectedly died.) For the rest of his life, Whistler would rarely be at a loss for paying sitters. But he hardly made his fortune from them, hampered as usual by his inability to give up a painting until he was sure it was right, compounded by his inability to recognize *when* it was right, leading to relentless buildings-up and scrapings-down that resulted in paintings unfinished or, equally bad, grossly overfinished. The example of John James Cowan, the Scottish industrialist and collector, is typical. Cowan began sitting for Whistler in May 1893. Work at first went smoothly, and by the end of June Whistler pronounced the work done and signed it. Then he changed his mind—and removed the signature. In 1894 Cowan could not sit, so Whistler worked with shoes and a cap he had left behind. Cowan resumed his sittings in 1895, noting "lots of rubbing out and despair" during one session. He sat for Whistler every year after that until 1900—sixty times in all, he estimated—and then stopped. Whistler struggled on without him but got nowhere, and the portrait was found unfinished in his studio after he died. All the while he struggled similarly with other commissions: Louise Kinsella, Marion Peck, Isaac Burnet Davenport, George Vanderbilt, Richard Canfield, Charles Freer. For most of that work, Whistler earned nothing.

He did however have his occasional successful commissions—his portrait of Arthur Jerome Eddy, for example, which he completed in six weeks in 1894, earning 350 guineas. He did manage to produce a sizeable amount of non-commissioned work at this time: inside the studio many portraits of Beatrix and her sisters, of nudes, of children; and outside of it a profusion of little beauties, most created during his working holidays: in Brittany in 1893, Lyme Regis in 1894, Honfleur in 1896, Étretat in 1897, Pourville-sur-Mer in 1899, Dublin in 1900, and Morocco and Corsica in 1901. His etchings, old and new, now sold more readily than ever, as did his lithography, the form he preferred in his later years, its softer lines well suited to his subtle atmospherics.* In short, although he never achieved the stratospheric incomes of his contemporaries Millais, Leighton, or Burne-Jones, and though he never ceased worrying about money—at times, with good reason—Whistler never faced serious debt again, and in the end was able to accumulate enough to give Ruskin, in a sense, a final commercial slap to the face: his estate amounted to £11,020, pipping Ruskin's £10,660, 2s. 8d.

For the three years after the sale of the *Mother*, Whistler remained true to his vow to abandon England for Paris. At the beginning of 1892 Beatrix joined him there, bringing her sister Ethel; the three took a suite at the Hotel Foyat while Whistler sought out a studio and a home. The studio he found in May, on the rue Notre Dame des Champs. "The finest place of the kind I have ever seen," he thought it, capacious enough to fit a full-scale printing shop, and with a stunning view of the nearby Luxembourg Gardens and all of Paris beyond: a view, however, that came at the cost of a six-story climb that became more grueling to Whistler with each passing year. The home he found two months later: "a sort of little fairy palace" in the Latin Quarter on the rue du Bac, which he had transformed by the end of the year into another Whistler arrangement, complete with his blue and white china, his pet parrot, and his growing collection of fine silver.

* In taking up lithography, a process involving the application of wax to limestone, Whistler—almost certainly without knowing it—again clashed with Ruskin, who hated the form, having denounced it long before as "wholly offensive to the eye of any well-trained artist." (Ruskin, *Works*, 19.159)

Until the end of 1894 he held court, contentedly surrounding himself with collectors and the curious, with friends, and with a new generation of followers—Arthur Studd, William Rothenstein, Howard Gardiner Cushing—who gave him the "exclusive loyalty and admiration" that he demanded. The art world, too, now showed its admiration more fully than ever before, as he continued to exhibit widely and, in everywhere but England, it seemed, was awarded: gold in Munich in 1892, in Chicago in 1893, and in both Philadelphia and Antwerp in 1894.

1892 thorough 1894, then, were his years of contentment, of enjoying the laurels that had finally come to him, if not of resting upon them. The struggle continued, and the enemies continued to fall. 1894 in particular was a good year for making enemies. At the beginning that year he met the first of them when Sir William Eden, baronet, amateur artist, collector, and determined tightwad,* with the assistance of mutual friend George Moore, convinced Whistler to paint a "sketch" of his wife Edith for a yet-to-be-determined price of between 100 and 150 guineas. By February, Whistler had produced something more than a sketch: a full-body, finished oil portrait. On the 14th Eden handed Whistler a "Valentine" that Whistler later opened to find a check for the minimum amount of 100 guineas. He shot Eden a sarcastic note—"You really are magnificent!—and have scored all round"—and resolved that Eden would *never* have the portrait. He then cashed Eden's check, not as a payment, but as the Valentine's Day gift that Eden pretended it to be. That Eden the next day agreed to pay £150 for the portrait did nothing to loosen Whistler's resolve. The battle was on, but as the Edens soon afterward left for an extended trip to India, it was deferred for months.

Within weeks of that confrontation, Whistler discovered another enemy in his old friend George du Maurier, whose fictionalized account of their shared bohemian days—the novel *Trilby*—had begun its serialization in *Harper's Monthly* that January. Whistler took little notice of the novel until its third installment, in which du Maurier introduced the minor

* And, incidentally, the father of future prime minister Anthony Eden.

character Joe Sibley: an exquisite and original artist, an eccentric dresser, a brilliant but caustic wit, and "the most irresistible friend in the world as long as his friendship lasted—but that was not forever!" Du Maurier had thought Sibley would stir "pleasant recollections" in Whistler, but Whistler was livid to be turned into a joke, and commenced war on all fronts. He blasted du Maurier with a volcanic private letter in April, and with a snidely witty public one in the *Pall Mall Gazette* the next month. He attempted to have du Maurier expelled from their mutual club, the Beefsteak—only to discover that du Maurier had quit the club the year before. He exhorted his ex-friends Stacy Marks and Edward Poynter, whom du Maurier had also caricatured in *Trilby*, to turn upon du Maurier as well. (Marks half-heartedly agreed; Poynter flatly refused.) He threatened to sue both *Harper's* and du Maurier personally unless they apologized and removed Joe Sibley from *Trilby*. *Harper's* quickly caved to Whistler's demands, giving him final approval of all the changes du Maurier might make. "I look upon this as one of the most brilliant and *complete* triumphs," Whistler crowed to his solicitor; "this Dumaurier on his dunghill has been wiped up forever! . . . Fancy having to write his book over again, and being forced to submit his manuscript to the man he was intended to destroy!—Could humiliation be greater—?" As it turns out, du Maurier's humiliation certainly could have been greater, for even without Joe Sibley—replaced by a "Bald Anthony" who bore no resemblance to Whistler—*Trilby* became one of the biggest bestsellers of the nineteenth century, Trilbymania gripped the United Kingdom and the United States, and du Maurier's own fame soared.

That October, as *Harper's* published its apology to Whistler, Sir William Eden returned from India and recommenced battle, demanding through his solicitors that Whistler hand over the portrait of his wife. When Whistler refused, Eden sued him for it, and for 1,000 francs—£40—in damages. Whistler in response belatedly returned to Eden his 100 guineas—which Eden refused to accept—and did his best to force the issue by rubbing out Lady Eden's head and painting in another woman's. Eden still demanded to have the painting—but now asked for damages ten times greater. The trial, to be held in a Paris courtroom, was set for February 1895.

By then, Whistler's Parisian idyll had come to a dismal end, as Beatrix's state of health, always fragile, had the November before collapsed: she suffered now from cancer of the cervix. Frantic with worry, Whistler found a French doctor willing to operate, but then in an agony of doubt he summoned his brother Willie to Paris to give his opinion. Willie came, concluded that Beatrix's illness was terminal, put a halt to the operation, and convinced Whistler to return with Beatrix to London, where she could be better cared for but could not be cured. The Whistlers followed his advice and were in London by December. Whistler could never quite accept his brother's grim prognosis, which he took as a sort of betrayal. A chill arose between them that eventually hardened into estrangement: a "grief to both," thought Willie's wife Helen, and one that, she was sure, drove Willie into certain "unfortunate habits" that would lead to his death five years afterward.

The particularly cold winter of 1894–1895, then, the Whistlers spent in London. At first they remained together at Long's Hotel, but as Beatrix's condition worsened they lived apart. Beatrix took a bed at the residence and clinic of Samuel Kennedy, a particularly unpleasant and bullying doctor—but one of the few who held out any hope for a cure. Whistler moved in with Willie and Helen and spent his days doing his best to work, alternating between the shop of his printers, the Ways, half-heartedly working on lithographs that he later wished destroyed, and the studio of Walter Sickert, where he attempted several portraits, the best one of which, *Portrait of Miss Laura Barr*, simply disappeared that February when Whistler, traveling to Paris to battle with Eden, attempted to bring it with him. He traveled alone: Beatrix instead left London to convalesce with her sister in Devonshire.

Eden v. Whistler was heard on February 27. Since there would be no witness testimony, Whistler was denied his opportunity to wield the sort of wit that had been so effective in *Whistler v. Ruskin*. He tried to make up for this a week later, when the court reassembled to hear judgment, showing up accompanied by the woman whose face he had painted over Lady Eden's. "I bolted over to Mrs. Hale," he chortled to Beatrix, "and told

her that she must come to the Court on Wednesday! . . . She must be seated on our side—as Lady Eden is on the other!—She must be dressed in the *brown costume*—just as in the picture—so that there can be *no doubt*." These theatrics availed nothing. Whistler lost the case, and lost badly: Eden got the painting, got his 100 guineas back, and got damages—though these were only for 1,000 francs, not the 10,000 he had asked for.

Whistler's first response was to claim total victory, gushing to his solicitor William Webb that "we have wiped up the place with the Baronet!" His second and more sensible response was to appeal the case. That ensured a rematch—but not for another two and a half years. His third response was to turn upon George Moore, who had brokered the original deal between Eden and Whistler, and who had publicly supported Eden in the case, claiming in the papers that in his opinion as an art critic, 100 guineas was a more than adequate payment for Lady Eden's portrait. To this Whistler responded with two caustic letters to Moore, one private, one public. Moore replied in kind, both personally and to the newspapers: "Yesterday," he wrote to Whistler and to the papers, "I saw an elderly excentric hopping about the edge of the pavement, his hat was in the gutter and his clothes were covered with mud. The pitiful part of the whole thing was that the poor old chap thought that every one was admiring him." For that "gross insult" Whistler challenged Moore to a duel, and when Moore laughed that off, Whistler proclaimed victory by default and declared Moore finished and forever ostracized—from Paris society, at least.

After the trial, Beatrix rejoined Whistler at the rue du Bac, where that spring and summer of 1895 Whistler did his best to cope with the "one long anxiety and terror" that had befallen them by throwing himself into his work. He took another commission, of Chicago debutante Marion Peck. This was something he would continue to work on for years, but in the end, it went nowhere. He began a full-length self-portrait, *Brown and Gold*, which followed a similar trajectory. He had more luck painting his favorite Parisian model, Carmen Rossi. "She is the most cut-throat person I've seen," thought Edward Kennedy, who nonetheless acknowledged the resulting portrait, *Crimson Note: Carmen*, to be a good one.

After a final attempt at festivity that July, when they hosted the wedding of Beatrix's sister Ethel to Charles Whibley, Paris correspondent for the *Pall Mall Gazette*, the Whistlers fled Paris in desperate hopes for Beatrix's recovery: first to the thermal springs of Bagnoles-de-l'Orne in Normandy, and then to Dorset and the spa town of Lyme Regis. In October the two separated, Beatrix returning to Samuel Kennedy's oppressive observation in London, while Whistler, enthralled by the aesthetic possibilities of Lyme Regis, stayed there and managed to produce a full set of lithographs and to paint several little beauties as well as two of the finest portraits of his later years: *The Little Rose of Lyme Regis* and *The Master Smith of Lyme Regis*. Finally, in December, he joined Beatrix in London. Seriously alarmed at her condition and apparently disenchanted with Dr. Kennedy, he briefly contemplated a transatlantic crossing with Beatrix to consult with a "great Medicine Man" in New York but in the end concluded she was simply too weak to make the voyage. They remained in London, restlessly shifting hotels: from Garlant's to the De Vere to the Savoy. In the evenings Whistler kept vigil over his wife; in the days he struggled to work. Again, he commandeered Sickert's studio, and then he commandeered John Singer Sargent's. In February he found a studio for himself near Fitzroy Square: a clear sign that this return to London would be a permanent one. He continued to spend time with the Ways at their shop, feverishly creating lithographs that Tom Way considered "the climax of all his black and white work." His aching concern for Beatrix drove him to new heights of sensitivity, best seen in the seven lithographs he created in his Savoy suite: five of them evoking the humming life far below, two capturing the ebbing one beside him.

At the beginning of April, they moved to a cottage in Hampstead, desperately hoping that the higher, purer air there would save her. "There is hope," Whistler wrote a friend from there, "great hope—amounting to certainty and happiness—and the weariness of the past—and the months gone by will count as nothing!—and all will be well." There was no hope; all would not be well. On May 10, 1896, Beatrix died, propelling Whistler into a mad, blind dash about the Heath. An acquaintance encountered him

there, and attempted to assist. "Don't speak! Don't speak! It is terrible!" Whistler cried, and ran off.

The madness passed. But the profound sense of dislocation remained, though Whistler did his best to remedy this by taking his wife's family as his own. Within four days of Beatrix's death, he had taken steps to make Beatrix's twenty-two-year-old sister, Rosalind, his legal ward. That summer he and Rosalind were living at the Hampstead cottage. By autumn Rosalind and her mother had settled into his home on the rue du Bac. Having in this way made a home for himself, Whistler remained largely aloof from it, preferring while in Paris to stay in a hotel, and now generally shunning Paris for London, shifting restlessly between bachelor companionship at William Heinemann's home and solitude at Garlant's Hotel. His days at the center of aesthetic society were now over. He no longer held court at either of his studios. There were no more Sunday breakfasts. He preferred now to dine with Joseph and Elizabeth Pennell, who had become his most fervent and his most jealously possessive followers. "At first he would not join us if we expected anyone," they remembered; "he liked to sit and talk, he said, but he could not meet other people. He saw few outside the studio, except Mr. Heinemann, Mr. Kennedy, and ourselves."

He did continue to practice the art of making enemies. Even the horrible distraction of Beatrix's final days had not prevented him from a passionate breach with his printers the Ways, father and son. What began as an aesthetic quarrel over the frontispiece of a catalogue the younger Way, Tom, was producing, erupted into a "battle royal" that April when Whistler, visiting Tom at home, spotted two of his paintings on the walls that he hadn't seen since the days of his insolvency, both part of a large collection of canvases the auctioneers selling off Whistler's assets had deemed damaged or unfinished, and therefore worthless. Though Whistler at the time had fumed at both Leyland and Howell for stealing them, it was actually the elder Thomas Way who had bought them from the auctioneers—quietly,

and at a pittance. Thomas Way had agreed to give some of them back to Whistler, but not all; some of these he kept, and some he gave to his son. Now, sensing huge profit, Whistler demanded that Tom Way give them back. When Way refused, Whistler abruptly ceased his collaboration with both son and father, and put into the hands of his solicitor both the settling of his longstanding bill to them, and the recovery of his paintings. After nearly a year and a half, in August 1897, they reached an agreement: Whistler paid off his debt at a discount, and in return got most, but not all, of his paintings. Tom Way retained the paintings Whistler had seen on his walls.*

By then, Whistler had made an enemy of Walter Sickert as well. Their friendship had long been a prickly one, largely because of Sickert's maddening refusal to kowtow to Whistler's greatness. But it came to an absolute end that October 1896, when Whistler was horrified to learn that Sickert had been seen "parading Bond Street with Sir William Eden and George Moore!" After vilifying Sickert both as Judas Iscariot and as Benedict Arnold, Whistler cut him off completely. Six months later, in April 1897, Whistler managed to make their private breach a public one by encouraging Joseph Pennell to sue Sickert for libel after Sickert attacked Pennell's method of drawing his lithographs on paper rather than stone as not lithography at all. (Since Pennell's method was Whistler's, Whistler took the attack personally.) At trial Whistler served as Pennell's chief witness, and when Pennell won the case Whistler appropriated his victory: "ENEMY MET AND DESTROYED," he telegraphed Rosalind.

Whistler was sixty-one when Beatrix died, but he suddenly seemed older than that, increasingly frail and exhausted, relentlessly battling colds or the grippe: influenza. Naps during the day and noddings-off during dinner were the norm. His wits lost their sharpness: the *mots* still came, but more rarely, and in place of his sparkling conversation in the evenings now came tedious and annoying lectures, most of them on the subject of

* One of those paintings—an early nocturne, *Cremorne Gardens*—Tom Way sold after Whistler's death for £1,200. It now hangs in New York's Metropolitan Museum of Art.

French superiority and English stupidity, lectures guaranteed to offend even friends: "it is astonishing, his lack of discrimination, and of justice," noted Edward Kennedy after one of them. Later Whistler's rants shifted with the times to rambling comparisons between Boer valor and British incompetence, but remained equally offensive: Kennedy nearly came to blows with Whistler over this at least once. He kept up his painting and his drawing, of course—but his best work was now clearly behind him. A few of his newer creations joined many of his older ones at the exhibitions, but most of them remained, underdone or overworked, in his studio, to be discovered after his death—if they weren't destroyed first. In every way, it seemed, his life was winding down.

In every way but one, that is: Whistler's will to fight for himself and his art remained fierce. During the seven years left to him he struggled to show his works widely, and to garner greater acclaim than ever before. He remained obsessed with the changing ownership of his art, determined to see his works in the hands of patrons more appreciative of his genius and more willing to promote it through exhibition. That in particular meant getting it away from England and its "Bunko Baronets." He directed his London agent, David Croal Thomson, to do exactly that: "I want you to stipulate for me that the gentlemen who acquire these charming things undertake to lend them to me nicely for exhibition when I ask it—In short I mean that you will see that these little works go to chosen places . . . Scotchmen or Americans or Frenchmen—you know. . . ." He kept up his war with the worst of the Bunko Baronets, Sir William Eden—in the press, among acquaintances, and, in November 1897, again in the courtroom, when the case came up for appeal. The court upheld Eden's claim in every respect but one. Though Whistler still had to return Eden's payment—with interest—and still had to pay damages, the court determined that Whistler and not Eden would keep the painting itself, declaring the artist to be "master and proprietor of his work till such time as it shall please him to deliver it." This uncategorical assertion of the artist's autonomy over his work allowed Whistler, legitimately this time, to proclaim a great victory, which he did in the customary way: by publishing in 1899 every document

connected with the case in *Eden versus Whistler: The Baronet and the Butterfly: A Valentine with a Verdict.*

That October, just before his final showdown with Eden, Whistler had in London embarked upon the first of the three projects that would consume him during these last years of the nineteenth century. Having sublet from a bootmaker for £90 a year a couple of upstairs rooms near Manchester Square and given them the usual Whistlerian makeover, having hung prints on the wall and set out a couple of little beauties on easels, and having engaged Christine Anderson, a woman of questionable abilities, as his manager, Whistler opened his company of the Butterfly: his attempt to cut out the middlemen and sell his art directly to the public. When Edward Kennedy—one of those middlemen—caught wind of this scheme, he warned Whistler that the company would fail in a month and that Whistler would lose all his money. Whistler should have listened to him, for though the company lasted for far more than a month, it was indeed a colossal failure. From the start, few sought out the place, and those who did generally found the doors locked and the manager elsewhere. Remarkably, Anderson retained her post for two years, but then she abruptly abandoned it, forcing Whistler to suspend operations until a similarly ineffective successor—the first of several—could be found. Almost no one bought anything from the company, and those who did—Kennedy and Charles Freer, for the most part—would have bought from Whistler in any case. For three and a half years the company limped along, only succeeding, as the Pennells noted, in proving to Whistler that dealers did have their uses.

Two months after the company of the Butterfly commenced its floundering existence Whistler took up a second, far more auspicious project, in agreeing once again to preside over an art society, this one from the start far more in line with Whistler's aesthetic ideals than the Society of British Artists had been. The International Society of Sculptors, Painters, and Gravers, as it became known—or, more familiarly, the International—had been the brainchild of the young American journalist Francis Howard, who aimed to create a new locus for the modern and the international in London, a replacement of sorts for the Grosvenor Gallery, which, after a long decline,

had closed for good in 1890. He assembled a council of progressive young artists that included Glasgow Boys and Whistler worshippers Edward Walton, John Lavery, and James Guthrie, offering them full autonomy in choosing exhibitors and complete freedom from financial liability. When Whistler caught wind of the plan, he, too, offered to cooperate—as fully as he could, anyway: now again residing in Paris and plagued by poor health, he missed the society's inaugural meeting on December 23, 1897, and indeed missed every single meeting over the next year and more. Nonetheless he ruled the International, and ruled absolutely. Elected chair of the council in February 1898, and made president in March, he made sure to pack the council with his most slavish supporters, including Joseph Pennell and Albert Ludovici, his aide-de-camp at the SBA. When some less loyal members of the council threatened to resign over Ludovici's appointment, Whistler happily let them go. He ensured the execution of his orders by insisting that the loyal John Lavery be appointed vice-chair. He demanded detailed reports of every meeting from Lavery, and from Ludovici, Pennell, and Howard as well, and to them sent his commands. He retained full veto power over exhibitors to the International's first exhibition, which meant friends were included and foes—Sickert, Stott of Oldham—were out. With the assistance of the council he combed Europe for artwork, and in Paris personally approached artists and dealers for works, obtaining in this way five sculptures by Rodin as well as Manet's *Execution of Maximillian*, which, besides Whistler's own works, proved to be the hit of the exhibition. He took charge—again, from afar—of transforming the site of the first exhibition, an ice-skating rink in Kensington, into a Whistlerian study in grey. He dictated the arrangement of works, intentionally grouping them without regard to school or to nationality, and arranged for the prominent placement of his own nine paintings,* poignantly insisting that three etchings done by Beatrix accompany them.

* Including his *Rosa Corder*, his Valparaiso nocturne, and his *Princesse du Pays de la Porcelaine*.

The first exhibition of the International, opening May 1898, was a revelation. Works came from across western Europe: paintings by Degas, Monet, Manet, Toulouse-Lautrec, Gustav Klimt, Ludwig Dill, Frits Thaulow, and Anders Zorn; prints by Renoir, Sisley, Pissarro, Cézanne, and the very recently deceased Aubrey Beardsley; sculptures by Frederick MacMonnies, Rodin, and Constantin Meunier. But the exhibition was a revelation only to those who saw it, and remarkably few did. Because of poor advertising, and because Whistler had adamantly refused to offer music or food with the art, crowds were sparse, averaging at first a meager 160 a day. Financial backers of the show lost heavily, but Whistler and his council did not; for them, this exhibition would mark the International's high point. After that, the participation of foreign artists dropped precipitously, since the council refused to entice them with the promise of prizes or medals. Although Whistler remained the society's president until the day he died, both his participation on the council and the amount of works he submitted declined. While the International succeeded in plowing on for another quarter-century, it never became the "fighting ship" of the art world Whistler hoped it would be.

By the autumn of 1898 Whistler's focus had shifted from London to Paris, and to perhaps the most ambitious of his projects, one initiated by Carmen Rossi, his still-young model and Neapolitan favorite, who had, with Whistler's financial backing and, crucially, with his promise to take on classes once a week, rented and furnished a house close to Whistler's Paris studio, and at the end of September issued a circular heralding her "Anglo Américan School—WHISTLER ACADEMY—Painting, Sculpture and Drawing—*Modéle vivant* all day—(Night lessons also)." Whistler followed that up with letters to newspapers in Paris and London confirming he would teach, but demurred taking the honor of the atelier's name. It became the Académie Carmen, and so it remained for the three troubled years of its existence. Carmen, who had set her fees at double the average of most of the other ateliers, dreamed of profit, and, at first, it came, as Paris's teeming population of expatriate art students deserted the other ateliers for hers, more than filling the men's and women's classes when they commenced

that October. Whistler, on the other hand, gave no thought to profit, agreeing to teach for nothing. It was, rather, posterity and his goddess that he wished to serve, hoping, he later confided to a student, "to win a few disciples and imbue them with my teachings that they may champion my art when Time shall render me unable to voice my own principles."

Championing *his* art, not theirs: that desire dictated his methods. He aimed to replicate the system of the great Renaissance schools of art, in which apprentices bound themselves to the techniques and to the vision of the master. Whistler, remembered the Italian artist Cyrus Cuneo, who for a short time served as an assistant at the Academy, "could only see Art from his own standpoint, and he insisted on our all using the same palette, the same brushes as himself." It was exactly what Whistler had done with the Greaves boys, three decades before, and the results now were similar. "It was almost an impossibility," concluded Cuneo, "to develop without becoming a slave and copying him in every way. . . . If one came with a spark of originality it was extinguished immediately by the dominating personality of The Master." Though Whistler would tell his students "I do not interfere with your individuality. I place in your hands a sure means of expressing it," the muddy and monotonous clones they produced suggested otherwise: "*beaucoup des petits Wheestlers!*" was how one amused French visitor to the atelier described them. Frederick MacMonnies, the American sculptor whom Whistler pressed into teaching with him at the Academy, was baffled when he observed the women's class "painting black as a hat" and somehow, as time passed, painting more darkly than that. Finally compelled to intervene, he grabbed the palette of one pupil and slapped some light and color onto the gloom of her canvas. "Mr. Whistler told me to paint it that way," she complained. MacMonnies was positive she had misunderstood Mr. Whistler, but she had not, as MacMonnies learned a few days later when Whistler gave him a dressing-down for his meddling. Eventually MacMonnies realized, and Whistler agreed, that his role at the Academy was superfluous. He resigned and was not replaced.

Not surprisingly many of the students—particularly among the men—were deeply dismayed by the method. "Whistler's knowledge of

a lifetime," one joked, could "be had in two lessons." Another vented his frustration on the studio wall:

> I bought a palette just like his,
> His colours and his brush.
> The devil of it is, you see,
> I did not buy his touch.

Defections followed. Whistler took the men's discontent as a sign of their ignorance—and early on, began to avoid their class. He came, Cuneo observed, "whenever, in fact, the spirit moved him, and to the sorrow of all the students the spirit moved him very seldom." He would generally offer perfunctory and cloudy criticism to a few, ignore the rest, and make a hasty exit. "You felt that as the door closed behind him, he said with relief, 'Thank God that's over,'" thought one student. Before long he took to visiting the women only (though never once a week, as he had promised Carmen), leaving the men "exasperated by hearing his footsteps dying away down the passage, and hearing his high piping voice say to Madame: 'À peut-être demain—pour les messieurs. Au revoir!'"* During the Academy's second year—autumn 1899 to summer 1900—Whistler avoided contact with the men completely, instead looking over their efforts in private and invariably concluding them unworthy of his criticism. As the men's class melted away, so did Carmen's dreams of profit, Whistler now subsidizing refunds to the "disagreeable students." When the Academy reopened that October in a smaller studio on the boulevard Montparnasse, the men's class was gone.

Whistler from the start preferred his female students: they were more amenable to his methods, more deferential to his genius, and more charmed by his wit. To Whistler's delight they treated him as a visiting dignitary during his sporadic visits, outvying one another to dress resplendently for the occasion. (He complimented them with his own sartorial study in black, set off

* "Tomorrow, perhaps—for the men. Farewell!"

by the bright red rosette of his Légion d'Honneur on his lapel.) "Nothing could be funnier," remembered one student, "than to see the little man picking his way around the easels, the *massiére* with an immaculate 'paint rag' in readiness, and the rest of us swinging after, like the tail of a comet. Awe and admiration were visible to the naked eye at such times." If the men's disdain convinced Whistler of their stupidity, the women's admiration convinced him of their savvy: he declared them "much stronger, much stronger!"

Though more devoted to them, from them, too, he was as time passed increasingly absent, distracted by maddeningly frequent bouts of influenza, by the demands of work and relentless exhibition,* and by constant travel: back and forth to London, long sojourns on the coast of Normandy, and once, in 1899, to Rome. To cover for these absences Whistler appointed assistants—*massiers*—chosen from among his students and picked for loyalty rather than talent. He chose at least four men to serve him in this way; none lasted long. But he chose only one woman, the Irishwoman Inez Bate, who from nearly the beginning to the end of the Academy's existence, with her slavish personal devotion and her profound adherence to his palette-centered pedagogy, gave him all he could ask for. For most of the existence of the Académie Carmen it would be Inez Bate (and then, after she married, Inez Addams), and not Whistler or Carmen, who kept the place going. So essential was Bate to Whistler that in July 1899 he rewarded her—and retained her—by signing her to a legal, if archaic, five-year apprenticeship, "his secrets [to] keep and his lawful commands [to] obey." When in 1900 she married, Whistler indentured her husband as well.

In October 1900 the Académie Carmen began its final year. Whistler made a valiant effort to resume his professorship in person, commuting

* Whistler submitted his work to at least sixteen exhibitions between 1898 and 1900, putting a particular effort into two that he was certain would boost his international reputation: the 1899 Esposizione Internazionale d'Arte in Venice, and the 1900 Exposition Universelle in Paris. He was right: the Venice exposition resulted in his becoming a Commander the Order of the Italian Crown, and the Paris exposition earned him *grands prix* for painting and etching.

twice from London in spite of worsening health. Those visits were to be his last. "Wearied" and "worried" that November, battling a nasty cold and persistent cough, he resolved to follow his doctor's advice and travel south for the sea air. By mid-December, with his young brother-in-law Ronnie Philip his traveling companion, he was off for Algiers and Tangier. He hated both places. Algiers was "cheap" and rainy, Tangier freezing cold and *entirely too* eastern." He spent a few days "in two stupid hotels with bad dinners," seeing in the new century, then fled North Africa for Marseille, which he found more inspirational, but so cold and snowy that he and Ronnie spent most of their time sitting before a fire in their hotel. Whistler did manage, however, to befriend a doctor there, who flatteringly gave him a clean bill of health, before nevertheless recommending two or three weeks' stay on the island of Corsica. At the end of January Whistler ferried to the island and settled into the Hotel Schweizerhof in Ajaccio. And there, for three months, he remained.

"This is such a wonderful place," he enthused to Rosalind. "As I sit in the hotel garden, with oranges and large white roses on the trees all about, I make up my mind that we ought to have a villa." Though he thought Ajaccio "full of beautiful things for panels or plates," he actually produced very little, for "directly I look at one of them and stand for a moment, some Mistral or tra Montana blows me back into the hotel with a new little cold." Rather than take on new projects, Whistler set about extricating himself from his old ones. At the end of January he instructed his solicitor William Webb to terminate his lease for the moribund Company of the Butterfly, and though Webb would struggle for months to unload the place, by February the Company was effectively out of business. In March Whistler directed Inez Addams to close the Académie Carmen after first assembling and reading to his remaining students a valedictory letter that jocularly begged them to forgive and forget "the despotic, narrow, and discouraging principles urged upon them"—to forget, that is, all but the one "Golden Precept . . . *Nothing matters!*" "Document read yesterday assemblage large sad stupefaction exists all shall be as you wish," Inez wired him on the third of April. "Last act! Curtain!! How do [you] like my play?" Whistler scribbled upon her telegram.

At around the same time, Whistler from afar fought the last, and the most ridiculous, lawsuit of his life. For years Whistler's upstairs neighbor at the rue du Bac, Madame Saleron, had maddened him by beating her dirty carpets above his windows, and when one day one of those carpets fell into his garden, he or one of his servants confiscated it. Madame Saleron then sued to get it back. The case was heard at the beginning of March: Whistler lost and was ordered to pay 25 francs and costs. When Whistler learned that Madame Saleron's *avocat* had shocked the judge with false tales of his models posing nude in the garden, he directed his own *avocat* to sue his neighbor for 20,000 francs (roughly, £1,000). Once his *avocat* assured him that this was a case he would never win, Whistler reluctantly gave up the idea.

After Ronnie Philip sailed home in mid-February, Whistler begged William Heinemann to join him, and that March Heinemann came, with a companion, for a week. Pouring rain kept them largely confined to the hotel and to a nearby café, where Heinemann taught Whistler to play dominoes—and Whistler taught Heinemann to put up with his relentless, juvenile cheating. Heinemann's departure left Whistler alone and, he confessed, "very down." But his depression soon gave way to revelation, to contentment, and to, he thought, a cure. "For *years*," he wrote to Rosalind at the beginning of April, "I have had *no play*! And have been the dull dog—the sad dull dog you have all known—moping in his kennel in Fitzroy Street through the black days of winter—desperate with his own darkness! hiding in strange inns and baying through the night—with no moon!— Years! think of it!—for years have I made for myself my own treadmill and turned upon it in mad earnest until I dared not stop—and the marvel is I lived to be free in this other Island—and to learn, in my exile, that again 'Nothing matters!'"

At the beginning of May, after a month of contented rest in the Ajaccio sun, Whistler returned to London "infinitely better, like himself again," Elizabeth Pennell thought. He returned to London, not Paris, for Paris had now lost its charm. His home on the rue du Bac had become damp and depressing, filled only with memories of Beatrix, Rosalind and her

mother having abandoned it long before for their family home on Tite Street. His studio on the Notre Dame des Champs oppressed him both with the thought of its impossible climb without and its exhausting work within. By that October he had given up his leases on both places. But he was in no hurry to find a permanent home in London, preferring instead to maintain an illusion of independence by dividing time between his several dependencies. While he remained close to his Philip in-laws he now resisted living with them, instead staying with his friend Heinemann when Heinemann was home—and at the Hotel Garlant when he wasn't. For his dinners and his evenings, he generally invited himself to the Pennells. Since he had by then designated them his official biographers, he spent much of the time—when he wasn't napping—regaling them with lengthy and random reminiscences.

When Whistler's health permitted, he attempted to work at his Suffolk Street studio, though that year he had little to show for it. Still, he continued to exhibit, which was now easier for him than ever, as others—Rosalind, Edward Kennedy, enthusiastic patrons, allies on the council of the International—were willing to do the work for him. His work appeared in 1901 at two shows in Scotland, three in London, one in the United States, and two in Germany, and his two great triumphs—in Dresden and in Buffalo—were, for him, effortless ones. To Dresden George Sauter—member of the International and by now his good friend—had sent eight Whistler etchings and one lithograph, a modest submission that paid great dividends: a gold medal and honorary membership for Whistler in Dresden's Académie Royale des Beaux-Arts. To the Pan-American exhibition in Buffalo, American patrons—apparently without Whistler's prompting—submitted works that netted Whistler two gold medals.*

Whistler's delight in the paintings that did appear that year, however, was more than offset by his growing conviction that others were disappearing. For some time that year, his apprentices Inez and Clifford

* After that exhibition some of those patrons sent their works on exhibition at Pennsylvania Academy of Fine Arts in early 1902, earning Whistler yet another gold medal. It would be his last.

Addams had been alarming him with news that lithographs of his had been appearing in Paris shops without his permission. Then in early July his patron John James Cowan, doubtful of the provenance of two paintings he had obtained, sent them to Whistler to examine. Whistler concluded that they were his—but had been stolen from his Notre Dame des Champs studio, finished by someone else, and sold. "It begins to be clear," he noted, "that there has been a sort [of] wholesale robbery going on for some time past!" For the next few months he became obsessed with solving the supposed crime. His favorite, Carmen Rossi, he thought, was involved in the thefts, fencing the paintings through a chain of three dealers, two—Charles Hessele and Gaston Bernheim—in Paris, and one—Alexander Reid—in Glasgow. Carmen he refused to prosecute: he could no more hurt her, he declared, than he could destroy one of his best paintings. Instead, he sought to force from her a confession that he could use against the dealers. At first he set his apprentices to getting the truth from her, and, when that didn't work, he summoned her that October to London where both he and his solicitor Webb attempted and failed to do the same. Carmen returned to Paris—and Whistler set another firm of solicitors, as well as a private detective, on her. She told wildly conflicting stories but never confessed. In the meantime, Whistler had attempted to confront the dealers directly by impounding as stolen two suspicious paintings that Alexander Reid had sent to London, hoping to precipitate a falling-out amongst the conspirators, or a lawsuit and an exposure in the courtroom. But then, abruptly—and wisely—Whistler abandoned his campaign altogether: from Paris, Bernheim had sent him an "icily polite" note quite accurately reminding him that it had been Whistler himself and not Carmen who had sold paintings to Hessele, and threatening to sue him for slander if he continued to trumpet his baseless claims. "Next year," Edward Kennedy remembered, "the matter was never heard of, the 'organised conspiracy' being a Chimera."

But though the conspiracy might only have been the product of Whistler's overheated, overtired brain, the stress it caused him was real and surely contributed to the collapse of his health that November. In quick

succession, illness forced him from Garlant's hotel to another one closer to Heinemann's, and then to Tite Street and the care of his in-laws—care that involved almost total isolation from the world outside: "we were never allowed to see him," the Pennells complained. That isolation became even more profound in December, when the Philips carried him away from the unhealthy fogs of London to waters of Bath where they remained for two months, although by January 1902 Whistler had improved enough to make several flying returns to London. In February the family returned to Tite Street and again "swallowed him up for a few weeks."

By then, Whistler had determined that if he could not escape his confinement, he could at least choose its location—and chose to return to the Chelsea riverside, taking a two-year lease at 74 Cheyne Walk and, with Rosalind, moving in that April. He quickly realized he had made a terrible mistake: "I have fallen into a trap," he groaned to William Webb, hoping (in vain) that Webb could extricate him. The house had been built two years before by Charles Ashbee, his landlord, in the then-popular and highly ornamental Arts and Crafts style: an affront to Whistler's own minimalist notions and, Whistler claimed, a prime example of "the disastrous effect of art upon the British middle classes." The disastrous effect of *Ruskin* upon the British middle classes, he might have added, for it was Ruskin with his insistence upon the free play of creative thought on the part of the artisan who had sparked the Arts and Crafts movement: aesthetically, Whistler now inhabited enemy territory.* It was territory, moreover, tortuous for Whistler to navigate, with the drawing and dining rooms an exhausting two stories above the ground floor and the bedrooms a floor above that. Worse, perhaps, was the fact that Ashbee had set the ground floor windows just below the ceiling, blocking any view of the river. And worse than any of this was the incessant racket that commenced when, soon after Whistler moved in and without warning, Ashbee began the construction of a new

* Whistler surely caught a whiff of that enmity when he met his landlord's wife. "It took me back almost within touch of Ruskin, Hamerton, and the other people in the '10 o'clock,' to have the little, horrid, cantankerous, curled perfumed creature on the floor before me," was how Janet Ashbee recalled her first sight of him. (Ashbee, 1561)

house in the lot next door. The "knock, knock, knock all day" shattered Whistler's nerves, spurred him to dangerous rages, and surely hurried his decline.

The house did have one redeeming feature: a spacious ground floor studio that allowed Whistler to paint without the now-onerous commute to Fitzroy Street. It was at home that spring of 1902, then, that he painted, in succession, the two Americans then emerging as the world's foremost collectors of Whistler's art. Richard Canfield was the first to come, beginning his sittings at Fitzroy Street at the beginning of March before moving them to Cheyne Walk in April. His coming alarmed Whistler's friends and followers, especially his American ones, who knew that Canfield had made the fortune that he was now beginning to sink into Whistlers by "cleaning out young millionaires" in his lavish gambling houses in Newport, Saratoga, and New York City. The Pennells considered him "odious," and when New Yorker Edward Kennedy attempted to warn Whistler about Canfield's notoriety there, he succeeded only in sparking an argument that put an abrupt end to Kennedy's own friendship with Whistler. For Whistler was charmed by the man ("hypnotised," the Pennells thought): highly cultured, a good listener to Whistler's stories, and, Whistler claimed, "the only man who never made a mistake in the studio." Moreover, he could mix a mean cocktail. These mutually enjoyable sittings lasted until May, and then Canfield left for New York just as Charles Lang Freer arrived from there to take his place.

Freer—who had made *his* millions in the possibly more respectable monopoly he had established in the manufacture of railway-cars—had come to Europe this time on a mission to track down and obtain as many Whistlers as he could, and it was Whistler who coaxed him to sit for his portrait. The two had, over the dozen years they had known one another, become the closest of friends, and on this trip Freer showed an uncanny power to make Whistler forget his illnesses, brave the "microbes" that now terrified him, and emerge from 74 Cheyne Walk at least once, at the end of May, for dinner, gin slings, and anti-British tirades at his Pall Mall Hotel. In late June, with Whistler driven frantic by Ashbee's incessant noise and

both of them appalled by the tasteless decorations springing up across London for the coronation of Edward VII, the two, with Rosalind in tow, set out for Amsterdam. Their decision was as dangerous as it was impulsive: en route Whistler collapsed with severe heart pains. They were forced to stop at The Hague, where Whistler took to bed at the Hotel des Indes, his condition there only worsening: by the beginning of July Rosalind's sister Ethel had been summoned, and Whistler, "fearing because of the great heart strain upon me the cord might at any moment snap," had dictated to Freer a new will, leaving everything to Rosalind. By July 11, however—Whistler's sixty-eighth birthday—he had improved, allowing Freer to leave him, and allowing Whistler to move with his sisters-in-law to private rooms near the hotel. Whistler remained in those rooms for another two months, hoping for a full recovery, and hoping as well to outwait Ashbee's construction. He succeeded in neither. On the crossing home he suffered a relapse, forcing him to bed at Cheyne Walk for a week while the noise outside continued.

From then until the end, 74 Cheyne Walk was indeed Whistler's trap. Visiting others was now out of the question, and those who visited him suffered Rosalind's and sometimes Ethel's dragonizing, which, according to the Pennells, "involved a restraint in [Whistler] and a sensation of oppression in his visitors." Climbing stairs was out of the question as well, and Whistler's bed was moved to a cell-like room adjoining his studio. Whistler no longer dressed, instead shuffling about wearing a shabby fur-lined coat over his nightshirt: he was always cold now. On his bad days, he lay immobile on an easy chair, barely speaking or listening, mostly dozing. On his better days he was able to return to the studio and paint. He worked on portraits of Rosalind, of Heinemann's wife, Magda, of his dentist Isaac Davenport, of models such as young Dorothy Seton, whom in a couple of hours one afternoon he painted holding an apple. The Pennells considered this painting, *A Daughter of Eve*, "the finest thing of his later period"—until Whistler overworked and ruined it. Much of Whistler's time in the studio he now spent not in painting but in sorting through his canvases, protecting his posthumous reputation by disposing of the ones he thought unworthy.

John Lavery one day came upon Whistler there, his fireplace filled with ashes. "To destroy is to exist, you know," Whistler told him.

That November Whistler showed a painting for the last time, sending to the Society of Portrait Painters the recent work *Garnet and Gold: the Little Cardinal*. Frederick Wedmore, critic for the *Standard*, was sure he had seen that work before, and said so in his review. (He was right; Whistler had shown it with four other works at the Champ de Mars Salon earlier that year.) Whistler, seeing this remark, was livid, considering it a snide insinuation that *Garnet and Gold* work was an old work. For the last time, Whistler lashed out publicly at a critic, laboriously working-up a letter to the *Standard* vilifying Wedmore for his parochialism, his "perfidious little Podsnap paragraphs." Petty, nonsensical, unhinged, this attack fell far short of Whistler's earlier efforts, and W. Graham Robertson, who happened to visit Whistler on the day he wrote the letter, knew it. But when Whistler asked Robertson his opinion about the letter, Rosalind intervened, whispering to him "don't tell him *now* if you don't like it. He has been over it all the morning and he's so tired."

He *was* tired. But he was not finished. This joust with Wedmore had inspired Whistler to work up a pamphlet targeting Wedmore's inanities over the years—and even to contemplate a third edition of *The Gentle Art of Making Enemies*. The Wedmore pamphlet got as far as the proof stage when, tormented by a cough so bad he could not speak, Whistler let it go. Three days later he found another source of rage, and a final enemy to make, when he learned that his Paris Mephistopheles, Robert de Montesquiou, had dared sell his portrait for what was obviously an immense profit. That Richard Canfield was its buyer did nothing to allay Whistler's fury. "Bravo, Montesquiou!" Whistler jeered in a private letter; "the portrait acquired as a poet, for a song, is resold, as a Jew on the rue Lafitte, for ten times that melody! Congratulations!"

At the beginning of 1903, Canfield, on the run after a raid upon his Manhattan casino, found refuge in Whistler's studio, while New York reporters badgered Whistler's friends for details. From January until May, on Whistler's good days, he and Canfield continued their convivial sessions.

In his *Portrait of Richard A. Canfield*, Whistler produced something that the Pennells thought "wonderfully fine." But Whistler had apparently lost any ability to know when a work was done, and the next time the Pennells saw that painting they thought it "ruined." It was almost certainly not the only work he marred at this time by touching up. Whistler's dentist Davenport returned to the studio during these months—to see Whistler fall asleep between brushstrokes. By the time that Charles Freer returned to him at the end of June, expecting to resume his sittings, Whistler's painting days were done.

So, of course, were his traveling days. When he learned that February that he had been elected an honorary member of the Royal Glasgow Institution of Fine Arts and that plans were afoot at the University of Glasgow to award him an honorary doctorate, Whistler briefly considered traveling to Scotland to accept it in person. But by the beginning of April Whistler acknowledged that this would be impossible, and the degree was given *in absentia*, his friend James Guthrie accepting it for him.

By then it was becoming clear to all that Whistler was dying. "Whistler's health varied so during the winter that we were often encouraged to hope," the Pennells remembered, "but with the spring hope lessened with every visit." The once intermittent influenza was now permanent, as was his drowsiness. He now entered the twilight world so familiar to Ruskin, and looked out of it with vague, dead eyes. Rosalind now restricted visits more than ever. Théodore Duret, one of the few allowed in, was overwhelmed to find him in a stupor, struggling to speak: "no one without a clue could have understood what he was talking about." Walter Greaves, still a neighbor but long-estranged, worked up the courage to knock on his master's door—and was turned away. So was Edward Kennedy. Charles Freer, on the other hand, Whistler welcomed and clung to as if his life depended upon it, sending him that July regular telegrams begging him to come to him. On July 12 the two sat together wordlessly, until Freer got up to leave, when Whistler whispered to him "come tomorrow sure." Freer did come, came nearly every day, usually managing to get Whistler bundled up and into a carriage so that he could see London and the Thames again:

they traveled at least once across the bridge to Battersea, and, on July 16 rode through Hyde and St. James's Park before returning home—the same trip Whistler had taken with his mother thirty-two years before, the day he painted his first London nocturne. That night, Whistler again cheated at dominoes with his sisters-in-law. Freer was to come tomorrow sure, and they were to ride again.

Freer came at 3:40 P.M. But Whistler was gone. A burst cerebral embolism had killed him five minutes before.

EPILOGUE

In the autumn of 1875, a headstrong American artist brought his art to the verge of abstraction by creating *Nocturne in Black and Gold: The Falling Rocket*, a depiction of fireworks bursting out of pitch-black darkness. Three years later, Britain's foremost art critic saw it, hated it, and shared his opinion in a public letter to his most devoted followers. Learning of the attack, the artist sued the critic for libel, and during two gloomy days in November 1878, twelve special jurors viewed the artist's paintings, heard other artists' and critics' testimony about them, wrestled with the confusions of the law, and with difficulty came to a decision: the artist won, and the critic lost.

That was the beginning of *Whistler v. Ruskin*. It was *only* the beginning.

As qualified as the jury's verdict might have been, both James Whistler and John Ruskin took it very seriously. Whistler—in public, at least—assumed total victory. He accepted his paltry farthing damages as a token of triumph, and for the rest of his life he never tired of reprising the trial, playing out all the parts, highlighting the embarrassment of his enemies and the vindication of his aesthetic. Ruskin, though he believed that the jury had made a colossal mistake, nevertheless suffered an overwhelming sense of loss, certain that the jury's decision expressed both the

will of the state, taxing him for speaking the truth, as well as the attitude of the public—*his* public—in showing its complete inability to understand the truth that he spoke. Crushed, certain he had been dislodged from his eminence as nation's sage and arbiter of art, he resolved at first to withdraw from public life altogether.

But if James McNeill Whistler touted his victory, and John Ruskin acknowledged his defeat, few others saw it that way. In the eyes of the world, the victory the jury had given Whistler with its verdict it had simultaneously taken away with its derisory damages, which posited Ruskin's loss, while real, to be insignificant. Whistler's great wit on the witness stand might have proved him to be a master of the *mot*, but it convinced few if any that he was a master of the palette. Many critics and most of the public continued to be baffled by his work. Sales of his paintings, if anything, shrank after the trial. As time passed and Whistler underwent his highly reported insolvency, it became clear that he and not Ruskin had suffered the most from the verdict.

The trial left both men with little if anything gained—and everything to prove. Whistler had hoped with the trial to establish the legitimacy of his art and his legitimacy as an artist; the trial and its consequences had served only to make that task a harder one. Ruskin had—for a time—relished the prospect of the trial, which gave him the opportunity to reassert his authority both as a critic of art and as a political economist. His own absence from the trial made this impossible—and the participation of his surrogates did nothing to help. After the inconclusive skirmish of *Whistler v. Ruskin*, both men became locked in an enduring campaign: in Whistler's case to establish his authority and gain the confidence of the public, and in Ruskin's, to *reestablish* his authority, and recover public confidence.

That campaign became, for Whistler, the all-consuming work of a lifetime. With every work he created and exhibited, every *mot* he uttered, every acidic letter he wrote and lecture he gave, every scandalous scene he staged, he promoted his art. Frederick Leyland had been right: to the core, James Whistler *was* an artistic Barnum. Succumbing to insolvency Whistler fled London, and then, rediscovering himself in Venice, clawed

his way back to solvency. Returning to London, Whistler reinvented the one-man exhibition and opened up new markets for his works. He exhibited his work doggedly and ever more widely, gaining greater and greater understanding and appreciation of his art: international honors became for him the expectation rather than the exception. He sought with the Society of British Artists to subvert the British art establishment, and, to an extent, he succeeded. With the purchases of the *Carlyle* and the *Mother*, he succeeded in attaining what had hoped in vain to attain with *Whistler v. Ruskin*: widespread acknowledgment of his artistic genius. He did not stop there. He schemed to get his earlier works, as they shot up in value, into the hands of more appreciative patrons—and onto the walls of museums. He aimed with his later projects—his Company of the Butterfly, his Académie Carmen, his International Society—to guarantee and perpetuate the dominance of his aesthetic. And he continued to create. Though his later projects met with limited success at best, and though the quality of his work in his later years declined, the appreciation for his art continued to grow. At the time of *Whistler v. Ruskin*, few besides Whistler himself acknowledged his aesthetic preeminence. By the time of his death, few did not.

John Ruskin's campaign to reestablish himself in the wake of *Whistler v. Ruskin* involved doing what he had always done: asserting publicly and copiously his authority upon practically everything—and attempting, at least, to do it as effectively as he had done in the decades before the trial. But in that attempt, he proved to be a greater enemy to himself than Whistler had ever been to him. In the face of the agonizing, relentless cycles of mental collapse and recovery, it was a near miracle that he produced at all. But he did. Besides supplementing and revising his older works, he produced an abundance of books in an ever-widening variety of disciplines. He reengaged with the public with his lectures. He revived his thundering, prophetic voice with his *Fors Clavigera* and with countless letters to the newspapers. Then, before plunging into a dozen years of mental twilight, he charmed the public as never before with his magical *Praeterita*. In short, while he could, he battled human fragility with superhuman effort. But he failed to regain the stature he had enjoyed before the trial. True, Ruskin

had become a monumental figure even before *Whistler v. Ruskin*, and for the rest of his life he remained one. In the years after 1878 he was a monumental figure in the fullest sense of the term: more and more, the world looked upon him as a reminder in the present of a far greater figure of the past. By 1878, the works that had given him his stature—*Modern Painters, The Stones of Venice, Unto This Last*—were behind him. He could and did tinker with them—but he could not outdo them. His prominence as a critic of contemporary art, which was slipping even before the trial, slipped drastically afterward as he withdrew altogether from any serious consideration of modern art; he largely avoided seeing it or speaking about it, and, when compelled by returning to Oxford to consider the subject, he instead steered clear of it by focusing awkwardly upon favorites and nonentities.

In the struggle, then, between James Whistler and John Ruskin to define and promote an aesthetic, a struggle that commenced in a courtroom in 1878 and endured—on Ruskin's part until his final breakdown in 1889 and on Whistler's part until the day of his death: the advantage clearly went to Whistler.

But that was not the end, either. *Whistler v. Ruskin* continued, and will continue, through the ongoing contest of their ideas and their ideals. Both had an astounding impact upon the world; both continue to do so.

Long before Ruskin's collapse and seclusion, Ruskin followers and enthusiasts had begun to take upon themselves the promotion of his thought. Less than a month after *Whistler v. Ruskin*, in fact—in December 1878—the very first Ruskin Society was formed in Manchester, its stated purpose to "promote the teachings, carry out the works, and unite the friends" of the master. Societies in Glasgow, Aberdeen, Sheffield, Birkenhead, and London soon followed and flourished, actively spreading the word not only through society discussion and public lectures, but also by promoting social improvement through involvement in progressive local projects. The Guild of St. George, as well, continued on after Ruskin relinquished his leadership of it, and survives today, keeping the idea of Ruskin's agrarian and cooperative utopianism alive, and, with the Sheffield

Museum—which still stands—continues to promote the soul-filling importance of culture for all rather than for the few.

Ruskin's belief in the existential need for creative expression, which he first and best expressed in 1851 with his "The Nature of Gothic," was taken up by others and outlived him. William Morris, who considered "The Nature of Gothic" "one of the very few necessary and inevitable utterances of the century," made a career out of that belief, forming in 1861 what eventually became Morris and Co., a company dedicated to producing imaginative, artisan handicrafts—carpets, wallpaper, windows, carvings—for everyday use in the home. Morris's passion proved contagious, and by the 1880s the Arts and Crafts movement had exploded across Europe, North America, and beyond, committed to bringing the creativity of the artisan to the manufacture of homes and furnishings. (Charles Ashbee, Whistler's last landlord, was—to Whistler's discomfort—one of the movement's leading lights.) Among the many architects, designers, and educators who adhered to Ruskin's ideal, in whole or in part, were American Frank Lloyd Wright and German Walter Gropius, founder of the Bauhaus. That the spirit of that movement has survived until now can be seen in the inclusion of art education in primary and secondary schools throughout the world, if less, perhaps, in any examples of creativity on the contemporary factory floor.

Among the many admirers of Ruskin who helped bring his moral vision and social activism into the twentieth century, two stand out. Leo Tolstoy, who considered Ruskin to be "one of the most remarkable men not only of England and our generation, but of all countries and times," and his reading of everything that Ruskin wrote—everything after *Unto This Last*, that is—galvanized him into his own wholehearted embrace of compassionate social activism. Mahatma Gandhi, similarly, found his own road to Damascus in 1904 on a train journey from Johannesburg to Durban, when he consumed *Unto This Last* in a single sitting. "I could not get any sleep that night," he remembered. "I determined to change my life in accordance with the ideals of the book." So he did—with earth-shattering consequences. Similarly animated by Ruskin's social idealism were the vast majority of the early Labour members of the British Parliament, and, after them, so

was the future Prime Minister Clement Attlee, who declared that "it was through this gate that I entered the Socialist fold." In that way a direct connection can be made between Ruskin's alternative political economy and the British welfare state.

One way that Ruskin's thinking has had a powerful and ever-growing impact upon the world stems from his hypersensitive awareness, as he put it in 1875, of "some terrible change of climate coming upon the world for its sin, like another deluge." This nightmare, which must often have seemed to Ruskin his alone, has become a global one. Ruskin's persistent Cassandra cries against the earth-destroying and soul-crushing consequences of industrial pollution, and his persistent calls for the preservation of nature—in the Alps, around his beloved lakes, and on the verges of the ever-bleaker cities—had a direct influence upon the formation of England's National Trust and has had an indirect one upon nature preservation throughout the world. His advocacy anticipated the modern green movement.

As far as Ruskin's impact specifically upon modern art is concerned: there, for the most part, he ceded the field to others. His art criticism—his *Modern Painters* theory, his *Academy Notes* judgments, his *Falling Rocket* condemnations—have had little staying power. *Modern Painters* continues to be admired for its exquisitely fine, if dated, prose, but is read by few if anyone as instruction in what art actually *is*. Long gone are the days when artists could, as Burne-Jones and Holman Hunt did, accept its five volumes, its *Theoria* and *Aesthesis*, as gospel. Ruskin's relevance as arbiter of art, eroding in the last decades of his life, was one that did not return after his death. In 1964 art historian Kenneth Clark, arguably Ruskin's last true follower and certainly his most ardent twentieth-century promoter, noted that by then Ruskin's reputation had suffered a "catastrophic" fall, leaving, he thought, "practically nothing but a malicious interest in the story of his private life." That interest, if anything, has grown, as recent films *Mr. Turner* and *Effie Gray* demonstrate. Though Clark understates the strength of Ruskin's legacy as a whole, or his influence upon the art critics who followed him—Clark very much included—in terms of a lasting impact, Ruskin's

ideas about art and his preferences in artists—J. W. M. Turner and the Pre-Raphaelites, perhaps, excepted—have very little influence today.

Where Ruskin ceded the field, Whistler rushed in. With Whistler's death, the value of his paintings rose, spurred on by three stunning Whistler retrospectives of his work, in 1904 and 1905, in Boston, Paris, and London.* Those sales continued the migration of his work that Whistler had so encouraged during the last years of his life—into the hands of more appreciative patrons, and from there, into museums. Charles Lang Freer proved to be the driving force behind this movement, both by snatching up every Whistler he could, and in 1906 by agreeing to leave his entire collection—over eight hundred paintings, prints, and drawings—to the Smithsonian Institution in Washington, DC, and therefore to the American people. In 1923 the Freer Gallery, the first national art museum in the United States, opened to the public, with its star attraction Whistler's *Peacock Room*, which Freer had bought whole in 1904, crated, and shipped across the ocean. Meanwhile, many other Whistlers found their way into museums, particularly American ones, so that today his paintings hang on the walls of over a hundred of them in thirty-five states. Among these works is the *Falling Rocket*, obtained in 1946 by the Detroit Institute of Art.

Long before that, in 1905, the other painting most connected with *Whistler v. Ruskin*, once titled *Nocturne in Blue and Silver* but now known as *Nocturne: Blue and Gold—Old Battersea Bridge*, found its museum, and the English people, finally, belatedly—and against Whistler's own wishes—obtained their first Whistler. The National Art Collections Fund bought the painting for £2,000—fully thirty times what was paid for it when it was jeered at auction in 1886—and presented it to the National Gallery. From there, it was quickly transferred to the Tate Gallery, now the Tate Britain, where it hangs today.

* With Whistler's death, those struggling to promote his legacy split into two warring camps: one championed by Rosalind Birnie Philip and Charles Lang Freer, who were instrumental in putting on the Boston and Paris exhibitions, and one championed by the Pennells, who with the International Society of Sculptors, Painters, and Gravers organized the London one.

In 1926, the aesthetic apotheosis that Whistler had so deeply desired truly came about when the *Arrangement in Grey and Black No. 1*—his *Mother*—after thirty-one years in the Luxembourg and four more in the Jeu de Paume, finally made its way to the Louvre.*

The enshrinement of Whistler's work, and the continuing acknowledgment of his greatness as an artist, is assured. But his impact upon others, and upon the course of modern art, has been more open to doubt. The modernist critic Roger Fry—whom Kenneth Clark had acclaimed as the most profound influence upon public taste since Ruskin—had within weeks of Whistler's death dismissed his "coldly abstract sensual vision" as an aesthetic dead end. Whistler, Fry argued, clung obsessively to the belief that beauty could be self-sufficient and divorced from life. Because of this, Whistler "cut away at a blow all those methods of appeal which depend upon our complex relations to human beings and nature": his theories "destroyed the humanity of art." To be sure, Fry's own theories about art would evolve dramatically in time, so that he, like Whistler, would come to believe in the primal importance of form in any work. But for Fry, the currents of the modern flowed not through Whistler but through Cézanne, Gauguin, and Van Gogh, and when Fry endeavored to chart those currents with his groundbreaking and controversial 1910 exhibition *Manet and the Post-Impressionists*, Whistler was nowhere to be seen.

In 1930, in a biography of Whistler clearly intended to serve as a corrective to the hagiography that the Pennells had published two decades before, James Laver dismissed Whistler's art as a Victorian relic completely removed from what art had become, positing, as Fry had, that the Impressionists and not Whistler had carried art forward. "Whistler," Laver declared, "was a superb decorator and his influence on decoration continues. . . . But in painting it is another story. He was too personal and too sophisticated. The neo-primitives of the modern studios, the admirers of Negro art, the 'strong painters' of today can have little use for an artist

* After sixty years in the Louvre, the *Mother* moved once again in 1986 to its present home in the Musée d'Orsay.

whose canvases were the epitome of all that is refined, civilized and reticent. The later impressionists with their 'treble' palette are the complete antitheses of Whistlerian twilight, and it is from them that modern painting derives its colour. The disciples of Cézanne, the apostles of 'construction in depth,' attempt the very opposite of Whistler's careful flattening, his narrowing of planes, and it is from the and from the exponents of the geometrical, that modern painters derive their interest in form. So far as modern easel-painting is concerned, Whistler is in complete eclipse, was so, indeed, before he died."

Both Fry and Laver were wrong: Fry in not foreseeing, and Laver in not seeing, that Whistler's ideas, revolutionary in his time, would become in the twentieth century commonplace in high art. Whistler, as Fry acknowledged, did insist that art could only have value in itself and for itself, and should be free of all "clap-trap," independent of narrative and of outside meanings and emotions. Art might take its inspiration from nature, but should improve upon it, not simply reflect it: "The imitator," he claimed, "is a poor kind of creature." Tone and form were all to him, context nothing, and it was this that compelled him to give his works the musical and abstract titles—arrangements, harmonies, symphonies—that so annoyed the public and Ruskin. In his portraits, his nocturnes, his shopfronts, and his seascapes he practiced a studied flatness that acknowledged the two-dimensionality of the canvas. And in his pursuit of non-representative beauty, darkness was his ally. As he put it, "as the light fades and the shadows deepen all petty and exacting details vanish, everything trivial disappears, and I see things as they are in great strong masses. . . ." Whistler, in other words, tended always to abstraction, and although he never got there, he certainly pointed the way. He was not alone in that, of course. But in his pugnacious and desperate need always to prove himself—and thanks in part to those such as Ruskin, who forced him to do so—he was by far the most persistent and strident among the artists who did. He was, in other words, foremost among those who kicked open the door to the modern. Once he did, he remained at the threshold as many others rushed through. Whistler anticipated them all.

Within three years of Whistler's death, Swedish artist Hilma af Klint had begun in private her astounding series of mystically inspired abstract works. By 1911, Russian Wassily Kandinsky was creating and exhibiting his own abstracts, born, he claimed, of "inner necessity" rather than outward inspiration. And in 1915 Kandinsky's compatriot Kazimir Malevich attained pure abstraction with his fully monochromatic *Black Square*, and later described his journey there with a passage that bears a striking resemblance to Whistler's own journey to the verge of abstraction: "The ascent to the heights of non-objective art is arduous and painful . . . but it is nevertheless rewarding. The familiar recedes ever further and further into the background. . . . The contours of the objective world fade more and more and so it goes, step by step, until finally the world—'everything we loved and by which we have lived'—becomes lost to sight."

With the *Falling Rocket* in particular, a work that could comfortably intermingle with paintings created eighty, ninety, one hundred years after it, Whistler's anticipation of the art to come becomes abundantly clear. Alfred Barr, the first director of New York's Museum of Modern Art—MoMA—certainly recognized that connection, and in *What Is Modern Painting*, the guide he wrote for the museum, he noted the striking modernism of Whistler's nocturnes, which, with their own "quiet horizontals, broad muted tones, evanescent surfaces and subtle edges," must have had the same effect upon knowledgeable Victorian viewers as Mark Rothko did in 1950 with the tonal and spatial play of rectangles in his painting with the Whistlerian title *Number 10*. Barr sensed the future of art not only in Whistler's nocturnes, but sensed it as well in the most famous Whistler painting of all. In 1932 Barr coaxed the Louvre to release the *Mother* for a triumphant two-year tour of the United States, clearly considering the *Mother* a seminal, if not *the* seminal, work of modernism. In his guide he essentially begins with that painting, diagramming its flattened, strictly geometric background, connecting it with a fully abstract 1936 painting by Piet Mondrian that also bears a Whistlerian title: *Composition in White, Black and Red*. Barr clearly hoped, in bringing the *Mother* to the United States, to demonstrate Whistler's potent influence upon modern art, but

in that, he largely failed: the public across the country flocked the see the painting, but saw it much more as a sentimental icon of motherhood than as a precursor to the work of Mondrian or Rothko. The public, in other words, saw the clap-trap and missed the revolutionary. In terms of seeing *all* Whistlers as Whistler wished them to be seen, we still have a long way to go.

Who then, Whistler or Ruskin, had the most lasting and impactful legacy? Quantifying and comparing achievements so diverse, so full, is an impossibility beyond the fair deliberation of any jury. Who won *Whistler v. Ruskin*? In the greater contest between the two men—the contest of two centuries rather than two days—neither did.

Or rather, both did.

ACKNOWLEDGMENTS

F or your support and your patience in seeing this story through to the end, thank you to Linda Gough, Steve and Nina Button, Tracy Ward, Mike Guilfoyle, John Watts, Mary Van Doren, John Zieman, Amelia Tuttle, Scott Woods, Din Tuttle, Margie Williams, Suzanne Hudson, and Don Eron. You are magnificent enablers, all of you, in the most benign sense of that term. To my wife, Tory Tuttle—the best sounding board, the best proofreader, the best lockdown companion anyone ever had: thank you. Love you. Thank you to the many librarians who made my research, both online and on-site, so uncomplicated and so pleasurable, and in particular to those at the British Library, at the Special Collections at the University of Glasgow, and at the University of Colorado. Finally, and emphatically, thank you once again to my agent, Charlie Olsen, and to Claiborne Hancock, Jessica Case, Maria Fernandez, Meghan Jusczak, and all the folks at Pegasus.

NOTES

Abbreviations

Correspondence: *The Correspondence of James McNeill Whistler, 1855–1903*, ed. Margaret F. MacDonald, Patricia de Montfort, and Nigel Thorp, and including *The Correspondence of Anna McNeill Whistler, 1855–1880*, ed. Georgia Toutziari, online edition (Glasgow: University of Glasgow, 2003–2010) Cited by correspondents, date, and Glasgow University Library [GUL] reference number. Unless otherwise noted all translations from the Whistler correspondence are those of the editors.

Works: The Works of John Ruskin. Library Edition. Ed. E. T. Cook and Alexander Wedderburn. 39 vols. Cited by volume number and page.

YMSM: Andrew McLaren Young, Margaret MacDonald, Robin Spencer, and Hamish Miles: *The Paintings of James McNeill Whistler*. New Haven, CT: Yale University Press, 1980. Cited by painting number.

Chapter 1: Whistler's Mother

p. 1 Anna crossed enemy lines to tend to her until her death: *Correspondence*, Anna Whistler to Deborah Haden, Aug. 4, 1863, GUL 16521.

p. 1 She boarded a steamship in the city of her birth, successfully ran the Union blockade: Mumford, 174–75.

p. 2 "General upheaval!!": *Correspondence*, James Whistler to Henry Fantin-Latour, Jan. 4–Feb. 3, 1864, GUL 08036.

p. 2 a mile away: Sutherland, *Whistler*, 88.

p. 2 "a great skirmish!": *Correspondence*, James Whistler to Henry Fantin-Latour, Jan. 4–Feb. 3, 1864, GUL 08036.

p. 2 Haden threw Whistler out of his home: Du Maurier, *The Young George Du Maurier*, 227.

p. 2 "God answered my prayers for his welfare, by leading me here": *Correspondence*, Anna Whistler to James H. Gamble, Feb. 10–11, 1864, GUL 06522.

p. 2 From her Jemie's earliest childhood, Anna Whistler had struggled to inculcate that belief: MacDiarmid, 34; Mumford, 42–43; Toutziari, *Anna Matilda Whistler's Correspondence*, 3.206.

p. 3 Anna managed to press her son into evangelical advocacy: Laver, 25.

p. 3 "Love Him & honor His day & study His word": *Correspondence*, Anna Whistler to James Whistler, Nov. 21, 1848, GUL 06372.

p. 3 "Shew you have moral courage, by resisting idle examples": *Correspondence*, Anna Whistler to James Whistler, Aug. 27, 1851, GUL 06399.

p. 3 "none can work out your sanctification but yourself!": *Correspondence*, Anna Whistler to James Whistler, Sept. 23–24, 1851, GUL 06401.

p. 3 "Oh Jemie keep innocency": *Correspondence*, Anna Whistler to James Whistler, July 11, 1856, GUL 06474.

p. 3 During his schoolboy year in England he took to drink: Sutherland, *Whistler*, 13.

p. 3 At West Point, he struggled academically but excelled at piling up demerits: Sutherland, *Whistler*, 23–24, 30.

p. 3 Whistler was treated at the Academy's infirmary for gonorrhea: Sutherland, *Whistler*, 29.

p. 3 Whistler took up a government job mapping for the US Coast Survey and quickly lost it: Anderson and Koval, 35.

p. 3 carousing with English and "no shirt" French artist friends: Pennell, *Life* [1919], 36–37.

p. 4 his "whimsical goddess": Whistler, *Gentle Art*, 156.

p. 4 "I wish to be one so *very* much": *Correspondence*, James Whistler to George Washington Whistler, Jan. 26–27, 1849, GUL 06667.

p. 4 an art form he had almost certainly dabbled in years before: Anderson and Koval, 19.

p. 4 the two lessons he *did* learn from him proved invaluable: Pennell, *Life* [1919], 35; Menpes, 70.

p. 4 constant debates about the opposed schools of Neoclassicism and Romanticism: Anderson and Koval, 45.

p. 4 "reappearing continually here and there like the same thread in an embroidery": *Correspondence*, James Whistler to Henri Fantin-Latour, Sept. 30–Nov. 22, 1868, GUL 11983.

p. 5 "the most vigorous piece of colouring in this year's exhibition": *Times* May 17, 1860, 11.

p. 5 "I never flatter . . . but I will say that your picture is the finest piece of colour": Du Maurier, *The Young George Du Maurier*, 4.

p. 5 They moved into rough quarters in Rotherhithe: *Census Returns of England and Wales, 1861*, for James Whistler; Jo Hiffernan is there deceptively and curiously listed as Whistler's wife, "Anna Whistler"—from Ireland.

p. 5 "among a beastly set of cads": Du Maurier, *The Young George Du Maurier*, 16.

p. 5 He and Jo took lodgings at 7a Queen's Road: Boyce, 35; Sutherland, *Whistler*, 71.

p. 6 "a sort of Peggotty family": Pennell, *Whistler Journal*, 97.

p. 6 Greaves had guided the aging artist: Pocock, 43.

p. 6 "Come over to my place," he suddenly said: Pocock, 56.

p. 6 "I lost my head over Whistler": Pocock, 56.

p. 6 they witnessed his often turbulent sessions with models: Pennell, *Whistler Journal*, 118.

p. 6 "He taught us to paint": Pennell, *Life* [1919], 77.

p. 6 white trousers, blue coat, and a sailor's hat: Pocock, 67.

p. 7 she quite happily joined him there: Pennell, *Life* [1919], 79.

p. 7 She instituted nightly prayers and Bible reading: *Correspondence*, Anna Whistler to Catherine Palmer, Oct. 29–Nov. 5, 1870, GUL 11841.

p. 7 its "Evangelic spirit": *Correspondence*, Anna Whistler to Margaret Getfield Hill, Dec. 14, 1868, GUL 11473.

p. 7 She insisted that her Jemie scrupulously honor the Sabbath: *Correspondence*, Anna Whistler to Frederick Leyland, Mar. 11, 1869, GUL 08162.

p. 7 simply to please her, he would stay for the service: *Correspondence*, Catherine Palmer to Margaret Getfield Hill, Jan. 28, 1864, GUL 04406.

p. 7 in time he did this less and less: Anderson and Koval, 144.

p. 7 he had with the help of the Greaves brothers painted two great ships onto the hallway walls: This actually occurred at the second home Whistler and his mother inhabited together, 2 Lindsey Row. Pennell, *Whistler Journal*, 121, 123.

p. 7 Seeing her Jemie sketch not long after he began to walk and talk: Pennell, *Life* [1919], 6.

p. 8 "uncommon genius": Anderson and Koval, 10.

p. 8 the academician William Boxall, who was commissioned in 1849 to paint fourteen-year-old Whistler: Sutherland, *Whistler*, 14, 17.

p. 8 she knew very well that she couldn't stop him: *Correspondence*, Anna Whistler to James Whistler, Feb. 15, 1849, GUL 06386.

p. 8 Anna became her son's most enthusiastic promoter: *Correspondence*, Anna Whistler to James Gamble, Dec. 5, 1858, GUL 06502.

p. 8 "His is natural religion": *Correspondence*, Anna Whistler to James Gamble, Nov. 6–22, 1872, GUL 06553.

p. 8 "The Artistic circle in which he is only too popular, is visionary & unreal tho so fascinating": *Correspondence*, Anna Whistler to James H. Gamble, Feb. 10–11, 1864, GUL 06522.

p. 8 One of Whistler's earliest patrons, the Greek consul Alexander Ionides, came often, and so did his family, whom Anna particularly liked: *Correspondence*, Anna Whistler to James H. Gamble, Feb. 10–11, 1864, GUL 06522.

p. 8 "Rossetti lot": Du Maurier, *The Young George Du Maurier*, 216.

p. 9 Murray Marks did his best to keep Tudor House overfurnished: Williamson, 63–68.

p. 9 "it was easier to get involved with Howell than to get rid of him": Pennell, *Life* [1919], 83.

p. 9 conversation lubricated by drink: Weintraub, 148; Prettejohn, 19.

p. 9 But Swinburne saved his excesses for elsewhere: Rooksby, 83, 120, 168; Fuller, 145.

p. 10 She was known to lecture him parentally on the evils of alcohol: Anderson and Koval, 143.

p. 10 When he suffered a convulsive fit in her home, it was Anna who nursed him: Rooksby, 82.

p. 10 "This Artistic abode of my son, is ornamented by a very rare collection of Japanese & Chinese": *Correspondence*, Anna Whistler to James H. Gamble, Feb. 10–11, 1864, GUL 06522.

p. 10 His acquaintances there—the etcher Félix Bracquemond and his printer Auguste Delâtre—began collecting woodcuts: Ives, 11–12.

p. 10 Dante Gabriel Rossetti in particular competed with Whistler to procure the best blue and white china available: William Michael Rossetti, *Some Reminiscences*, 1.276; Laver, 94–95.

p. 10 "A girl seated as if intent upon painting a beautiful jar": *Correspondence*, Anna Whistler to James H. Gamble, Feb. 10–11, 1864, GUL 06522.

p. 11 Anna assisted, providing an "American" lunch at 2:00: Pennell, *Life* [1919], 88.

p. 11 "a group in Oriental costume on a balcony": *Correspondence*, Anna Whistler to James H. Gamble, Feb. 10–11, 1864, GUL 06522.

p. 11 This was *The Balcony*—actually painted upon the Whistlers' upstairs balcony: Pennell, *Life* [1919], 87.

p. 11 "I should like to talk to you about myself and my own painting": *Correspondence*, James Whistler to Henry Fantin-Latour, Jan. 4–Feb. 3, 1864, GUL 08036.

p. 12 "no wonder Jemie is not a rapid painter": *Correspondence*, Anna Whistler to James H. Gamble, Feb. 10–11, 1864, GUL 06522.

p. 12 The work went quickly at first: Pennell, *Life* [1919], 87–88.

p. 12 his small studio in the upstairs back of the house: Pennell, *Life* [1919], 86.

p. 12 "I am never admitted there, nor any one else but his models": *Correspondence*: Anna Whistler to James H. Gamble, June 7, 1864, GUL 06524.

p. 13 "posing for 'the all-over!'": Pennell, *Life* [1919], 99.

p. 13 It was again rejected—as were three-fifths of all the paintings submitted: Sutherland, *Whistler*, 78.

p. 13 the painting was "bizarre": *Athenæum*, June 28, 1862, 859.

p. 14 "I had no intention whatsoever of illustrating Mr. Wilkie Collins's novel": *Correspondence*, James Whistler to William Hepworth Dixon, July 1, 1862, GUL 13149.

p. 14 Whistler brought Jo back to live with him: Fleming, 107–108.

p. 14 two verses of which Whistler appended to its frame: Pennell, *Life* [1919], 92.

p. 14 "whatever merit my song may have, it is not so complete in beauty": Swinburne, 1.130.

p. 14 "Whistler (as any artist worthy of his rank must be)": Algernon Charles Swinburne to John Ruskin, Aug. 11, 1865, qtd. *Works*, 36.xlviii.

p. 15 ". . . of all the few great or the many good painters now at work among us": W. Rossetti and Swinburne, 32.

p. 16 "a bit of a mongrel!": *Correspondence*, James Whistler to Henry Fantin-Latour, Aug. 16, 1865, GUL 11477.

p. 16 "Oh Fantin I know so little!": *Correspondence*, James Whistler to Henry Fantin-Latour, Jan. 4–Feb. 3, 1864, GUL 89036.

p. 16 "I feel I am reaching the goal that I set myself": *Correspondence*, James Whistler to Henry Fantin-Latour, Aug. 16, 1865, GUL 11477.

p. 17 carrying dispatches for Confederate agents in England: *Correspondence*, William Whistler to Robert R. Hemphill, Nov. 29, 1898, GUL 07028.

p. 17 "almost inseparable": *Correspondence*, Anna Whistler to Margaret Getfield Hill, Oct. 22, 1865, GUL 11965.

p. 17 he brought her for treatment to a spa at Malvern, and after that to Koblenz to visit a celebrated oculist: Anderson and Koval, 152–53.

p. 17 Whistler accompanied them to Germany: *Correspondence*, James Whistler to Henri Fantin-Latour, Sept. 1865, GUL 08037.

p. 17 he hoped to produce some saleable seascapes: *Correspondence*, James Whistler to Lucas Ionides, Oct. 20, 1865, GUL 11310.

p. 17 Jo "played the clown to amuse us": *Correspondence*, Gustave Courbet to James Whistler, Feb. 14, 1877, GUL 00695.

p. 17 Courbet now referred to Whistler as "my pupil": Weintraub, 116.

p. 18 Another was Henry Doty, an acquaintance of Willie's who had designed torpedoes for the Confederate navy: Sutherland, "James McNeill Whistler in Chile," 63.

p. 18 the expedition offered the enticing prospect of a steady wage, travel and living expenses, and a hefty commission—if they succeeded: Sutherland, "James McNeill Whistler in Chile," 65.

p. 18 Willie Whistler, on the other hand, fell away from the mission: Sutherland, "James McNeill Whistler in Chile," 65.

p. 19 he got at least as far as Lima: William Michael Rossetti, *Rossetti Papers*, 196.

p. 19 "I and the officials turned and rode as hard as we could, anyhow, anywhere": Pennell, *Whistler Journal*, 42.

p. 19 Whistler had little to do except wait, drink, smoke a mountain of cigars, and socialize with, borrow from, and apparently sleep with Mrs. Doty: Sutherland, "James McNeill Whistler in Chile," 65.

p. 19 Five, perhaps six paintings survive from Whistler's journey to Valparaiso: the doubtful one is *Nocturne: The Solent*, generally considered to have been painted on that trip: Whistler traveled some of the way to Chile on the steamship *Solent*. But *Nocturne: The Solent* suggests to me advances upon Whistler's style at Valparaiso, and in his "Whistler's Paintings in Valparaiso: *Carpe Diem*" Robert H. Getscher makes a persuasive case that the painting "must date from after his trip, and therefore is not one of the Valparaiso paintings, or one of his first painted nocturnes" (14).

p. 20 He publicly accused Whistler of seducing Mrs. Doty, but withdrew the accusation: *Correspondence*, Henry B. Edenborough to James Whistler, Dec. 20, 1867, GUL 01040; James Whistler to William Boxall, Dec. 24, 1867, GUL 00498.

p. 20 who "made himself . . . obnoxious to me, by nothing in particular except his swagger and his colour": Pennell, *Whistler Journal*, 43.

p. 20 Edward Burne-Jones, also there, "did not give vent to words of indignation": William Michael Rossetti, *Some Reminiscences*, 2.318.

p. 20 "a strong abolitionist": *Correspondence*, James Whistler to William Boxall, Dec. 24, 1867, GUL 00498.

p. 20 For this "astounding impudence": *Correspondence*, James Whistler to William Boxall, Dec. 24, 1867, GUL 00498.

p. 20 "this is Whistler the artist, a scoundrel, a seducer, a betrayer of his trust; mark him!": *Correspondence*, Horace [sic] H. Doty to Rodolph Nicholson Wornum, Dec. 9, 1867, GUL 12947.

p. 21 She posed for Courbet's *Le Sommeil*: Sutherland, *Whistler*, 100. Sutherland states that Hiffernan may have posed as well for Courbet's *L'Origine du Monde*, an aggressively provocative depiction of a woman's vagina and abdomen, but very recent research has established that this was almost certainly not the case (Jones). In her recent study of Hiffernan and Whistler, *The Woman in White*, Margaret MacDonald raises doubts as to whether she posed at all for *Le Sommeil*—and questions whether Hiffernan traveled to Paris in 1866 at all (26).

p. 21 "a fluttering of purple fans": Pennell, *Life* [1919], 98.

p. 21 The parlor he painted dark red with black woodwork: Sutherland, *Whistler*, 100.

p. 21 "We three worked like mad," Walter Greaves said: Pennell, *Life* [1919], 99.

p. 21 a "whirl of excitement of ambition and hopes and disappointments and bitterness": *Correspondence*, James Whistler to Anna Matilda Whistler, Apr. 27/May 1867, GUL 06529.

p. 21 "they have been more or less damned by *every* body." *Correspondence*, James Whistler to George Lucas, Nov. 20, 1867, GUL 09194.

p. 21 he did have a "complete success" at the Salon: *Correspondence*, James Whistler to Anna Whistler, Apr. 27/May 1867, GUL 06529.

p. 22 *Symphony in White, No. 3* "is not precisely a symphony in white": *Saturday Review*, June 1, 1867, 691.

p. 22 *"Bon Dieu!* did this wise person expect white hair and chalked faces?": *Correspondence,* James Whistler to the *Saturday Review,* June 1867, GUL 11386.

p. 22 "covered me in wounds," Legros claimed: *Correspondence,* Alphonse Legros to Francis Seymour Haden, June 16, 1867, GUL 12943.

p. 22 Burne-Jones was particularly enraged, wanting to "call in the police": Sutherland, *Whistler,* 103–4.

p. 22 Traer's was the funeral "of a dog got rid of": *Correspondence,* William Whistler to Deborah Haden, May 3, 1867, GUL 06994.

p. 23 "I can never again enter the door of 62 Sloane St.": *Correspondence,* Anna Whistler to Deborah Haden, Dec. 14, 1867, GUL 06541.

p. 23 "degenerate student": *Correspondence,* James Whistler to Henri Fantin-Latour, Sept. 1867(?), GUL 08045.

p. 23 "exacting and demanding": *Correspondence,* James Whistler to Henri Fantin-Latour, Sept. 1867(?), GUL 08045.

p. 24 "It was his habit," he remembered, "to pose his model beside a skeleton": Way, 27.

p. 24 Whistler drew cartoons, full outlines on paper, and transferred these to his canvas by means of pinpricks and charcoal dust: Merrill, *Peacock Room,* 100.

p. 24 a "modern-day Medici": Merrill, "Leyland, Frederick Richards."

p. 24 Leyland had commissioned Whistler to paint two paintings: *Correspondence,* Anna Whistler to Frederick Leyland, Mar. 11, 1869, GUL 08182.

p. 24 the suspicious resemblance between the arrangement of the *Three Girls* and that of Moore's *Pomegranates:* Merrill, *Peacock Room,* 87.

p. 25 "I am up to my neck in work!" *Correspondence,* James Whistler to Henri Fantin-Latour, Sept. 30–Nov. 22, 1868, GUL 11983.

p. 25 Anna felt abandoned by her son, as he shut himself up in his studio all day while she turned away visitors: *Correspondence,* Anna Whistler to James H. Gamble, Oct. 30, 1868, GUL 06537.

p. 25 eventually paying more than Whistler had asked for: *Correspondence,* Anna Whistler to Frederick Leyland, Mar. 11, 1869, GUL 08182.

p. 25 costs for supplies and models "who *must* be paid": *Correspondence,* James Whistler to Thomas Winans, Sept./Nov. 1869, GUL 10632.

p. 25 "We all & each have to be very prudent in our expenses": *Correspondence,* Anna Whistler to Margaret Getfield Hill, Dec. 14, 1868, GUL 11473.

p. 25 "unproductive and uneventful": Pennell, *Life* [1919], 104.

p. 25 to rub his canvas "down to the bed-rock": Pennell, *Life* [1919], 104.

p. 25 "I had a large picture of three figures nearly life size fully underway": *Correspondence,* James Whistler to Thomas Winans, Sept./Nov. 1869, GUL 10632.

p. 25 wandering in despair with Jameson: Pennell, *Life* [1919], 109.

p. 26 "Leyland must be written to! but I cannot do it!": *Correspondence,* Anna Whistler to Frederick Leyland, Mar. 11, 1869, GUL 08182.

p. 26 Whistler did try to make good on his debt to Leyland: *Correspondence,* Anna Whistler to Frederick Leyland, Mar. 11, 1869, GUL 08182; James Whistler to Thomas Winans, Sept./Nov. 1869, GUL 10632.

p. 26 Whistler instead agreed to paint portraits of the Leylands, both parents and children: Pennell, *Life* [1919], 18; Whistler was at work on the portrait of Leyland by the summer of 1870 (*Correspondence,* Anna Whistler to James H. Gamble, Sept. 7–10, 1870, GUL 06545), and upon that of Mrs. Leyland—and possibly one of the Miss

Leylands—by the autumn of 1871 (*Correspondence*, James Whistler to Walter Greaves, Oct.–Nov. 1871, GUL 11469.)

p. 26 his mother . . . endeared herself to the Leylands: Merrill, *Peacock Room*, 122.

p. 27 "we may each paint our picture without harming each other": *Correspondence*, James Whistler to Albert Moore, Sept. 12/19, 1870, GUL 04166.

p. 27 "effect & treatment": *Correspondence*, William Eden Nesfield to James Whistler, Sept. 19, 1870, GUL 04263.

p. 27 "my own martyrdom": *Correspondence*, Frederick Leyland to James Whistler, Nov. 8, 1872, GUL 02565.

p. 27 Leyland's martyrdom would continue: YMSM, 97.

p. 27 "I only warn you not to be a butterfly sporting about from one temptation to illness to another. . . ." *Correspondence*, Anna Whistler to James Whistler, Jan. 20, 1849, GUL 06382.

p. 28 his "infidelity to Jo": Pennell, *Whistler Journal*, 163.

p. 28 Charles Hanson was farmed out to a nurse, but after that Whistler entrusted his upbringing to Jo: Sutherland, *Whistler*, 116.

p. 28 Louisa Fanny Hanson married and had a family after her son's birth: *Census Returns of England and Wales, 1891*, for Louisa F. Fisher; *London and Surrey, England, Marriage Bonds and Allegations, 1597–1920*, for Louisa Fanny Hanson, Mar. 19, 1872.

p. 28 "hope deferred which maketh the heart sick": *Correspondence:* Anna Whistler to Catherine Palmer, Nov. 3–4, 1871, GUL 10071.

p. 28 For his model Whistler had found a beautiful fifteen-year-old girl named Maggie: At least two biographers of Whistler have concluded that Maggie must be Maggie Graham, daughter of the man who commissioned the painting. She was not. Graham had no daughter named Maggie (Genealogy of William Graham, *The Cobbold Family History Trust*, http://family-tree.cobboldfht.com/tree/view/person:4589). And while there would be nothing out of the ordinary in Graham's commissioning a nude painting, his commissioning a nude portrait of his own fifteen-year-old daughter beggars belief.

p. 29 Maggie was a "novice" of a model: *Correspondence*, Anna Whistler to Catherine Palmer, Nov. 3–4, 1871, GUL 10071.

p. 29 "I saw his misery": *Correspondence*, Anna Whistler to Catherine Palmer, Nov. 3–4, 1871, GUL 10071.

p. 29 possibly a study for the *Three Girls*: Way, 71.

p. 29 "I was not as well then as I am now," *Correspondence*, Anna Whistler to Catherine Palmer, Nov. 3–4, 1871, GUL 10071.

p. 29 He at first posed her standing: M. Macdonald, "Painting," 34.

p. 30 "Art . . . should be independent of all clap-trap": Whistler, *Gentle Art*, 127–28.

p. 30 "To me . . . it is interesting as a picture of my mother": Whistler, *Gentle Art*, 128.

p. 30 "Jemie had no nervous fears in painting his Mother's portrait": *Correspondence*, Anna Whistler to Catherine Palmer, Nov. 3–4, 1871, GUL 10071.

p. 30 washing in broad masses of color with paint so diluted with turpentine that it bled completely through: Walden, 55–56.

p. 30 at one point lowering footstool, chair, and his mother's body on the canvas: M. MacDonald, "Painting," 54.

p. 30 "Only at one or two points . . . I heard him ejaculate 'no!'": *Correspondence*, Anna Whistler to Catherine Palmer, Nov. 3–4, 1871, GUL 10071.

p. 31 "Jemie so seldom goes out in the day": *Correspondence*, Anna Whistler to Catherine
 Palmer, Nov. 3–4, 1871, GUL 10071.

p. 32 "Oh Jemie dear": *Correspondence*, Anna Whistler to Catherine Palmer, Nov. 3–4, 1871,
 GUL 10071.

p. 32 "To Mr. Whistler . . . a boat was always a tone": Qtd. Pocock, 81.

p. 33 "as the light fades and the shadows deepen": Qtd. Eddy, 214.

Chapter 2: No Wealth but Life

p. 34 her "limb," as she delicately put it: G. Burne-Jones, 1.252.

p. 34 shuffling through the house clutching to the back of one: G. Burne-Jones, 1.252.

p. 35 How *can* you . . . sit there and listen to such a pack of lies?" Collingwood, 2.115.

p. 35 "Do you love God?" G. Burne-Jones, 1.300.

p. 35 "sheer love of contradiction": G. Burne-Jones, 1.300.

p. 35 "sharp, decisive manner": G. Burne-Jones, 1.252.

p. 35 "She always persecuted *me* . . .": Ruskin, *Diaries*, 3.710.

p. 36 "patient solitude": Ruskin and Norton, 230.

p. 36 His duties at Oxford had been "worrying": Ruskin and Norton, 231.

p. 36 There had been horrible, daily reports from France: *Works*, 22.444.

p. 36 Ruskin . . . had recently been forced to share with his lawyers: Hilton, *Later Years*, 215.

p. 36 "the sky is covered with grey cloud": *Works*, 27.132–33.

p. 37 "within an ace of the grave": *Works*, 37.34.

p. 37 she was sure he had died: Birkenhead, 199.

p. 37 he canceled his Michaelmas lectures at Oxford: Birkenhead, 205.

p. 38 "your infant is a most promising one": Ruskin et al., 1:93.

p. 38 "he is . . . beginning to give more decided proof": Ruskin et al., 1:96.

p. 38 "this I trust will be cured by a good whipping" Ruskin et al., 1:98.

p. 38 "Being always summarily whipped if I cried": *Works*, 35.21.

p. 38 "One evening": *Works*, 20.372.

p. 38 the difference "between the nature of this garden, and that of Eden": *Works*, 35.36.

p. 38 "the most radiant Punch and Judy she could find in all the Soho bazaar" *Works*,
 35.20.

p. 39 He did have toys: Ruskin et al., 1.127.

p. 39 a "monastic poverty": *Works*, 35.20.

p. 39 "contentedly in tracing the squares and comparing the colours of my carpet": *Works*,
 35.20.

p. 39 Margaret Ruskin . . . committed her son to the service of God: *Works*, 35.13; Hilton,
 Early Years, 16, 50.

p. 39 "She read alternate verses with me": *Works*, 35.40.

p. 40 "Any children I see appear half idiots compared to him": Ruskin et al., 1.152–53.

p. 40 John James as a young man had had his own dreams of a literary career: Hilton, *Early
 Years*, 1.

p. 40 He supplied John with geological specimens. He filled the family library with
 literature: Hilton, *Early Years*, 15, 17.

p. 40 he had generated a second, better, more virtuous Lord Byron: Ruskin et al., 1.404.

p. 40 The first poem published, "On Skiddaw and Derwent Water": *Works*, 2.265. The editor
 of the *Spiritual Times* happened to be the Rev. Edward Andrews, Ruskin's minister and
 one of his tutors (Nicoll, 321).

p. 41 Margaret, surprisingly, had proposed the trip: *Works*, 35.79.

p. 41 "I had certainly more passionate happiness": *Works*, 35.81.

p. 41 "They were clear as crystal": *Works*, 35.115.

p. 42 "I went down that evening from the garden-terrace of Schaffhausen": *Works*, 35.116.

p. 42 "I took them for my only masters": *Works*, 35.79.

p. 42 "familiar at once, and revered": *Works*, 35.117.

p. 42 Ruskin dismissed as having "little charm in colour": *Works*, 35.217.

p. 42 *The Fountain of Indolence* and *The Golden Bough*, to Ruskin, were unpleasantly fantastic: *Works*, 35.217.

p. 43 "skill and enthusiasm": *Works*, 35.217. *Juliet and Her Nurse*, incidentally, was another night painting—of St. Mark's Square in Venice—but one apparently redeemed in Ruskin's mind by blazing fire and fireworks that render the night scene almost a daylight one, leaving no detail obscured by darkness.

p. 43 "thrown higgledy-piggledy together": John Eagles in *Blackwood's Magazine*, Oct. 1836, 551.

p. 44 "Shakespearean in its mightiness": *Works*, 3.638.

p. 44 "the soul and essence of beauty": *Works*, 3.639.

p. 44 "He is a meteor": *Works*, 3.638.

p. 44 "I never move in these matters, they are of no import save mischief . . .": *Works*, 35.218.

p. 44 "all our earthly happiness depends on him": Ruskin et al., 2:567.

p. 44 "Ruskin was only famous as a sort of *butt* . . .": Kitchin, 20.

p. 44 One day a fellow gentleman-commoner . . . rode Ruskin like an ass: Collingwood, 1.94.

p. 45 "You and my mother used to be delighted": Ruskin, *Winnington Letters*, 369–70.

p. 45 incidentally beating out the submission by the greater poet Arthur Hugh Clough: Hilton, *Early Years*, 51.

p. 45 "entirely ridiculous and ineffable conceit and puffing up" Ruskin recited his poem: *Works*, 35.613.

p. 46 "at a miserably low ebb": *Works*, 1.6.

p. 46 "lamentable deficiency of taste and talent": *Works*, 1.8.

p. 46 he considered the province of the builder rather than the architect: *Works*, 1.105.

p. 46 "my entire delight": *Works*, 35.166.

p. 47 "to amuse a little girl": *Works*, 35.303–304.

p. 47 "are produced as if by throwing handfuls": Qtd. *Works*, 3.xxiv.

p. 47 "This gentleman has on former occasions . . .": Qtd. *Works*, 3.xxiv.

p. 47 "to write a pamphlet": *Works*, 3.666.

p. 48 "that which ought to have been a witness . . .": *Works*, 3.22.

p. 48 "oscillations of temper, and progressions of discovery": *Works*, 7.9.

p. 48 "In the main aim and principle of the book": *Works*, 7.9.

p. 49 "colourful daguerreotypeism": *Works*, 3.215.

p. 49 "the exquisite designs": *Works*, 3.165.

p. 49 "there is not the commonest subject": *Works*, 4.262.

p. 49 "animal consciousness": *Works*, 4.47.

p. 49 "the full comprehension and contemplation of the Beautiful": *Works*, 4.47.

p. 50 "Nasty crowded party at Inglis's": Ruskin, *Diaries*, 1.262.

p. 50 "One sees nothing but subjects for lamentation": Ruskin, *Ruskin in Italy*, 51.

p. 50 "a mass of Hieroglyphics . . .": *Works*, 8.xxiii.

p. 51 "lowly born and lowly bred": Lutyens, *Millais and the Ruskins*, 251.

p. 51 He offered a host of reasons: Lutyens, *The Ruskins and the Grays*, 108; *Millais and the Ruskins*, 188.

p. 51 "though her face was beautiful, her person was not formed to excite passion": Lutyens, *Millais and the Ruskins*, 191.

p. 51 "My own passion . . . was much subdued by anxiety": Lutyens, *Ruskins and the Grays*, 189.

p. 52 "is valuable or otherwise, only as it expresses the personality": *Works*, 11.201.

p. 52 Ruskin dated the fall of Venetian art from 1418: *Works*, 9.21.

p. 52 "Since the first dominion of men was asserted over the ocean . . .": *Works*, 9.17.

p. 53 "And now, reader, look round this English room of yours . . .": *Works*, 10.193.

p. 54 "These last days I have been sitting to Millais": Lutyens, *Young Mrs. Ruskin in Venice*, 344.

p. 54 Effie fled for good: Lutyens, *Millais and the Ruskins*, 184–86.

p. 54 "They have got him now": Lutyens, *Millais and the Ruskins*, 210.

p. 55 "I can scarcely see how you can conceive it possible": Lutyens, *Millais and the Ruskins*, 248.

p. 55 he sent Rossetti all his written works: *Works*, 36.166.

p. 5 "Turner, Watts, Millais, Rossetti, and this girl": *Works*, 36.217.

p. 55 "He is the best friend I ever had *out of my own family*": D. Rossetti, *Letters of Dante Gabriel Rossetti*, 1.250.

p. 56 "my days of serious critical influence": *Works*, 35.391.

p. 56 "twenty years of severe labour": *Works*, 14.5.

p. 56 "very bad pictures may be divided into two principal classes": *Works*, 14.9.

p. 56 "I takes and paints": *Punch*, May 24, 1856, 209.

p. 57 Ford Madox Brown . . . was another: Hilton, *Early Years*, 230.

p. 57 So was William Powell Frith: Frith, 3.5.

p. 57 "I gave up my art-work and wrote this little book": *Works*, 22.512.

p. 57 their "science of darkness": *Works*, 17.92.

p. 57 "the folly and horror of humanity enlarge to my eyes daily": Ruskin and Norton, 77.

p. 57 "the utter imbecility of Mr. Ruskin's reasoning powers": *Saturday Review*, Nov. 10, 1860, 582–84.

p. 58 "one of the most melancholy spectacles": *Literary Gazette*, Nov. 3, 1860, 372.

p. 58 "It is no pleasure to see genius mistaking its power": Lancaster, 299.

p. 58 These essays . . . provoked vitriol stronger, if anything, than before: *Works*, 17.lxix.

p. 59 "THERE IS NO WEALTH BUT LIFE": *Works*, 17.105.

p. 60 "I am . . . a violent Tory of the old school." *Works*, 35.13.

p. 60 the "Goddess of Getting-on": Works, 18.448.

p. 60 "Continue to make that forbidden deity your principal one": *Works*, 18.458.

p. 60 Ruskin's audience felt no shame and recognized no error: *Leeds Mercury*, Apr. 22, 1864, 3.

p. 60 "this *unlucky* paper": Qtd. *Works*, 17.xxvii.

p. 61 Dante Gabriel Rossetti thought the entire work "bosh": D. Rossetti, *Letters of Dante Gabriel Rossetti to William Allingham*, 228.

p. 61 "You go down through those unfortunate dismal-science people": Qtd. *Works*, 27: xxxii–xxxiii.

p. 61 "there is a felicity of utterance in it": Qtd. *Works*, 27.lxx.

p. 61 "My dearest Papa": *Works*, 37.115.

p. 61 Having failed to convince his son to "spare his brain": *Works*, 27.xxvii.

p. 61 "it is rather amusing to see the commotion they make": Qtd. *Works*, 27.xxvii.

p. 61 "Mind critiques as little as possible": *Works*, 27.lxix.0.

p. 61 "We disagree about all the Universe": *Works*, 36.414.

p. 62 "God-given power": *Works*, 29.89.

p. 62 "There never was such mind and soul so fused through language yet": G. Burne-Jones, 1.85.

p. 62 "I am in a state of subdued fury whenever I am at home": *Works*, 36.414.

p. 63 "At Boulogne we stayed the night": G. Burne-Jones, 1.242.

p. 63 "Since that day of April, 1862": Leon, 369.

p. 63 "I know my resolution to stay here must give you much pain": *Works*, 36.418.

p. 64 In November 1863, John James Ruskin dashed his son's escape plans altogether: Hilton, *Later Years*, 63; *Works*, 17.lxxv.

p. 64 "I *have* quite given up all thoughts of that house in Switzerland now": *Works*, 36.459.

p. 64 his father . . . abruptly stood up: Hilton, *Later Years*, 65.

p. 64 "You have never had": *Works*, 36.333.

p. 65 he promptly distributed £17,000 to them: Hilton, *Later Years*, 66.

p. 65 "rather nice, half crazy old French lady": *Works*, 36.511.

p. 65 for some reason to buy a lizard canary: *Works*, 36.502.

p. 65 In 1868 Ruskin abruptly and without surviving explanation dispensed with Howell's services: Ruskin, *Diaries*, 2:645, based upon this entry for Mar. 21, 1868: "Y[esterday] put things in order with Howell. Wrote grave letters, to say I would write no more." William Michael Rossetti claims that the arrangement lasted until 1870—and his diary does suggest that Howell did do errands for Ruskin after March 1868 (D. Rossetti, *Letters of Dante Gabriel Rossetti*, 1.258; W. Rossetti, *Rossetti Papers*, 334).

p. 65 Howell's habit of blabbing all of Ruskin's secrets: W. Rossetti, *Rossetti Papers*, 195, 196, 225–26, 238, 297, 300, 313, 334.

p. 66 "black blight": Ruskin, *Diaries*, 2.617.

p. 66 "Nature herself not right": Ruskin, *Diaries*, 2.590.

p. 66 "Black fog and storm all day . . .": Ruskin, *Diaries*, 2.620.

p. 66 Rose's mother, Maria, was so troubled by Ruskin's falling away from evangelicalism: Hunt, 281.

p. 66 Rose's father, John, a fervid and freshly converted evangelical: Hilton, *Early Years*, 267.

p. 67 "quite unnatural": Leon, 405.

p. 67 "all is ascertained & safe": Ruskin, *Letters of John Ruskin to Lord and Lady Mount-Temple*, 298.

p. 67 "she sent an answer": Ruskin, *Letters of John Ruskin to Lord and Lady Mount-Temple*, 310.

p. 68 "There is so much misery and error in the world": Works, 19.xxii–xxiii.

p. 68 His appointment was largely due to the efforts of two friends: Hilton, *Later Years*, 167.

p. 68 "is an index of the moral purity and majesty of the emotion it expresses": *Works*, 20.74.

p. 69 "One day last November . . . ": *Works*, 28. 14–15.

p. 69 "own peculiar opinions": *Works*, 20.xx.

p. 70 "I could easily teach you": *Works*, 20.114.

p. 70 "the thousand things flitting in my mind . . .": *Works*, 28.460.

p. 71 replace the body- and soul-destroying illth of industrialism with life-giving material and spiritual wealth: *Works*, 27.90.

p. 71 Seeded by the £7,000 of his fortune: *Works*, 27.199.

p. 71 "my mother is so very feeble": Ruskin and Norton, 237.

p. 72 "Here I have rocks, streams, fresh air": Ruskin and Norton, 238.

p. 72 "My mother has been merely asleep": *Works*, 37.42-3.

p. 72 "one ghastly monotony of indescribable shadows": Ruskin and Norton, 244.

p. 72 Ruskin confided to his readers that he wrote it while sitting beside her corpse: *Works*, 27.232.

p. 72 a sky-blue coffin: Rawnsley, 191.

p. 72 reclaiming and purifying a spring near Croydon: *Works*, 22.xxiv.

p. 72 "for the contrary of love and kindness": *Works*, 22.xxiii.

p. 72 "I never loved my mother": Leon, 471.

Chapter 3: Nocturnes

p. 73 "unique and striking": *Examiner*, Oct. 28, 1871, 12.

p. 73 "vagaries in colour": *London Daily News*, Oct. 24, 1871, 2.

p. 73 "peculiar smudges": *Morning Advertiser*, Nov. 10, 1871, 3.

p. 73 "To . . . willfully reduce art to this, its very simplest infantine expression": *Illustrated London News*, Oct. 28, 1871, 10.

p. 73 "concentration in them of the most delicate and evanescent kind of truth": *Pall Mall Gazette*, Nov. 9, 1871, 11.

p. 73 "exquisite harmony in chromatics": *Athenæum*, Oct. 28, 1871, 565.

p. 74 Anna Whistler was so delighted by this last review: *Correspondence*, Anna Whistler to Catherine Palmer, Oct. 3–4, 1871, GUL 10071.

p. 74 "are illustrations of the theory": *Times*, Nov. 14, 1871, 4.

p. 75 Walter Greaves sent a copy of the article to Whistler: *Correspondence*, James Whistler to Walter Greaves, Nov. 14/Dec. 1871, GUL 11496.

p. 75 "forcing up the blues": Pennell, *Whistler Journal*, 116.

p. 75 "The day is grey, the sky is grey and the water is grey, therefore the canvas should be grey": Pennell, *Whistler Journal*, 121.

p. 75 Whistler allowed the two to paint beside him: Pocock, 86.

p. 75 "seeing the Nocturnes set out along the garden wall to bake in the sun": Pennell, *Life* [1919], 115.

p. 76 "I say I can't thank you too much for the name 'Nocturne' as a title for my moonlights": *Correspondence*, James Whistler to Frederick Leyland, Nov. 2/9, 1872, GUL 08794.

p. 76 a very similar scene upon a folding screen: YMSM, 139.

p. 77 For that painting, Walter Greaves remembered, Whistler called for a leaden undercoat: Pennell, *Life* [1919], 115.

p. 77 the climactic—apocalyptic—moment during the nightly fireworks display at Cremorne when ground, gallery and sky burst with flares, illuminations and rockets: Dorment *et al.* 137.

p. 77 Whistler later freely admitted that anyone hoping to *see* that view in his painting would be seriously disappointed: *Morning Post*, Nov. 26, 1878, 3.

p. 77 a sward according to Victorian maps of Cremorne: See, for example, the 1874 Ordnance Survey map of Battersea, Chelsea, and Kensington, available online through the National Library of Scotland at https://maps.nls.uk/view/103313072.

p. 78 "He attained to that extreme region": Duret, 45.

p. 78 "Mr. Whistler sends two pictures which almost drive us to ask him whether he is poking fun at us": *London Daily News*, Oct. 23, 1875, 2.

p. 78 "that an artist who might have done so much for art has wasted his time and talent upon a mere whimsical theory": *The Era*, Nov. 28, 1875, 11.

p. 78 "felt and realised with great truth": *Academy*, Oct. 30, 1875, 462.

p. 78 "a marvellous study of pictorial harmonies": *Bell's Life in London and Sporting Chronicle*, Nov. 13, 1875, 5.

p. 79 "The painter . . . appraises them beyond their value": *Times*, Dec. 2, 1875, 4.

p. 79 "You will be pleased to hear": *Correspondence*, James Whistler to Alan Summerly Cole, Dec. 2/19, 1875, GUL 07888.

p. 80 "If it could have been so that I could have kept the *friend*": G. MacDonald, 113.

p. 80 "when I think what you *might* have been.": Leon, 488.

p. 80 "I will not move unless in certainty of seeing her": Leon, 490.

p. 80 "if nothing can be done—I will have not talking": G. MacDonald, 117.

p. 80 consisted one day of "three green peas": G. MacDonald, 120.

p. 81 "days of heaven": G. MacDonald, 120.

p. 81 he took a room at the Euston Square Hotel: Ruskin, *Diaries*, 2:729; Hilton, *Later Years*, 2:245.

p. 81 Rose refused his letters and would not write him: Hilton, *Later Years*, 2:268.

p. 81 a letter Rose sent to Joan in the autumn of 1874: Ruskin and Norton, 342; Hilton, *Later Years*, 2:286.

p. 81 From October until December he visited with her: Hilton, *Later Years*, 2:288–90.

p. 81 "*Of course* she was out of her mind in the end": Ruskin, *John Ruskin's Letters to Francesca*, 118.

p. 82 "At twenty, I wrote *Modern Painters*": *Works*, 39.137.

p. 83 "plunged . . . into such abysses": *Works*, 25.122.

p. 83 "I never saw anything so impudent": *Works*, 23.49.

p. 84 "only like to buy their tea": *Works*, 28.205.

p. 84 "gem-like flame": Pater, 210.

p. 85 digging holes, he claimed, was a favorite activity: Hilton, *Later Years*, 255.

p. 85 sending for his Brantwood gardener to fix up a clogged fountain: Ruskin, *Christmas Story*, 118.

p. 85 He was comfortable enough there: Ruskin, *Christmas Story*, 117.

p. 85 "I was always ready to accept miracles": Ruskin, *Letters of John Ruskin to Lord and Lady Mount-Temple*, 30.

p. 85 "doubtful and painful enquiry": Ruskin, *Christmas Story*, 67.

p. 86 "The truth is shown me": Ruskin, *Diaries*, 3.877.

p. 86 "I have a couple of hours tete-a-tete with St. Ursula": Ruskin and Norton, 387.

p. 86 focusing upon the painting's individual details: *Works*, 37.216, 221; Leon, 508.

p. 86 "There she lies, so real, that when the room's quite quiet, I get afraid of waking her!": *Works*, 24.xxxvii.

p. 87 The second, from a botanist friend, contained a flower—a sprig of verbena: Hilton, *Later Years*, 347.

p. 87 "Last night, St. Ursula sent me her dianthus 'out of her bedroom window, with her love.'" *Works*, 29.30.

p. 87 "My duty was to yield to every impulse . . .": Ruskin, *Christmas Story*, 230.

p. 87 Ruskin attempted to lay out this revelation in *Fors* that February: *Works*, 29.46.

p. 87 "a horrid monster with inflamed eyes, as red as coals": Ruskin, *Christmas Story*, 256.

p. 88 "leaving me again in this material world": *Works*, 28.760n.

p. 88 "yesterday, for a companion to little Bear, I began painting the Doggie": *Works*, 37.221.

p. 88 "My old nursery feeling like true home": Ruskin, *Diaries*, 3.962.

Chapter 4: Damages

p. 89 "the handsomest man in England": James, *Complete Letters*, 2.105. Henry James observed this after meeting Lindsay at one of Whistler's celebrated breakfasts.

p. 89 Istrian limestone with jasper pillars: *Builder,* Apr. 1877, 424.

p. 89 at least £120,000: *London Evening Standard,* May 3, 1877, 6; *Times,* Mar. 12, 1877, 4.

p. 89 £14 million today: exactly £14,305,979.38 in 2020 according to "Inflation," the online
 inflation calculator of the Bank of England.

p. 90 painted ceilings: The most notable of these was in the main gallery—the West Gallery:
 a series of stylized nocturnes that Whistler's friend and fellow artist Walter Crane had
 claimed Whistler had done. More likely they were the work of Coutts Lindsay himself.
 Crane, 175; *London Evening Standard,* May 3, 1877, 6; *Art Journal,* July 1877, 244.

p. 90 Ionic pilasters: These pilasters had been salvaged from Paris's Italian Opera; *Builder,*
 Apr. 1877, 424.

p. 90 "The walls are hung with scarlet damask": *Dublin University Magazine,* July 1878, 118.

p. 91 it earned nothing but a few lukewarm reviews: Pennell, *Life* [1919], 110; Anderson and
 Koval, 183.

p. 91 still smarting from the skying of two of his paintings: Hueffer, 84.

p. 91 his "diseased imagination": *Art Journal,* June 1, 1869, 173.

p. 91 Burne-Jones then resigned from the Society: G. Burne-Jones, 2.11.

p. 91 "There are several thoughtful men in London": *Art Journal,* July 1, 1877, 244.

p. 92 "gives rest to the eye and mind": *Times,* May 1, 1877, 10.

p. 93 "at least acquired fame tho not yet money": *Correspondence,* Anna Whistler to Mary
 Emma Harmar Eastwick, Sept. 9, 1874, GUL 11843.

p. 93 "The visitor is struck": Henry Blackburn in *The Pictorial World,* June 13, 1874, 231.

p. 93 "It is a simple fact": W. Rossetti, *Dante Gabriel Rossetti,* 307.

p. 93 Prickly Ford Madox Brown refused: Hallé 106.

p. 93 provided Rossetti with the excuse he needed to bow out: *Times,* Mar. 27, 1877, 6.

p. 94 Prime Minister William Gladstone, composer Arthur Sullivan, Robert Browning,
 George Eliot and George Henry Lewes, Henry James—and young Oscar Wilde: Kate
 Field in *Truth,* May 10, 1877, 595–97; Henrey, 204; James, *Complete Letters,* 1.108;
 Oscar Wilde in *Dublin University Magazine,* July 1878, 125n.

p. 94 an astounding seven thousand people crammed the galleries: *Illustrated London News,*
 May 12, 1877, 450.

p. 94 "the old black evil sky": Ruskin, *Diaries,* 3.963.

p. 94 "wholly virtueless and despicable": *Works,* 5.93.

p. 94 the stones of this doorway, Palladian or not: While many newspapers of the day,
 clearly relying upon information put out by Coutts Lindsay himself, reported that the
 doorway originally graced the church (*possibly* designed by Palladio) of Santa Lucia, an
 examination of a photograph and a drawing of the church before its 1860 destruction
 raises questions about whether this is actually the case: see https://en. wikipedia.org
 /wiki/Santa_Lucia,_Venice; Musolino facing p. 33; Surtees, 147 n. 44.

p. 95 a Chelsea neighbor of both Carlyle and Whistler had brought the two together:
 Pennell, *Life* [1919], 119.

p. 95 "And now, mon, fire away!": Pennell, *Life* [1919], 119.

p. 95 "for God's sake, don't move!": Allingham, 226.

p. 95 Whistler seemed much more obsessed with depicting his coat: Allingham, 226.

p. 95 "Mr. Whistler to be an artist of very great power": Oscar Wilde in *Dublin University
 Magazine,* July 1878, 125.

p. 95 "poor in itself": *Works,* 29.158.

p. 96 "an amateur both in art and shopkeeping": *Works,* 29.157.

p. 96 "the monotony of their virtues": *Works,* 29.158.

p. 96 Millais's skill in that painting only gave the barest hint: *Works*, 29.161.

p. 97 "their eccentricities are almost always in some degree forced": *Works*, 29.160.

p. 97 "Since painting was an art": Sidney Colvin in *Fortnightly*, June 1, 1877, 826.

p. 97 "we deliberately reckon Mr. Burne Jones": *Examiner*, May 5, 1877, 563.

p. 98 "he belonged to the world": G. Burne-Jones, 2:75.

p. 98 the only living artist truly capable of drawing a leaf: *Works*, 35.304.

p. 98 "I mean by a picture a beautiful romantic dream": Qtd. Monkhouse vii.

p. 98 "the more perfect truth of things": *Works*, 34.156.

p. 98 repose, that quality essential to Ruskin's aesthetics: *Works*, 4.113.

p. 99 "His work, first": *Works*, 29.159.

p. 99 "one of the most morbid symptoms": *Works*, 3.620.

p. 99 confident he could finish it: *Correspondence*, Diary of Alan Summerly Cole, May 1, 1876, GUL 13132.

p. 99 scraping the canvas bare: Menpes, 76.

p. 100 Irving eventually gave up sitting: Weintraub, 162. Years later, he did buy the portrait (Pennell, *Life* [1919], 144).

p. 100 "a blonde lady in white muslin": William Michael Rossetti in *The Academy*, May 26, 1877, 467.

p. 100 "Mr. Whistler's full-length arrangements": Tom Taylor in *Times*, May 1, 1877, 10.

p. 100 "Great Dark Master": Oscar Wilde in *Dublin University Magazine*, July 1878, 124.

p. 101 "among the loveliest of the painter's works": William Michael Rossetti in *The Academy*, May 26, 1877, 467.

p. 101 "not for the purpose of pressing you": *Correspondence*, William Graham to James Whistler, July 23, 1877, GUL 01783.

p. 101 Instead Whistler—without asking—sent Graham the Battersea Bridge: *Correspondence*, James Whistler to William Graham, July 23/30, 1877, GUL 01784.

p. 102 "are simply conundrums": *Art Journal*, July 1877, 244.

p. 102 "enigmas sometimes so occult": *Daily Telegraph*, May 1, 1877, 5.

p. 103 "No art": *Works*, 29.547n.

p. 103 "For Mr. Whistler's own sake": *Works*, 29.160.

p. 104 Ruskin crossed London: Ruskin, *Diaries*, 3:963.

p. 104 But *Fors* had another vigilant readership: *Works*, 27.lxxxvi.

p. 104 The attack first reappeared in the *Sheffield Independent*: *Sheffield Independent*, July 9, 1877, 2.

p. 104 *The Architect* . . . devoted almost a full page to all of Ruskin's remarks: *The Architect*, July 1877, 18.

p. 105 "an impudent coxcomb who throws a pot of paint against his canvas": *Leeds Mercury*, July 19, 1877, 4.

p. 105 on a quiet evening in the middle of the month: Boughton, 212. Exactly when this happened could have been on any evening between Saturday, July 14, when *The Architect* was issued, and Wednesday, July 18, the day before the *Leeds Mercury* first offered a clue about Whistler's reaction.

p. 105 It was Boughton who first snatched up that periodical: Boughton, 212. Boughton, writing in 1904, remembered the periodical he was reading as *The Spectator*, but he is wrong: *The Spectator* did not carry Ruskin's remarks. *The Architect*, apparently alone among art journals, had carried Ruskin's attack early enough for Whistler to see it on this evening.

p. 105 "rather enjoyed adverse criticism": Boughton, 212.

p. 105 when Ruskin used the term "Cockney," as he often did: see, for example, *Works*, 23.308; 29.72; 33.153; 34.173.

p. 106 "It is the most debased *style* of criticism I have had thrown at me yet": Boughton, 212.

p. 107 In 1874 he had negotiated down the stiff charges: Weintraub, 191.

p. 107 prompting Whistler to send a panicked note: *Correspondence*, James Whistler to James Anderson Rose, July 6, 1877, GUL 08726.

p. 107 It was not the first time that bailiffs had descended upon his home: They had already come a month before this, according to Alan Summerly Cole, who wrote in his diary "J. came to dine—very hard up had the bailiffs in his house. . . ." *Correspondence*, Alan Summerly Cole diary, June 6, 1877, GUL 13132.

p. 108 Although Whistler and Rose hesitated for some time: The first mention of £1,000 damages, and costs, occurs in a statement of their claim dating from the first week of November 1877. *Correspondence*, James Anderson Rose to Warburton Pike, Nov. 5, 1877, GUL 12072.

p. 108 He had not sold the Mother: *New York Herald*, Apr. 10, 1876, cited in Young et al., 60; Pennell, *Life* [1919], 163.

p. 109 Whistler had originally asked 300 guineas: *Correspondence*, James Whistler to Cyril Flower, July/Aug. 1874, GUL 09093; YMSM, 71.

p. 109 Whistler later asked that same amount for his *Nocturne—Blue and Silver—Bognor*: *Correspondence*, James Whistler to Murray Marks, Feb. 1876, GUL 09300.

p. 109 "times are too bad at present": *Correspondence*, Alfred Chapman to James Whistler, July 5, 1876.

p. 109 the assistance of a nude model named Fosco: Merrill, *Peacock Room*, 129.

p. 109 not to the satisfaction of his own artistic scruples: *Correspondence*, James Whistler to Frederick Leyland, July 25, 1877, GUL 02596.

p. 110 "never known an artist to be more conscientious": Pennell, *Whistler Journal*, 102.

p. 110 "If you will not think me too capricious": *Correspondence*, James Whistler to Rachel Agnes Alexander, Aug./Dec. 1872, GUL 07572.

p. 110 And so eight-year-old Cicely became in her own word Whistler's "victim,": Pennell, *Life* [1919], 122.

p. 110 "I know I used to get very tired and cross": Pennell, *Life* [1919], 122.

p. 111 William Holman Hunt, for example, earned an unprecedented sixteen times as much: Spencer, 28.

p. 112 "Matters at home are getting better": *Correspondence*, James Whistler to Anna Whistler, Sept. 26/27, 1876, GUL 06564.

p. 112 *Truite Saumonée Hollandaise*: *Correspondence*, Menu of June 21, 1873, GUL 10965.

p. 112 often shifted to finer bottles: Ionides, 10–11.

p. 112 "sort of Japanese bath": Pennell, *Whistler Journal*, 102.

p. 112 "my Mother exerts her influence over me": *Correspondence*, James Whistler to William Grapel, [1869/1873], GUL 01795.

p. 113 "the tender mercy of the Lord in answer to my children's prayers": *Correspondence*, Anna Whistler to James H. and Harriet Gamble, Sept. 9–20, 1875, GUL 06555.

p. 113 "at night the gas lights through its streets": *Correspondence*, Anna Whistler to James H. and Harriet Gamble, Sept. 9–20, 1875, GUL 06555.

p. 113 until Whistler finished his leisurely and noisy bath: Pennell, *Life* [1919], 138.

p. 113 "family Bible": Pennell, *Life* [1919], 134.

p. 113 "He ask me a leetle while ago to breakfarst": Joseph Comyns Carr, 136. Hesketh Pearson identifies this artist as Martini: Pearson, *The Man Whistler*, 65.

p. 113 "ideas on art unfettered by principles": *Correspondence*, Alan Summerly Cole diary, entry for Nov. 16, 1875, GUL 13132.

p. 113 "One met all the best in Society there": Jopling, 228.

p. 114 "Though short and small": Pennell, *Life* [1919], 138.

p. 114 "An almost awful exhibit of nervous power and concentration": Edward Godwin noted this in his diary on July 22, 1877; YMSM, 112.

p. 114 "as original as himself or his work, and equally memorable": Boughton, 215.

p. 114 "Lindsey Row was lined with the carriages": Pennell, *Life* [1919], 132.

p. 114 "not merely the only tradesman who can afford to deal with me": Alice Comyns Carr, 105.

p. 114 "very delicate cocoa colour and gold": *Correspondence*, Alan Summerly Cole diary, entry for Mar. 24, 1877, GUL 13132.

p. 115 "so frantically that it seemed to be raining gold": Menpes, 130.

p. 115 "wave pattern": *Correspondence*, James Whistler to Frederick Leyland, c. Aug. 9, 1876, GUL 08791.

p. 115 "I was up at 6": *Correspondence*, James Whistler to Frances Leyland, Aug. 20/31, 1876, GUL 08054.

p. 115 a critic who had seen the room published a glowing account: *Academy*, Sept. 2, 1876, 249.

p. 116 "I can only repeat what I told you": *Correspondence*, Frederick Leyland to James Whistler, Oct. 21, 1876, GUL 02570.

p. 116 "Put not your trust in Princes": *Correspondence*, Oct. 24/30, 1876, GUL 02573.

p. 116 "Shorn of my shillings": *Correspondence*, Oct. 31, 1876, GUL 02575.

p. 116 "mad with excitement": *Correspondence*, Alan Summerly Cole diary, entry for Nov. 10, 1876, GUL 12986.

p. 116 "I just painted as I went on": Pennell, *Life* [1919], 148.

p. 117 Whistler's "artistic feeling": *Times*, Feb. 15, 1877, 4.

p. 117 available in a bowl on the counter at Liberty & Co.: Merrill, *Peacock Room*, 251.

p. 117 "At the time so many newspaper puffs": *Correspondence*, Frederick Leyland to James Whistler, July 24, 1877, GUL 02593.

p. 117 Whistler dismissing her husband to guests as a *parvenu*: Pennell, *Whistler Journal*, 106.

p. 118 "the meanness of your thus taking advantage": *Correspondence*, Frederick Leyland to James Whistler, July 6, 1877, GUL 02581.

p. 118 "if ever after this intimation": *Correspondence*, Frederick Leyland to James Whistler, July 17, 1877, GUL 02585.

p. 118 "All of this annoyance is the result": *Correspondence*, James Whistler to Arthur Lasenby Liberty, July 1877/June 1878, GUL 02611.

Chapter 5: "Ruskin Wouldn't Go"

p. 119 After directing his clerk to purchase three copies of *Fors Clavigera*: *Correspondence*, James Anderson Rose to James Whistler, Dec. 14, 1878, GUL 08905.

p. 119 That writ went out on August 3 and never reached Ruskin: *Correspondence*, John M. Davenport to James Anderson Rose, Aug. 4, 1877, GUL 12101.

p. 119 a second copy, which reached Ruskin on the 8th: George Gatey to James Anderson Rose, Aug. 9, 1877, GUL 11941.

p. 119 with Ruskin acting as his own counsel: Merrill, *A Pot of Paint*, 62.

p. 120 "I am nearer breaking down myself": Ruskin and Norton, 393–94.

p. 120 His diaries for the next few months: Ruskin, *Brantwood Diary*, 41–43, 45, 47, 53–58.

p. 120 "If that advertising Yankee quack teazes you": E. Burne-Jones, "Autograph letter."

p. 120 "You're a *couple* of darlings": *Works*, 37.225.

p. 121 "the most important course I have ever yet given": Ruskin, *Diaries*, 3.967.

p. 121 "I gave yesterday the twelfth and last of my course of lectures": *Works*, 37.231.

p. 121 "fair and bonâ fide criticism": *Correspondence*, Walker, Martineau and Co. to James Anderson Rose, Dec. 6, 1877, GUL 08906.

p. 121 "the Plaintiff joins issue": *Correspondence*, James Anderson Rose to Walker, Martineau and Co., Dec. 11, 1877, GUL 11915.

p. 121 desperately hoping for a recurrence of his supernatural communion: Hilton, *Later Years*, 366.

p. 122 "Very lifeless compared to this time last year": Ruskin, *Diaries*, 3.970.

p. 122 "I'm horribly sulky this morning": *Works*, 37.236.

p. 122 "in some respects an unrivalled guest": William Gladstone qtd. *Works*, 36.lxxxiii.

p. 122 "I have seldom been more ill without serious illness": Ruskin, *Diaries*, 3.974–75.

p. 122 "His talk at dinner was altogether delightful": Ruskin, *Letters to M. G & H. G.*, 4. The speaker of this comment is anonymous, but is more than likely George Wyndham, who wrote the preface to the book in which it appears.

p. 122 "Morning entirely divine": Ruskin, *Brantwood Diary*, 80.

p. 122 Hill . . . had disparaged Ruskin's ability: *Works*, 26.354.

p. 123 "would injure you": *Works*, 26.359.

p. 123 "the seat of the scornful": *Works*, 26.365n.—a translation of Ruskin's "Cathedra Pestilentiæ."

p. 123 an arguably libelous denunciation of the writer Harriet Martineau: *Works*, 26.361.

p. 123 "Enter ye in": Ruskin, *Brantwood Diary*, 99.

p. 123 "we've got married—after all after all": Leon, 510.

p. 123 "*Good* Friday": Ruskin, *Brantwood Diary*, 100.

p. 124 "I felt convinced that the only way to meet him": H, 226.

p. 124 "utterly gone": Drew, 161.

p. 124 "we gave up all hope": Qtd. Ruskin, *Brantwood Diary*, 65 (unpublished letter to Charles Eliot Norton, Mar. 3, 1878).

p. 124 "long dream": Works, 37.246.

p. 124 "ugly croaking voice": H, 225–26.

p. 124 he tortured her with accusations: Birkenhead, 263–64.

p. 125 "Rosy Posy": Qtd. Birkenhead, 262.

p. 125 "Everything white! Everything black!": Ruskin, *Dearest Mama Talbot*, 77.

p. 125 "I never heard him speak better": Ruskin, *Dearest Mama Talbot*, 93.

p. 125 "I would be well content": *Works*, 37.245.

p. 125 "While my illness at Matlock encouraged me: *Works*, 37.249.

p. 125 "acute mental suffering or misfortune": H, 226.

p. 126 "I went crazy about St. Ursula": Ruskin and Norton, 412.

p. 126 "a *little* Turner work." *Works*, 37.253.

p. 126 "no diminution of charm": William Gladstone qtd. *Works*, 36.lxxv.

p. 126 a young woman whom Ruskin considered a "pet": Qtd. Hilton, *Later Years*, 395.

p. 127 "the greatest master whom the school has yet produced": *Works*, 34.148.

p. 127 "The result of the trial may turn on a small matter": *Correspondence*, James Anderson Rose to James Whistler, June 12, 1878, GUL 05226.

p. 128 "Enclosed another torpedo!": *Correspondence*, James Whistler to James Anderson Rose, Aug. 22/23, 1877, GUL 08982.

p. 128 That autumn a coal dealer named John Johnson: *Correspondence*, Edmund Newman to James Anderson Rose, Oct. 1, 1877, GUL 12196; Oct. 13, 1877, GUL 12201; Nov. 16, 1877, GUL 12210; Nov. 27, 1877, GUL 12211.

p. 128 he threw over two dozen of them: Sutherland, 149.

p. 129 another, smaller one, and a separate etching room: Godwin, 257.

p. 129 "in effect it was to be a simple colour harmony": Godwin, 252.

p. 129 The rent was cheap: Cox, 35.

p. 129 walls "had gone up ten to twelve feet": Cox, 36.

p. 129 "That it was not *Gothic*": Godwin, 253.

p. 130 threatening to sue them: *Correspondence*, James Whistler to the Metropolitan Board of *Works* May 23, 1878, GUL 04060.

p. 130 "triumph of Art and ingenuity": *Correspondence*, James Whistler to George and William Webb, Mar. 1, 1878, GUL 10760.

p. 130 The house had cost over £2,700: Godwin, 261.

p. 130 "I am going to build": *Correspondence*, James Whistler to Stephen Tucker, Sept. 3, 1877, GUL 05865.

p. 130 "I was sitting looking out of the window in Lindsey Row": Pennell, *Whistler Journal*, 59.

p. 131 the two apparently complicit in creating and selling Rossetti forgeries: Angeli, 241.

p. 131 "and there were orders flying about": Pennell, *Whistler Journal*, 60.

p. 131 Corder remembered sitting forty times: Robertson, 190.

p. 131 Howell records paying 100 guineas: Pennell, *Life* [1919], 165.

p. 131 money that turned out to be Whistler's own: Robertson, 190; Pennell, *Life* [1919], 164.

p. 131 Howell, however, botched that deal to serve his own interests: *Correspondence*, Charles Howell to James Whistler, Feb. 27, 1878, GUL 02183; James Whistler to Jonathon [sic] Blott, Mar. 5, 1878, GUL 00309; James Whistler to Jonathon [sic] Blott, Apr. 26, 1878, GUL 09002; James Whistler to Jonathon [sic] Blott, May 31, 1878, GUL 09255. Although the details are sketchy, it seems that Whistler satisfied Blott with the security of another painting, and eventually paid off his debt—possibly by painting Blott's portrait years later. The identity of "Blott"—never given a first name in any record connected with Whistler—is a bit of a mystery, and the editors of Whistler's correspondence propose two candidates: Jonathon (or Jonathan) Blott, a Bethnal Green colorman, or Eugène Blott, for whom I have found no evidence of existing in London at the time at all. A much more likely candidate for this Blott, I suggest, would be Walter Blott, a wealthy builder, fellow of the Royal Historical Society, and art collector who lived in South Norwood—exactly where Whistler in a letter to Blott states he lives: *Correspondence*, James Whistler to Eugène [sic] Blott, Mar. 1881/1883, GUL 11162.

p. 132 Howell made sounder arrangements with Jane and Urban Noseda: Pennell, *Life* [1919], 164; *Correspondence*, James Anderson Rose to Urban Noseda and Matthew Elden, Nov. 22, 1878, GUL 13738; Merrill, *Pot of Paint*, 127: but Merrill there incorrectly claims that the Nosedas had four (rather than two) of the Grosvenor paintings in their possession.

p. 132 a product that, according to Howell, delighted Whistler: Pennell, *Life* [1919], 165.

p. 132 "And then . . . he sat to Millais!": Pennell, *Life* [1919], 165.

p. 132 "Go away, go away, little man": Robertson, 198.

p. 132 "lent ten pounds to Whistler": Pennell, *Whistler Journal*, 69.

p. 133 "I walked home, damn him": Pennell, *Whistler Journal*, 69.

p. 133 "ten pounds and a sealskin coat.": Pennell, *Life* [1919], 145. That ten-pound painting now hangs in New York's Metropolitan Museum of Art. The fate of the sealskin coat is unknown.

p. 134 "I was rather surprised to find": Crane, 199.

p. 134 "that the libel case": Crane, 199.

p. 134 "Ruskin wouldn't go": Severn, 114.

p. 134 Dr. Parsons had once again declared Ruskin unfit to appear at trial:
 Correspondence, Walker, Martineau and Co. to James Anderson Rose, Nov. 9,
 1878, GUL 12097. Parsons traveled from Coniston to London to make the
 declaration. *Works*, 25.xl.

p. 135 Ruskin had ordered his lawyers to proceed without him: *Correspondence*, James
 Anderson Rose to James Whistler, Dec. 14, 1878, GUL 08905.

p. 135 "the public would at once recognize the coxcombry of a composer": *Works*, 29.586.

p. 135 "It is a critic's first duty": *Works*, 29.587.

p. 136 "I should like you to express": Qtd. Birkenhead, 374.

p. 136 "it would . . . be hopeless": Qtd. *Works*, 29.xxiii n.

p. 136 "the alleged libel is privileged": *Correspondence*, Walker, Martineau and Co. to James
 Anderson Rose, Dec. 6, 1877, GUL 08906.

p. 136 "The point and matter seems to me to be this": Qtd. Merrill, *Pot of Paint*, 295–97.

p. 137 *filets de sole, côtelettes purée d'or*: *Correspondence*, Nov. 23, 1878, GUL 10617.

p. 138 Among these paintings were the *Carlyle* and the *Mother*: Though many accounts of the
 trial make clear that Whistler exhibited the *Carlyle* for the jury, not one mentions that
 he exhibited the *Mother* as well. But Algernon Graves, whose company was holding the
 Mother, made clear in a letter he wrote to Whistler immediately after the trial that both
 of those paintings were a part of the collection (*Correspondence*, Algernon Graves to
 James Whistler, Nov. 26, 1878, GUL 01798).

p. 138 he was flabbergasted: Parry, 167–68.

p. 138 his special guest: Gilbert, Nov. 24, 1878.

p. 139 "Moore my dear brother professor": *Correspondence*, James Whistler to Albert Joseph
 Moore, Nov. 22 [sic], 1878, GUL 04167. Evidence within this letter suggests that
 Whistler actually wrote it one or two days before the 22nd.

p. 139 As breakfast broke up and the Gilberts departed, Whistler's lawyers returned: Gilbert,
 Nov. 24, 1878.

p. 139 "an army of volunteers": *Correspondence*, James Whistler to Albert Moore, Nov. 22,
 1878, GUL 04167.

p. 139 "as many witnesses as possible": *Correspondence*, William Comer Petheram to James
 Anderson Rose, Nov. 22, 1878, GUL 12002.

p. 139 "my art is quite apart": *Correspondence*, James Whistler to James Anderson Rose,
 Nov. 20, 1878, GUL 05230.

p. 140 Earlier that month Whistler had written an effusive letter: *Correspondence*, James
 Whistler to George Washington Curtis Lee, Oct. 26/Nov. 1878, GUL 02504. The
 commission was not awarded for another nine years, and then not Boehm but the
 French sculptor Jean Antoine Mercié got it.

p. 140 he quickly made it clear to Whistler that he had no desire to testify: *Correspondence*,
 James Anderson Rose to James Whistler, Dec. 14, 1878, GUL 08905.

p. 140 "My poor Tissot": *Correspondence*, James Whistler to James Jacques Tissot, Nov. 26,
 1878, GUL 05843.

p. 140 "he would freely have given all his dramatic laurels": Wills, 75.

p. 141 "Ruskin is an old and valued friend": *Correspondence*, William Michael Rossetti
 to James Anderson Rose, Nov. 22, 1878, GUL 08786. The editors of the
 Correspondence speculate that "that picture" to which Rossetti refers is *Nocturne:*

Grey and Gold—Westminster Bridge. Much more likely, it refers to the principal bone of contention at the trial, *Nocturne in Black and Gold: The Falling Rocket.*

p. 141 a little-known artist and a friend of Whistler's named Matthew Elden: Pennell, *Life* [1919], 225.

p. 141 "Yes . . . had you been a witness": Pennell, *Whistler Journal*, 63. Rose actually did attempt to serve Howell with a subpoena—but when the server brought it to Howell's home, Howell was nowhere to be found [*Correspondence*, James Anderson Rose to James Whistler, Dec. 14, 1878, GUL 08905].

p. 141 "a disinclination to appear and give evidence against an artist, however bad": Qtd. Merrill, *Pot of Paint*, 100, from the defense brief.

p. 141 The painter Henry Stacy Marks: *Correspondence*, James Whistler to Albert Joseph Moore, Nov. 22, 1878, GUL 04167.

p. 142 "hundreds of us are eager to do something": Qtd. Ruskin, *Brantwood Diary*, 423.

p. 142 "I knew Whistler and admired his work": Severn, 114–15.

p. 142 Ruskin asked him whether he knew the artist William Powell Frith: Birkenhead, 275.

p. 142 Frith, however, loathed courtroom appearances: Panton, 328; *Morning Post*, Nov. 27, 1878, 3.

p. 142 "entire absence of details": *Times*, May 1, 1877, 10.

p. 143 He had arranged for the finest room of the St. Stephen's Club: *Correspondence*, James Whistler to James Anderson Rose, Nov. 15/22, 1878(?) [Nov. 22], GUL 08777. Whistler does not actually name the club, but makes clear that it is the one to which his junior counsel, William Petheram, belongs. *The Indian Biographical Dictionary* (Rao, 325) lists that club as St. Stephen's.

p. 143 "Certainly not!": *Correspondence*, James Whistler to James Anderson Rose, Nov. 10, 1878, GUL 0875.

p. 143 Whistler refused: *Correspondence*, James Anderson Rose to James Whistler, Dec. 14, 1878, GUL 08905.

p. 144 packed in the van of Whistler's frame makers Foord and Dickinson: *Correspondence*, Foord and Dickinson to James Whistler, Aug. 1878/1879 [likely Aug. 1879], GUL 08944.

p. 144 And from Herne Hill across the river came Arthur Severn: Severn, 115.

p. 145 Having been up most of the night scrutinizing Ruskin's works: *Correspondence*, James Anderson Rose to James Whistler, Dec. 14, 1878, GUL 08905.

p. 145 "I keep fairly well": Ruskin and Norton, 417–18. The letter is dated November 26—the second day of the trial.

Chapter 6: *Whistler v. Ruskin*

A note on the sources for *Whistler v. Ruskin*: No official or complete record of *Whistler v. Ruskin* exists. But innumerable unofficial and incomplete ones do, as newspapers across the country did their best to provide their readers with some idea of what transpired in the Court of Exchequer on November 25 and 26, 1878. Reporters for a number of major daily and weekly newspapers took their place in the crowded gallery, recorded witness testimony, lawyer's speeches, and judge's instructions and rulings—and delivered accounts of the proceedings of varying accuracy and comprehensiveness. Their accounts were picked up and repeated by newspapers across the country, almost always less accurately and less completely. Besides these many public versions of the trial, a single non-public one exists: a record of witness testimony recorded on the first day of the trial apparently by a clerk to James Anderson Rose, James Whistler's solicitor. It is from a thorough comparison of the several primary accounts that I have attempted to reconstruct as complete and as accurate an account of *Whistler v. Ruskin* as possible. It was a process, of course, that involved a continuous exercise

of personal judgment to choose the most logical, the most coherent, and at times the most mellifluous variant from several alternatives. Quite often, the choice was clear. When it was less so, I have done my best in the notes to the chapter to note significant variants. For clarity, I have provided quotation marks to differentiate speakers, something not usually provided in the original sources.

For a full, reconstructed transcript of *Whistler v. Ruskin*, following generally the method that I have used here, though not always with the same textual choices, see Linda Merrill's *A Pot of Paint*, 133–97.

p. 146 "the last of the Barons": Rigg. The creation of Barons of the Exchequer was suspended in when with the passing of the Judicature Act of 1875 the independent Court of Exchequer became the Exchequer Division of the High Court of Justice.

p. 146 he had markedly improved his standing in society and politics: Rigg.

p. 146 he had gained a reputation as a "strong" judge: *Times*, Dec. 6, 1890, 9.

p. 146 he had a morbid antipathy to drafts: *St. James's Gazette*, Jan. 21, 1885, 4–5; *Pall Mall Gazette*, Jan. 23, 1885, 3; *Times*, Dec. 6, 1890, 9; *The Green Bag* [Boston], Mar. 1893, 106–107.

p. 146 The report that he also had every keyhole plugged: *Pall Mall Gazette*, Jan. 9, 1913, 10.

p. 146 the onset of his chronic illness still a year away: *Times*, Dec. 6, 1890, 9.

p. 147 "cloudy and showery": *London Evening Standard*, Nov. 26, 1878, 7.

p. 147 "gloomy, dull and foggy": *London Evening Standard*, Nov. 27, 1878, 6.

p. 147 a task, Severn admitted, for which he was hardly qualified: Severn, 115.

p. 147 Special juries were commonly employed: Oldham, 151.

p. 147 not particularly distinguished for his knowledge of the law: *London Evening Standard*, Jan. 12, 1880, 3; *London Daily News*, Jan. 12, 1880, 5.

p. 148 "as a winner of verdicts in cases": *London Daily News*, Jan. 12, 1880, 5.

p. 148 "Sleepy Jack Holker": Hamilton, 133.

p. 148 "To lay a plain case before a jury": *Daily Telegraph* May 25, 1882, 5.

p. 148 "a Gentleman": *Correspondence*, James Anderson Rose to James Whistler, Nov. 30, 1878, GUL 05233.

p. 148 He would in time become chief justice of Bengal: *Times*, May 19, 1922, 13.

p. 148 his obsession with assiduous preparation: Lentin.

p. 148 "cases," he once said, "are won at chambers": Cunningham, 135.

p. 149 "I am *known* and *always have been known*": *Correspondence*, James Whistler to James Anderson Rose, Nov. 20, 1878, GUL 05230.

p. 150 "He occupied a somewhat independent position in art": *Times*, Nov. 26, 1878, 9. The varying accounts in the newspapers of Parry's words here invariably have him stating "almost" rather than the far more likely "[utmost]."

p. 150 "injurious and hurtful": *Morning Post*, Nov. 26, 1879, 3.

p. 150 the "impossible" conditions of the courtroom: *Leeds Mercury*, Nov. 26, 1878, 6.

p. 150 Baron Huddleston thought it "exceedingly desirable": *Morning Post*, Nov. 26, 1879, 3.

p. 150 the seven Grosvenor paintings that "Mr. Ruskin had in his mind": *Morning Post*, Nov. 26, 1878, 3.

p. 150 "We don't know what Mr. Ruskin had in his mind": *Leeds Mercury*, Nov. 26, 1878, 6.

p. 151 "independent work": *Morning Post*, Nov. 26, 1879, 3.

p. 151 "Will you tell us the meaning of that word 'nocturne'": *Daily Telegraph*, Nov. 26, 1878, 2.

p. 152 "I was bound to do the best I could for my client": Armstrong, 209.

p. 153 "You have sent pictures to the Academy which have not been received": *Morning Post*, Nov. 26, 1878, 3.

p. 153 "What is the subject of the *Nocturne in Black and Gold?*": *Morning Post*, Nov. 26, 1878, 3.

p. 154 "You know that Mr. Ruskin's view": *Morning Post*, Nov. 26, 1878, 3.

p. 154 "Why do you call Mr. Irving an *Arrangement in Black?*": *London Daily News*, Nov. 26, 1878, 2.

p. 154 "I suppose you are willing to admit": *Morning Post*, Nov. 26, 1878, 3.

p. 154 "Did it take you much time to paint the *Nocturne in Black and Gold?*": *Morning Post*, Nov. 26, 1878, 3.

p. 155 "I beg your pardon—": *Leeds Mercury*, Nov. 26, 1878, 6.

p. 155 "one day to do the work, and another to finish it": *Morning Post*, Nov. 26, 1878, 3.

p. 155 "And that was the labour for which you asked 200 guineas?": *Morning Post*, Nov. 26, 1878, 3.

p. 155 "You know that many critics entirely disagree": Morning Post, Nov. 26, 1878, 3.

p. 156 "it would be scarcely fair": *Morning Post*, Nov. 26, 1878, 3.

p. 156 "inasmuch as the plaintiff's character was attacked": *Morning Post*, Nov. 26, 1878, 3.

p. 156 And the jury made clear their perfect willingness: *Leeds Mercury*, Nov. 26, 1878, 6.

p. 156 Holker got his way: Armstrong, 209.

p. 156 "Once," remembered Arthur Severn: Severn, 115–16.

p. 157 "When the nocturne was brought in": Horner, 56–57.

p. 157 "Your lordship is too close at present": *Morning Post*, Nov. 26, 1878, 3.

p. 157 "Do you say that this is a correct representation": *Echo*, Nov. 25, 1878, 3.

p. 157 "I did not intend to paint a portrait of the bridge": *Leeds Mercury*, Nov. 26, 1878, 6.

p. 157 "Are those figures on the top of the bridge intended for people?": *Morning Post*, Nov. 26, 1878, 3.

p. 158 "I completed the work": *Morning Post*, Nov. 26, 1878, 3.

p. 158 "All the hand work is done rapidly": *Leeds Mercury*, Nov. 26, 1878, 6.

p. 158 flanked by officers of the court: *Leeds Mercury*, Nov. 26, 1878, 6.

p. 158 "This is Cremorne?": *Morning Post*, Nov. 26, 1878, 3.

p. 158 "I dare say I could make it clear": *Leeds Mercury*, Nov. 26, 1878, 6. The *Morning Post* transcription here largely misses the wit: "It would be impossible for me to explain to you, I am afraid, although I dare say I could to a sympathetic ear" (Nov. 26, 1878, 3).

p. 158 "You offer that picture to the public as one of particular beauty": *Morning Post*, Nov. 26, 1878, 3.

p. 159 "a rather strong experiment upon public submissiveness": W. Rossetti, "Grosvenor Gallery (Second Notice)" 467.

p. 159 "You have seen the *Nocturne in Black and Gold* before?": *Morning Post*, Nov. 26, 1878, 3.

p. 160 "artistic and beautiful representation": *London Daily News*, Nov. 26, 1878, 2.

p. 160 "I think it a very fine portrait": *Leeds Mercury*, Nov. 26, 1878, 6.

p. 160 "What is your judgment of the works in the Grosvenor Gallery": *Morning Post*, Nov. 26, 1878, 3.

p. 161 "What is the peculiar beauty of the *Nocturne in Black and Gold*": *Morning Post*, Nov. 26, 1878, 3.

p. 162 "I think it is the full value of the picture": *Morning Post*, Nov. 26, 1878, 3.

p. 162 "I have often seen fireworks represented before in pictures": *Morning Post*, Nov. 26, 1878, 3.

p. 162 "The picture produced": *Morning Post*, Nov. 26, 1878, 3.

p. 162 "I wish I could paint as well": *Correspondence*, anonymous clerk of the High Court of Justice to James Anderson Rose, Nov. 25, 1878, GUL 11991.

p. 162 "if I were rich I would buy them myself": *Morning Post*, Nov. 26, 1878, 3.

p. 162 "Regarding Mr. Whistler's position": *Leeds Mercury*, Nov. 26, 1878, 6.
p. 163 "the practice of art as he follows it": *Morning Post*, Nov. 26, 1878, 3.
p. 163 it was that of the great Velázquez: *Leeds Mercury*, Nov. 26, 1878, 6.
p. 163 "I should call it originality": *Morning Post*, Nov. 26, 1878, 3.
p. 163 "great consideration and knowledge": *Morning Post*, Nov. 26, 1878, 3.
p. 163 "I have never seen the *Nocturne in Black and Gold* before": *Morning Post*, Nov. 26, 1878, 3.
p. 163 "Surely this is a question for the jury": *Morning Post*, Nov. 26, 1878, 3.
p. 164 "to spare the court the examination": *Morning Post*, Nov. 26, 1878, 3.
p. 164 "The real question": *London Evening Standard*, Nov. 26, 1878, 2.
p. 164 "[I] should like to know": *Morning Post*, Nov. 26, 1878, 3.
p. 164 "something more than a few flashes of genius.": *Leeds Mercury*, Nov. 26, 1878, 6.
p. 164 "A picture to which a high price is demanded": *Leeds Mercury*, Nov. 26, 1878, 6.
p. 165 "meagre and worthless affair": *Leeds Mercury*, Nov. 26, 1878, 6.
p. 165 "Mahomet's coffin or Jacob's ladder": *Leeds Mercury*, Nov. 26, 1878, 6.
p. 165 the courtroom "was becoming a nocturne": *Leeds Mercury*, Nov. 26, 1878, 6.
p. 165 sitting beside him . . . was his wife, Lady Diana Huddleston: *Illustrated London News*, Nov. 30, 1878, 510.
p. 165 "an artistic chop served in a plate of ancient pattern": *Daily Telegraph*, Nov. 27, 1878, 2.
p. 166 "They would, of course, have some difficulty in getting near them": *Daily Telegraph*, Nov. 27, 1878, 2.
p. 166 "they would ask, 'What is it?'": *Daily Telegraph*, Nov. 27, 1878, 2.
p. 166 "Mr. Whistler did not see things which other people saw": *London Evening Standard*, Nov. 27, 1878, 2.
p. 167 Holker admitted Whistler capable of "exceedingly good things": *Daily Telegraph*, Nov. 27, 1878, 2.
p. 167 "had looked the word up": *London Evening Standard*, Nov. 27, 1878, 2.
p. 167 "If Mr. Whistler's reputation as an artist": *London Evening Standard*, Nov. 27, 1878, 2.
p. 167 "satirical and amusing": *Pall Mall Gazette*, Nov. 26, 1878, 7.
p. 167 "Mr. Ruskin would cease to write": *London Daily News*, Nov. 27, 1878, 2.
p. 168 he left the Exchequer Chamber for another courtroom and another case: the *Morning Post*, Nov. 27, 1878, 7, notes that on the final day of *Whistler* v. *Ruskin* Holker served as senior counsel in the case of *The Emma Mine Company* v. *Lewis and Son*. The fact that he never appears again in any transcript of this case after completing his opening suggests he left *Whistler* v. *Ruskin* for that trial at this point. The *Daily Telegraph* (Nov. 27, 1878, 2) notes that his junior, Charles Bowen, summed up for the defense "in the absence of the Attorney-General."
p. 168 "Tuesday the Horrible-th": Qtd. Ruskin, *Brantwood Diary*, 424.
p. 168 "moved earth and hell": E. Burne-Jones, *Burne-Jones Talking*, 70n.
p. 168 "carried me metaphorically in his arms to the door of the court": Qtd. Ruskin, *Brantwood Diary*, 426.
p. 168 "wigs and sterile faces": Ruskin, *Brantwood Diary*, 426.
p. 168 He was mortified to see friends: Horner, 57; Ruskin, *Brantwood Diary*, 424.
p. 168 he had begged Ruskin's lawyers to restrict their questioning: Ruskin, *Brantwood Diary*, 426.
p. 168 "In your opinion what part do finish": *Morning Post*, Nov. 27, 1878, 3.
p. 169 "masterly in some respects": *Leeds Mercury* Nov. 27, 1878, 3.
p. 169 "I don't think it has the merit": *Morning Post*, Nov. 27, 1878, 3.

p. 169 "going a little too far": *Globe*, Nov. 27, 1878, 5.

p. 169 an "undoubted" Titian rubbed down to reveal a full-length portrait of George III: *Morning Post*, Nov. 27, 1878, 3.

p. 169 "I believe it is a real Titian": *Daily Telegraph*, Nov. 27, 1878, 2.

p. 170 "Mr. Whistler gave great promise at first": *London Evening Standard*, Nov. 27, 1878, 2.

p. 170 "a mere accident of the sale room": *Morning Post*, Nov. 27, 1878, 7.

p. 170 "You would not call a man a wilful imposter": *Morning Post*, Nov. 27, 1878, 7.

p. 170 "They wouldn't ask me the questions": Ruskin, *Brantwood Diary*, 424.

p. 170 "You have seen the pictures of Mr. Whistler": *Morning Post*, Nov. 27, 1878, 7.

p. 171 filled with the "commonplace of vulgarity and crime": *Correspondence*, James Anderson Rose to John Humffreys Parry, Nov. 1878(?), GUL 12040.

p. 171 "We know that Turner is an idol of Mr. Ruskin?": *Morning Post*, Nov. 27, 1878, 7.

p. 172 "Are you aware that it has been described by a critic": *Daily Telegraph*, Nov. 27, 1878, 2.

p. 172 "Lobster salad": *Daily Telegraph*, Nov. 27, 1878, 2.

p. 172 "only come one step nearer pictures": *Times*, Dec. 2 1875, 4.

p. 172 "materialized spirits and figures in a London fog": Taylor, "The Grosvenor Gallery" 10.

p. 172 "was rarely very successful with juries": Cunningham, 135–36.

p. 173 "both sides had wandered from the field": *London Daily News*, Nov. 27, 1878, 2.

p. 173 "was clear and sharp": *Morning Post*, Nov. 27, 1878, 7.

p. 174 "not a scintilla": *London Daily News*, Nov. 27, 1878, 2.

p. 174 "given an additional sting": *Globe*, Nov. 27, 1878, 5.

p. 174 "When the honorable and learned gentleman": *Morning Post*, Nov. 27, 1878, 7.

p. 174 "Sitting on the throne of art": *Globe*, Nov. 27, 1878, 5.

p. 174 "crush and ruin": *Morning Post*, Nov. 27, 1878, 7.

p. 175 "something dirty and disagreeable": *Daily Telegraph*, Nov. 27, 1878, 2.

p. 175 "conscientious, hard-working, and industrious": *London Evening Standard*, Nov. 27, 1878, 2.

p. 175 "Was he to be expelled from the realm of art": London Evening Standard, Nov. 27, 1878, 2.

p. 175 "Mr. Serjeant Parry put the case for Mr. Whistler": *Spectator*, Nov. 30, 1878, 1486.

p. 176 "they would have expressed their decided disapproval": *Daily Chronicle*, Nov. 27, 1878, 7.

p. 176 "after the evidence of Mr. Burne-Jones": *Daily Telegraph*, Nov. 27, 1878, 2.

p. 176 "No one would entertain a doubt": *Morning Post*, Nov. 27, 1878, 7.

p. 176 It was of the "last importance": *Morning Post*, Nov. 27, 1878, 7.

p. 176 "reflections of a personal character": *Daily Telegraph*, Nov. 27, 1878, 2.

p. 177 "nobody ever had equaled": *Morning Post*, Nov. 27, 1878, 7.

p. 177 "whether Mr. Ruskin's criticism": *Daily Telegraph*, Nov. 27, 1878, 2. In some transcriptions of the trial, Huddleston's language is more consistent than in others; in the *Morning Post* and the *London Evening Standard*, for example, he is reported to stick largely to the same phrase in defining the jury's duty: "fair and *bonâ fide*." In others (such as the *Daily Telegraph*), he is reported to juggle the three terms "fair," "honest," and "*bonâ fide*" much more indiscriminately. In every transcript, however, Huddleston does employ all three terms—and never sets out specific differences in their meanings.

p. 177 "Mr. Ruskin undoubtedly called a spade a spade": *Daily Telegraph*, Nov. 27, 1878, 7.

p. 177 "gross character": *Morning Post*, Nov. 27, 1878, 7.

p. 178 "honest, fair, and *bonâ fide*": *Globe*, Nov. 27, 1878, 5.

p. 178 "The jury had agreed": *Morning Post*, Nov. 27, 1878, 7.

p. 178 Whistler's solicitor Rose among them: *Correspondence*, James Anderson Rose to James Whistler, 30, GUL 05232.

p. 178 "the question for them": *Morning Post*, Nov. 27, 1878, 7.

p. 179 "look at the words": *Morning Post*, Nov. 27, 1878, 7.

p. 179 "The way the case is put by some jurors": *Morning Post*, Nov. 27, 1878, 7.

p. 180 "That's a verdict for me, is it not?": G. Smalley, "Whistler: A Tribute."

Chapter 7: The Show

p. 181 Coniston's snows: according to Sheila Birkenhead, Walter Severn arrived in Coniston in a snowstorm; Birkenhead, 275.

p. 181 "Oh, horrid thing!": Severn, 115.

p. 181 "yes—he said *humble* & he said *industrious*": Qtd. Ruskin, *Brantwood Diary*, 425.

p. 182 "The result of the Whistler trial": *Works*, 29.xxv.

p. 182 "It is much better that the resignation of the office": *Works*, 29.xxv.

p. 183 "I can't be Professor any more": *Works*, 25.xl.

p. 183 "I will knock off the fourth *Fésole*": *Works*, 37.268.

p. 183 "Though I think I can draw": unpublished letter from Ruskin to Rawdon Brown, Jan. 16, 1879, qtd. Ruskin, *Brantwood Diary*, 139.

p. 183 "Comic enough, the whole trial, the public may think": *Works*, 37.268.

p. 184 Dante Gabriel Rossetti around this time estimated it at £800: W. Rossetti and Morris, 104.

p. 184 "I suppose you know that people aren't going to let you have one penny to pay": Qtd Ruskin, *Brantwood Diary*, 425.

p. 184 "Mr. Ruskin's Costs": *Pall Mall Gazette*, Nov. 29, 1878, 14.

p. 184 Within two weeks . . . donations reached £150: *Athenæum*, Dec. 14, 1878, 1; Pennell, *Life* [1919], 180.

p. 184 Five months later, Huish sent Ruskin news: Ruskin, *Brantwood Diary*, 462.

p. 184 "I am grateful to them": *Works*, 30.96.

p. 185 "Well, Saint-Gaudens": Saint-Gaudens, 2:180.

p. 185 "Nothing could have been finer": *Correspondence*, James Whistler to James Anderson Rose, Nov. 30, 1878, GUL 08750.

p. 185 In 1890 the American poet Harriet Monroe witnessed the "historic farthing": Monroe, 105. Although Whistler's friends and first biographers Elizabeth and Joseph Pennell—who had first met Whistler long after this time—state that "we never saw [the farthing], we never knew him to wear a watch-chain" (Pennell, *Life* [1919], 178), many others recalled seeing both.

p. 186 "to find my table strewn": *Correspondence*, James Whistler to James Anderson Rose, Nov. 30, 1878, GUL 08750. Evidence suggests that Whistler wrote this letter not on November 30, but on the 29th.

p. 186 "very grieved at the very insignificant sum": *Correspondence*, Algernon Graves to James Whistler, Nov. 26, 1878, GUL 01798.

p. 186 "we are annoyed at the result of your action": *Correspondence*, Elisabeth Lewis to James Whistler, Nov. 26, 1878, GUL 02519.

p. 186 "what can you expect": *Correspondence*, George Washburn Smalley to James Whistler, Nov. 27, 1878, GUL 05460.

p. 186 Joseph Comyns Carr proposed to contribute his "mite": *Correspondence*, Joseph Comyns Carr to James Whistler, Nov. 26, 1878, GUL 08747.

p. 186 "as a mark of sympathy with you": *Correspondence*, John Postle Heseltine to James Whistler, Nov. 29, 1878, GUL 08920.

p. 186 "wholly incomprehensible if it had not come from a British jury": *British Architect*, Nov. 29, 1878, 207.

p. 186 "if [Whistler] had obtained the damages he asked for": *Art Journal*, Jan. 1849, 18.

p. 187 "something very like a drawn battle": *London Evening Standard*, Nov. 27, 1878, 5.

p. 187 a "censure on both": *Times*, Nov. 28, 1878, 9.

p. 187 "a periodical which only six people in all the universe are allowed to see": *Referee*, Dec. 1, 1878. Humorist George Robert Sims is the author here.

p. 187 "Mr. Whistler is clever and original": *Spectator*, Nov. 30, 1878, 1487.

p. 187 "We do not remember": *Saturday Review*, Nov. 30, 1878, 687.

p. 187 "a singular and most regrettable exhibition": James, *Views and Reviews*, 208.

p. 187 "kept dinner-tables supplied with animated conversation": *Chicago Daily Tribune*, Jan. 1, 1879, 13.

p. 188 "The Law allows it": *Punch*, Dec. 7, 1878, 254.

p. 188 "in what must be a most trying and irritating time": *Correspondence*, Edward Linley Sambourne to James Whistler, Dec. 1, 1878, GUL 05367.

p. 188 "If Punch in person": *Correspondence*, James Whistler to Edward Linley Sambourne, Dec. 3, 1878, GUL 08123.

p. 189 "The question at issue": *Correspondence*, James Whistler to James Anderson Rose, Nov. 30, 1878, GUL 08750.

p. 189 "To have said that Mr. Ruskin's pose among intelligent men": Whistler, *Whistler v. Ruskin*, 6.

p. 189 "Now about the war—": *Correspondence*, James Whistler to James Anderson Rose, Nov. 30, 1878, GUL 08750.

p. 190 The witnesses for Whistler . . . were "first rate." *Correspondence*, James Anderson Rose to James Whistler, Nov. 30, 1878, GUL 05233.

p. 190 "This of course," Rose cautioned him, "you must be wise enough to keep to yourself.": *Correspondence*, James Anderson Rose to James Whistler, Nov. 30, 1878, GUL 05232.

p. 190 When Rose brought to Whistler's attention: *Correspondence*, James Anderson Rose to James Whistler, Nov. 29, 1878, GUL 05231.

p. 190 "quite in keeping with our dignity": *Correspondence*, James Whistler to James Anderson Rose, Nov. 30, 1878, GUL 08750.

p. 190 A subscription was duly established at the London offices of the French journal *L'Art*, where Comyns Carr was editor: Esposito.

p. 190 "between the brush and the pen": Whistler, *Whistler v. Ruskin*, 5.

p. 190 he filled draft pages with *mots*: *Correspondence*, James Whistler to none, Dec. 1878, GUL 06768.

p. 191 "Mr. Whistler writes in an off-hand, colloquial style": James, *Views and Reviews*, 211.

p. 191 a "most rattling" twelve-page article: *Correspondence*, James Whistler to James Anderson Rose, Dec. 18, 1878, GUL 08753. That this article actually was *Whistler v. Ruskin: Art and Art Critics* can be deduced from an observation in the *Chicago Daily Tribune* on New Year's Day, 1879, page 13: "Mr. Whistler is shortly to contribute a paper on art and art-criticism to the *Nineteenth Century*."

p. 191 "a life passed among pictures makes not a painter": Whistler, *Whistler v. Ruskin*, 7.

p. 191 "The Observatory at Greenwich": Whistler, *Whistler v. Ruskin*, 15–16.

p. 191 "Poor Art!": Whistler, *Whistler v. Ruskin*, 10.

p. 191 "Let there be no critics!": Whistler, *Whistler v. Ruskin*, 12.

p. 192 "quite alone stands Ruskin": Whistler, *Whistler v. Ruskin*, 16.

p. 192 "Tough old Tom": Whistler, *Whistler v. Ruskin*, 13.

p. 192 "slovenly in execution": Whistler, *Whistler v. Ruskin*, 13.

p. 192 The first printing of *Whistler versus Ruskin* . . . sold out in three days: *Correspondence*,
 Chatto & Windus to James Whistler, Jan. 29, 1879, GUL 11808.

p. 192 "His facts are hazy": *Art Journal*, 41 (1879), 227.

p. 192 "the excess of bad taste": *Examiner*, Jan. 11, 1879, 28.

p. 192 Whistler's attack "overshoots the mark": *British Architect*, Jan. 10, 1879, 13.

p. 193 "We presume that this is its author's first literary production": *The Academy*, Jan. 25,
 1879, 25. This review is anonymous. But William Michael Rossetti, the previous art
 critic at *The Academy*, wrote to Whistler to disassociate himself from this review—and
 to hint strongly that Comyns Carr was its author. *Correspondence*, William Michael
 Rossetti to James Whistler, Jan. 27, 1879, GUL 05248.

p. 193 "Let work, then, be received in silence": Whistler, *Whistler v. Ruskin*, 12.

p. 193 "My Own Article on Whistler": *Works*, 29.585–87.

p. 193 "sans rancune": Whistler, *Gentle Art*, 35.

p. 194 "Dead for a ducat, dead!": Whistler, *Gentle Art*, 37.

p. 194 "Pardon me, my dear Whistler": Whistler, *Gentle Art*, 38.

p. 194 "Why, my dear old Tom": Whistler, *Gentle Art*, 39.

p. 194 Rose had sent Whistler his bill for £261 that December: *Correspondence*, James
 Anderson Rose to James Whistler, Dec. 14, 1878, GUL 08905.

p. 194 Those others, by 1879, had become a multitude: *Correspondence*, London Bankruptcy
 Court to James Anderson Rose, May 7, 1879, GUL 11711.

p. 194 Whistler's largest creditor: The Winans were actually Whistler's largest *unsecured*
 creditors; the North London Permanent Building and Investment Society were the
 largest creditors with security, holding a £1,500 mortgage upon the White House.
 Correspondence, London Bankruptcy Court to James Anderson Rose, May 7, 1879,
 GUL 11711.

p. 194 "shocking," "awfully hot," and in a "strangled state": *Correspondence*, James Whistler
 to Charles Augustus Howell, Dec. 23, 1878, GUL 02816; James Whistler to Walter
 Théodore Watts-Dunton, Dec. 5, 1878, GUL 07386; James Whistler to Lucas Ionides,
 Dec. 5, 1878, GUL 02366.

p. 195 Louis Herrman, a dealer in classical art: *Post Office London Directory for 1882*, Part 3,
 1782.

p. 195 "really we must have *some* pounds for Herrman": *Correspondence*, James Whistler to
 Charles Augustus Howell, May 24, 1878, GUL 02778.

p. 195 "A note from Herrman": *Correspondence*, James Whistler to Charles Augustus Howell,
 June 19, 1878, GUL 02781.

p. 195 "Herrman is hot!": *Correspondence*, James Whistler to Charles Augustus Howell,
 Aug. 15, 1878, GUL 02782.

p. 195 "What *am* I to do about Herrman?": *Correspondence*, James Whistler to Charles
 Augustus Howell, Dec. 31, 1878, GUL 02834.

p. 195 Nightingale obtained the legal right to recover his £450: *Correspondence*, George
 Francis to John Mackrell, Nov. 25, 1878, GUL 12028.

p. 195 the furnisher of Whistler's piano, Frederick Oetzmann, successfully sued for £23:
 Correspondence, Dod and Longstaffe to James Whistler, Nov. 1, 1878, GUL 12025;
 Charles Henry Walton to Frederick Oetzmann & Son, Dec. 2, 1878, GUL 12019.

p. 195 one day after that one of Whistler's picture framers, George Tacchi, did the same
 for £26: *Correspondence*, Samuel Price to Theodore Allingham, Nov. 28, 1878, GUL
 12045; Joseph Kaye to Samuel Price, Dec. 3, 1878, GUL 12041.

p. 195 "Your servants seem to be extremely attentive": William Michael Rossetti, *Some Reminiscences*, 2:319.

p. 196 "Do get me out of this mess": *Correspondence*, James Whistler to James Anderson Rose, Dec. 6, 1878, GUL 08751.

p. 196 "We must be careful now": *British Architect and Northern Engineer*, Dec. 13, 1878, 232.

p. 196 "I trust myself also soon to bring you gold": *Correspondence*, James Whistler to James Lasenby Liberty, Nov. 26/31, 1878, GUL 02613.

p. 196 Rose negotiated paying back Nightingale's £450 in two installments: *Correspondence*, John Mackrell & Co to James Anderson Rose, Dec. 19, 1878, GUL 12014.

p. 196 Howell would, in the end, only pay the first: *Correspondence*, Charles Augustus Howell to Benjamin Nightingale, Jan. 27, 1879, GUL 13216.

p. 196 a ruse concocted with George Lucas: Mahey, 253–54.

p. 197 February 23, 1879, the day Maud gave birth to a daughter: M. MacDonald, "Maud Franklin," 23.

p. 197 "It is *all important*": *Correspondence*, James Whistler to James Anderson Rose, Jan. 15, 1879, GUL 08756; Richard Wright to James Anderson Rose, Jan. 15, 1879, GUL 08876.

p. 197 Whistler actually did complete one painting at this time: *Correspondence*, James Whistler to James Anderson Rose, Jan. 19, 1879, GUL 08757.

p. 197 Whistler came up with the £50 he needed: *Correspondence*, James Whistler to James Anderson Rose, Jan. 29, 1879, GUL 08760; Dod and Longstaffe to Levy and Co, GUL 12021.

p. 197 "The man is out—hurah!": *Correspondence*, James Whistler to James Anderson Rose, Feb. 5, 1879, GUL 08761.

p. 197 "in a storm of mad fury": Redesdale, 2:646. The date of this destruction is unclear—but Whistler's terror of the bailiffs suggests late 1878 or early 1879.

p. 198 "nobody but you could have done it so beautifully": G. Smalley, *Anglo-American Memories*, 279.

p. 198 for a cool £500: Later, in declaring insolvency, he gave the painting—and the *Mother*—that value. *Correspondence*, The London Bankruptcy Court to James Anderson Rose, May 7, 1879, GUL 11711. Much later, according to the Pennells, Whistler recognized that "the picture was a failure": *Whistler Journal*, 183.

p. 198 The *Carlyle* mezzotints, for one thing, remained popular: *Correspondence*, Algernon Graves to James Whistler, Feb. 8, 1879, GUL 01799.

p. 198 He resurrected some of his old etchings, publishing one of them in *Portfolio* magazine: Petri, 234.

p. 198 These he sold both by print and by copperplate to several dealers: Katharine A. Lochnan, 237, claims that all but one of these were published by the Fine Art Society. But the correspondence between Marcus Huish and Whistler at this time suggests that the Fine Art Society only bought two: *Old Putney Bridge* and *Old Battersea Bridge*. *Correspondence*, Marcus Huish to James Whistler, Aug. 6, 1879, GUL 01103. The rest Whistler likely printed himself and sold through several dealers.

p. 198 One plate—*Old Putney Bridge*—he offered in March 1879 to Marcus Huish: *Correspondence*, Marcus Bourne Huish to James Whistler, Mar. 14, 1879, GUL 01098.

p. 198 Huish changed his mind, bought it for 80 guineas: *Correspondence*, Marcus Bourne Huish to James Whistler, Apr. 7, 1879, GUL 01099 (where "the plate of Fulham Bridge" is apparently a mistake for *Old Putney Bridge*); Marcus Bourne Huish to James Whistler, Apr. 18, 1879, GUL 01100).

p. 198 Whistler and his solicitor Rose hatched a desperate plan: *Correspondence*, James Whistler to James Anderson Rose, Feb./Apr. 1879(?) (almost certainly late February or early April), GUL 08902; James Whistler to James Anderson Rose, Mar. 27, 1879, GUL 08766.

p. 199 Whistler, at his brother Willie's house, happily accepted Rose's summons: *Correspondence*, James Whistler to James Anderson Rose, Mar. 27, 1879, GUL 08766.

p. 199 Rose expressly directed them not to prevent Whistler from sending his art to the Grosvenor Gallery: *Correspondence*, James Anderson Rose to [Newtons Auction and Estate Offices?], Apr. 2, 1879, GUL 11932.

p. 199 under Sir Coutt Lindsay's protection: *Correspondence*, James Whistler to Lawson James McCreary, Mar. 27, 1879, GUL 08733.

p. 199 Rose drew up a bill of sale for the rest: *Correspondence*, James Anderson Rose to James Whistler, [Feb./Mar. 1879?], GUL 08902. Other correspondence between Rose and Whistler strongly suggests that this conditional bill of sale dates to the beginning of April 1879.

p. 199 Rose served him with a *second* summons: *Correspondence*, James Anderson Rose to James Whistler, Apr. 10, 1879, GUL 12046.

p. 199 In their absence the implacable Louis Hermann struck: "Louis Herrman, Picture Dealer, has issued execution in respect of £125. 1. 4 (two Bills of Exchange) and is now in possession of the furniture and effects at The White House." *Correspondence*, London Bankruptcy Court to James Anderson Rose, May 7, 1879, GUL 11711; Newton's Auction and Estate Agents to James Anderson Rose, Apr. 22, 1879, GUL 11937.

p. 199 "Now what absurdity can this all be!": *Correspondence*, James Whistler to Lawson James McCreary, Apr. 26, 1879, GUL 08773.

p. 199 "The show is so frightfully afire": *Correspondence*, Maud Franklin to George Aloysius Lucas, May 3, 1879, GUL 09200.

p. 199 Rose came to Chelsea: *Correspondence*, James Whistler to James Anderson Rose, May 2, 1879, GUL 08775. This was Whistler's last surviving letter to Rose; when, years later, Rose wrote to Whistler on business, he wrote as if to a stranger.

p. 200 the petition that Whistler, affecting buoyancy, submitted to the London Bankruptcy Court: Pennell, *Life* [1919], 183–84.

p. 200 Declaring debts of £4,641 against somewhat fanciful assets of £1,824: *Correspondence*, London Bankruptcy Court to James Anderson Rose, May 7, 1879, GUL 11711.

p. 200 this was actually a way to *avoid* bankruptcy: *Roche and Hazlitt*, 91.

p. 200 "ludicrously muddy and ugly," "glaringly eccentric," and "aesthetically speaking, a deplorable error to depict": *Saturday Review*, May 3, 1879, 555; *Examiner*, June 21, 1879, 18; *Athenæum*, May 10, 1879, 607.

p. 200 "That it is one of the most disagreeable and vulgar things": *Builder*, May 17, 1879, 535.

p. 200 "if he would keep to etching": *Morning Post*, May 1, 1879, 6.

p. 201 "as if the artist had upset the inkstand, and left Providence to work out its own results": Augustus Hare qtd. Pennell, *Life* [1919], 184.

p. 201 Whistler obliged, stunning his audience with a volcanic tirade: Pennell, *Life* [1919], 184.

p. 201 "How charmingly characteristic of your own meanness": *Correspondence*, James Whistler to Frederick Leyland, [May/June 1879], GUL 02600.

p. 202 One depicted Leyland as a nonentity: MacDonald and Petri, M.0718, M.0719, M.0720, M.0721.

p. 202 Charles Howell did his best to take advantage of his position on the committee: *Correspondence*, James Waddell to Charles Augustus Howell, Aug. 21, 1879, GUL 02852.

p. 202 "State 'distinctly and in writing'": *Correspondence*, Charles Augustus Howell to James Whistler, Aug. 25, 1879, GUL 02187.

p. 202 "The little head ought to have been far away more charming": *Correspondence*, James Whistler to Ada Jarvis, Sept. 6, 1879, GUL 09170.

p. 202 At the beginning of August Marcus Huish agreed to buy a second copperplate: *Correspondence*, James Whistler to Ernest Brown, Aug. 4, 1879, GUL 01102; Marcus Huish to James Whistler, Aug. 6, 1879, GUL 01103.

p. 202 Whistler invited Huish to the White House: *Correspondence*, James Whistler to Marcus Huish, Aug. 13, 1879, GUL 02988.

p. 202 the Society would pay £700, with a £150 advance: Minute Books of the Fine Art Society, qtd. Lochnan, 244, 245.

p. 202 Considering that the Society had, just a year before, paid Whistler's brother-in-law: Fine Art Society account book, cited in Faberman, 154.

p. 202 "vamoose the Ranch": *Correspondence*, James Whistler to James Waddell, [Sept. 1879], GUL 06006.

p. 203 unique to his paintings: YMSM, 208.

p. 203 Whistler reproduced the caricature: *Glasgow Evening Citizen*, Sept. 22, 1879, 2.

p. 203 Whistler took note of a 300-year old inscription chiseled over the central gable. Houfe, 284.

p. 203 "a lovely inspiration! A last Kick!": *Correspondence*, James Whistler to Matthew Robinson Elden, Sept. 13, 1879, GUL 12815.

p. 203 made final preparations, which included destroying much of his unfinished work: Pennell, *Life* [1919], 187.

p. 203 after a final breakfast with Lillie Langtry: P. Smalley, 110.

p. 203 Whistler, with his son Charles Hanson, emerged from the White House: Pennell, *Whistler Journal*, 163.

p. 204 "the Whistlerian Derangement": *Echo*, Sept. 19, 1879, 2.

p. 204 "Will you do me the pleasure to come here on the afternoon of Thursday": *Sportsman*, Sept. 20, 1879, 4.

p. 204 "there was literally nothing which the most enthusiastic Whistlerian": *Glasgow Evening Citizen*, Sept. 22, 1879, 2.

p. 204 finally went for £2,700: Pennell, *Life* [1919], 187.

p. 204 "can only be laughed at": *Spectator*, Jan. 25, 1879, 120.

p. 204 "Tommy's dead. I'm lonesome": Seitz, 46–47.

p. 204 "Alas for Jemmy Whistler!": Dante Gabriel Rossetti, *Correspondence*, 220.

p. 205 "I have fought the White House devilish well": *Correspondence*, James Whistler to James Waddell, Sept. 1879, GUL 06006.

Chapter 8: Venice

p. 206 "strange, bright, gifted": Collingwood, 2.191.

p. 206 Ruskin grew closer to his Coniston neighbors: Hilton, *Later Years*, 403.

p. 206 "He is aged by this illness," qtd. Ruskin, *Brantwood Diary*, 139.

p. 207 "folded lace-veils": Ruskin, *Brantwood Diary*, 151.

p. 207 "miniature ranges of basaltic pillars": *Works*, 26.347–48.

p. 207 the thin crust of ice that shot—or was "*breathed*": *Works*, 26.358.

p. 207 "Fearful darkness yesterday at evening": Ruskin, *Brantwood Diary*, 170.

p. 207 "the blackest evening the devil has yet brought upon us": Ruskin, *Brantwood Diary*, 182.

p. 207 His studies and writings at the time were remarkably diversified: Ruskin, *Brantwood Diary*, 140–67.

p. 208 That January he discovered that someone had forged his signature: Ruskin, *Brantwood Diary*, 150; Hitchcock *et al.*

p. 208 "the lawyers forced me": *Works*, 37.278.

p. 208 he was allowed to testify from the judge's bench: *Times*, Apr. 1, 1879, 12.

p. 208 "good for nothing but thankful to be as well as I am": Ruskin, *Brantwood Diary*, 167.

p. 208 Ruskin helped set him up in a better career: Collingwood, 2.208.

p. 208 two years before had composed a letter: *Works*, 24.lx–lxi.

p. 208 Thomas Rooke, an assistant of Burne-Jones: *Works*, 24.lxi.

p. 209 "Yesterday very dismal": Ruskin, *Brantwood Diary*, 165.

p. 210 That fantasy he most fully realized on the afternoon of October 22: *Sheffield Daily Telegraph*, Oct. 23, 1879, 5; *Sheffield and Rotherham Independent*, Oct. 23, 1879, 2.

p. 210 "I am thinking of living as much there as possible": Ruskin and Norton, 438.

p. 210 a lecture at the London Institution: *Times*, Dec. 2, 1879, 6.

p. 210 "schemers of physical science": *Works*, 34.410.

p. 210 "more sense of declining vital power than I've ever been conscious of": Ruskin, *Brantwood Diary*, 202. He does note an exception, here: "some afternoons at Oxford—which I too easily forget."

p. 211 but had focused upon him because his diocese happened to be the locus of the orthodox political economy: *Works*, 34.406.

p. 211 He was encouraged on New Year's Day: Ruskin, *Brantwood Diary*, 59, 215.

p. 211 "I'm very nearly done with toasting my bishop": *Works*, 27.307.

p. 211 "ravings of a lunatic": Hughes, 305.

p. 212 "I went mad because nothing came of my work": *Works*, 39.386.

p. 212 "The want—for a whole winter—of one pure sunrise!": Ruskin, *Brantwood Diary*, 226.

p. 212 "The hell-fog unbroken": Ruskin, *Brantwood Diary*, 216.

p. 212 "The Abyss of darkness": Ruskin, *Brantwood Diary*, 217.

p. 213 "But the curse on the sky is my chief plague": Ruskin, *Brantwood Diary*, 228.

p. 213 "the *Cause Célebre*" of *Whistler v. Ruskin*: *Glasgow Herald*, Jan. 19, 1880, 8.

p. 213 "more pleased . . . than perhaps some of my friends": *Works*, 34.544.

p. 213 "the principal annoyance": *Works*, 34.544.

p. 213 "although it is not necessary for any young persons": *Works*, 26.304.

p. 214 "a serpent is a honeysuckle": *Works*, 26.306.

p. 214 "All these living forms": *Works*, 26.305.

p. 214 "he held us in the hollow of his hand": Wedmore, 103–104.

p. 214 Having . . . taken a visit from both the elderly Carlyle and the errant Froude: Birkenhead, 283–84.

p. 214 he began writing letters to Marcus Huish, Hilton, *Later Years*, 406.

p. 214 "This morning my head so full of crowded thoughts about Museums": Ruskin, *Brantwood Diary*, 238.

p. 215 "not in the least disposed myself to stand in any contest": *Glasgow Herald*, Oct. 7, 1880, 3.

p. 215 "What in the devil's name": *Glasgow Herald*, Oct. 12, 1880, 4.

p. 215 Ruskin soon found himself apologizing to his very offended friend: *Works*, 37.327–29.

p. 215 Bright trounced Ruskin, 1,128 votes to 814: *Glasgow Herald*, Nov. 16, 1880, 7.

p. 216 On October 17, in Amiens, he began to write: Ruskin, *Diaries*, 3.988.

p. 216 "the most important *Fors* I have yet written": *Works*, 37.327.

p. 216 some bafflement by the unions at his offer: *Edinburgh Evening News*, Oct. 15, 1880, 2.

p. 216 Ruskin had intended to return from France to Brantwood at the beginning of October: *Works*.37.326.

p. 216 this time with Arthur Severn and two of his artist friends: Severn, 80.

p. 216 "an inspiring, appealing, intensely moving performance": Benson, 25.

p. 216 "much beaten and tired": Ruskin, *Brantwood Diary*, 254.

p. 216 a fully drawn *cross pattée*: Ruskin, *Brantwood Diary*, 265.

p. 217 Carlyle's death "is no sorrow to me": *Works*, 37.341.

p. 217 "I am bored to death": *Correspondence*, James Whistler to Helen Euphrosyne Whistler, Oct./Nov. 1879, GUL 06686.

p. 217 "struggling on in a sort of Opera Comique country": *Correspondence*, James Whistler to Deborah Delano Haden, Jan. 1, 1880, GUL 11563.

p. 217 "No winter like this known for at least thirty years": *Correspondence*, James Whistler to Helen Euphrosyne Whistler, Jan./Feb. 1880, GUL 06687. It was, indeed, one of the harshest winters ever recorded, in Venice and throughout Europe: W. U., 485; Camuffo et al.

p. 217 "the rage of the pent up painter": *Correspondence*, James Whistler to Matthew Robinson Elden, Apr. 15/30, 1880, GUL 12816.

p. 217 When Marcus Huish, therefore, wrote Whistler in mid-January 1880: *Correspondence*, Marcus Bourne Huish to James Whistler, Jan. 14, 1880, GUL 01105.

p. 217 "I can't fight against the Gods": *Correspondence*, James Whistler to Marcus Bourne Huish, Jan. 21/26, 1880, GUL 02992.

p. 217 "hurry back with all your trophies." *Correspondence*, Marcus Bourne Huish to James Whistler, Feb. 5, 1880, GUL 01108.

p. 217 "it has opened for me a mine": *Correspondence*, James Whistler to Matthew Robinson Elden, Apr. 15/30, 1880, GUL 12816.

p. 218 "After the wet": *Correspondence*, James Whistler to Anna Matilda Whistler, Mar./May 1880, GUL 13502.

p. 218 "I have learned to know a Venice in Venice": *Correspondence*, James Whistler to Marcus Bourne Huish, Jan. 21/26, 1880, GUL 02992.

p. 218 "the foolish sketcher": *Correspondence*, James Whistler to Matthew Robinson Elden, Apr. 15/30, 1880, GUL 12816.

p. 218 He remained obsessed in particular with the circumstances of the artwork: *Correspondence*, Matthew Robinson Elden to James Whistler, GUL 01049, 01048; James Whistler to Helen Euphrosyne Whistler, GUL 06689. While the fate of the *Three Girls* remains a mystery, *The Loves of the Lobsters* and *Mount Ararat* were taken not by Howell or Leyland, but by Thomas Way, who paid a nominal sum for them and several other canvases. In 1896 Way returned these works to Whistler—who apparently destroyed them.

p. 218 "entanglement of beautiful things": James Whistler to Matthew Robinson Elden, Apr. 15/30, 1880, GUL 12816.

p. 218 Accompanied always by his personal gondolier: Bacher, 97. At least two gondoliers worked for Whistler in Venice.

p. 219 "the secret of drawing": Menpes, 22–23.

p. 219 "far more delicate in execution": *Correspondence*, James Whistler to Marcus Bourne Huish, Jan. 21/26, 1880, GUL 02992.

p. 219 "something so new in Art": *Correspondence*, James Whistler to Helen Euphrosyne Whistler, Feb. 20/Mar. 1880, GUL 06690.

p. 220 Bunney according to Ruskin labored fully 600 days on this project: *Works*, 30.356.

p. 220 "I am totally blind": Pennell, *Life* [1919], 193.

p. 220 "cat's meat and cheese parings": Pennell, *Whistler Journal*, 164.

p. 220 Maud, barred for propriety's sake: Pennell, *Whistler Journal*, 165.

p. 220 "there is no mistake that he is the cheekiest scoundrel out": Fildes, 66.

p. 221 Others, however, acknowledged that Whistler repaid his debts: Bacher, 35–36.
 Whistler actually settled a debt with Woods himself before leaving Venice: Fildes, 67.

p. 221 They fell into a routine of early morning bathing: Bacher, 238.

p. 221 "praising France, abusing England, and thoroughly enjoying Italy": Pennell, *Life*
 [1919], 195.

p. 221 they threw him an elaborate fête: Bacher, 258–61.

p. 221 Whistler savaged them for their obtuse stinginess: *Correspondence*, James Whistler to
 Marcus Bourne Huish, Oct. 25, 1880, GUL 01113.

p. 221 "Keep it dark and on the strict QT": *Correspondence*, James Whistler to Helen and
 William McNeill Whistler, Oct. 19/26, 1880, GUL 06999.

p. 222 "'Dear me!' I said. 'Still the same old sad work! Dear me!'": Pennell, *Whistler Journal*, 187.

p. 222 "The moment I saw him": Menpes, 89.

p. 222 Rennell Rodd, who had been encouraged by Burne-Jones to take up art: Loraine.

p. 222 "The Whistler Followers": Menpes, 15.

p. 223 "Look here my dear Huish": *Correspondence*, James Whistler to Marcus Bourne Huish,
 Nov. 28/29, 1880, GUL 07974.

p. 223 "arranged on a maroon-coloured cloth": *British Architect*, Dec. 10, 1880, 247.

p. 223 "the great artistic value of his etchings": *Globe*, Dec. 3, 1880, 3.

p. 223 "clever though disappointing": *Architect*, Feb. 5, 1881, 90.

p. 223 Harry Quilter found them "interesting": *Spectator*, Dec. 11, 1880, 1587.

p. 223 Huish paid him the remainder of his Venice commission: *Correspondence*, Fine Art
 Society to James Whistler, Dec. 20, 1880, GUL 01120.

p. 223 "an arrangement in brown gold & Venetian Red": *Correspondence*, Maud Franklin to
 Otto Bacher, Mar. 21, 1881, GUL 11621.

p. 224 "The mere method of display is a triumph of 'tone'": *Daily Telegraph*, Feb. 1, 1881, 3.

p. 224 The pastels "are the *Fashion*". *Correspondence*, Maud Franklin to Otto Bacher, Mar. 21,
 1881, GUL 11621.

p. 224 "done with a swiftness and dash that precludes anything like care and finish": *Pictorial
 World*, Feb. 5, 1881, qtd. *British Architect*, Feb. 25, 1881, 99.

p. 224 "Venice," observed the critic for the *Standard*: *London Evening Standard*, Jan. 31,
 1881, 2.

p. 224 "commends itself to an impressionist": *Times*, Feb. 9, 1881, 4.

p. 224 An astounding 42,830 came to view: Fine Art Society minutes for July 6, 1881, qtd.
 Bendix, 223.

p. 224 "Four hundred pounds' worth went the first day": *Correspondence*, Maud Franklin to
 Otto Bacher, Mar. 21, 1881, GUL 11621.

p. 225 "The next Saturday afternoon": Pennell, *Whistler Journal*, 252.

p. 225 "It would have been better had I been a parson as she wanted!": Pennell, *Life* [1919], 206.

p. 225 "I've just been enjoying myself": *Correspondence*, Maud Franklin to Otto Bacher,
 Apr. 23/30, 1881, GUL 10057.

p. 225 Whistler was able to begin paying down his debt: *Correspondence*, Henry Graves and
 Co. to James Whistler, Jan. 10, 1881, GUL 01800; Feb. 9, 1881, GUL 01801.

p. 226 "What of the 'Society for the Preservation of Beautiful Buildings'?": *Correspondence*, James Whistler to Edmund Hodgson Yates, Oct. 14, 1883, GUL 11403.

p. 227 He redecorated, painting over the "execrable" walls: *Correspondence*, James Whistler to Jackson and Graham, May 5/30, 1881, GUL 02397.

p. 227 "sort of grey flesh-tint" . . . "strangely vigorous blue-green": Minnie Hawthorne, 658.

p. 227 visiting Whistler felt "as if standing inside an egg": Pennell, *Life* [1919], 210.

p. 227 "You will be pleased to hear that H. R. H. smoked a cigar": *Correspondence*, James Whistler to Helen Euphrosyne Whistler, [Sept. 1881?], GUL 06694.

p. 228 "There was one man who was always there": Pennell, *Life* [1919], 213.

p. 228 a "sort of claque": *Correspondence*, Alan Summerly Cole diary, May 2, 1882, GUL 13132.

p. 228 "often full of talent, but always mad": Pennell, *Life* [1919], 226.

p. 228 "hopeless—domesticity and whisky having proved too much": *Correspondence*, James Whistler to Thomas Waldo Story, Feb. 5, 1883, GUL 09430.

p. 228 carted off to Bethlehem Hospital: Commissioners in Lunacy, entry 96388.

p. 228 "raving mad": Pennell, *Life* [1919], 226.

p. 228 "devoted . . . with the pertinacity of the Redskin to the scalping of Howell": *Correspondence*, James Whistler to Samuel Wreford Paddon, Mar. 22, 1882, GUL 08103.

p. 228 Whistler somehow happened upon the pawnshop that contained the upper part: *Correspondence*, William Alexander Chapman to James Whistler, June 9, 1881, GUL 00590.

p. 228 "paint all the fashionables": *Correspondence*, Alan Summerly Cole diary, May 26, 1881, GUL 13132, with mistranscription corrected.

p. 229 "What became of that unfinished picture": Langtry, 56.

p. 229 "merely touched the light on his shoes": *Correspondence*, Alan Summerly Cole diary, Apr. 17, 1882, GUL 13132.

p. 229 Walter Sickert, for one, was certain Whistler had killed him: Sickert, 647.

p. 229 Three times he attempted to paint his sponger Matthew Elden: YMSM, 243, 244, 245, all listed as *Portrait of H. R. Eldon* [I, II, III].

p. 229 "quite a pet of Whistler's": Pickford Waller qtd. YMSM, 127.

p. 230 "It was terrible to watch him": Menpes, 116.

p. 230 "scarecrow in a blue dress": *Pall Mall Gazette*, June 6, 1882, 4.

p. 230 For no sooner had Whistler made arrangements with Blott than he began again as before to fend him off: *Correspondence*, James Whistler to Eugène [sic] Blott, Mar. 1881/1883, GUL 11162; May 1881, GUL 07617.

p. 230 She had been born Susan Langdon: Wilson.

p. 230 "I suppose we are both a little *eccentric*": *Correspondence*, Valerie Meux to James Whistler, Jan. 13, 1892, GUL 04071.

p. 231 "What he does . . . no other man can do": Minnie Hawthorne, 618.

p. 231 "Whistler held in his left hand a sheaf of brushes": Julian Hawthorne, 2957.

p. 231 "see here, Jimmy Whistler!": Harper Pennington, qtd. Pennell, *Life* [1919], 211.

p. 231 In 1886 Meux had her furs altered: *Correspondence*, Augustus Harris to James Whistler, July 26, 1886, GUL 02044; James Whistler to Valerie Meux, July 30, 1886, GUL 04068.

p. 231 "the Moon-Lady, the Grey Lady": *Correspondence*, Oscar Wilde to James Whistler, June 1882, GUL 09547.

p. 232 she painted her own rooms in the spirit of Whistler's *Peacock Room*: Campbell in her *Rainbow Music*, 12–19, makes clear her indebtedness to Whistler's design for her own.

p. 232 "Dear me, no": Qtd. Eddy, 120.

p. 232 "harmony in silver greys": Pennell, *Life* [1919], 215.

p. 232 "a street walker encouraging a shy follower with a backward glance": Robertson, 367–68.

p. 232 leaving Whistler "utterly discouraged": Duret, 67.

p. 232 It was up to Duret to chase Lady Archie to her hansom: Pennell, *Life* [1919], 216.

Chapter 9: *La Fortune*

p. 233 "famous," and "an old acquaintance": *New York Times*, Apr. 6, 1882, 5.

p. 233 "It is a very extraordinary performance": *New York Times*, Apr. 6, 1882, 5.

p. 234 "clever," "charming," "delightful": *Saturday Review*, May 27, 1882, 663; *Pall Mall Gazette*, June 6, 1882, 4; *London Evening Standard*, May 1, 1882, 4.

p. 234 "the buffoon of the Grosvenor": *Atlantic Monthly*, Aug. 1882, 257.

p. 234 "strange," "dismal," "a premeditated error": from the *Republique Francais* and *Clarion*, qtd. Fleming, 227; *Courrier de l'art*, June 22, 1882, 293.

p. 234 "An astonishing Whistler": Qtd. YMSM, 228: "un Whistler étonnant, raffiné à l'excès."

p. 234 "nocturnes—and various": *Correspondence*, James Whistler to Thomas Waldo Story, Dec. 1882, GUL 09434.

p. 234 "practical joke for the amusement of the public": *Portfolio*, Apr. 1883, 85.

p. 234 "Great Shebang": *Correspondence*, James Whistler to Thomas Waldo Story, Feb. 5, 1883, GUL 09430.

p. 234 "Another crop of Mr. Whistler's little jokes"; "In Mr. Whistler's productions one might safely say that there is no culture"; "form and line are of little account to him": Whistler, *Gentle Art*, 93, 100, 103.

p. 235 "express the inexpressible: form without form, color without color": Alfred de Lostalot in *Gazette des Beaux-arts*, July 1883, 80.

p. 235 "move Heaven and Earth to show them": *Correspondence*, James Whistler to Thomas Waldo Story, Mar. 5, 1883, GUL 05606.

p. 235 Whistler behaved "like a fool": Qtd. Mathews, 170.

p. 236 "At first it suggests a saturated blotting paper": *Chicago Tribune*, Oct. 21, 1883, 11.

p. 236 Whistler had put the painting on sale, priced at $2,500: *St. Louis Post-Dispatch*, Nov. 24, 1883, 12.

p. 236 showing . . . in Baltimore, Boston, and Philadelphia in 1883, and in Chicago and Detroit in 1884: Merrill, "Whistler in America." Though Merrill claims the *Falling Rocket* traveled to each city, I have found no evidence that it appeared anywhere but in New York.

p. 236 The Belgian critics were entranced: Newton, 48.

p. 236 "Adverse criticism must be silent": Qtd. Maus, 8.

p. 236 "Two superb canvases": *L'Art Moderne*, June 13, 1884, 211.

p. 236 The influential critic J. K. Huysmans proclaimed the *Carlyle* "astounding": *La Revue Indépendante*, June 1884, 110.

p. 236 To an international exhibition at the Crystal Palace in London that April Whistler sent two paintings: *Manchester Guardian*, May 22, 1884, 8.

p. 237 "I wish my dear Whistler that you would do yourself and me more justice": *Correspondence*, Coutts Lindsay to James Whistler, Apr. 15, 1884, GUL 01867.

p. 237 "Sir Coutts has been too horrid": *Correspondence*, James Whistler to Thomas Waldo Story, May 20/25, 1884(?), GUL 09451.

p. 237 some no larger than the average-sized postcard: Six of the paintings measured 3.5 by 5.25 inches. Myers, 14.

p. 237 "little beauties": *Correspondence*, James Whistler to Charles William Dowdeswell, [May 1/14, 1884?], GUL 08635.

p. 237 "We were placing Whistler on a plane where he should be": Menpes, 119.

p. 238 "unconventional methods and personal eccentricities": George R. Halkett in *Scotsman*, Oct. 6, 1884, 7.

p. 238 he upped his price to 1,000 guineas: *Correspondence*, James Whistler to Henry Graves, Oct. 10, 1884, GUL 10918.

p. 238 a request from the hanging committee of Dublin Sketching Club: *Correspondence*, James Whistler to Henry Graves, June/Nov. 1884(?) (more likely November), GUL 10929. The Club specifically requested the *Carlyle* and the *Mother*.

p. 238 The Dublin press soon caught wind of these hostilities: *Dublin Daily Express*, Dec. 1, 1884, 5.

p. 238 "for it is a joy to me to see": *Correspondence*, James Whistler to William Booth Pearsall, Dec. 4/11, 1884(?), GUL 08109.

p. 238 "How can it ever have been supposed that I offered the picture of my mother for sale!": *Correspondence*, James Whistler to William Booth Pearsall, Dec. 4/11, 1884(?), GUL 08109.

p. 239 Whistler arranged with Helen Lenoir: *Correspondence*, Helen Lenoir to Archibald Forbes, Jan. 8, 1885, GUL 00924.

p. 239 "Every dull bat and beetle": *The American Architect*, Nov. 26, 1887, 259.

p. 239 "Is he going to pulverize Oscar Wilde": *Truth*, Jan. 22, 1885, 121.

p. 239 "whimsical goddess": Whistler, *Gentle Art*, 156.

p. 239 "nature is usually wrong": Whistler, *Gentle Art*, 143.

p. 239 "And when the evening mist clothes the riverside": Whistler, *Gentle Art*, 144.

p. 240 "If familiarity can breed contempt": Whistler, *Gentle Art*, 134.

p. 240 "collecting—comparing—compiling—classifying—contradicting": Whistler, *Gentle Art*, 149.

p. 240 "Mr. Whistler could not be heard by nine-tenths of his audience": *Telegraph*, Feb. 21, 1885, 3.

p. 241 Oscar Wilde did exactly that in his *Pall Mall Gazette* review: *Pall Mall Gazette*, Feb. 21, 1885, 1–2.

p. 241 That Helen Lenoir and D'Oyly Carte apparently convinced him: *Correspondence*, George Henry Hathaway to Helen Lenoir, Nov. 16, 1885, GUL 02054; Helen Lenoir to Richard D'Oyly Carte, Nov. 19, 1885, GUL 00927; Richard D'Oyly Carte, Dec. 2, 1885, GUL 00940.

p. 241 "Ask Mamma" and "Don't Tease Baby" pictures: *Spectator*, Dec. 26, 1885, 1738.

p. 241 Whistler, with Walter Sickert's help, made his desire to join known to the society: Ludovici, 193–94.

p. 242 "You remind me of a ship-load of passengers": Menpes, 110.

p. 242 From the start, then, he faithfully attended Society meetings: Ludovici, 194.

p. 242 Whistler grumbled when he was awarded no medals: *Correspondence*, James Whistler to George Aloysius Lucas, June 23, 1885, GUL 09206.

p. 242 the critics generally praised as the spectacular work among a mass of mediocrity: *Sporting Gazette*, Nov. 29, 1884, 1512–13; *Athenæum*, Dec. 6, 1884, 743; *Musical World*, Dec. 6, 1884, 772.

p. 242 "chiefly for its price": *St. James's Gazette*, Dec. 10, 1884, 6.

p. 243 "certainly one of the most original and powerful portraits": *Pall Mall Gazette*, Apr. 20, 1885, 4.

p. 243 "Time was": *London Evening Standard*, Apr. 18, 1885, 5.

p. 243 "there is now no gallery in London": *Spectator*, Dec. 26, 1885, 1737.

p. 243 Maud, for years, had assumed that role: Pennell, *Whistler Journal*, 165.

p. 244 "a sort of chandelier of argand burners": Way, 79.

p. 244 She was known to interrupt the sittings of others: Pennell, *Whistler Journal*, 166.

p. 244 George Lucas recorded in his diary: Lucas, 2.625.

p. 244 "Jimmie threw them all into the street and shut the house": Pennell, *Whistler Journal*, 119.

p. 244 "I *am* woefully busy": *Correspondence*, James Whistler to Captain Eyre Massey Shaw, Mar. 27, 1886, GUL 08124.

p. 244 "products of impulses and aesthetic systems wholly French": *Era*, May 1, 1886, 13.

p. 245 "the Artistic event of the season": *Correspondence*, James Whistler to Charles William Dowdeswell, July 27, 1886, GUL 08638.

p. 245 "so great was the crowd which filled his small exhibition room": *Western Times*, May 10, 1886, 4.

p. 245 Rossetti's *Ecce Ancilla Domini* . . . went for 800 guineas: *Times*, Apr. 5, 1886, 12.

p. 245 Millais's *Vale of Rest* fetched an astounding 3,000 guineas: *Observer*, Apr. 4, 1886, 6.

p. 245 The crowd now gave it a feeble cheer that the *Times* designated "ironical": *Times*, Apr. 5, 1886, 12.

p. 245 The painting fetched a meager 60 guineas: YMSM, 140.

p. 245 "May I beg": *Observer*, Apr. 11, 1886, 2.

p. 246 "Whistler's portrait of Sarasate is full of subtleties": *L'Emancipation* (Brussels), Feb. 21, 1886, 1.

p. 246 "His portrait of Sarasate is a sort of apparition": *Gazette des Beaux-arts*, June 1, 1886, 464.

p. 246 he sent to the Berlin Academy of Arts both his *Lady Archibald Campbell* and his Carlyle. *Times*, May 29, 1886, 6.

p. 246 Carlyle "is held in great reverence": *Correspondence*, James Whistler to Henry Graves, Mar. 14/20, 1886(?), GUL 10920.

p. 246 Nor did they consider Whistler worthy of one of one of their gold medals: *Manchester Guardian*, July 26, 1886, 6.

p. 246 "In the case of all three pictures": *Glasgow Herald*, Aug. 16, 1886, 8.

p. 246 "cleansing the Society": Menpes, 106.

p. 246 masses of gilt and brown-papered walls: *Liverpool Mercury*, Nov. 27, 1886, 5.

p. 247 placing Mortimer Menpes and Stott of Oldham on the hanging committee: Sturgis, 143.

p. 247 "never weary": Menpes, 106.

p. 247 Nearly three times as many people came to this show: *Pall Mall Gazette*, Dec. 31, 1886, 4.

p. 247 revenues had approached £8,000: *Pall Mall Gazette*, July 6, 1888, 2.

p. 247 "In Suffolk-street the wail is loud, long, and piercing": *Pall Mall Gazette*, Nov. 27, 1886, 6.

p. 247 raised that amount through some Howellian double-dealing: *Correspondence*, Helen Lenoir to James Whistler, Dec. 9, 1866, Jan. 31, Apr. 5, 1877, GUL 00932, 00937, 00938.

p. 247 he had personally repainted in a yellow dazzling enough to vex the conservatives: Pennell, *Life* [1919], 264.

p. 247 the paintings he preferred . . . outnumbered their once-ubiquitous banalities: *Illustrated Sporting and Dramatic News*, Apr. 9, 1887, 91.

p. 247 "Sir, it has none": Pennell, *Life* [1919], 263.

p. 248 "singly—with a space between each": *Correspondence*, James Whistler to G. William Agnew, Apr. 16/18, 1887(?) (quite likely before), GUL 03983.

p. 248 Whistler . . . angrily telegraphed Manchester demanding the immediate return of his work: *Correspondence*, William Agnew to James Whistler, Apr. 18, 1887, GUL 03984.

p. 248 "Whistler, by the way, does not care for luminosity": Pissarro, 108.

p. 248 only to learn that while "Imperial" was out of the question, "Royal" was possible: *Correspondence*, Godfrey Lushington to James Whistler, July 30, 1887, GUL 01837.

p. 249 he put forward a proposal banning members from his society from retaining membership: *Correspondence*, The Royal Society of British Artists to James Whistler, Nov. 1, 1887(?), GUL 05314.

p. 249 A month later Whistler put forth a similar proposal: *Correspondence*, Horace Henry Cauty to the Royal Society of British Artists, Nov. 28, 1887, GUL 05307.

p. 249 *Symphony in White and Red*: *The Magazine of Art*, Feb. 1, 1888, 110.

p. 249 "pert and puny" . . . "knock-kneed" . . . "vulgar trollop": *Saturday Review*, Dec. 3, 1867, 760; *St. Louis Post-Dispatch*, Dec. 21, 1887, 2; *Truth*, Dec. 1, 1887, 899.

p. 250 "visit from Maud": Lucas, 2.662–65.

p. 250 he recommenced his Sunday breakfasts—with Beatrix now his hostess: *Correspondence*, James Whistler to Charles James Whistler Hanson, June 14, 1888, GUL 08008.

p. 250 At a luncheon that Monet organized, Whistler renewed his acquaintance with the Symbolist poet: Abélès, 163.

p. 250 had declined Whistler's offer to come to Putney to read it to him personally: *Correspondence*, James Whistler to Walter Theodore Watts-Dunton, Oct. 20, 1885, GUL 07407.

p. 250 Now he made up for his neglect with a blistering attack upon Whistler's theory: *Fortnightly*, June 1, 1888, 745–51.

p. 250 Whistler . . . dispatched to Swinburne on the same day two bitter *Et tu, Brute?* letters: Whistler, *Gentle Art*, 259–60, 262.

p. 251 "They brought up the maimed, the halt, the lame, and the blind": *Pall Mall Gazette*, June 11, 1888, 2.

p. 251 Whistler turned instead to Sir Coutts Lindsay: *Leeds Mercury*, Apr. 30, 1888, 4.

p. 251 He again priced it at £1,000: YMSM, 137.

p. 251 "As usual, you had the greatest success": *Correspondence*, Octave Maus to James Whistler, Mar. 21, 1888, GUL 05495.

p. 251 she claimed that Whistler's and Renoir's works alone saved the show from disaster: Anderson and Koval, 291.

p. 252 Rennell Rodd . . . had coaxed him to exhibit there: *Correspondence*, James Rennell Rodd to James Whistler, Jan. 12, 1888, GUL 05207.

p. 252 "pray convey my sentiments of tempered and respectable joy": *Correspondence*, James Whistler to the First Secretary, Central Committee, International Art Exhibition, Sept. 3, 1888, GUL 07979.

p. 252 "There is a great row about you": *Correspondence*, James Rennell Rodd to James Whistler, Sept. 25, 1888, GUL 05215.

p. 252 "They have made me Hon. Member of the Royal Academy of Bavaria": *Correspondence*, James Whistler to William Cleverly Alexander, Mar. 12, 1889, GUL 07566.

p. 252 Louise Jopling was one of the few guests and recalled Whistler's uneasy glances: Pennell, *Whistler Journal*, 167.

p. 253 "yoking of the butterfly": *Pall Mall Gazette*, Aug. 11, 1888, 8.

p. 253 "Shameful imposition": *Correspondence*, James Whistler to Robert Walker, Feb. 12, 1889, GUL 03521.

p. 253 "if there were as many as half a dozen people who cared for good work": Pennell, *Life* [1919], 283.

p. 253 sixty watercolors, pastels, and oils—including the *Falling Rocket*: *Correspondence*, H. Wunderlich and Co., Mar. 1888(?) (list of exhibits), GUL 10621.

p. 254 the American commissioner, fellow West Pointer General Rush C. Hawkins, informed him: *Correspondence*, Rush C. Hawkins to James Whistler, Apr. 3, 1889, GUL 04408.

p. 254 Whistler learned that July that he had been awarded a first-class medal: *Correspondence*, Stéphane Mallarmé to James Whistler, July 21, 1889, GUL 03786.

p. 254 "since at the moment, in Paris": *Correspondence*, Théodore Duret to James Whistler, July 29, 1889, GUL 00985.

p. 255 "they have given me a *Grande Medaille d'Or* at the Dutch Salon": *Correspondence*, James Whistler to Julian Story, Oct. 9/29, 1889, GUL 08149.

p. 255 sending a friend to seek out a suitable studio for him there: *Correspondence*, James Whistler to Julian Story, Jan. 1/15, 1890, GUL 09439.

p. 255 Whistler then—according to Whistler, but denied by Stott—leapt up: *Correspondence*, James Whistler to the Committee of the Hogarth Club, Jan. 4, 1889, GUL 13461.

p. 255 Stott's attempts to defend himself: *New York Herald* [Paris edition], Jan. 19, 1889, 3.

p. 256 "the early rat who leaves the sinking ship": Pennell, *Life* [1919], 268.

p. 256 what Whistler saw as Menpes's pilfering his own ideas about home decoration: *Pall Mall Gazette*, Dec. 13, 1888, 5; *Truth*, Mar. 28, 1889, 7.

p. 256 "You will blow your brains out": *Correspondence*, James Whistler to Mortimer Menpes, Mar. 28, 1889, GUL 04034.

p. 256 an article in the *Sun* claiming that Wilde was again stealing ideas and phrases: *Sun*, Nov. 17, 1889, 4.

p. 256 "You have stolen *your own scalp!*": *Truth*, Jan. 2, 1890, 5.

p. 256 "as for borrowing Mr. Whistler's ideas": *Truth*, Jan. 9, 1890, 8.

p. 257 "now—for the first time do I clearly perceive": *Correspondence*, James Whistler to Mary Bacon Ford, Sept. 27/Oct. 4, 1888, GUL 01449, 01450.

p. 257 "was measurably within sight of the promised land of printer's proofs": *St. Stephen's Review*, Sept. 21, 1889, 12.

p. 257 seeking publishers in London and New York: *Correspondence*, Field and Tuer to Lewis and Lewis, GUL 02498; Frederick A. Stokes to Lewis and Lewis, Apr. 15, 1890, GUL 05602.

p. 257 Ford then fled to Antwerp and found a printer to produce two thousand copies: *Correspondence*, James Whistler to Miss Köhler (draft), Mar. 24, 1890, GUL 02440.

p. 257 Ford slipped away to Ghent, found another printer: *Nation*, July 14, 1910, 31. Whistler apparently never knew of this printing, thinking instead that these copies had been printed in Paris.

p. 257 Whistler himself came upon a copy in a Chelsea bookstall: Sutherland, 244.

p. 259 "ridiculously perched in paradise": *Le Voleur Illustre*, May 15, 1890, 309 ("ridiculement perché au paradise").

p. 259 rejecting both nocturnes outright: *Correspondence*, Gérard Harry to James Whistler, Oct. 3, 1890, GUL 02265. The letter clearly refers to the exhibition in Brussels this year, not the one in Paris, as the editors of the *Correspondence* assume.

p. 259 "They are perfect": *La Jeune Belgique* 9 (1890): 378 ("ils sont parfaits.") The critic here is Georges Destrée.

p. 259 "*Isn't she beautiful*": Robertson, *Time Was*, 190.

p. 259 rumors of a fraud supposedly committed by Edward Godwin some years before: *Sheffield Independent*, Sept. 10, 1890, 4; Glover, 100–101.

p. 260 setting his solicitors upon any paper that dared contradict his version of events: *Correspondence*, George and William Webb to Sidney J. Low, Sept. 11, 1890, GUL 13260; James Whistler to the editor, *Sunday Times*, Sept. 13, 1890, GUL 09461.

p. 260 "The second volume of the *Gentle Art* is starting!": *Correspondence*, Stéphane Mallarmé to James Whistler, Sept. 11, 1890, GUL 13446.

p. 260 Edward A. Walton and James Guthrie, had wanted the *Carlyle* permanently in Glasgow: Pennell, *Life* [1919], 298.

p. 260 Walton sent this first to Whistler: *Correspondence*, Edward Arthur Walton to James Whistler, Jan. 12, 1891, GUL 06013.

p. 260 It was, Whistler replied, dropping: *Correspondence*, James Whistler to Edward Arthur Walton, Jan. 19, 1891, GUL 06015.

p. 260 borrowing the £220 he needed from his solicitor: *Correspondence*, George Henry Lewis to James Whistler, Apr. 7, 1891, GUL 02554.

p. 260 freshly cleaned, varnished, and reframed: *Correspondence*, James Whistler to George Henry Lewis, Jan. 29, 1891(?), GUL 02550; Sutherland, 249.

p. 261 "The picture has come & fits into its place": *Correspondence*, Elisabeth Lewis to James Whistler, Feb. 21, 1885, 02618, GUL 02618.

p. 261 The subcommittee granted it on the spot: *Correspondence*, Glasgow Town Council, Sub-committee on Galleries and Museums (minutes), Feb. 27, 1891, GUL 12326.

p. 261 Walton having discreetly asked Whistler his price: *Correspondence*, James Whistler to Edward Arthur Walton, Feb. 3, 1891, GUL 06019.

p. 261 "I received them, well, you know, charmingly": Pennell, *Life* [1919], 299.

p. 262 "a simple dignity which satisfied even 'the Master'": Thomson, 266.

p. 262 "'rub in' this sentiment": Thomson, 266.

p. 262 roughly three times what he had been paid for the *Carlyle*: Walden, 134.

p. 262 according to the critics, to outshine them all: *Globe*, July 2, 1891, 6; *St. James's Gazette*, July 2, 1891, 4; *Pall Mall Gazette*, July 9, 1891, 2; *Truth*, July 9, 1891, 35; *Athenæum*, July 18, 1891, 105; *Graphic*, July 25, 1891.

p. 262 "wholly original and supremely beautiful": *Speaker*, July 1, 1891, 50.

p. 262 "Bad—so jolly bad!": *Correspondence*, James Whistler to Beatrix Whistler, June 11, 1891, GUL 06591.

p. 263 This did not prevent him from visiting Degas: *Correspondence*, James Whistler to Beatrix Whistler, June 12/13, 1891, GUL 06592.

p. 263 On the same trip he visited two others: *Correspondence*, James Whistler to Beatrix Whistler, June 14, 1891, GUL 06593.

p. 263 "works of such fine psychology": *La Justice*, July 1, 1891, 1 ("ces oeuvres de si fine psychologie, de vérité si fière, de si hautaine étrangeté").

p. 263 displayed to potential buyers at the galleries of Boussod, Valodon & Cie: *Correspondence*, Maurice Joyant to David Croal Thomson, June 16, 1891, GUL 05676.

p. 264 "painters, literati and amateurs" ["un Comité de peintres, de littérateurs et amateurs"]: *Correspondence*, Maurice Joyant to David Croal Thomson, Oct. 13, 1891, GUL 00379.

p. 264 "the Luxembourg . . . is I really believe not so far off": *Correspondence*, James Whistler to Beatrix Whistler, Oct. 28/29, 1891, GUL 06601.

p. 264 On November 4, the *Gaulois* carried on its front page: *Le Gaulois*, Nov. 4, 1891, 1.

p. 264 "If you see Roujon": *Correspondence*, James Whistler to Stéphane Mallarmé, Nov. 7, 1891, GUL 03818.

p. 265 Mallarmé therefore recommended to Whistler that they delay: *Correspondence*,
 Stéphane Mallarmé to James Whistler, Nov. 9, 1891, GUL 03819.

p. 265 Whistler agreed: *Correspondence*, James Whistler to Stéphane Mallarmé, Nov. 10,
 1891, GUL 03820.

p. 265 "something new, something very new": *Correspondence*, Stéphane Mallarmé to James
 Whistler, Nov. 11, 1891, GUL 03821.

p. 265 "Consult with Joyant": *Correspondence*, James Whistler to Stéphane Mallarmé, Nov. 13,
 1891, GUL 03822.

p. 265 And that, Mallarmé later told Whistler, "hastened everything": *Correspondence*,
 Stéphane Mallarmé to James Whistler, Nov. 27, 1891, GUL 03829.

p. 265 both Mallarmé and Duret . . . wrote Whistler to spell out the formalities:
 Correspondence, Stéphane Mallarmé to James Whistler, Nov. 14, 1891, GUL 03823;
 Théodore Duret to James Whistler, Nov. 18, 1891, GUL 0988.

p. 266 "Let's not talk about that for the moment": *Correspondence*, Théodore Duret to James
 Whistler, Nov. 18, 1891, GUL 00988.

p. 266 This "means also everything": *Correspondence*, James Whistler to Beatrix Whistler,
 Feb. 1, 1892, GUL 06610.

p. 266 "ACCEPTE LA SOMME DICTEE": *Correspondence*, James Whistler to Stéphane
 Mallarmé, Nov. 25, 1891, GUL 09301.

p. 266 "the portrait of an elderly lady" ["d'une dame âgée"]: *Correspondence*, Léon Bourgeois to
 [unknown], Nov. 30, 1891, GUL 12318.

p. 266 "Well well I think do you know the Whistlers are bound to win": *Correspondence*, James
 Whistler to William McNeill Whistler, Feb. 1/14, 1892, GUL 07006.

p. 266 "Now that France takes the Mother forever": *Correspondence*, James Whistler to
 Stéphane Mallarmé, Nov. 21 and 24, 1881, GUL 03825.

p. 267 "it would be interesting to hear what [Ruskin] now has to say": *New York Tribune*,
 Dec. 6, 1891, 1.

p. 267 "I wonder what the Press thinks of itself to-day": *Speaker*, Dec. 19, 1891, 747.

Chapter 10: Ghosts

p. 268 The "old dragon sat opposite": Qtd. Hunt, 407.

p. 268 her "dragonizing": Joan Severn to Charles Eliot Norton, Sept. 24, 1885, qtd.
 Birkenhead, 309.

p. 268 "the Coz shuns pen and ink and paper": Joan Severn to Charles Eliot Norton, Dec. 27,
 1890; qtd. Birkenhead, 346.

p. 269 "little glimmers of consciousness": Joan Severn to Charles Eliot Norton, Apr. 26,
 Dec. 27, 1890; qtd. Birkenhead, 345.

p. 269 "It is a sort of calm drifting of life": Joan Severn to Charles Eliot Norton, Feb. 5,
 1892, 347.

p. 269 "I must be very cautious in using my brains yet, awhile": Ruskin and Norton, 443.

p. 269 "quite afloat again in my usual stream": Ruskin and Norton, 444.

p. 269 "I begin the last twelfth of the year": *Works*, 33.xxix.

p. 270 a "loss of motive and spirit which makes progressive work hopeless": Ruskin, *Diaries*,
 3.1008.

p. 270 "Dismal—Dismal—Abysmal—all day long and every day alike": Ruskin, *Diaries*,
 3.1013.

p. 270 "Bothered away from it, and never went again": Collingwood, 2.213.

p. 270 "I'm afraid I'm going off the rails again": Ruskin, *Brantwood Diary*, 502.

p. 270 "the stars rushing at each other": Ruskin and Norton, 461.

p. 270 "alarmed and stupefied": John Ruskin to Henry Swan, qtd. Hunt, 385.

p 270: He attended the Oval that year: Hilton, *Later Years*, 436.

p. 270 "I *am* very naughty about Tinys & Rosalinds": John Ruskin to Joan Severn, July 8, 1882: Ruskin, *John Ruskin's Correspondence*, 203.

p. 271 "The Mont Blanc *we* knew is no more": Ruskin and Norton, 448.

p. 271 he bought it on the spot for 600 guineas: *Works*, 32.xxii.

p. 271 "The recent errors of the French schools": *Works*, 37.421.

p. 271 "Dear Friend, may all good attend you": *Works*, 33.xlv–xlvi.

p. 272 Ruskin reprised not only that lecture: Ruskin, *Brantwood Diary*, 310. Oddly, nearly all of Ruskin's biographers claim that he only gave this particular lecture only once.

p. 272 "vexed" him: Ruskin, *Diaries*, 3.1048.

p. 272 "a greater thing than Raphael's St. Cecilia." *Works*, 37.332.

p. 273 "I had left him in 1873": *Works*, 33.xlvii.

p. 273 "black fog and cold": Ruskin, *Brantwood Diary*, 289.

p. 273 "horrible 'plague-and-fury' wind": Ruskin, *Diaries*, 3.1056.

p. 274 "Remember, for the last twenty years": *Works*, 34.40–41.

p. 274 "We cannot swallow the 'plague-cloud'": *Graphic*, Feb. 9, 1884, 122.

p. 274 "My work now a mere breccia": Ruskin, *Diaries*, 3.1070–71.

p. 274 "so many thoughts": Ruskin, *Diaries*, 3.1078.

p. 274 "How shall I describe that painful performance?": Herkomer, 2.87–88.

p. 275 "Badly off the rails": Ruskin, *Diaries*, 3.1089.

p. 275 "I must never stir out of quiet work more": Ruskin, *Diaries*, 3.1089.

p. 275 "I have written . . . of what it gives me joy to remember": *Works*, 35.11.

p. 276 "contrary and exciting elements": Qtd. Birkenhead, 308.

p. 276 "This last illness": Ruskin and Norton, 486–87.

p. 276 summoning a lawyer to Brantwood to sign over the estate: Birkenhead, 309.

p. 276 "The sweet Joan": Ruskin and Norton, 491.

p. 277 "The present phase is *most trying*": Qtd. Birkenhead, 310.

p. 277 "The poor Coz": Qtd. Birkenhead, 312–13.

p. 277 his desperate need to prove himself master of his household and of his affairs led him into extravagant spending: Birkenhead, 314–15.

p. 277 "He's a foony man is Meester Rooskin." Harker, 48.

p. 278 That August he ceded his checkbook to Joan: Hilton, *Later Years*, 541.

p. 278 instructed her to keep his whereabouts a secret: Birkenhead, 320.

p. 278 Instead, his depression cycled to a manic excitement: Birkenhead, 320–22; Hilton, *Later Years*, 542–43.

p. 278 "He is simply the laughing stock of the people about": Qtd. Hilton, *Later Years*, 543.

p. 278 "horsey, boozy, boaty": Qtd. Spence, 528.

p. 278 not one but two residences: *Lakes Herald*, Jan. 20, 1888, 7.

p. 278 he could in sad solitude sit before a bow window: Ruskin, *Gulf of Years*, 20; Ruskin and Norton, 501.

p. 278 "I'm alone in a room about the size of a railway carriage": Harker, 380.

p. 278 "misery of Sandgate": Ruskin, *Diaries*, 3.1145.

p. 279 His addresses to her between the autumn of 1887 and the spring of 1888 progressed: Ruskin, *Gulf of Years*, 18–41.

p. 279 "humdrum Hotel life": Qtd. Birkenhead, 323.

p. 280 "I am keeping abroad as long as I can stand it": Qtd. Birkenhead, 334.

p. 280 "perhaps the happiest of my whole life": Cockerell, 53.

p. 280 her painful naivete about "ordinary life." Ruskin, *Gulf of Years*, 79.

p. 280 "for the present you belong altogether to me": Ruskin, *Gulf of Years*, 68.

p. 281 "in Paris—you shall enter—a world": Ruskin, *Gulf of Years*, 73–74.

p. 281 "and you *will* be happy with me, while yet I live": Ruskin, *Gulf of Years*, 78.

p. 281 who ended contact between the two permanently: Ruskin, *Gulf of Years*, 80–81.

p. 281 they telegraphed Joan: Birkenhead, 342.

p. 282 "surely more beautiful than those more elaborate and gilded ones": Woolf, 52.

p. 282 "How things bind and blend themselves together!": *Works*, 35.561–62.

p. 282 "He seemed lost among the papers": Birkenhead, 344.

p. 283 assuring unexpected callers and sympathetic enquirers: Hilton, *Later Years*, 582.

p. 283 "looking not unlike his old self": Cockerell, 59.

p. 283 "tranquil, rather wistful, shrunken": Cockerell, 60–61.

p. 283 "silently and for long intervals together gazing": Harrison, 163.

p. 284 pains "all over": *Works*, 35.xliv.

p. 284 While Joan held his hand as Baxter moistened his lips: *Works*, 35.xliv.

p. 284 David Croal Thomson had suggested to him the means to that end: Pennell, *Life* [1909], 2.119–20.

p. 285 three passages culled from *Modern Painters*: *Gentle Art*, 298–99, 307, 320–21.

p. 285 "Painting, or art generally": *Works*, 3.87.

p. 285 Six thousand viewers crammed the gallery on opening day: Anderson and Koval, 352.

p. 285 "he is a bigger minded man than one would have thought": *Correspondence*, David Croal Thomson to James Whistler, Mar. 23, 1892, GUL 05706.

p. 285 "much vexed to see his old opinions come to daylight again!": *Correspondence*, David Croal Thomson to James Whistler, Mar. 26, 1892, GUL 05708.

p. 285 "*Ruskin* . . . did you send him by the way a Card?": *Correspondence*, James Whistler to David Croal Thomson, Apr. 4, 1892, GUL 08344.

p. 286 "Mr. Ruskin, Mr. B. Jones and the Attorney genl of England": *Correspondence*, James Whistler to Algernon Graves, Dec. 12/15, 1893(?), GUL 01834.

p. 286 "*my* labour—*my* brain—*my* name!!": *Correspondence*, James Whistler to David Croal Thomson, Jan. 22/23, 1894, GUL 08276.

p. 286 "It is intolerable": *Correspondence*, James Whistler to Alexander Ionides, Aug. 15, 1895, GUL 02364.

p. 286 That summer he sold his *Fur Jacket* and his portrait of Lady Archie: YMSM, 181, 242.

p. 286 "Let Mr. Untermeyer know": *Correspondence*, James Whistler to David Croal Thomson, Nov. 6, 1892, GUL 08325.

p. 287 "the 'Pot of paint flung into the face'": *Correspondence*, James Whistler to David Croal Thomson, Nov. 6, 1892, GUL 08325.

p. 287 "*commercial* slap in the face": *Correspondence*, James Whistler to George Webb, Nov. 8, 1892, GUL 06171.

p. 287 his commission for full-lengths of the Duke and Duchess of Marlborough: *Correspondence*, David Croal Thomson to James Whistler, May 10, 1892, GUL 05737. Thomson speaks of a price of £2,500, but, knowing Whistler, he would certainly have negotiated in guineas and not pounds.

p. 287 "lots of rubbing out and despair": Qtd. YMSM, 402.

p. 288 his estate amounted to £11,020: Petri, 525.

p. 288 "The finest place of the kind I have ever seen": *Correspondence*, James Whistler to Helen Euphrosyne Whistler, Aug. 1/5, 1892, GUL 06717.

p. 288 "little fairy palace: *Correspondence*, James Whistler to Helen Euphrosyne Whistler, Aug. 1/5, 1892, GUL 06717.

p. 289 "exclusive loyalty and admiration": Rothenstein, 267.

p. 289 a "sketch" of his wife: *Correspondence*, William Eden to James Whistler, Jan. 5, 1894, GUL 01033.

p. 289 "You really are magnificent!": *Correspondence*, James Whistler to William Eden, Feb. 14, 1894, GUL 02688.

p. 290 "the most irresistible friend in the world": Du Maurier, *Trilby*.

p. 290 "pleasant recollections": *Pall Mall Gazette*, May 19, 1894, 1.

p. 290 He blasted du Maurier: *Correspondence*, James Whistler to George du Maurier, Apr. 4, 1894(?), GUL 00971; *Pall Mall Gazette*, May 15, 1894, 2.

p. 290 He attempted to have du Maurier expelled from their mutual club: *Correspondence*, James Whistler to the Committee of the Beefsteak Club, May 7, 1894, GUL 00268.

p. 290 Marks half-heartedly agreed; Poynter flatly refused: *Correspondence*, Henry Stacy Marks to James Whistler, May 24, 1894, GUL 04017; Edward Poynter to James Whistler, May 27, 1894, GUL 05015.

p. 290 "I look upon this as one of the most brilliant and *complete* triumphs": *Correspondence*, James Whistler to William Webb, Aug. 22/25, 1894(?), GUL 06199.

p. 290 Sir William Eden returned from India and recommenced battle: Whistler, *Eden versus Whistler*, 12–15.

p. 291 summoned his brother Willie to hurry to Paris: *Correspondence*, James Whistler to William McNeill Whistler, Nov. 15, 1894, GUL 07015.

p. 291 "grief to both": Pennell, *Whistler Journal*, 254.

p. 291 a particularly unpleasant and bullying doctor: *Correspondence*, James Whistler to Beatrix Whistler, Nov. 3, 1895, GUL 06632, Nov. 18, 1895, GUL 06641. Kennedy was a proponent of the Mattei cure, a controversial herbal treatment for cancer (Baylen, 156).

p. 291 half-heartedly working on lithographs that he later wished destroyed: Pennell, *Life* [1919], 329.

p. 291 Beatrix instead left London to convalesce with her sister in Devonshire: *Correspondence*, James Whistler to Mrs. Talbot, Mar. 13, 1895, GUL 05656.

p. 291 "I bolted over to Mrs. Hale": *Correspondence*, James Whistler to Beatrix Whistler, Mar. 3, 1895, GUL 06626.

p. 292 "we have wiped up the place with the Baronet!": *Correspondence*, James Whistler to William Webb, Mar. 24/31, 1895, GUL 06243.

p. 292 in his opinion as an art critic: *New York Herald* [Paris], Mar. 2, 1895, 3.

p. 292 "Yesterday . . . I saw an elderly excentric": *Correspondence*, George Moore to James Whistler, Mar. 11, 1895, GUL 04197.

p. 292 "gross insult": *Correspondence*, James Whistler to George Moore, Mar. 12, 1895, 04182.

p. 292 Moore laughed that off: *Correspondence*, George Moore to James Whistler, Mar. 13, 1895, GUL 04183.

p. 292 "one long anxiety and terror": *Correspondence*, James Whistler to John James Cowan, Apr. 4, 1896, GUL 00712.

p. 292 He took on another commission, of Chicago debutante Marion Peck: YMSM, 439.

p. 292 "She is the most cut-throat person I've seen": *Correspondence*, Edward Guthrie Kennedy to James Whistler, Feb. 18, 1896, GUL 07263.

p. 293 he briefly contemplated a transatlantic crossing to consult with a "great Medicine
 Man": *Correspondence*, James Whistler to Edward Guthrie Kennedy, Dec. 9, 1895,
 GUL 09735, Feb. 2, 1896, GUL 09736.

p. 293 he commandeered Sickert's studio, and then he commandeered John Singer Sargent's:
 Pennell, *Life* [1919], 332.

p. 293 "the climax of all his black and white work": Way, 126.

p. 293 "There is hope": *Correspondence*, James Whistler to John James Cowan, Apr. 4, 1896,
 GUL 00712.

p. 294 "Don't speak!": Pennell, *Life* [1919], 335. The acquaintance was Sydney Pawling,
 William Heinemann's business partner.

p. 294 he had taken steps: *Correspondence*, William Webb to Rosalind Birnie Philip, May 14,
 1896, GUL 06230.

p. 294 "At first he would not join us if we expected anyone": Pennell, *Life* [1919], 336.

p. 294 "battle royal": *Correspondence*, James Whistler to Edward Guthrie Kennedy, Apr. 30,
 1896, GUL 09744.

p. 295 put into the hands of his solicitor both the settling of his longstanding bill to them,
 and the recovery of his paintings: *Correspondence*, Greenfield and Cracknell to George
 and William Webb, Aug. 10, 1897, GUL 01854; George and William Webb to James
 Whistler, Aug. 11, 1897, GUL 06241.

p. 295 "parading Bond Street with Sir William Eden": *Correspondence*, James Whistler to
 Rosalind Birnie Philip, Oct. 12, 1896, GUL 4681.

p. 295 After vilifying Sickert both as Judas Iscariot and as Benedict Arnold: *Correspondence*,
 James Whistler to Walter Sickert, Oct. 13/20, 1896, GUL 10613; Nov. 20/24, 1896,
 GUL 05445.

p. 295 "ENEMY MET AND DESTROYED": *Correspondence*, James Whistler to Rosalind
 Birnie Philip, Apr. 6, 1897, GUL 04705.

p. 296 "It is astonishing, his lack of discrimination": *Correspondence*, Edward Guthrie
 Kennedy to none, June 7, 1897, GUL 09769.

p. 296 Kennedy came to blows with Whistler over this at least once: Pennell, *Whistler
 Journal*, 209.

p. 296 "Bunko Baronets": *Correspondence*, James Whistler to David Croal Thomson, July 14,
 1896, GUL 08404.

p. 296 "I want you to stipulate for me": *Correspondence*: James Whistler to David Croal
 Thomson, July 14, 1896, GUL 08404.

p. 296 "master and proprietor of his work": Whistler, *Eden Versus Whistler*, 78.

p. 297 sublet from a bootmaker for £90 a year: Hopkinson, 701, 704.

p. 297 he warned Whistler that the Company would fail in a month: *Correspondence*, Edward
 Guthrie Kennedy, May 23, 1897, GUL 09768.

p. 297 Anderson retained her post for two years: Hopkinson, 704.

p. 297 proving to Whistler that dealers did have their usefulness Pennell, *Whistler
 Journal*, 15.

p. 297 the brainchild of the young American journalist Francis Howard: Athill, 22.

p. 298 offering them full autonomy: Pennell, *Life* [1919], 369.

p. 298 When some less loyal members of the council threatened to resign: Athill, 23.

p. 298 foes—Sickert, Stott of Oldham—were out: Athill, 23.

p. 298 obtaining in this way five sculptures by Rodin: Newton and MacDonald, 120;
 Sutherland, 309.

p. 298 proved to be the hit of the exhibition: Athill, 25.

p. 298 arranged for the prominent placement of his own nine paintings: *Correspondence*, James Whistler to Albert Ludovici, Apr./May 1898, GUL 10694.

p. 299 averaging at first a meager 160 a day: *Correspondence*, Albert Ludovici to James Whistler, May 23, 1898, GUL 02313.

p. 299 the council refused to entice them with the promise of prizes or medals: Athill, 29.

p. 299 "fighting ship": *Correspondence*, James Whistler to John Lavery, Apr. 12, 1898, GUL 11307.

p. 299 "Anglo Américan School": *Correspondence*, Académie Carmen to James Whistler, Sept. 1898, GUL 00008.

p. 299 Carmen, who had set her fees at double the average: Asleson, 76.

p. 300 "to win a few disciples and imbue them": Crawford, 388.

p. 300 "could only see Art from his own standpoint": Cuneo, 532.

p. 300 "I do not interfere with your individuality": Pennell, *Life* [1919], 380.

p. 300 "*beaucoup des petits Wheestlers!*": Qtd. Cuneo, 532.

p. 300 "painting black as a hat": Frederick MacMonnies, qtd. Pennell, *Life* [1919], 387.

p. 300 "Whistler's knowledge of a lifetime": Simon Bussy, qtd. Asleson, 77.

p. 301 "I bought a palette just like his": Pennell, *Life* [1919], 392.

p. 301 "whenever, in fact, the spirit moved him: Cuneo, 531.

p. 301 "You felt that as the door closed behind him": Paul Henry, qtd. Asleson, 79.

p. 301 "exasperated by hearing his footsteps dying away": Cuneo, 532.

p. 301 "disagreeable students": "*Éleves désagreables*"; *Correspondence*, James Whistler to Carmen Rossi, July 9, 1900, GUL 10742.

p. 301 outvying one another to dress resplendently: Cuneo, 540.

p. 302 set off by the bright red rosette of his *Légion d'Honneur*: Anna Ostrovmova-Ledbedeva, qtd. Anderson and Koval, 436; Crawford, 388.

p. 302 "Nothing could be funnier": Mullikin, 237.

p. 302 "much stronger, much stronger!" Cuneo, 534.

p. 302 "his secrets [to] keep and his lawful commands [to] obey." *Correspondence*, William Webb to James Whistler, July 20, 1899, GUL 00019. There is some confusion in this document; the apprenticeship might have been for ten, not five years.

p. 303 "Wearied" and "worried" that November: *Correspondence*, James Whistler to Helen Euphrosyne Whistler, Nov. 30, 1900, GUL 03305.

p. 303 Algiers was "cheap" and rainy, Tangier freezing cold and "*entirely too* 'Eastern.'" *Correspondence*, James Whistler to Rosalind Birnie Philip, Jan. 11, 1901, GUL 04784.

p. 303 he and Ronnie spent most of their time: *Correspondence*, James Whistler to John James Cowan, Feb. 18, 1901, GUL 00741.

p. 303 Whistler did manage, however, to befriend a doctor there: *Correspondence*, James Whistler to Rosalind Birnie Philip, Jan. 18, 1901, GUL 04785.

p. 303 "This is such a wonderful place": *Correspondence*, James Whistler to Rosalind Birnie Philip, Jan. 30, 1901, GUL 04788.

p. 303 "the despotic, narrow, and discouraging principles": *Correspondence*, James Whistler to Inez Addams, Mar. 1901, GUL 00005.

p. 303 "Document read yesterday": *Correspondence*, Inez Addams to James Whistler, Apr. 3, 1901, GUL 00223.

p. 304 he directed his own *avocat* to sue his neighbor for 20,000 francs: *Correspondence*, James Whistler to Rosalind Birnie Philip, Mar. 8, 1901, GUL 04797.

p. 304 his *avocat* assured him that this was a case he would never win: *Correspondence*, Antoine Ratier to James Whistler, Mar. 9, 1901, GUL 05111.

p. 304 Heinemann taught Whistler to play dominoes: Pennell, *Life* [1919], 408.

p. 304 "very down": *Correspondence*, James Whistler to Rosalind Birnie Philip, Mar. 20, 1901, GUL 04799.

p. 304 "For *years* . . . I have had *no play!*": *Correspondence*, James Whistler to Rosalind Birnie Philip, Apr. 6, 1901, GUL 04803.

p. 304 "infinitely better, like himself again": Pennell, *Whistler Journal*, 208.

p. 305 To Dresden George Sauter . . . had sent eight Whistler etchings: *Correspondence*, Max Lehrs to James Whistler, Oct. 9, 1901, GUL 00947.

p. 305 American patrons—apparently without Whistler's prompting—submitted works: *Pan-American Exposition*, 12–13, 108–110.

p. 306 lithographs of his had been appearing in Paris shops without his permission: Pennell, *Whistler Journal*, 243–44.

p. 306 "It begins to be clear": *Correspondence*, James Whistler to John James Cowan, July 2–4, 1901, GUL 00746.

p. 306 he could no more hurt her, he declared, than he could destroy one of his best paintings: *Correspondence*, James Whistler to Clifford and Inez Eleanor Addams, Aug. 27, 1901, GUL 00124.

p. 306 At first he set his apprentices to getting the truth from her: *Correspondence*, James Whistler to Inez Addams, Oct. 21, 1901, GUL 00091.

p. 306 he summoned her that October to London: *Correspondence*, Rosalind Birnie Philip to James Whistler, [misdated] Oct. 10, 1901, GUL 04815; Pennell, *Whistler Journal*, 244.

p. 306 impounding as stolen two suspicious paintings: *Correspondence*, James Whistler to John James Cowan, Oct. 26/30, 1901.

p. 306 from Paris, Bernheim had sent him an "icily polite" note: *Correspondence*, Edward Guthrie Kennedy to [none], Sept. 1903, GUL 09875. Proof that Whistler himself sold in July 1899 seven paintings to a dealer—most likely Hessele—can be found in *Correspondence*, James Whistler to Edward Guthrie Kennedy, July 8, 1899, GUL 09790. Though it is likely that the "Bernheim" to whom Kennedy refers was Gaston Bernheim, it might actually have been Alexandre Bernheim, his father—also a dealer in art.

p. 306 "Next year": *Correspondence*, Edward Guthrie Kennedy to [none], Sept. 1903, GUL 09875.

p. 307 "we were never allowed to see him": Pennell, *Whistler Journal*, 221.

p. 307 "swallowed him up for a few weeks": Pennell, *Whistler Journal*, 234.

p. 307 "I have fallen into a trap": *Correspondence*, James Whistler to William Webb, Apr. 1902/1903, GUL 06268.

p. 307 "the disastrous effect of art upon the British middle classes": Pennell, *Life* [1919], 414.

p. 308 "knock, knock, knock all day": Pennell, *Life* [1919], 415.

p. 308 spurred him to dangerous rages: Pennell, *Whistler Journal*, 242

p. 308 "cleaning out young millionaires": Pennell, *Whistler Journal*, 235.

p. 308 "odious": Pennell, *Whistler Journal*, 271.

p. 308 "hypnotised": Pennell, *Life* [1919], 422.

p. 308 a good listener to Whistler's stories: *Cincinnati Enquirer*, July 21, 1903, 4.

p. 308 "the only man who had never made a mistake in the studio": Pennell, *Life* [1919], 426.

p. 308 he could mix a mean cocktail: Pennell, *Whistler Journal*, 279.

p. 308 it was Whistler who coaxed him to sit for his portrait: Freer, 90.

p. 308 "microbes": Pennell, *Whistler Journal*, 257.

p. 308 dinner, gin slings, and anti-British tirades: Lawton and Merrill, 52.

p. 309 appalled by the tasteless decorations springing up across London: Freer, 128–30.

p. 309 "fearing because of the great heart strain": *Correspondence*: Whistler to none [his will], July 1, 1902.

p. 309 On the crossing home he suffered a relapse: *Correspondence*, Charles Lang Freer to Rosalind Birnie Philip, Oct. 30, 1902, GUL 13832.

p. 309 "involved a restraint": Pennell, *Life* [1919], 424.

p. 309 "the finest thing of his later period": Pennell, *Life* [1919], 426.

p. 310 "To destroy is to exist, you know," Pennell, *Whistler Journal*, 258.

p. 310 Frederick Wedmore, critic for the *Standard*, was sure he had seen that work before: *London Evening Standard*, Nov. 13, 1902, 3.

p. 310 "perfidious little Podsnap paragraphs": *London Evening Standard*, Nov. 21, 1902, 5.

p. 310 "Don't tell him *now*": Robertson, 201.

p. 310 "Bravo, Montesquiou!": *Correspondence*, James Whistler to Robert de Montesquiou-Fézensac, Dec. 7, 1902, GUL 04161.

p. 310 New York reporters badgered Whistler's friends for details: Pennell, *Whistler Journal*, 273.

p. 311 "wonderfully fine": Pennell, *Whistler Journal*, 286.

p. 311 to see Whistler fall asleep between brushstrokes: Sutherland, 335.

p. 311 Whistler briefly considered traveling to Scotland: *Correspondence*, James Whistler to Robert Herbert Story, Feb. 28, 1903, GUL 01683.

p. 311 Whistler acknowledged that this would be impossible: *Correspondence*, James Whistler to Robert Herbert Story, Apr. 4, 1903, GUL 01687.

p. 311 James Guthrie accepting it for him: Anderson and Koval, 456. They note that Guthrie and another—Professor of English Literature Walter Raleigh—accepted the degree.

p. 311 "Whistler's health varied so during the winter": Pennell, *Life* [1919], 428.

p. 311 vague, dead eyes: Pennell, *Whistler Journal*, 289.

p. 311 "no one without a clue": Pennell, *Whistler Journal*, 290.

p. 311 Walter Greaves . . . was turned away: Pocock, 136–37.

p. 311 "come tomorrow sure": Freer.

p. 312 A burst cerebral embolism: Sutherland, 338; *Correspondence*, Stanley George Moslin to Edith Whibley [death certificate], July 20, 1903, GUL 06964.

Epilogue

p. 316 "promote the teachings": *The Academy*, Dec. 21, 1878, 523.

p. 316 Societies in Glasgow, Aberdeen, Sheffield, Birkenhead and London soon followed: Eagles.

p. 317 "one of the very few necessary and inevitable utterances of the century": Morris, i.

p. 317 "one of the most remarkable men": Tolstoy, 188.

p. 317 "I could not get any sleep": Gandhi, 44.313.

p. 317 Similarly animated by Ruskin's social idealism: Stead, 568–82.

p. 318 "it was through this gate": Attlee, 18.

p. 318 "some terrible change of climate": *Works*, 37.101.

p. 318 a "catastrophic" fall: Clark and Ruskin, xiv.

p. 319 over eight hundred prints, paintings, and drawings: Rogers, 142.

p. 319 his paintings hang on the walls of over a hundred of them: Trippi, 48.

p. 320 the most profound influence upon public taste since Ruskin: Clark, ix.

p. 320 "coldly abstract sensual vision": Roger Fry in *The Athenæum*, July 25, 1903, 133.

p. 320 "cut away at a blow": Roger Fry in *The Athenæum*, July 25, 1903, 133.

p. 320 "Whistler . . . was a superb decorator": Laver, 245.

p. 321 "clap-trap": Whistler, *Gentle Art*, 127

p. 321 "The imitator . . . is a poor kind of creature": Whistler, *Gentle Art*, 128.

p. 322 "inner necessity": Kandinsky, 30.

p. 322 "The ascent to the heights of non-objective art": Malevich, 68.

p. 322 "quiet horizontals, broad muted tones": Barr, 43.

p. 322 In his guide he essentially begins with that painting: Barr, 10.

BIBLIOGRAPHY

Abélès, Luce. "Mallarmé, Whistler, and Monet." *Turner Whistler Monet: Impressionist Visions*. Ed. Katharine Lochnan. Toronto: Art Gallery of Ontario, 2003, 163–68.

Allingham, William: *William Allingham: A Diary*. Ed. H. Allingham and D. Radford. London: Macmillan, 1907.

Anderson, Ronald, and Anne Koval. *James McNeill Whistler: Beyond the Myth*. New York: Carroll & Graf, 1994.

Angeli, Helen Rossetti. *Pre-Raphaelite Twilight: The Story of Charles Augustus Howell*. London: Richards, 1954.

Armstrong, Thomas. *Thomas Armstrong, C. B.: A Memoir: 1832–1911*. London: Martin Secker, 1912.

Ashbee, Felicity. "Dandy in Decline: Whistler's Last Home." *Country Life* (Nov. 22, 1894): 1560–61.

Asleson, Robyn. "The Idol and His Apprentices: Whistler and the Académie Carmen of Paris." In *After Whistler: The Artist and His Influence on American Painting*. New Haven, CT: Yale University Press, 2003, 74–85.

Athill, Philip. "The International Society of Sculptors, Painters and Gravers." *Burlington Magazine*, 127.982 (Jan. 1985), 21–29.

Attlee, Clement. "The Pleasure of Books." *National and English Review* (Jan. 1954): 17–21.

Bacher, Otto H. *With Whistler in Venice*. New York: Century, 1909.

Barr, Alfred H., Jr. *What Is Modern Painting?* Rev. ed. New York: Museum of Modern Art, 1956.

Baylen, Joseph O. "The Mattei Cancer Cure: A Victorian Nostrum." *Proceedings of the American Philosophical Society* 113.2 (1969): 149–176.

Bendix, Deanna Mahron. *Diabolical Designs: Paintings, Interiors and Exhibitions of James McNeill Whistler*. Washington, DC: Smithsonian Institution Press, 1995.

Benson, A. C. *Memories and Friends*. London: John Murray, 1924.

Birkenhead, Sheila. *Illustrious Friends: The Story of Joseph Severn and His Son Arthur*. New York: Reynal & Company, 1965.

Boughton, George Henry. "A Few of the Various Whistlers I have Known." *Studio* 30 (1904): 210–18.

Boyce, George Price. *The Diaries of George Price Boyce*. Ed. Virginia Surtees. London: Old Water-Colour Society, 1980.

Bragman, Louis J. "The Case of John Ruskin: A Study in Cyclothymia." *American Journal of Psychiatry* 91 (1935): 1137–59.

Burne-Jones, Edward. Autograph letter signed to John Ruskin, Nov. 5, 1878 [actually 1877]. Mark Samuels Lasner Collection, University of Delaware. Available online at https://exhibitions.lib .udel.edu/whistler/home/the-butterfly-goes-to-court/.

———. *Burne-Jones Talking: His Conversations, 1895–1898*. Ed. Mary Lago. Columbia: University of Missouri P, 1981.

Burne-Jones, Georgiana. *Memorials of Edward Burne-Jones*. New York: Macmillan, 1906.

Campbell, Lady Archibald. *Rainbow-Music: or the Philosophy of Harmony in Colour-Grouping*. London: Bernard Quaritch, 1886.

Camuffo, Dario, Chiara Bertolin, Alberto Craivich, Rossella Granziero, and Silvia Enzi. "When the Lagoon was Frozen over in Venice from A. D. 604 to 2012: evidence from written documentary sources, visual arts and instrumental readings." *Méditerranée—Journal of Mediterranean Geography*. https://journals.openedition.org/mediterranee/7983.

Carr, Alice Comyns. *Mrs. J. Comyns Carr's Reminiscences*. Ed. Eve Adam. London: Hutchinson & Co., nd.

Carr, Joseph Comyns. *Some Eminent Victorians: Personal Recollections in the World of Art and Letters*. London: Duckworth, 1908.

Census Returns of England and Wales, 1861. Kew, Surrey, England: The National Archives of the UK, 1861.

Census Returns of England and Wales, 1891. Kew, Surrey, England: The National Archives of the UK, 1891.

Clark, Kenneth. "Introduction." *Last Lectures by Roger Fry*. Cambridge: Cambridge University Press, 1939.

Clark, Kenneth, and John Ruskin. *Ruskin Today*. New York: Holt, Rinehart and Winston, 1964.

Cockerell, Sydney Carlyle. *Friends of a Lifetime: Letters to Sydney Carlyle Cockerell*. Ed. Viola Meynell. London: Jonathan Cape, 1940.

Collingwood, W G. *The Life and Work of John Ruskin*. 2 vols. London: Methuen, 1893.

Commissioners in Lunacy. Lunacy Patients Admission Registers 1846–1912: Class MH 94, Piece 27 (Jan. 1883–Dec. 1884).

Cook, E. T. *The Life of John Ruskin*. New York: Macmillan, 1911. 2 vols.

Cox, Devon. *The Street of Wonderful Possibilities*. London: Frances Lincoln, 2015.

Crane, Walter. *An Artist's Reminiscences*. London: Methuen, 1907.

Crawford, Earl Stetson. "The Gentler Side of Mr. Whistler." *The Reader* 3.4 (Mar. 1904): 388–90.

Cuneo, Cyrus. "Whistler's Academy of Painting. Some Parisian Recollections." *Pall Mall Magazine* (Nov. 1906): 531–40.

Cunningham, Henry Stewart. *Lord Bowen: A Biographical Sketch*. London: John Murray, 1897.

Dorment, Richard, Nicolai Cikovsky, Ruth Fine, Geneviève Lacambre, and Margaret F. Macdonald. *James McNeill Whistler*. New York: Harry N. Abrams, 1995.

Drew, Mary Gladstone. *Catherine Gladstone*. London: Nisbet & Co., 1919.

Du Maurier, George. *Trilby*. Published serially in *Harper's New Monthly Magazine* 88 (Dec. 1893–May 1894): 577.

———. *The Young George du Maurier: A Selection of His Letters, 1860–67*. Ed. Daphne du Maurier. New York: Doubleday, 1952.

Duret, Théodore. *Whistler*. Trans. Frank Rutter. London: Grant Richards, 1917.

Eagles, Stuart. "The History of the Ruskin Society." Ruskin Society of North America. https ://www.ruskinsocietyna.org/history.

Eddy, Arthur Jerome. *Recollections and Impressions of James A. McNeill Whistler.* New York: Benjamin Blom, 1972 [1904].

Esposito, Anthony. "Carr, Joseph William Comyns (1849–1916)." *Oxford Dictionary of National Biography.* Online ed. Ed. David Cannadine. Oxford: Oxford University Press, 2004.

Faberman, Hilarie. "'Best Shop in London': The Fine Art Society and the Victorian Art Scene." In *The Grosvenor Gallery: A Palace of Art in Victorian England.* Ed. Susan P. Casteras and Colleen Denney. New Haven, CT: Yale University Press, 1996.

Fildes, L. V. *Luke Fildes, R. A.: A Victorian Painter.* London: Michael Joseph, 1968.

Fleming, G. H. *James McNeill Whistler: A Life.* Gloucestershire: Windrush Press, 1991.

Freer, Charles Lang. *Charles Lang Freer's Letters to Frank Hecker during Foreign Travels, 1899–1903.* Smithsonian Institution Transcription Center, Freer Gallery of Art and Arthur M. Sackler Gallery.

Frith, William Powell. *My Autobiography and Reminiscences.* 3 vols. London: Richard Bentley and Son, 1888.

Fuller, Jean Overton. *Swinburne: A Critical Biography.* London: Chatto & Windus, 1968.

Gandhi, Mahatma. *The Collected Works of Mahatma Gandhi.* New Delhi: Publications Division, Ministry of Information and Broadcasting, Government of India, 2000.

Genealogy of William Graham. The Cobbold Family History Trust interactive search for William Graham (1818–1885). https://family-tree.cobboldfht.com/4589/william-graham.

Getscher, Robert H. "Whistler's Paintings in Valparaiso: *Carpe Diem.*" In *Out of Context: American Artists Abroad.* Ed. Laura Felleman Fattal and Carol Salus. Westport, CT: Prager, 2004, 11–22.

Gilbert, William Schwenck. *Correspondence and Papers of Sir William Schwenck Gilbert.* British Library, Add MS 49322.

Glover, James. *Jimmy Glover, His Book.* London: Methuen, 1911.

Godwin, E. W. *Is Mr. Ruskin Living Too Long? Selected Writings of E. W. Godwin on Victorian Architecture, Design, and Culture.* Ed. Juliet Kinchin and Paul Stirton. Oxford: White Cockade, 2005.

H [likely George Harley]. "The Late Mr. John Ruskin." *British Medical Journal* (Jan. 27, 1900): 225–26.

Hallé, Charles. *Notes from a Painter's Life: Including the Founding of Two Galleries.* London: John Murray, 1909.

Hamilton, John Andrew. "Holker, Sir John (1828–1882)." *Dictionary of National Biography.* Ed. Sidney Lee. 27:133–34.

[Harker, Lizzie]. "John Ruskin in the 'Eighties." *Outlook*, Feb. 11, 1899, 48–49; Oct. 21, 1899, 379–80.

Harrison, Frederic. *John Ruskin.* London: Macmillan, 1920.

Hawthorne, Julian. "A Champion of Art." *The Independent*, Nov. 2, 1899, 2954–60.

Hawthorne, Minnie [Mrs. Julian Hawthorne]. "Mr. Whistler's New Portraits." *Harper's Bazaar*, Oct. 15, 1881, 658–9.

Henrey, [Mrs.] Robert. *A Century Between.* New York: Longmans, Green & Co, 1937.

Herkomer, Hubert von. *The Herkomers.* London: Macmillan, 1911. 2 vols.

Hilton, Tim. *John Ruskin: The Early Years.* New Haven, CT: Yale University Press, 1985.

———. *John Ruskin: The Later Years.* New Haven, CT: Yale University Press, 2000.

Hitchcock, Tim, Robert Shoemaker, Clive Emsley, Sharon Howard, Jamie McLaughlin, et al. "James Burden: Deception: Forgery" [https://www.oldbaileyonline.org/browse.jsp?id=def1-379 -18790331&div=t18790331-379]. *The Old Bailey Proceedings Online*, 1674–1913.

Hopkinson, Martin. "Whistler's 'Company of the Butterfly.'" *Burlington Magazine* 136.1099 (Oct. 1994): 700–704.

Horner, Frances. *Time Remembered.* London: Heinemann, 1933.

Houfe, Simon. "Whistler in the Country: His Unrecorded Friendship with Lewis Jarvis." *Apollo* 98 (1973): 282–85.

Hueffer, Ford M. *Ford Madox Brown: A Record of His Life and Work*. New York: Longman, Green & Co., 1896.

Hughes, Thomas. *James Fraser, Second Bishop of Manchester: A Memoir, 1818–1885*. Np.: n. p., 1887.

Hunt, John Dixon. *The Wider Sea*. New York: Viking, 1982.

"Inflation." The Bank of England. https://www.bankofengland.co.uk/monetary-policy/inflation.

Ionides, Luke. *Memories*. Ludlow, UK: Dog Rose Press, 1996 [1925].

Ives, Colta Feller. *The Great Wave: The Influence of Japanese Woodcuts on French Prints*. New York: Metropolitan Museum of Art, 1974.

James, Henry. *The Complete Letters of Henry James, 1876–1878*. Ed. Pierre A. Walker and Greg W. Zacharias. 2 vols. Lincoln: University of Nebraska Press, 2012.

———. *Views and Reviews*. Boston: Ball, 1908.

Jones, Jonathan. "Mystery Solved? Identity of Courbet's 19th-Century Nude Revealed." *Guardian*, Sept. 25, 2018. Https://www.theguardian.com/artanddesign/2018/sep/25/origin-of-gustave -courbet-scandalous-painting-revealed.

Jopling, Louise. *Twenty Years of My Life: 1867 to 1887*. London: Bodley Head, 1925.

Kandinsky, Wassily. *On the Spiritual in Art*. First complete English translation. New York: Solomon R. Guggenheim Foundation, 1946.

Kempster, P. A., and J. E. Alty. "John Ruskin's Relapsing Encephalopathy." *Brain* 131 (2008): 2520–25.

Kitchin, G. W. "Ruskin at Oxford." *St. George* (Jan. 1901): 15–43.

Lancaster, H. H. *Essays and Reviews*. Edinburgh: Edmonston and Douglas, 1876.

Langtry, Lillie. *The Days I Knew*. North Hollywood, CA: Panoply, 2005 [1925].

Laver, James. *Whistler*. London: White Lion, 1951 [1930].

Lawton, Thomas, and Linda Merrill. *Freer: A Legacy of Art*. Washington, DC: Freer Gallery of Art, 1993.

Lentin, A. "Bowen, Charles Synge Christopher, Baron Bowen (1835–1894)." *Oxford Dictionary of National Biography*. Online ed. Ed. David Cannadine. Oxford: Oxford University Press, 2004.

Leon, Derrick. *Ruskin: The Great Victorian*. London: Routledge & Kegan Paul, 1949.

Lochnan, Katharine A. *Whistler's Etchings and the Sources of His Etching Style 1855–1880*. New York: Garland, 1988.

London and Surrey, England, Marriage Bonds and Allegations, 1597–1920. Kew, Surrey, England: National Archives of the UK.

Loraine, Percy. "Rodd, James Rennell, First Baron Rennell (1858–1941)." Revised by Alan Campbell. *Oxford Dictionary of National Biography*. Online ed. Ed. David Cannadine. Oxford: Oxford University Press, 2008.

Lostalot, Alfred de. "Expositions Diverses a Paris." *Gazette des Beaux-arts* 28 (July 1883): 77–91.

Lucas, George A. *The Diary of American Art Agent in Paris, 1857–1909*. Ed. Lilian M. C. Randall. 2 vols. Princeton, NJ: Princeton University Press, 1979.

Ludovici, Albert. "The Whistlerian Dynasty at Suffolk Street." *Art Journal* (July–Aug. 1906): 193–95, 237–39.

Lutyens, Mary. *Millais and the Ruskins*. London: John Murray, 1967.

———. *The Ruskins and the Grays*. London: John Murray, 1972.

———. *Young Mrs. Ruskin in Venice*. New York: Vanguard Press, 1965.

MacDiarmid, Kate R. *Whistler's Mother: Her Life, Letters and Journal*. North Wilkesboro, NC: N.p., 1936?

MacDonald, Greville. *Reminiscences of a Specialist*. London: George Allen & Unwin, 1932.

MacDonald, Margaret. "Maud Franklin." *James McNeill Whistler: A Reexamination*. Ed. Ruth E. Fine. Washington DC: National Gallery of Art, 1987.

———. "The Painting of Whistler's Mother." *Whistler's Mother: An American Icon*. Ed. Margaret MacDonald. Aldershot, Hampshire: Lund Humphries, 2003.

———. *The Woman in White: Joanna Hiffernan and James McNeill Whistler*. New Haven, CT: Yale University Press, 2020.

MacDonald, Margaret, Patricia de Montfort, Nigel Thorpe, and Georgia Toutziari, eds. *The Correspondence of James McNeill Whistler, 1855–1903*, including *The Correspondence of Anna McNeill Whistler*. Online edition. Glasgow, University of Glasgow, 2003–2010.

MacDonald, Margaret and Grischka Petri. *The Paintings of James McNeill Whistler: A Catalogue Raisonné*. University of Glasgow, 2014. Website at http://whistlerpaintings.gla.ac.uk.

Mahey, John A. "The Letters of James McNeill Whistler to George A. Lucas." *Art Bulletin* 49 (1971): 247–57.

Malevich, Kasimir. *The Non-Objective World*. Chicago: Paul Theobald & Co., 1959.

Mathews, Nancy Mowll. *Mary Cassatt: A Life*. New Haven, CT: Yale University Press, 1998.

Maus, Otto. "Whistler in Belgium." *Studio* 32 (1904): 7–12.

Menpes, Mortimer. *Whistler As I Knew Him*. London: Adam and Charles Black, 1904.

Merrill, Linda. "Leyland, Frederick Richards (1831–1892)." *Oxford Dictionary of National Biography*. Online ed. Ed. David Cannadine. Oxford: Oxford University Press, 2004.

———. *The Peacock Room: A Cultural Biography*. Washington, DC: Freer Gallery of Art, 1998.

———. *A Pot of Paint: Aesthetics on Trial in* Whistler v. Ruskin. Washington, DC: Smithsonian Institution Press, 1992.

———. "Whistler in America." In Merrill et al., *After Whistler*. New Haven, CT: Yale University Press, 2003, 10–31.

Monkhouse, Cosmo. *Exhibition of Drawings and Studies by Sir Edward Burne-Jones, Bart*. London: Burlington Fine Arts Club, 1899.

Monroe, Harriet. *A Poet's Life: Seventy Years in a Changing World*. New York: Macmillan, 1938.

Morris, William. "Preface." In *The Nature of Gothic a Chapter of the Stones of Venice*, by John Ruskin. Hammersmith: Kelmscott Press, 1892.

Mullikin, Mary Augusta. "Reminiscences of the Whistler Academy." *The Studio*, 34.145 (Apr. 1905): 237–41.

Mumford, Elizabeth. *Whistler's Mother: The Life of Anna McNeill Whistler*. Ann Arbor, MI: Plutarch Press, 1971.

Musolino, Giovanni: *Santa Lucia a Venezia: Storia—Culto—Arte*. [Venice]: Ferdinando Ongania, 1961.

Myers, Kenneth John. *Mr. Whistler's Gallery: Pictures at an 1884 Exhibition*. Washington, DC: Smithsonian, 2003.

Newton, Joy. "Whistler and La Société des Vingt." *Burlington Magazine* 143 (Aug. 2001): 480–88.

Newton, Joy, and Margaret MacDonald. "Whistler, Rodin, and the 'International.'" *Gazette des Beaux-Arts* 103 (Mar. 1984): 115–23.

Nicoll, W. Robertson. "The First Published Writings of Mr. Ruskin." *Bookman* (June 1895): 321.

O'Gorman, Francis. "Religion." In *The Cambridge Companion to John Ruskin*. Ed. Francis O'Gorman. Cambridge: Cambridge University Press, 2015, 144–56.

Oldham, James. "Special Juries in England: Nineteenth Century Usage and Reform." *Journal of Legal History* 8 (1987): 148–66.

Panton, Jane Ellen. *Leaves from a Life*. London: Eveleigh Nash, 1908.

Parry, Edward Abbot. *The Drama of the Law*. New York: Charles Scribner's Sons, 1924.

Pater, Walter H. *Studies in the History of the Renaissance*. London, Macmillan, 1873.

Pearson, Hesketh. *Lives of the Wits*. New York: Harper & Row, 1962.

———. *The Man Whistler*. New York: Harper, 1953.

Pennell, Elizabeth Robins, and Joseph Pennell. *The Life of James McNeill Whistler*, 5th ed. London: William Heinemann, 1911.

———. *The Life of James McNeill Whistler*, 6th ed. Philadelphia: J. B. Lippincott, 1919.

———. *The Whistler Journal*. Philadelphia: J. B. Lippincott, 1921.

Petri, Grischka. *Arrangement in Business: The Art Markets and the Career of James McNeill Whistler*. Hildesheim, Germany: Georg Olms Verlag, 2011.

Pissarro, Camille. *Letters to His Son Lucien*. Ed. John Rewald. Trans. Lionel Abel. New York: Pantheon, 1943.

Pocock, Tom. *Chelsea Reach: The Brutal Friendship of Whistler and Walter Greaves*. London: Hodder and Stoughton, 1970.

Post Office London Directory for 1882. London: Frederic Kelly, 1882.

Prettejohn, Elizabeth. *Rossetti and His Circle*. New York: Steward, Tabori & Chang, 1997.

Quilter, Henry. *Opinions on Men, Women, and Things*. London: Swan Sonnenschein, 1909.

Rao, C. Hayavadana, ed. *The Indian Biographical Dictionary*. Madras: Pillar & Co., 1915.

Rawnsley, H. D. *Ruskin and the English Lakes*. Glasgow: James MacLehose and Sons, 1902.

Redesdale, Algernon Bertram Freeman-Mitford, Baron. *Memories*. 2 vols. London: Hutchinson, 1916.

Rigg, J. M. "Huddleston, Sir John Walter (1815–1890). *Oxford Dictionary of National Biography*. Online ed. Ed. David Cannadine. Oxford: Oxofrd University Press, 2004.

Robertson, W. Graham. *Time Was*. London: Hamish Hamilton, 1931.

Roche, Henry Philip, and William Hazlitt. *The Bankruptcy Act of 1869*. London: Stevens & Haynes, 1870.

Rogers, Josephine White. *Patronage, Power, and Aesthetic Taste: The Marketing of James McNeill Whistler's Art and Legacy*. 2015. PhD dissertation, Rutgers University. *ProQuest*, proquest.com /docview/1748999806.

Rooksby, Rikky. *A. C. Swinburne: A Poet's Life*. Aldershot, Hants: Scolar Press, 1997.

Rossetti, Dante Gabriel. "The Grosvenor Gallery." *Times*, Mar. 27, 1877, 6.

———. *The Correspondence of Dante Gabriel Rossetti: The Last Decade 1873–1882: Kelmscott to Birchington*. Ed. William E. Fredeman. Completed by Roger C. Lewis, Jane Cowan, Roger W. Peattie, Allan Life, and Page Life. Woodbridge, Suffolk, UK: D. S. Brewer, 2006.

———. *Letters of Dante Gabriel Rossetti*. Ed. Oswald Doughty and John Robert Wahl. 4 vols. Oxford: Clarendon, 1965–1967.

———. *Letters of Dante Gabriel Rossetti to William Allingham, 1854–1870*. Ed. George Birkbeck Hill. New York: Frederick A. Stokes, 1898.

Rossetti, Dante Gabriel, and Jane Morris. *Dante Gabriel Rossetti and Jane Morris: Their Correspondence*. Ed. John Bryson and Janet Camp Troxell. Oxford: Clarendon, 1976.

Rossetti, William Michael. *Dante Gabriel Rossetti: His Family-Letters*. 2 vols. London: Ellis and Elvey, 1895.

———. *Rossetti Papers: 1862 to 1870*. London: Sands & Co., 1903.

———. *Some Reminiscences*. 2 vols. New York: Charles Scribner's Sons, 1906.

Rossetti, William Michael and Algernon Charles Swinburne. *Notes on the Royal Academy Exhibition, 1868*. London: James Camden Hotten, 1868.

Rothenstein, William. *Men and Memories: Recollections of William Rothenstein 1872–1900*. New York: Coward-McCann, 1931.

Ruskin, John. *The Brantwood Diary of John Ruskin*. Ed. Helen Gill Viljoen. New Haven, CT: Yale University Press, 1971.

———. *Christmas Story: John Ruskin's Venetian Letters of 1876–1877*. Ed. Van Akin Burd. Newark: University of Delaware Press, 1990.

———. *Dearest Mama Talbot: A Selection of Letters Written by John Ruskin to Mrs. Fanny Talbot.* Ed. Margaret Spence. London: George Allen & Unwin, 1966.

———. *The Diaries of John Ruskin.* Ed. Joan Evans and John Howard Whitehouse. 3 vols. Oxford: Clarendon, 1958.

———. *The Gulf of Years: Letters from John Ruskin to Kathleen Olander.* Commentary by Kathleen [Olander] Prynne. Ed. Rayner Unwin. London: George Allen & Unwin, 1953.

———. *John Ruskin's Correspondence with Joan Severn.* Ed. Rachel Dickinson. London: Legenda, 2009.

———. *John Ruskin's Letters to Francesca and Memoirs of the Alexanders.* Boston: Lothrop, Lee & Shepard, 1931.

———. *The Letters of John Ruskin to Lord and Lady Mount-Temple.* Ed. John Lewis Bradley. Columbus: Ohio State University Press, 1964.

———. *Letters to M. G. & H. G.* Ed. George Wyndham. London: Ballantyne Press, 1903.

———. *Ruskin in Italy.* Ed. Harold I. Shapiro. Oxford: Clarendon, 1972.

———. *The Winnington Letters.* Ed. Van Akin Burd. London: George Allen & Unwin, 1969.

Ruskin, John, and Charles Eliot Norton. *The Correspondence of John Ruskin and Charles Eliot Norton.* Ed. John Lewis Bradley and Ian Ousby. Cambridge: Cambridge University Press, 1987.

Ruskin, John, et al. *The Ruskin Family Letters.* Ed. Van Akin Burd. 2 vols. Ithaca, NY: Cornell University Press, 1973.

Saint-Gaudens, Augustus. *The Reminiscences of Augustus Saint-Gaudens.* 2 vols. New York: Century, 1913.

Seitz, Don. *Whistler Stories.* New York: Harper & Brother, 1913.

Severn, Arthur. *The Professor: Arthur Severn's Memoir of John Ruskin.* London: George Allen & Unwin, 1967.

Sickert, Walter. *The Complete Writings on Art.* Ed. Anna Gruetzner Robins. Oxford: Oxford University Press, 2000.

Smalley, George Washburn. *Anglo-American Memories: Second Series.* London: Duckworth, 1912.

———. "Whistler. A Tribute from One of His Old Friends." *New York Tribune,* Aug. 19, 1903, 10.

Smalley, Phoebe Garnaut. "Mr. Whistler." *The Lamp* 27.2 (1903): 110–12.

Spence, Margaret E. "Ruskin's Correspondence with His God-daughter Constance Oldham." *Bulletin of the John Rylands Library* 43 (1961): 527–37.

Spencer, Robin. "Whistler's First One-Man Exhibition Reconstructed." In *The Documented Image: Visions in Art History.* Ed. Gabriel P. Weisenberg and Laurinda S. Dixon. Syracuse, NY: Syracuse University Press, 1987, 27–49.

Stead, W. T. "The Labour Party and the Books That Helped to Make It." *Review of Reviews* 33 (1906): 568–82.

Sturgis, Matthew. *Walter Sickert: A Life.* London: HarperCollins, 2005.

Surtees, Virginia. *Coutts Lindsay: 1824–1913.* Wilby, Norwich: Michael Russell, 1993.

Sutherland, Daniel E. *Whistler: A Life for Art's Sake.* New Haven, CT: Yale University Press, 2014.

———. "James McNeill Whistler in Chile: Portrait of the Artist as Arms Dealer. *American Nineteenth Century History* 9.1 (2008): 61–73.

Swinburne, Algernon Charles. *The Swinburne Letters.* Ed. Cecil Y. Lang. 6 vols. New Haven, CT: Yale University Press, 1959–62.

Thomson, David Croal. "James Abbott McNeill Whistler. Some Personal Recollections." *Art Journal* (Sept. 1903): 265–68.

Tolstoy, Leo. "An Introduction to Ruskin's Works." In *Recollections & Essays.* Trans. Aylmer Maud. London: Oxford University Press, 1946, 188.

Toutziari, Georgia. "Ambitions, Hopes, and Disappointments: The Relationship of Whistler and
 His Mother as Seen in Their Correspondence." *James McNeill Whistler in Context*. Ed. Lee
 Glazer, Margaret F. MacDonald, Linda Merrill, and Nigel Thorp. Washington DC: Freer
 Gallery of Art, 2003.
———. *Anna Matilda Whistler's Correspondence—An Annotated Edition*. Dissertation, University of
 Glasgow, 2002. 3 vols.
Trippi, Peter. "Whistler, Freer, and Their Living Legacy." *Fine Art Connoisseur* 12.1 (Jan./Feb. 2015):
 48–53.
W. U. "The Winter of 1879–80 in Europe." *Science* (Apr. 18, 1884): 486–87.
Walden, Sarah. *Whistler and His Mother: An Unexpected Relationship*. London: Gibson Square, 2003.
Ward, Leslie. *Forty Years of "Spy."* New York: Brentano's, 1915.
Way, Thomas R. *Memories of James McNeill Whistler*. London: John Lane, Bodley Head, 1912.
Wedmore, Frederick. *Whistler and Others*. New York: Charles Scribner's Sons, 1906.
Weintraub, Stanley. *Whistler: A Biography*. New York: Weybright and Talley, 1974.
Whistler, James McNeill. *Eden versus Whistler: The Baronet ad the Butterfly: A Valentine with a Verdict*.
 New York: R. H. Russell, 1899.
———. *The Gentle Art of Making Enemies*, 2nd ed. London: Heinemann, 1892.
———. *Whistler versus Ruskin: Art and Art Critics*. London: Chatto & Windus, 1878.
Whistler, James McNeill, et al. *The Correspondence of James McNeill Whistler, 1855–1903*. Ed. Margaret
 F. MacDonald, Patricia de Montfort, and Nigel Thorpe, and including *The Correspondence of
 Anna McNeill Whistler, 1855–1880*, ed. Georgia Toutziari. Online ed. University of Glasgow,
 2003–2010.
Wilenski, R. H. *John Ruskin*. London: Faber & Faber, 1933.
Williamson, G. C. *Murray Marks and His Friends*. London: John Lane, 1919.
Wills, Freeman. *W. G. Wills: Dramatist and Painter*. New York: Longmans, Green, and Co., 1898.
Wilson, R. G. "Meux Family (*per*. 1757–1910)." *Oxford Dictionary of National Biography*. Online ed.
 Ed. David Cannadine. Oxford: Oxford University Press, 2008.
Woolf, Virginia. "Ruskin." In *The Captain's Death Bed and Other Essays*. New York: Harcourt Brace
 Jovanovich, 48–52.
Young, Andrew McLaren, Margaret MacDonald, Robin Spencer, and Hamish Miles. *The Paintings
 of James McNeill Whistler*. New Haven, CT: Yale University Press, 1980.

INDEX